Shooting from the Hip

Shooting from the Hip

Photography, Masculinity, and Postwar America

Patricia Vettel-Becker

University of Minnesota Press
Minneapolis || London

A shorter version of chapter 2 originally appeared as "Destruction and Delight: World War II Combat Photography and the Aesthetic Inscription of Masculine Identity," *Men and Masculinities* 5, no. 1 (July 2002): 80–102. A shorter version of chapter 5 originally appeared as "Bad Boys: Bruce Davidson's Gang Photographs and Outlaw Masculinity," *Art Journal* 56, no. 2 (Summer 1997): 69–74.

Published by the University of Minnesota Press
111 Third Avenue South, Suite 290
Minneapolis, MN 55401-2520
http://www.upress.umn.edu

Library of Congress Cataloging-in-Publication Data

Vettel-Becker, Patricia.
 Shooting from the hip : photography, masculinity, and postwar America / Patricia Vettel-Becker.
 p. cm.
 Includes bibliographical references and index.
 ISBN 0-8166-4301-6 (hc : alk. paper) — ISBN 0-8166-4302-4 (pb : alk. paper)
 1. Photography—Social aspects—United States—History—20th century. 2. Masculinity—United States—History—20th century. I. Title.
 TR183.V48 2005
 770'.973'09045—dc22

 2004021031

Printed in the United States of America on acid-free paper

The University of Minnesota is an equal-opportunity educator and employer.

12 11 10 09 08 07 06 05 10 9 8 7 6 5 4 3 2 1

For my daughters, Angelica and Shoshana

Contents

ix Introduction

1 1. Gendering Photographic Practice: Amateurs, Breadwinners, and Artists

31 2. Combat Photography: Adventurers, Heroes, and Martyrs

61 3. Tough Guys in the City: Cameramen and Street Photographers

87 4. Female Body: Artists, Models, Playboys, and Femininity

113 5. Masculine Triumph: The Male Body, the Beats, and Existentialist Modernism

143 Acknowledgments

145 Notes

191 Index

Introduction

The phallus can only play its role as veiled.
—*Jacques Lacan*

In 1955, the Museum of Modern Art launched The Family of Man, a photography exhibition that has yet to be surpassed in terms of notoriety, popularity, and international impact. After the exhibition was displayed at the museum, the U.S. Information Agency sent it on tour throughout the world for seven years. In all, more than nine million people visited The Family of Man, and its exhibition catalog has yet to go out of print.[1] Edward Steichen, the director of the photography department and the driving force behind the exhibition, spent three years preparing this monumental visual extravaganza, through which he hoped to spread the message that humanity is "one." That Steichen believed his message to be urgent is evident in his display, near the end of the exhibition, of a large photograph of a hydrogen bomb blast. This mural, which was not included in the exhibition catalog, survives in an installation shot taken by Wayne Miller of his wife and four children standing in the small darkened gallery in which it was hung (Figure 1). Miller's photograph encapsulates the duality that informs The Family of Man and postwar society in general: anxiety and its alleviation, the terror of the bomb, and the comfort of the family.

Miller was Steichen's chief assistant on The Family of Man and was thus in a

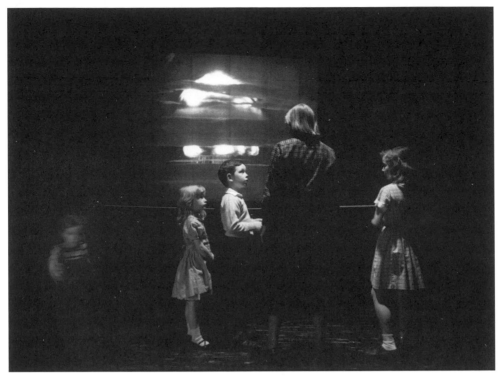

Figure 1. Wayne Miller, "Wayne Miller's Wife and Children in Front of a Picture of the H-Bomb at The Family of Man Exhibition at the Museum of Modern Art" (1955). Copyright Wayne Miller/ Magnum Photos.

prime position to have photographs of his family included in the exhibition. Indeed, his shots of his wife in labor, giving birth, and nursing her baby formed the centerpiece of the twenty-page section of the catalog devoted to motherhood. Only four pages addressed the issue of fatherhood. This imbalance is not surprising, for Steichen had made a special plea for "photographs that reveal the selflessness of mother love," not just the "Madonna element" but "her all embracing love, with the sense of security she gives to her children and to the home she creates in all its warmth and magnificence, its heartaches and exaltations."[2] As did the cult of domesticity that dominated U.S. culture in the 1950s, The Family of Man looked to women to soothe Cold War fears, to sacrifice themselves to the needs of others, to strengthen the shaky foundation on which postwar masculinity was erected. Although Miller's shot of his family before the image of the bomb may be read in terms of that intense need to embrace the creation and nurturance of life rather than its destruction, it also stands as testament to the postwar fascination with the aesthetics of that very destruction, the sublime and unprecedented beauty achieved through these seemingly miraculous explosions wrought by modern science.

Today, reference to the 1950s conjures up notions of a simpler time, an era when kids hung out at soda counters, Mom wore an apron, and Father knew best. Even those of us who did not live through those years have formed a collective memory of

it through the television reruns that have kept the era alive. However, like The Family of Man, those fictional programs should be understood not as reflections of the reality of U.S. life in the 1950s[3] but as reactions against the cultural anxieties that were bubbling beneath the surface, including those concerning gender roles. Indeed, what those television programs do not reveal is the acute insecurity, and often guilt and shame, that men experienced in the aftermath of World War II. Not only had the women in their lives made do without them, but many men had killed or, even worse, had been unable to kill,[4] thus failing to live up to the warrior ideal society expected of them.

According to Kaja Silverman, World War II disrupted belief in what she terms the "dominant fiction," the ideology of masculine wholeness, mastery, and autonomy that is necessary to the maintenance of patriarchy—the domination of women by men and the prioritizing of the masculine over the feminine. She argues that the dominant fiction remains "intact" only so long as the soldier is on the battlefield, somewhat shielded from war trauma through his identification with the warrior group. After the war, when the traumatized veteran is alone, without the fortification of his comrades, nothing stands between him and the "abyss" upon which his masculine identity is constituted. Furthermore, the civilian population no longer has the "heroic abstraction" of the invincible soldier in which to believe. The visible veterans, who are often psychologically or physically wounded, sometimes dismembered, are not able to uphold collective belief in the dominant fiction.[5] War is thus a case of "historical trauma," which Silverman defines as any historical event, whether socially engineered or naturally occurring, that forces a large group of male subjects to confront their inability to measure up to the masculine ideal.[6]

After the trauma of World War II, masculinity was strictly differentiated from femininity. For example, a faculty member at the all-women Stephens College bragged in 1948 that the successful marriage rate of its graduates was a result of the school's emphasis on femininity as "the opposite of directness, aggressiveness, and forcefulness," which were considered masculine traits.[7] In fact, it was commonly assumed that no man would want to marry a woman who exhibited such characteristics. Femininity was forced to function as a negative mirror for masculinity. For example, because masculinity was characterized as hard, active, and rational, femininity must be soft, passive, and emotional, so that men could feel secure in their gender identity. Women were thus made responsible for maintaining masculinity. If they did not remain within the confines of their feminine roles, they were blamed for men's masculine "failures." Mothers were excoriated for imposing their wills on their sons. Wives were considered responsible for any marital problems that arose, especially if they worked outside the home, for no man could be a *real* man if his wife had to, or wanted to, work.[8]

Shooting from the Hip explores the way photography functioned within the postwar restructuring of the dominant fiction. Not only was photography able to offer proof that intact male bodies still existed, the practice itself became an arena in which to enact a variety of masculine types—breadwinner, warrior, tough guy, playboy, and rebel—all of which worked to support the dominant fiction, even though they

seemed, at times, to oppose each other. Art historian Abigail Solomon-Godeau speaks of this "elasticity," the ability of various models of ideal masculinity to exist simultaneously without necessarily challenging or subverting the patriarchal order.[9] Although the coexistence of these different masculine formations may appear to call into question the masculine/feminine binary discussed above, I would argue that the surfacing of alternative models may at times prompt an even stricter enforcement of this binary. It is also important to remember that gender constructions are never stable; nor do they ever fully explain or match the actual lived experiences of individuals, who must navigate their way through these shifting ideologies.

Like the term "masculinity," the term "art" is fluid, rather than fixed. "Art" is a status conferred on objects, presumably because of universal notions of aesthetic quality but actually in relation to issues of power. Some postwar photographers used the term "art" to legitimize their practice and to associate themselves with a certain social and economic class; others distanced themselves from the term because of what they saw as its feminized connotations. My discussion of the "photography world" separates it from the other "art worlds,"[10] primarily because that is how these photographers saw themselves—as separate. Except in those museums that exhibited both photography and the traditional arts of painting and sculpture, such as the Museum of Modern Art in New York, the two spheres rarely intersected. Even museums that included photography usually displayed it in a separate department. Postwar photographers had their own journals, organizations, and agencies; they competed with, and spoke to, each other. Even those photographers who aspired to the status of fine art for their work were much more concerned with the activities and opinions of photojournalists and commercial photographers than they were with those of painters and sculptors and their institutional supporters. In the majority of photography journals, articles about such fine-art luminaries as Paul Strand and Ansel Adams appeared alongside articles about how to set up a home darkroom, how to take photographs at a crime scene, and how to deal with a demanding magazine editor. Even Beaumont Newhall, one of the most outspoken champions of fine-art photography, published articles in such journals as *Popular Photography* and even *Popular Mechanics,* which frequently addressed issues of concern to photographers. Although each photography journal had a somewhat different focus, none—not even *Aperture,* which concerned itself primarily with fine-art and particularly modernist photography—was constructed entirely along the lines of a separation between fine-art and commercial/journalistic photography. In fact, these two categories were problematic for postwar male photographers, as I discuss in chapter 1. Therefore, I make no attempt to separate artistic from commercial or journalistic photography, except to examine these categories as photographers used them to construct their own masculine positions in relation to other photographers and other artistic practitioners, such as painters and writers. In fact, the concept "art" was primarily a weapon to be used in the establishment of a masculine pecking order. Furthermore, photographs continually crossed boundaries during this period—any photograph, no matter its original context, could undergo "museumization" and become "art."[11]

Thus, my project deals with those canonized and not canonized, as well as with the mechanism of canonization itself. Indeed, one of my primary concerns is the way gender informs the writing of the canon. For example, within the history of photography, a key canon-forming text has been John Szarkowski's *Looking at Photographs: 100 Pictures from the Collection of the Museum of Modern Art*. Although women figure prominently among the represented photographers whose works date from before 1945, no women are among those chosen to represent the postwar period.[12]

Chapter 1 of *Shooting from the Hip* addresses the gendered discourse surrounding the practice of photography. From the late nineteenth century through the 1930s, photography was deemed acceptable, even promoted as ideal, for women. Women were considered especially suited to the practice of portraiture, the foremost professional field. Moreover, the amateur practice of pictorialism was actually feminized in an attempt to gain the medium's acceptance as an art form equivalent to painting. Grace, delicacy, and an eye for beauty—qualities believed essential to women—were valued because they were considered important in mitigating the severe mechanical effects of the camera.

Although professional standards and financial reward had long been a concern for photographers, attempts to professionalize and profit from the practice intensified after World War II, partly due to the increasing cultural prominence of photojournalism. Dissatisfied with the narrow space afforded photography within the institutional art world and with the loss of New Deal financial support, photographers turned to other strategies to create spaces for themselves within the expanding postwar marketplace. These strategies included photo agencies, photographic books, filmmaking, professional organizations, and stricter guidelines regarding the rights of freelance photojournalists. I examine this professionalization as an attempt by male practitioners to reclaim the identity of breadwinner, a response to postwar status anxiety, which was related to the increasing number of women in the workplace and to the homogenization of the corporate sphere. Professional photographers became especially concerned with differentiating themselves from amateurs, many of whom were women, and with the rejection, even denigration, of pictorialism, which was still a major presence in the photography world.

Modernist photographers also sought to distance themselves from the pictorialists,[13] a much more difficult task because both factions subscribed to the notion of "art" photography. Unlike pictorialists, however, modernists privileged straight photography, the photographer's eye rather than the mediated print. Working in the tradition of Alfred Stieglitz, modernists also continued to promote photography as a practice independent of financial concerns, for to sacrifice autonomy to please others was considered a form of emasculation. The photojournalist and the modernist photographer, representing two different models of masculinity, engaged in a heated debate that was constructed along the dichotomies of science and art, realism and artifice, public and private, and commercialism and creative autonomy.

In chapter 2, I examine the combat photographer as "autonomous adventurer," the antithesis of the corporate-suburban breadwinning male. As a photographer, a

man could fashion himself as an "action hero," traveling to military conflicts all over the world. Combat photography involved danger and the willingness to risk one's life, and it thus infused the profession with an active physicality that not only affected the practice of other genres, such as street photography, but extended to the photographic aesthetic itself. Indeed, because of the valorization of action and danger, the blurred shot became a signifier of credibility, thus of truth.

Through a reading of combat photographs, I discuss the way the imagery of war is intertwined with the ideology of masculinity. Both are predicated on violence and the subjugation of the feminine, which in war is encoded in the body and territory of the enemy. This subjugation is even more extreme when the enemy is of another race—for example, the Japanese in World War II or the Koreans in the Korean conflict. The voyeuristic pleasures of domination enabled by photography reach an extreme in the imagery of the atomic bomb; however, because these images are presented through the conventions of the landscape tradition, such pleasures are deemed morally sound through the socially acceptable act of aesthetic contemplation.

In chapter 3, I trace the decline of social documentary, the prominent photographic mode of the 1930s, and the rise of street photography. After World War I, street photography became linked to the hard-boiled specialization of crime photography, a field exemplified by the career and carefully constructed persona of Weegee (Arthur Fellig). I examine Weegee's popular 1945 photographic book *Naked City* within the context of detective novels and film noir, not only in terms of subject matter and aesthetics but also in terms of the parallels between Weegee and the masculine heroes of these novels and films, who go underground to capture and demystify the objects they stalk.

Postwar street photography was concerned with capturing a brutally direct image, often by provoking the subject. Therefore, unlike earlier practitioners working in the tradition of Eugène Atget, some postwar photographers sought an aggressive relationship with the life and culture of the street. This attitude was exemplified by the work of William Klein, whose approach to street photography was like that of a boxer who refuses to obey the rules. In fact, for Klein, shooting the street was an intensely physical experience, not unlike the action painting practiced by his contemporary Jackson Pollock. For Klein, the city functioned as a canvas, and his photographs as indexical traces of his physical presence.

Chapter 4 concerns the rise of fashion, glamour, and centerfold photography. Fashion photography was a major source of income and artistic expression for photographers, many of whom, including Weegee and Klein, also worked as street photographers. The postwar "stars" in the world of fashion were Richard Avedon and Irving Penn, whose highly publicized relationships with their models functioned to sexualize fashion photography. I discuss the relationship between the photographer and the fashion model within the context of the traditional artist-model trope—the possession and subsequent transformation of the female body through the creative "genius" of the male practitioner. This asymmetrical power relationship is carried to an extreme in the photographing of the female nude. Indeed, centerfold photography

became a cultural phenomenon with the 1953 founding of *Playboy* magazine, whose photographers were publicized as the consummate playboys.

Chapter 5 deals with the importance of the male body to sports photography, a rapidly growing field, and to those photographers who subscribed to the masculinist philosophy and aesthetic of the Beats. Sports photography highlighted not the passive female subject of fashion and centerfold but the active and the highly developed male body. Whereas fashion and centerfold photographers looked to the female body as the site of interior truth, the "essence" of femininity, sports photographers fetishized the male body as the site of exterior truth, as visual proof of phallic power and unity. The aggressive nature of sports drew attention away from the homoerotic connotations of such close scrutiny, placing it safely within the realm of heterosexual spectatorship.

The Beat movement centered on the autonomous male and the primacy of experience. A pivotal figure within this discussion is Robert Frank, who fashioned himself as an avant-garde artist, as an alienated and misunderstood outsider who did not believe in "selling out." The publicity generated by Frank's 1959 photographic book *The Americans* secured the photographer's status as societal rebel. Frank's anti-establishment attitude entered his imagery in the form of an anti-aesthetic—a gritty, dark, blurred quality to his prints—and in his choice of "outsider" men as subject matter. The Beats romanticized men who they believed had been neither emasculated by the corporate sphere nor domesticated by women: African Americans, juvenile delinquents, outlaws, and drifters. I close chapter 5 with a discussion of Bruce Davidson's photographic series on a Brooklyn gang, imagery that exemplifies Beat notions of a potent masculinity outside the law. Davidson is one of the most important of Frank's "successors," emulating him in both subject matter and aesthetic, as well as in the rejection of exterior political motivations in favor of an apolitical subjective stance.

The work of Frank and Davidson also marked the triumph of a "new" modernist photography, one centered on individual artistic expression but opposed to the formalist aesthetics of previous forms of modernism, which had come under attack as effeminate, sterile, and escapist. Rather than advocating being true to the medium and adhering to a transcendental aesthetic, this modernism sought an existentialist truth and anti-aesthetic predicated on the primacy of masculine subjectivity and the authenticity of the male body. This continuing quest for truth, central to the tenets of modernism, was related to Cold War anxiety. Indeed, the realism enabled by photography provided security by packaging the world for consumption, containing it within iconic images, and at the same time serving as evidence of the male photographer's perilous, yet successful, journey through that world.

Shooting from the Hip is as much an engagement with existing historical narratives about postwar photography as it is an attempt to narrate anew, an intervention that insists that gender no longer be taken for granted. In fact, I would argue that gender is not an extraneous category, that it is arguably the primary structuring principle through which we construct our personal identities and thus the practice of our lives, and that it is intricately intertwined with other aspects of identity, such as race,

class, sexuality, nationality, ethnicity, and age. Moreover, it is not possible to extract one aspect of identity from others, including a gendered identity from an artistic or professional one. My overall goal is thus to allow the photographs and the primary discourse to appear within the context of gender, so that power relationships can be denaturalized and thus *seen,* and so that the veneer of neutrality and universality can be removed, the phallus unveiled.

1 | Gendering Photographic Practice: Amateurs, Breadwinners, and Artists

Photography is a mass of detail to which few men are fitted, and, at the best, are never equal to women.
—*George G. Rockwood, 1900*

Somewhere in the shuffle, the pretty girl has gotten herself on the wrong side of the camera and thereby pushed photography back twenty years. No one seems able to tell these charmers it isn't enough to get an image on a sheet of film. There's a disarming, almost childlike delight when confronted with one of their own, handmade pictures that can only be considered as an offshoot of the maternal instinct (especially if, fortuitously, her husband happens to be a photographer, too).
—*Male fashion photographer, 1951*

Far from being unusual, the above quotations are typical in their attribution of success in the photographic field to the photographer's gender. From the nineteenth century, when photography was in its infancy, through the postwar era and beyond, gender has played a fundamental role in the formation of photography's discursive and institutional fields. Photography functions as an organizational culture, a "system of meanings produced and reproduced when people interact," and as the sociologist Silvia Gherardi argues, "organizations, despite their claim to be neuter and neutral, are structured according to the symbolism of gender."[1] Capitalism is mutable; it changes as new technologies and work processes are introduced. This fluidity extends to the sexual division of labor. New patterns of segregation and sex-typing arise to replace the old, in keeping with contemporary notions of masculinity and femininity. Therefore, as both society and photography change, so does the ideological climate surrounding the profession, which determines whether photography is hospitable or inhospitable to women. Such sex-typing of occupations is also related to the importance placed on a particular profession by society at large; therefore, tasks that are at one time considered "women's" may come to be defined

1

as "men's" if that task becomes more culturally relevant.[2] The period between World War II and the ascendancy of television in the late 1950s was the peak years of the picture magazines, particularly *Life*. Never before had photography played such an authoritative role in everyday life, and as I will argue, never before had photography been so heavily gendered masculine, so characterized by traits traditionally associated with men.

The Professional Breadwinner and Postwar Photography

Before the postwar period, the practice of photography had been constructed as more hospitable to women. In 1890, Margaret Bisland claimed that "beyond any possible, probable shadow of a doubt, women with their cameras surpass all traditions and stand as the equals of men in their newly-found and now most ardently-practiced art."[3] Not only did U.S. women enjoy success as photographers around the turn of the century,[4] but photography was actually promoted as an occupation or amateur activity ideally suited for women. In her 1897 book *Occupations for Women*, Frances E. Willard claimed that a woman's "pleasing manners" and "obliging disposition" were conducive to professional success in the field, because nearly two-thirds of a photographer's patrons were women and children. Moreover, she held, a woman is blessed with the "natural gift" of a "perfectly developed" artistic sight; thus, a woman photographer "quickly grasps the beautiful and harmonious in nature and in art" and "naturally understands posing, colors in dress, and all the details that make up the artistic photographs of women and children."[5] Richard Hines Jr. echoed these sentiments in 1899, going so far as to claim that "there is no more suitable work for woman than photography." According to Hines, not only do women have natural artistic talent and a "light, delicate touch," but they also possess cleanliness and patience, which he considered to be two of the most important qualities necessary to succeed as a photographer.[6]

Photography was also a widely practiced amateur activity, and for ten dollars, one could buy a small camera, a tripod, lens, plates or film, and a supply of preparations for developing and printing. A woman could set up a home studio—a corner of a room and an empty closet for a darkroom would suffice. Amateur photography was often seen as a means by which genteel women could express their artistic desires without neglecting their domestic responsibilities.[7] A home studio could also benefit the professional, however, as could "home" photography, the taking of portraits in the sitter's residence. According to a 1914 article, a woman was more readily admitted to the "intimacies" of the private home, and if anyone could understand the relationship between children and mothers, a necessity in photographing them, "it must surely be another woman."[8] Women were also encouraged to be "snapshooter" hobbyists, a group that had grown considerably since George Eastman began marketing the Kodak in 1888. A small camera with film that could be sent back to the factory for processing enabled one to "be" a photographer without access to a darkroom. As the company's slogan promised: "You press the button; we do the rest." Recognizing the

role of women in handling the family's money, Eastman began to direct his advertising specifically toward middle-class women. He also capitalized on the promotion of bicycling as an ideal sport for women. Because the Kodak did not require setting exposure times or focusing, one could snap a picture while cycling.[9] The "Kodak Girl" became the central motif in advertisements for Kodak cameras and remained so until 1945.[10]

By the 1940s, articles promoting women's unique abilities as photographers had all but disappeared. In fact, in 1943, the editor of *Popular Photography* asked why women photographers were not more successful, claiming that although they have "lovely faces and good publicity to help them get started, they're pretty far behind the men."[11] Although one may wonder what "lovely faces" have to do with success as a photographer, the raising of the question does signal that a change in the profession had occurred. Indeed, by World War II, professional photography came to be characterized more by photojournalism than by portraiture. Although private studio and commercial photography continued to flourish, the practice of photojournalism began to dominate professional discourse. With the ascendancy of the picture magazines, such as *Life* and *Look,* and with increasing public demand for photographs during the war, the photojournalist had also become an important cultural figure. *Life,* with a circulation of nearly six million and a readership estimated at over twenty million,[12] paid its photographers well; they also traveled in style on generous expense accounts. W. Eugene Smith, one of *Life*'s star war-correspondent photographers, enjoyed a salary of $26,000 a year in 1946,[13] about seven times the average income of a white-collar employee in the late 1940s.[14] Not surprisingly, to be on the staff at *Life* became the ultimate goal for many photographers. As Gordon Parks recalled, after successful stints working for Roy Stryker at the Farm Security Administration (FSA) and the Standard Oil Company, what he "wanted was what so many photographers, black and white, found almost impossible to get; a staff job at *Life* magazine." Soon after Parks was hired—the first African American photographer to be so—he was assigned to the Paris Bureau for two years, during which he and his family were housed in a luxurious four-story English Tudor building with maid and butler and were given use of a vacation home at Cannes, with a housekeeper-cook.[15]

According to sociologists writing at the time, the immediate postwar years were a time of anxiety and frustration. The war had caused massive societal upheaval; families had been torn apart, women had entered the workforce in large numbers, and an economic boom had replaced the Great Depression. The transition from market to corporate capitalism, marked by the specialization and centralization of labor, necessitated bureaucratization to control the growth in the scale and increasing complexity of organizations. With such rapid stratification, people were forced to scramble for their "place." Returning soldiers needed to readjust, and those already working feared for their jobs. The middle class was growing rapidly, and status began to depend more and more upon occupation and conspicuous consumption. A house in a fashionable suburb became the American Dream, and making money was a man's first priority.[16]

In *Homeward Bound: American Families in the Cold War Era,* Elaine Tyler May analyzes what she terms the "domestic version of containment," the postwar ideal of "successful breadwinners supporting attractive homemakers in affluent suburban homes."[17] The nuclear family was ideologically constructed as a safe haven from an anxiety-ridden and dangerous world, and its stability was dependent on firmly established and separate gender roles for men and women. According to one postwar sociologist, "the American male, by definition, *must* 'provide' for his family. He is *responsible* for the support of his wife and children. His primary area of performance is the occupational role, in which his status fundamentally adheres; and his *primary* function in the family is to supply an 'income,' to be the 'breadwinner.'"[18]

Not surprisingly, such intense pressure led to rampant status anxiety, and sociologists began to recognize what they termed the "other-directed" and the "organization" man, those members of the new middle class who felt pressured to conform, to merge with the group to be successful.[19] Belonging and a sense of safety had become more important than individual autonomy. The provider role took precedence over personal achievement; these men accommodated themselves to bureaucratic restraints in exchange for financial security for their families. For an "organization man," one of the only avenues available for individuation was to carve out a special niche within his occupation that differentiated him from the "mass." David Riesman coined the term "marginal differentiation" to refer to this anxious need to prove one's uniqueness without stepping too far outside the boundaries of the defined norm for the group.[20]

Male photographers, like all men, felt pressured to make money and create a professional space for themselves. Amateurs were advised to "turn pro" by opening their own studios, and veterans who had received photographic training during the war were told that they could make a living wage by putting these new skills to work as news, advertising, or portrait photographers.[21] Other growing postwar fields included photographing for corporate magazines and shooting film stills on Hollywood movie sets, where fees ranged from five hundred to one thousand dollars a week.[22] The increased status of photography as a career was expressed in a letter to the editor of the *National Photographer: The Professional Journal of Photography,* which was founded in 1950 as the new official publication of the Photographer's Association of America, in existence since 1879. The writer claimed that the members of this organization were finally "headed for the long deserved, but never attained, recognition as professional men worthy of a place among professionals of the highest calibre."[23]

Few photographers enjoyed financial success as strictly fine-art photographers. There was little market for this type of work. Julian Levy was one of the few New York art dealers who had exhibited photography in the 1930s and 1940s. In his memoir, he lamented that he had failed in his "attempt to bring photographs into the market as fine art in a price range adequate to justify limited editions."[24] Most full-time photographers who did fine-art work also did commercial work to support themselves, and some had worked for the government as documentary photographers. After New

Deal support ended in 1943, these photographers felt even more pressured to construct a new professional space for themselves, one that answered the needs of the expanding postwar market and that "differentiated" them from other image makers as well as from other photographers.

In the 1950s, there were few places in New York City that exhibited photography. One was Helen Gee's Limelight Gallery and coffeehouse, in business from 1954 to 1961, which also acted as a meeting place for photographers. Gee had conceived of the coffeehouse as a means to financially support the gallery, which she knew would be unable to sustain itself.[25] Indeed, the average sale from an exhibition was about two prints at $25 each, of which the gallery received a 25 percent commission. Prices ranged from $10 for an Imogen Cunningham or Minor White to $125 for a Paul Strand, whose high-priced prints did not sell.[26] The Limelight's most successful exhibition was its 1954 Christmas group show, in which nineteen of forty-five prints were purchased.[27] Even for a photographer granted a one-person show, the earnings were minimal. A 1955 Eliot Porter show of sixty-three photographs resulted in the sale of one print at a price of $50, minus Limelight's commission.[28]

Laurence Siegel's Image Gallery also exhibited photographs, but because photographers were charged about $75 for gallery space, they were unable even to recover expenses.[29] In 1954, Brentano's on Fifth Avenue exhibited forty photographic prints for sale at $25 each; however, only two sold.[30] Other exhibition spaces were the Photo League, which disbanded in 1951; Roy DeCarava's short-lived Photographer's Gallery, a small exhibition space in his home; and the Museum of Modern Art, whose photography department was under the direction of the photographer Edward Steichen from 1947 to 1962.[31] Steichen changed the format of exhibitions, moving away from the art-historical or connoisseurial style established by his predecessor, Beaumont Newhall, and toward a journalistic format, in which he manipulated scale, cropped prints, and often omitted mats, frames, and even the photographers' names.[32] Indeed, Steichen's adoption of a photo essay model for his museum exhibitions signifies the extent to which magazines, particularly *Life*, had come to define photographic practice. In addition to his emulation of the photo essay for a number of exhibitions, Steichen paid tribute to the photojournalist in his 1949 exhibition, The Exact Instant: Events and Faces in 100 Years of News Photography, and in his 1951 Memorable Photographs by Life Photographers; in the press release for the latter exhibit, he explained that "photographers working in the field of journalism have collectively made a major contribution to the art of photography" and that photographic journalism "is becoming a new force in the molding of public opinion, and in explaining man to man."[33]

Because photography was afforded such a small space within the institutional parameters of fine art, even photographers who aspired to such status for their work were forced to construct their profession outside the museum-gallery framework. In addition to seeking commercial work with magazines and advertising agencies, some turned to the photographic book and to filmmaking as ways to further their financial potential and gain publicity. Weegee, Ansel Adams, William Klein, Richard Avedon,

Philippe Halsman, David Douglas Duncan, Robert Capa, and Robert Frank were among those who published books of their work during the postwar years. Among the photographers who worked as filmmakers were Weegee, Helen Levitt, Morris Engel, Robert Capa, William Klein, Robert Frank, Louis Faurer, Ted Croner, Bruce Davidson, and Don Donaghy.[34]

Therefore, photographers dealt with status anxiety by expanding and defining their profession. Moreover, by constructing a separate institutional and discursive field, photographers worked to differentiate their profession from such fine arts as painting. Thus, photography could operate on its own terms, not on those set by a gallery-museum system that privileged other media. In fact, picture agencies had arisen to provide photographers with professional management in much the same way as a gallery dealer represented a painter or sculptor. Among the leading agencies were Black Star, FPG, Graphic House, Globe, Pix, and Rapho Guillumette. Most professional agencies charged a fee of between 35 and 50 percent, but in turn, they usually provided their photographers with a steady income based on a drawing account arrangement. Although the primary functions of an agency were to secure work and provide secretarial services, agents also acted as critics and researchers,[35] thus providing a wide range of professional support for their photographers.

In 1947, Magnum was formed as a cooperative agency by the photographers Henri Cartier-Bresson, Robert Capa, David Seymour (known as Chim), George Rodger, and Bill Vandivert. Also among the original investors were Rita Vandivert, agency president and head of the New York office, and Maria Eisner, secretary-treasurer. In a cooperative, photographers enjoyed independence and control; they worked for themselves and not for an outside agency or magazine. At Magnum, photographers turned over between 25 and 40 percent of their earnings to the organization. In return, they were able to choose their assignments and retain the rights to their negatives. As Jacquelyn Judge stated in a 1949 article, "Magnum gives its members the prestige of an organization without the usual drawbacks."[36] Agencies gave photography the status of a business and their photographers the persona of the professional middle-class male. A cooperative promised the same "prestige," with the added connotations of entrepreneurship.

Professional associations were also founded. The most prominent and influential was the American Society of Magazine Photographers (ASMP), which was organized by thirteen photographers in October 1944 and elected its first officers in February 1945. By the end of 1945, the society had grown to 125 members and had published its first bulletin, later called the *ASMP News,* and after 1952, *Infinity.* By 1954, its membership had risen to 331. The purpose of the ASMP was to raise the prestige of the profession and to gain economic protection for its members. In 1951, the society established its first Code of Minimum Standards, which "[authorized a] constant survey of rates paid by magazines, prohibited members from working below minimums authorized by the Society for various publications, outlawed speculative practices in which editors agree to pay only if the work is accepted, and imposed penalties

for infractions."[37] The ASMP further reinforced magazine photography as a profession by retaining legal services for the society and its members, securing workmen's compensation for freelance photographers, sponsoring university short courses, and making health and accident insurance available.[38] The ASMP also functioned to masculinize photojournalism. As the sociologist Jeff Hearn argues, professionalization makes a job more appealing to men. It increases the status of the position and it establishes a professional ethic based on rationality, coded masculine, rather than emotionality, coded feminine.[39]

Gender Anxiety/Gender Divisions

Anxiety over social status based on income and profession was joined in the postwar years by anxiety over gender roles. The Great Depression had worked to undermine the authority granted to men as the breadwinners in the family, and during the war that followed, many women had become the heads of their households, some the major financial support. However, the entire country had been sold on a war based on masculine honor, on fighting for the women back home. How could a brave and heroic soldier maintain this position as a civilian? How could men negate those gains that had been made by women in order to regain what they believed was their rightful place in society and within the home?

As an organizational culture, photography worked to ameliorate this anxiety by creating physical and symbolic divisions that reinforced the strict differentiation between genders that characterized postwar society. These divisions structured both the social and cultural role of the photographer and the nature of photography itself. Articles in photography journals assumed that the photographer was a man and that the object to be photographed was a woman, rarely vice versa. Men were instructed on how to light bare shoulders, on how to photograph their wives at home and their girlfriends on the beach.[40] Women often played the role of the long-suffering photographer's wife, as in the 1950 article "I Married a Lensman!": "If I am to have any companionship, I must make the dark room a part of my life forever."[41] As a "fair warning to intrepid young ladies currently seeking positions as photographers' wives," *Infinity* published a tongue-in-cheek letter from Ruth Hartmann to Princess Margaret of Great Britain, who was about to marry the photographer Antony Armstrong-Jones. Hartmann warned the princess about the pitfalls of marrying a photographer, advising her to stay out of the darkroom and never to call any print "Pretty."[42] Other articles argued that women should assist their husbands. *Infinity* had previously published an article written by a photographer's wife about the "thousand ways in which you can be Helpful," prefaced with the statement: "We have felt for a long time that the wives behind the men behind the cameras deserved more recognition for their contributions to magazine photography."[43] Wife-as-helpmate was also the subject of a 1949 article in which the author writes that she does not wish to go back to being the girlfriend, "the center of and reason for every picture," but

prefers the "secondary functions" of "holding things," keeping track of equipment, and washing off the prints he "left soaking overnight in the laundry tubs." Indeed, she declares that she would "trade the limelight any time for the shared fun and excitement of being just a photographer's wife!"[44]

As photography took its practitioners out of the home and into the public sphere, the profession increasingly depended upon a "servicer," usually a wife, who was needed to perform duties for her husband so that he could devote his full energy to the furthering of his career. As Anne Witz and Mike Savage argue, the assumption that a servicer is necessary contributes to the masculine gendering of a profession.[45] Indeed, Mrs. Clinton E. Ford considered her career to be that of a "photographer's wife," a "career of cleaning up chemical stains."[46] Another article advised women on how to utilize their husbands' darkroom equipment in their household chores, since their husbands' photography hobby would take financial precedence over replacing worn-out kitchen equipment.[47]

Barbara Ehrenreich has argued that the importance of hobbies for postwar men was related to the valorization of the suburban family home and the simultaneous need to "escape" from the confines of that domestication.[48] Whereas the late-nineteenth-century "home" amateur was a woman who had set up a darkroom in a corner of her house so that she could pursue her favorite pastime without neglecting her household duties, the postwar hobbyist was a man with a darkroom in the basement or attic, where he could flee from his wife and children. The exclusion of women from this space is represented by the term "darkroom widow," which appeared in numerous articles in photography journals, referring not only to the wives of professional photographers but to the wives of amateurs as well. In 1946, one such "widow," Jane Ellis, wrote an article pleading with men to allow their wives to share their cameras and darkrooms. Ellis rejects the arguments men use to keep women away from photography: Wives would break their husbands' cameras; women do not understand mechanics and chemistry; women do not want to stain their hands; women do not have the time to devote to it. Instead, she claims that "photography is a man's game" only "because he made it so," and that "it is the men, not the fear of a few brown stains, that keep women from enjoying it."[49] Enid Rubin reiterates Ellis's argument fourteen years later, blaming "photocentric" men for teaching their wives "to regard a viewfinder not as a window on the world but as a nasty forbidden keyhole."[50] Indeed, Lucille Nappi's requests to photograph were repeatedly met by her husband's argument that photography is a "man's game."[51] One female rebel was even compelled to ask whether women were "allergic" to photography, for men had usurped the role so completely that it had become as "mysterious" as the "world of science" (Figure 2).[52] On the other hand, some wives were permitted access to their husband's hobby—as models and equipment carriers (Figures 3, 4).[53] The extent to which men dominated the practice is evident in a 1959 *U.S. Camera* article that profiles the journal's average reader. Dubbed "Mr. U.S. Camera," he is described as a married man in his thirties with two children who holds a professional or managerial position and earns between five thousand and ten thousand dollars a year.[54]

Figure 2. John Ruge, from Rita Cummings, "Are Women Allergic to Photography?" *Popular Photography* 43 (July 1958). Copyright John Ruge.

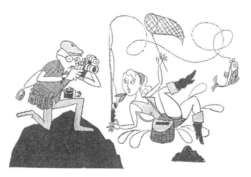

Figure 3. Joyce M. Starr, "Serving as model for those dramatic action photos," from "How to Live with Your Husband's Hobby," *Camera 35* 3, no. 3 (1959). Copyright Joyce M. Starr.

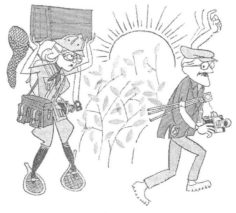

Figure 4. Joyce M. Starr, "Accompanying friend husband on an early morning trek," from "How to Live with Your Husband's Hobby," *Camera 35* 3, no. 3 (1959). Copyright Joyce M. Starr.

The historian Peter N. Stearns argues that the increased emphasis on photography as a specialized hobby was related to the desire of postwar men to maintain the masculine tradition of "developing skills and manipulating things," a reaction against women's growing presence in the workplace.[55] The overwhelming number of articles dealing with the technical elements of photography speaks to this continual drive to specialize the practice, one fueled in large part by the advertising campaigns of manufacturers of photographic equipment.[56] Middle-class men, especially those whose professions lacked the opportunity for physical labor, turned to their leisure activities to reinforce a threatened masculine identity. Photography allowed a man to reconnect with the artisanal tradition—to "work with his hands"—and it also allowed him freedom from the physical confines of both home and workplace. For example, a medical doctor wrote that photography was an ideal outlet for the "professional man" because it brings him "out into the open" where he can "appreciate nature in all her varying moods," after which he can return to "his office refreshed in body and spirit."[57]

Another issue concerning sex discrimination that many women raised was that of the all-male camera club. In an article entitled "Sixteen Men and a Girl," Rita Connolly reported on a meeting of the Baltimore Camera Club during which the members shot photographs of a female model who had been invited to attend.[58] As in a bachelor party with female entertainment, the woman was allowed into the masculine space only to serve as the object of their collective gaze. In 1948, to prove it was "progressive," the Camera Club of New York held a Women's Invitation Exhibition, which featured the work of such prominent photographers as Lisette Model and Nina Leen.[59] This compartmentalizing of women photographers was not confined to camera clubs. In 1949 and 1950, the Museum of Modern Art held an exhibition entitled Six Women Photographers, which featured the work of Margaret Bourke-White, Helen Levitt, Dorothea Lange, Tana Hoban, Esther Bubley, and Hazel Frieda Larsen. The purpose of the exhibition was not only, or perhaps not even primarily, to showcase the talents of these six women; rather, it was to demonstrate how their photographs were used in a program to provide educational posters for the National Foundation for Infantile Paralysis.[60]

Professional organizations were also structured along gender lines. In 1949, four of the five stockholders at Magnum were men; the one woman was not a photographer, however, but the manager of the New York office, where she was assisted by "four young ladies earnestly prodding their typewriters."[61] At *Life* magazine, the majority of photographers were men; picture editors, researchers, and reporters tended to be women. In 1948 and 1949, thirty-three of the thirty-five staff photographers at the magazine were men, but all ten picture researchers were women. In 1952, former *Life* editor Wilson Hicks wrote that researchers are "invariably young women who collect and check facts primarily in the office and by telephone," whereas reporters work primarily outside the office.[62] In 1950, Nina Leen was the only woman staff

photographer out of thirty-eight, yet thirty-seven of the forty-seven reporters at *Life* were women. As Dora Jane Hamblin, a former researcher and reporter, remembers:

> There was a vague theory that the combination of male photographer and female re-
> porter created a social unit which was more easily managed and assimilated when the
> team dealt with people. They could fit as a "couple" into dinner parties, outings, any
> social occasion. Perhaps that was true, though it has always been my conviction that in
> those preliberation days it was simply easier for *Life* to convince women to be photog-
> raphers' handmaidens than it would have been to force men into the role.[63]

Hamblin describes this relationship as a "mutual dependence which quickly grew into a love-hate relationship not unlike a marriage." The reporter would resent having to carry the heavy camera bags and serving as the target of the photographer's scorn, for he would blame her for holding him to the shooting script, which he considered a restraint on his creativity.[64]

The gender dynamics informing this relationship are evident in a 1952 *Infinity* article in which the photographer Robert Mottar complains about working with women staff members:

> Whelp that he is in his chosen field, the magazine photographer has been able to
> toddle and count for nigh onto twenty years, which is roughly how long ago the first
> picture story stood up and flexed its muscles to an illustrated text. But appallingly,
> many of those who traffic with the photographer in getting out their publications, still
> assume a benignly maternal attitude toward him, overlooking the fact that they are
> not more experienced—and frequently less so—in the picture story medium than the
> man they coddle.[65]

Gendered discourse infuses this text and is reinforced by the accompanying illustra-tion (Figure 5). In fact, Mottar goes on to say that the relationship of picture editor to photographer often resembles that of a "patient and wary mother dealing with a lovable but somewhat irresponsible child" and that this "kind of eagle-eyed hand-holding inhibits the photographer." He also compares a detailed shooting script to an "apron-string," and he finds "maddening" the method of "spoon-feeding" the photographer by forcing him to be accompanied by a "governess, alias researcher" while on assignment.[66]

Not only is being given orders by a woman a threat to the male photographer's autonomy, but it is also a particular type of emasculation, that which was known at the time as "Momism." The writer Philip Wylie had introduced this term to the public in 1942 in *Generation of Vipers,* in which he accused mothers of smothering their sons, creating a generation of weak men who would never be able to break free of their mothers' influence. Momism was not restricted to mothers, however; Wylie attributed the "disorder" to any woman who attempted to "control" a man by telling him what to do or by expecting favors or financial support.[67] Edward A. Strecker lent scientific authority to this misogynist argument in 1946 with *Their Mother's Sons:*

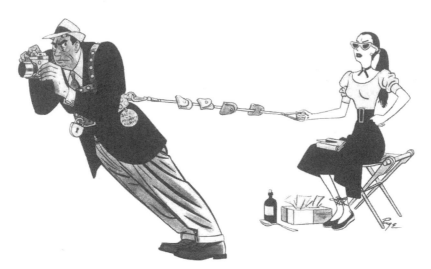

Figure 5. John Ruge, from Robert Mottar, "Look, Maw . . . No Hands!" *Infinity* 1 (April 1952). Copyright John Ruge.

The Psychiatrist Examines an American Problem, which blamed mothers for emasculating their sons by overprotecting them and demanding their constant devotion. Strecker cautioned that these coddled sons would be unable to ascend to the positions of authority reserved for men in both the public and the private spheres.[68]

This attitude was also expressed in an *ASMP News* article by *Life* photographer Eliot Elisofon, who had made a name for himself as a combat photographer during World War II. According to Hamblin, Elisofon epitomized the "God the Photographer" mentality that characterized *Life,* for he "required at least 50 ccs of flattery a day and kept on about it until some exhausted reporter agreed, 'Yes, Eliot, you are undoubtedly a genius.'"[69] Responding to an article published the previous month by an anonymous reporter who had complained about the overinflated egos of the male photographers whom she accompanied on assignment,[70] Elisofon launched a counterattack against reporters in which he chastised them for overstepping the boundaries of their position. Presuming that "Miss Anonymous" worked for *Life,* Elisofon went on to list those "basic things" that a *Life* photographer would expect from her, the first being that she should be able to take care of all the "details that a good secretary could accomplish." Reporters should also assist with the equipment without lagging behind, never get in front of the camera, have the "patience and tact to work with the photographer even if he gets difficult," never try to change the photographer's shot or disturb the subject by speaking, and "never undermine the subject's confidence in the photographer by casting doubt about the shot or by her attitude to the photographer."[71]

Like Wylie and Strecker, Mottar and Elisofon wanted women to stay in their "place," a servicing one. Indeed, men can only be sure they are men if women repress masculine qualities; thus they pressure women into passivity to appease their own

gender anxiety. As Gherardi states, the "attributes of femininity" are the "attributes of the powerless." Therefore, "it is possible to occupy a feminine position, not because of biological destiny but because of a political or organizational social dynamic."[72] In a picture magazine such as *Life*, the image was prioritized over the word. The photographers became public celebrities; the "supporting" staff remained anonymous. Hence, the sex-typing of those jobs is not surprising. Within an organization, high-level positions are gendered "male," lower-level ones, "female."[73] After World War II, women were forced out of heavy industry and ideologically pressured into the home or placed in low-paying "female" jobs, especially clerical, sales, and service positions, categories that expanded enormously in the postwar era.[74] Thus, when women were granted entrance into the workplace, they were barred from the upper echelons of masculine power and authority. At *Life,* the clerical job of picture researcher was assigned to women; men had just begun to encroach upon the role of reporter, a position of somewhat higher prestige.[75] Although many picture editors were women, they commanded little authority. Their role was to eliminate from consideration some of the 350,000 photographs submitted by freelancers each year. According to Hicks, however, the managing editor was, and always had been, responsible for choosing the photographs that actually got published.[76] During the postwar years, *Life*'s managing editors were men: Daniel Longwell until 1947, then Edward K. Thompson until 1961.

Even when a woman was "allowed" to be a photographer, she was often given assignments believed appropriate to her gender, what Virginia Deer referred to in 1949 as the "so-called feminine specialties."[77] *Life*'s Nina Leen was renowned for her animal photography, and many of her other assignments centered on the home, schools, and fashion.[78] Charlotte Brooks, who in 1951 became the first woman photographer on staff at *Look* magazine, had apprenticed with the dance photographer Barbara Morgan and worked as a staff photographer for a chain of three suburban newspapers in New Jersey, where she covered local service organizations, schools, and social functions.[79] Constance Bannister was a well-known baby photographer; Tana Hoban was renowned for her photographs of children; and Ylla (Kamilla Koffler), like Leen, specialized in animal photography.[80]

The exception to such containment would seem to be the case of Margaret Bourke-White. She had been one of the four photographers chosen for *Life*'s staff at its founding in 1936, and she had become a public celebrity when she became the first woman accredited as a war photographer and the first U.S. woman allowed to fly in bombing missions. Yet during the 1950s, Bourke-White suffered negative press, for she was linked to communism by the House Un-American Activities Committee (as was Hansel Mieth, who photographed for *Life* from 1937 through 1950, after which she lost work because of these political suspicions).[81] Bourke-White was also afflicted with Parkinson's disease, and after 1957, she was unable to carry on photographic work. Moreover, she did not fit the stereotype of the postwar woman. She had been divorced twice after brief marriages, she had no children, and she was enormously successful in her career and had been since the 1920s. She was especially renowned

for the daring feats she performed in order to obtain industrial and architectural photographs; she was a woman "not afraid of anything" who "thrives on heights and danger depths and disaster."[82] Bourke-White was frequently constructed as "one of the boys" through publicity photos and articles, especially during World War II.[83] She was the exception that proved the rule—to be successful in photography, a "man's racket,"[84] a woman had to be like a man.

This masculinization of the profession extended to the photograph itself. Recall Mottar's observation that the picture story "flexed its muscles to an illustrated text." Furthermore, Mottar claimed that if a photographer has "served any time in the business," he considers "himself more of a camera-reporter than a salon artist. So the severing of apron strings when he's sent on a story doesn't mean that he'll come back clutching abstracts of sea-shells if he happens to be assigned to a light-house story." In fact, one of the reasons that the photographer fears the detailed shooting script is that he wants not "prefabricated" images but ones that are *real*.[85] To Mottar, art is prefabricated, abstract, illustrated, pretty salon imagery—fake, thus feminine— whereas photojournalism reports the real; it is a business, trafficking in the harsh everyday world, the public realm, the masculine.

This valorization of the real is related to the postwar fascination with the scientific, to the public's unquestioned acceptance of science as authority. As a technological invention, photography had always had one foot in the category of science, the other in that of art. Whereas earlier photographic movements had attempted to construct photography as an art, photojournalism, in its emphasis on capturing and uncovering the real, treads closer to the discourse of science, which has always been gendered masculine.[86] As the biophysicist Evelyn Fox Keller argues, to "scientists and their public, scientific thought is male thought, in ways that painting and writing—also performed largely by men—have never been." Male thought is objective and rational, thus "hard"; female thought is sentimental and emotional, thus "soft." Scientific ideology divides the world into two parts, that which knows (mind), and the knowable (nature).[87] The goal of the scientist is to "consummate" the marriage of mind (masculine) and nature (feminine) "through reason rather than feeling" and thus to "ensure emotional and physical inviolability for the subject," which is "quite consistently identified as male."[88]

Keller's account of the scientist's function is not unlike that attributed to the photographer by Wilson Hicks: The photographer's purpose, Hicks claimed, "is to give order to the chaos of form which is reality." Moreover, "in this process, the all-important act of selection is the overt manifestation of the photographer's judgment. It is in the exercising of his intellectual faculty, rather than in the expressing of his emotions, that his imagination becomes his ready and willing servant."[89] Reality is the photographer's material, out of which he selects that which will make known the underlying order of nature. Because of his special judgment, his unique point of view, the photographer is able to know the truth, whereas others only see chaos. That photography's authority had even usurped the reporter's pen was expressed by

Louis M. Lyons, curator of the Nieman Fellowships at Harvard, during his 1959 television interview with photojournalists W. Eugene Smith and Dan Weiner:

> These men are not just news photographers sent out to illustrate a news story. They use their cameras to tell the whole story. And, as they do it, this is really the seeing eye. They have an advantage over the reporter with a pencil, for their cameras can penetrate behind the headline, below the surface, and show the forces that cause these developments we call news. They can probe to a vivid reality. The writer at his best can only imitate this.[90]

The immense authority wielded by photographers is also revealed in the numerous episodes recalled by Hamblin of the "casual arrogance" of *Life* photographers. For example, in 1950, Gordon Parks asked the commander of Denmark's military forces to move his entire army back two steps in order to effect a more pleasing composition.[91]

The last section of Hicks's 1952 book *Words and Pictures: An Introduction to Photojournalism* is written in the form of a conversation between "author" and "friend" on the nature of the photograph, especially how it relates to painting. After friend presents his lengthy case against photography as a fine art, author grants that indeed, photography may not be "art in the painting sense," but it does have a "unique ability to capture reality, reality that hasn't been tampered with, reality that *is*." Furthermore, the photograph is able to get "closer to the realities of our senses" than either words or painting can. Moreover, prioritizing subjectivity is a "foolish thought" in an "extrovert culture," which shares the "scientists' insistence on direct observation and on making everything mean something." Indeed, author reminds friend that the "camera is a scientific instrument," a child of the Industrial Revolution. However, author relinquishes not the idea that photography is an art but only the idea that it is similar to painting; the "real art" for a photographer is the "art of using his eyes."[92] This theory was reinforced by the publication of the influential 1952 book by French photographer Henri Cartier-Bresson, *The Decisive Moment,* which stressed the importance of the "eye," rather than equipment or developing techniques, in creating a photograph: "What the camera does is simply to register upon film the decision made by the eye." Thus, the act of photographing—the ordering of reality—becomes the actual "art" of photography, not the resulting print.[93]

Because it was seen as standing in such a close relationship to the real and to the scientific, photography may have enjoyed more public clout than did other visual media, particularly painting, which was tied to the mythic and imaginary realm. As Hicks claimed, "art derives out of the imaginative life of the artist. In photojournalism, the photograph is derivable only out of reality itself."[94] As did science, photography proposed that the world could be known, that it was understandable, that it could be captured and contained. Whereas turn-of-the-century photographers appropriated feminine characteristics to construct photography as an art *equal* to painting, postwar photographers adopted the masculine rhetoric of science to promote photography as an art *greater* than painting.

The designation "artist" may also have carried with it effeminate connotations. Indeed, in an article arguing in favor of photography's status as an "art," Siegfried R. Gutterman felt compelled to include the following statement: "I don't wish to create the impression that I'm a long haired aesthete. On the contrary, my hair, what is left, that is, is quite short."[95] As the anthropologist Margaret Mead noted in 1949, the "choice of music or painting or poetry as a serious occupation is suspect for an American male."[96] Hicks also linked art to effeminacy, claiming that the terms "art" and "artist" seem of "too dainty a character to grace the talk of men with such robust jobs as taking journalistic pictures."[97] The feminization of art was so pervasive that in his best-selling book *The Tastemakers, Harper's* magazine editor Russell Lynes characterized the Museum of Modern Art as a fickle woman, one whose "mannerisms sometimes seem like those of a woman of fifty who wants to be treated with the respect due her age—at the same time that she tries to act and dress as though she were still only twenty."[98]

Anxiety over homosexuality had intensified after the 1948 publication of the Kinsey reports on the sexual behavior of men, which revealed that male-male sexual activity was much more common than had been publicly acknowledged.[99] Within the breadwinner ethic, which assumed heterosexuality as the norm, homosexuality was considered "failed" manhood, not just sexual deviancy. Furthermore, homosexuality was linked to certain professions. In his 1955 book *All the Sexes: A Study of Masculinity and Femininity,* the psychiatrist George W. Henry included a statistical study that ranked the occupational category "actors, artists, art teachers" second out of twenty-one categories in terms of the number and percentage of "male sex variants" in New York City. Although "photographer" was not listed, the categories closest to science, "engineers" and "physicians," were ranked among the bottom three.[100]

During and after World War II, photographers increasingly moved away from the contemplative realm of art to the empirical realm of science, from passive reflection to active intervention. Unlike painting, especially in the postwar trend toward abstraction, photography held out the possibility of an intelligent, *scientific* art, one grounded in reality and the quest for truth rather than in the abstract realm of intuition and unrestrained emotion.

Competing Paradigms of Masculinity: Breadwinning versus Artistic Autonomy

Material reward was a concern even for many photographers who considered themselves artists. To be financially unsuccessful was to fail as a man, but to these photographers, to sacrifice one's personal vision in order to sell one's work was also a form of masculine failure.[101] Their dilemma was exacerbated by the increased social and economic status of photojournalists. As sociologist Cynthia Cockburn explains, work is second only to warfare as the "arena in which men wrestle with each other for status and survival." Because men identify work with masculinity, work-related "tensions and power struggles" are actually conflicts "among and between men *as men.*"[102]

The modernist philosophy of artistic autonomy, a legacy of photographers Alfred

Stieglitz and Paul Strand, was promoted by the Photo League and its publication *Photo Notes*. Although the league had long been an advocate of social-documentary photography, by the postwar years, the focus of some members had begun to shift from photography as a tool for social change to photography as an artistic medium. An important concern was how to reconcile an emphasis on individual creative expression with the commercial world. As photographer Walter Rosenblum argued in a 1947 *Photo Notes* article, one of the "basic reasons" for the existence of the Photo League was its "intense desire" to help the photographer "emerge as a creative individual" without being "consumed in the fires of economic insecurity or the emotional instability which is its resultant."[103]

Andreas Huyssen has drawn attention to the way modernists have feminized mass culture, as opposed to the masculine gendering of high art—the domain of individual artistic genius. Mass culture is considered inauthentic culture, whereas high art is deemed authentic culture. Within modernist ideology, this authenticity is connected to the myth of the noncommercial artist, which is founded on the premise that genuine artists maintain their creative integrity. They are not co-opted by commerce but, rather, remain independent of the mass, avoiding contamination.[104] Photographers who aspired to the status of high art for their medium had always had to struggle against its fundamental role in mass culture; however, in the years following World War II, the strict divide between high art and mass culture became more difficult to maintain, especially if a photographer wanted to fill the breadwinner role. Advertising was an especially lucrative field for photographers willing to sell their formalist aesthetic. Furthermore, postwar Americans reserved their highest respect for businessmen, not artists.[105] To devote oneself to amateur photography full-time was to be socially marginalized and thus feminized. Speaking of the difficulties facing artistic intellectuals in an increasingly bureaucratized postwar society, the sociologist C. Wright Mills argued that when an artistic intellectual is hired by the information industry, his aims must be set by others rather than by himself. Indeed, in a society where "money is supreme," the artistic intellectual becomes merely the "technician."[106]

A key figure in the articulation of this dilemma is the photographer Ansel Adams. In a speech to the Photo League in 1948, Adams claimed that the characterization of photography as a "folk art" angered him; therefore, in order to give photography more "dignity" and to clarify any confusion over such terms as "pictorial" and "documentary," he proposed a new set of classifications: record, reportage, illustration, and expressive photography. He went on to say that of those four categories, only expressive photography comes from within the photographer; the "motivation" for the other four categories comes from without. However, Adams rejected abstract or nonobjective photography as "escapism" and documentary photography as "two-dimensional." In fact, he did not believe that any photographer should work "along a particular ideological or propaganda line." He also dismissed pictorialism as a "flitting thing," claiming that any "real art requires the utmost expenditure of energy, intelligence, and imagination." He closed by saying that "more guts and integrity are

needed" and by confessing that he lay awake at night, because he knew he was "guilty of an awful lot of compromise."[107]

By the early 1950s, however, Adams had taken a far more conciliatory tone toward the commercial market. In 1952, he served as one of the founding members of the journal *Aperture,* published in San Francisco with Minor White as editor. *Aperture* was committed to photography as a creative activity. White was, and remained, especially disdainful of commercial photography, believing that the "serious" photographer should forgo material gain to pursue "his personal vision."[108] By the third issue of *Aperture,* however, Adams was admitting that the "creative spirit permeates practically all fields of photography," a much more inclusive statement than his earlier one, which deemed only "expressive" photography creative, denying this distinction to his other three categories. By 1952, Adams was more concerned with maintaining professional standards than with denying photographers the badge of creativity because of their chosen field. He argued that "severe standards of professional training and professional certification" were necessary, for the flood of inadequate professionals reduced the income of all photographers, good and bad. Adams defined all professions as vehicles for the "social realization of the creative spirit," whether the "profession be an art, science, or craft." In fact, he claimed that photography was all three—"science, craft, and art."[109]

Adams thus sought to reconcile two different models of male subjectivity—the professional breadwinner and the autonomous artist. However, that goal had to be accomplished without commercial co-optation: "In the first place, a profession is not defined merely by the money-making aspects of an art. We all have to live somehow, and we must all receive something for our efforts. But the doing of the job is the prime consideration; the returns are secondary in this discussion."[110] One way in which photographers could combine the two roles was to teach, although opportunities were limited. In 1946, Adams had founded the Department of Photography at the California School of Fine Arts in San Francisco, the first university department to teach photography as a profession. In a 1960 article published in *Infinity,* Adams called upon teachers to set stringent standards, suggesting that schools require photography students to take courses in the liberal arts and humanities, the social sciences, and science, after which they should serve apprenticeships and be required to pass a state examination before they could call themselves "professional photographers." However, Adams continued to privilege creative success over financial success, even though he acknowledged the importance of both.[111]

Adams's emphasis on a college degree as a requirement for professional status was also related to class anxiety. Because of the postwar blurring of boundaries between blue-collar and white-collar work and between upper and lower white-collar work, a college degree had become an important status marker, signaling membership in what the postwar writer Vance Packard termed the "diploma elite," a group removed from the taint of manual labor and from the service sector, which was largely made up of retail and clerical workers, feminized and thus low-status occupations. In fact, Packard suggested that a hierarchy of "diploma elite" over "supporting sector" should

replace the older system of upper, middle, and lower classes. Breadwinners would obviously desire a college degree for economic and social reasons, and autonomous artists would belong to what Packard classified as intellectuals or bohemians, groups that valued higher education but also nonconformity, preferring to do their "snooting" on the margins, apart from both the proletariat and the "babbitts."[112]

As a promoter of photography as a fine art, Adams clearly aspired to the category of the intellectual, as long as it was not affiliated with leftist politics. Throughout the postwar era, he argued against the type of documentary photography associated with the New Deal and the early Photo League. Adams's dislike for documentary photography is evident in his arguments against the influence of outside ideologies and in his desire to eradicate the term "documentary" altogether and replace it with "record," or later, "humanistic." He went so far as to accuse documentary photographers of creating a "new race" of people, a "shadow-world proletariat" that existed only "through *connotation*." Indeed, he claimed that he had never seen anyone in the "real world" who even remotely resembled the subjects of these photographs.[113] Although this stance is certainly related to Cold War anxiety and the desire to reassert fine-art photography as the dominant photographic mode, I would argue that Adams was also motivated by concern over his own class status. Many documentary photographers had come from working-class backgrounds and conceived of photography as a tool for social change, particularly as a means to expose the negative effects of capitalism. By the early 1950s, not only was Adams supported primarily by corporate money, but his increasing emphasis on the photographer as a freelance professional included a fear that the ASMP, of which he was a member, would be perceived as a union and thus as a working-class organization rather than a professional society.[114] In fact, Adams promoted the recognition of a separate "artist class," one composed of autonomous individuals; he claimed that if a photographer listened to others, the practice would be reduced to a "trade."[115]

However, Adams also feared affiliation with middle-class "babbittry"; therefore, he prioritized individual creative expression over technical and financial matters. In fact, Adams's desire to secure his position as the legitimate successor to what he considered the "great triumvirate" of modern photography—Stieglitz, Strand, and Edward Weston—necessitated such a stance.[116] Maintaining a belief in the unique vision of the artist was also essential to his goal of saving the practice of photography from too close a relationship to the mundane matters of the business world. Yet at the same time, Adams desired success as a breadwinner; he was a married man with a wife and children to support. To fail economically would be to fail as a man. Adams found the solution to this dilemma in teaching and, even more profitably, in serving as a consultant to manufacturers of photographic equipment. In 1952, the same year in which he changed his stance regarding creativity within the various modes of photography, Adams began receiving a monthly fee from the Polaroid Corporation. Although his initial fee was $100 a month, by 1954 it had increased to $667.67 and by 1955 to $1,200, the amount at which it continued throughout the postwar era. He also began to receive occasional consulting fees from Eastman Kodak in 1955, many

amounting to over $1,000 each. With the aid of these fees, which, unlike his pho-
tographic business, carried no overhead expenses, his gross income increased from
$29,423 in 1952 to $56,734 in 1957, only $4,209 of which was from the sale of prints,
both fine art and commercial.[117]

Besides valuing education, the professional breadwinner and the modern artist
also shared an aversion to pictorialism, which was still a widely practiced mode of
photography, one associated with salon exhibitions and camera clubs. Indeed, it was
this fight against the pictorial that most reveals the masculine bias that united these
two factions. Hicks claimed that he chose the term "photojournalism" for the title
of his book rather than "pictorial journalism" because of the latter's "connotation
of pictorialism and pictorialists." Hicks celebrated the photojournalists' rejection of
what he called "'pretty' pictures of pat and easy subjects within the photographers'
immediate environment, pictures fraught with the artifice and sterility of thorough-
going pictorialism." Of course, it was the "immediate environment" that had served,
of necessity, as subject matter for so many women photographers. To Hicks, pictorial-
ism was just a stop on the way to photojournalism, the pinnacle of the photographic
profession. According to Hicks, many photographers never advance beyond this
"scenic stop," which merely adds "arty portraits and arty nudes" and "arty pastorals,
sea pieces and nocturnes" to the "fat and happy babies" of the first step.[118] Charles
Arrowsmith went so far as to argue that photography "transcends" the question of art
altogether, for it is "too firmly wedded to our way of living to permit a sterile estheti-
cism to sap its strength."[119]

Photojournalists, like most Americans, considered any "art" photography to be
pictorial, and thus modernist photographers emphatically sought to differentiate
themselves from pictorialists. In fact, because the subject matter of pictorialism and
modernism is often so similar, an "untrained eye" might be unable to discern between
a pictorial and a modernist work, for example, between a photograph by the renowned
pictorialist Adolf Fassbender and a photograph by Ansel Adams (Figures 6 and 7).
Both depict mist over water, with hills in the background and a tree branch in the
foreground. The difference is presumably only in the degree of focus, Fassbender's
soft and Adams's sharp. To counteract such seeming similarities, modernists, who
were much fewer in number, went on the attack. Adams's disdain for pictorialism
is evident not only in his frequent dismissal of it in his writings but in his deroga-
tory, and undoubtedly gendered, term for it: "fuzzy-wuzzies."[120] In a 1951 article
published in the eclectic journal *American Photography,* Minor White separates
the pictorialists from the "purists," the practice of "camera-as-brush" from that of
"camera-as-extension-of-vision." White denigrates pictorialism as "distaste for the
literal or an inability to cope with it." "Reality," he claimed, "is not to be avoided,
it is to be penetrated to its other side."[121] Thus, like the photojournalists, modernist
photographers insisted that their work was grounded in the "real," that, like science,
it was predicated on a search for nature's "truth." Indeed, Adams later adopted the
term "transcendental" to describe his mode of photography, for he believed it meant

Figure 6. Adolf Fassbender, "Mist over Mohawk, 1952." Copyright 1998 Center for Creative Photography, the University of Arizona Foundation.

the opposite of "pictorial." To him, it signified "art in the most penetrating sense of the term."[122] This genre, whose lineage has been constructed from Stieglitz through Strand and Weston to Adams, a trajectory that Ellen Handy refers to as the "boys' club of landscape symbolism,"[123] was predicated on a belief in the photographer's unique ability to "previsualize" the final print.[124] Thus, the reality of the image is not the subject matter itself but the photographer's subjective vision as projected onto the land; nature is merely the material through which this vision is realized. Nature is penetrated, forced to submit "her" secrets to the superior male intellect.

Deborah Bright has addressed the gendering of landscape photography, arguing that it has remained a "reified masculine outpost—a wilderness of the mind." Indeed, she maintains that the "image of the lone, male photographer-hero, like his proto-types, the explorer and hunter, venturing forth into the wilds to capture the virgin beauty of Nature, is an enduring one."[125] Bright traces this notion back to nineteenth-century landscape painting and the taste for the sublime and to Stieglitz's early-twentieth-century concept of the photographic equivalent, whereby nature served merely as a metaphor for the artist's vision or feelings. In the postwar years, it was Ansel Adams who was most successful in combining these two traditions. Indeed, his grand photographs of pristine western landscapes were immensely popular with the general public, a factor Bright attributes to a conservative postwar climate, during

Figure 7. Ansel Adams, "Mono Lake, California" (1947). Copyright Ansel Adams Publishing Rights Trust/CORBIS.

which the United States enjoyed its "reborn Manifest Destiny as a world superpower." This glorification of the West was reinforced by the renewed popularity of the cowboy film, which Bright credits with further masculinizing the western landscape.[126]

Another prominent modernist genre was the high formalism associated with the Chicago Institute of Design, particularly the work of one of its most influential teachers, Aaron Siskind. Like a number of photographers responding to Cold War conser-

vatism and paranoia, Siskind had rejected the social-documentary work of his Photo League years in favor of a more personal expression. Although his photographs of everyday objects tend toward the abstract because of the strong emphasis on formal structure, Siskind insisted that his work was faithful to the objects, that it was "real." However, he also stressed that the objects were transformed from the everyday to the aesthetic through "the act of seeing, and not by manipulation."[127] In other words, they were not transformed through mechanical means (tampering with the negative or print). Thus, it is his subjective vision that is prioritized, that is able to reveal the "truth" of the object. Siskind maintained that he had been influenced by the abstract expressionist painters in their "absolute belief" that the canvas is an "area of struggle," an "arena" where "the fight is taking place," a statement that Abigail Solomon-Godeau characterizes as "macho posturing," a "heroicizing of self-expression . . . so extreme as to border on the parodic." However, this "existential chest-thumping," as she calls it, is only one facet of Siskind's rejection of political meaning in his work, of his conversion from the social concerns of documentary to formalism, for he went so far as to deny the politics even in his photographs of political writing by claiming that the subject of these works was the structure of the objects, not their literal meaning.[128] Thus, like the abstract expressionists, Siskind sought universal transcendence through abstraction, although mediated through an exclusively white male subjectivity. Indeed, he felt compelled to imbue his artistic practice with machismo to remove it from the feminine taint of the merely decorative. For example, about his 1960 photograph "Chicago" (Figure 8) Siskind wrote that there is a "heroic quality" about it, a "virility," because through his unique ability to see, the form is able to "communicate more" than it otherwise would.[129]

Despite such "heroic" attempts, the traditional equating of the pictorial with the artistic was difficult to escape. In a scathing editorial in *Aperture*, White railed against the Photography in the Fine Arts exhibition held in 1959 at the Metropolitan Museum of Art in New York. White called the exhibition a "threat to Fine Photography" because of the involvement of the Photographic Society of America (PSA), a champion of "mediocre pictorialism" whose members "do not know their art from a hole in the ground." He argued that if the "PSA, after all its years of investigation, had ever come to the obvious realization that a photograph *per se* might stimulate the aesthetic reaction, rather than the kitten, one could hope for the best." But, White charged, the "PSA still acts as if they were firmly convinced that only the cute baby is ART."[130]

The fear of such pictorial connotations is revealed by an earlier incident in which Ansel Adams had implored Nancy Newhall not to include Weston's cat photographs and "fuzzy-wuzzies" in the 1946 retrospective of his work that she was organizing at the Museum of Modern Art. Despite Weston's desire to include them, Adams claimed that these photographs were "definitely not Edward as he really is" and had nothing to do with "Edward Weston, the photographer."[131] When Newhall responded that she was going to include five from the "fuzzy" period despite his protests, Adams asked

Figure 8. Aaron Siskind, "Chicago" (1960). Copyright Aaron Siskind Foundation. Collection of the Center for Creative Photography, the University of Arizona.

her to isolate them completely from the main body of Weston's work, suggesting for them a backdrop of a "strange Victorian color."[132]

A number of pictorialists also fought against traditional pictorial subject matter, especially kittens and babies, arguing that a broad range of subjects should be explored. Indeed, some men insisted that what made a photograph pictorial was excellence in developing and printing techniques, not the nature of the subject matter. Others downplayed the decorative and ornamental elements of pictorialism, privileging composition and symbolic expression instead.[133] However, the attacks from within on certain facets of pictorialism were not nearly as virulent as those launched against it from without, by modernists and photojournalists. Most male pictorialists were amateurs; they were either members of a leisured class or practiced another profession, one that imparted to them their masculine identity. Therefore, they were not dependent on photography to do so. One pictorialist wrote, "Pictorial photography has increased my interest in, and sharpened my outlook on, life by furnishing an esthetic outlet to a technical career. It has furnished fun and relaxation as a hobby should."[134]

Photojournalists also criticized the Photography in the Fine Arts exhibition. Sey Chassler, executive editor of *Pageant* magazine, expressed his anger that photojournalism had not been segregated from artistic photography. He argued that the

ASMP should have been involved in the planning, for they knew the difference between the categories.[135] Chassler's views demonstrate the extent to which photojournalism considered itself worthy of recognition as an art yet sought to distance itself from what had traditionally been considered art photography—both pictorialism and modernism. In fact, in an open letter addressed to the Metropolitan Museum concerning its photography exhibition the following year, nine photojournalists, whom *Infinity* columnist Ray Shorr termed "angry young men," referred to the panel of judges as "strangers to our world of photographic imagery" and rejected the museum's claim to represent photography as an art form.[136]

Both factions claimed the authority of truth. The photojournalists claimed external truth; the modernists claimed internal truth. Indeed, in his numerous Museum of Modern Art exhibitions entitled Diogenes with a Camera, Steichen included both modernists and photojournalists as representative of "photography's contribution to the search for truth."[137] To both groups, pictorialism was false. Those "feminine" qualities that had once been prized—taste, delicacy, softness, grace—were now denigrated by the dominant voices of the camera world. As Steichen explained, "To the serious photographer of today, the term 'pictorial' is anathema."[138] The manipulated print associated with pictorialism was especially despised, for it was considered the very antithesis of truth.

Pictorialism's fundamental role in gaining acceptance for photography as an artistic medium was actually "written out" of the history of photography, as revealed in two major postwar exhibitions that sought to examine the state of photography at midcentury. In the catalog essay for the 1950 Photography at Mid-Century exhibition at the Los Angeles County Museum, Ebria Feinblatt traced the origins of modern photography to 1902, the year in which the Photo-Secession and *Camera Work* were founded. Included in this exhibition were modernist and social-documentary photographs, but no pictorialist ones, even though Feinblatt admitted that the "pictorialist or salon interpretation with its basically sentimental anecdotalism" still existed. Feinblatt claimed, however, that it existed only "as a superseded attitude which fails to distinguish between power and prettiness."[139] Nine years later, in the catalog essay for the Photography at Mid-Century exhibition at the George Eastman House, Beaumont Newhall did not even mention pictorialism. Rather, he listed the four "dominant" trends and their founding fathers: the "straight approach," pioneered by Stieglitz, Strand, Weston, and Adams; the "experimental," characterized by the work of Man Ray and Laszlo Moholy-Nagy; the "photo-journalistic," as practiced by Henri Cartier-Bresson; and the "equivalent," first explored by Stieglitz.[140] Although both essays emphasize Stieglitz's role as the father of modernist photography, neither mentions his earlier years as a pictorialist.

According to Hearn, full professionalization is achieved only when an activity is fully dominated by men, not only in terms of membership but also in the monopolization and control of emotionality. Female-dominated practices must be rendered nonthreatening to the now masculinized profession.[141] Pictorialism, long associated with women and emotionality, had to be exorcised from the master narrative of

photography's past in order to be neutralized in the present. Indeed, in a contribution to *American Photography*'s examination of photography at midcentury, Dody, an employee of Adams and one-time student of Weston, argued that the "purists," Strand, Weston, and Adams, had actually returned to a much earlier tradition "in spirit," to the "mercilessly exact daguerreotype."[142] Thus, pictorialism is completely erased from the linear progression leading to postwar modernist photography.

The attempt to purge itself of pictorialist connotations was not the only battle modernism faced; it was under siege from many directions. Not only did it have to struggle against the cultural dominance of photojournalism, as well as its own co-optation by commerce in the form of advertising, but it was forced to rebel against what would seem to have been its most supportive ally: the Museum of Modern Art.

Edward Steichen, the Museum of Modern Art, and Modernist Rebellion

In 1947, Edward Steichen was appointed director of the Department of Photography at the Museum of Modern Art, usurping curator Beaumont Newhall, whose views on photography were markedly different. In 1940, when the department was first established, Newhall had cautioned that because photography had become the "art of the people, practiced by millions," the "danger" existed that "quality may become submerged." Consequently, he claimed that his role was to select the "best work" he could assemble from photography's hundred-year history, those photographs that he deemed "works of art."[143] Newhall's aim, therefore, was to construct the history of photography like the history of painting and sculpture, with a canon of great works by great masters, to create, as Christopher Philips has phrased it, "an art history of photography."[144] Newhall was aided in this quest by Ansel Adams, who had been named vice chairman of the new department. Their first exhibition, Sixty Photographs: A Survey of Camera Esthetics, emphasized the rarity and authenticity of the prints chosen and claimed that each photograph was an "individual personal expression."[145] The exhibition set the stage for the majority of the nearly thirty exhibitions mounted over the following six years. The vocabularies of connoisseurship and artistic modernism were applied to all photographs exhibited, whether produced by self-conscious modernists, Civil War documentarians, or early western landscape photographers.

Although a founding member of the Photo-Secession and an early promoter of European modernism, Steichen had received fame and fortune as a fashion, portrait, and advertising photographer in the 1920s. He had also served as an aerial photographer with the Army Signal Corps during World War I, and he had led the Navy's photographic unit during World War II. Steichen was invited to organize an exhibition at the Museum of Modern Art in 1942 entitled Road to Victory, which was followed by his 1945 Power in the Pacific, both of which emulated the photo essay style of *Life* magazine rather than the "painting" exhibition format established by Newhall— framed and matted prints of equal size hung at eye level. Indeed, Steichen's war exhibitions, with installations designed by Herbert Bayer and George Kidder Smith,

respectively, required the viewers to interact with the images rather than merely to contemplate them. Viewers were forced to wend their way through free-standing enlargements of photographs, murals of up to ten feet by forty feet. The photographs exhibited in Power in the Pacific were intended to "take the visitor through the full circle of preparation, attack and return by men, ships and planes of our Navy"[146] rather than to speak to the aesthetic merits of a photographer's vision or the technical exquisiteness of particular prints; a unified theme was privileged over individual expression. Indeed, not one of the photographers was credited by name.

Both exhibitions drew huge crowds and critical acclaim. It was perhaps for these reasons that the Board of Directors invited Steichen back to the museum as director of the department. As the board president, Nelson Rockefeller, stated:

> Steichen, the young man who was so instrumental in bringing modern art to America, joins with the Museum of Modern Art to bring to as wide an audience as possible the best work being done throughout the world, and to employ it creatively as a means of interpretation in major Museum exhibitions where photography is not the theme but the medium through which great achievements and great moments are graphically represented.[147]

This shift from photography as a fine art to photography as a mass medium was a total reversal of Newhall's goals for the department. Newhall chose to leave the museum rather than work under Steichen, and he went on to become director of the George Eastman House in Rochester, New York. Not surprisingly, Steichen's hiring angered modernist sympathizers. Steichen's salary was to be financed by $100,000 donated by ten manufacturers of photographic equipment who had been approached by Steichen and his friend Tom Maloney, editor of the annual publication *U.S. Camera Annual*.[148] Ansel Adams deplored Steichen's ties to commercialism, dubbing him "the anti-Christ of photography." In fact, like Stieglitz, Adams claimed that he would rather have his prints in the collection destroyed than have them fall under the control of Steichen.[149] In this light, it is easy to understand the motivation behind Adams's manifesto that opened the first issue of *Aperture*: "We have nothing to lose but our photography."[150]

Steichen remained as director of the department until 1962, when he retired at the age of eighty-two. During his tenure, the department held forty-three exhibitions, including the most famous photography show of all time, The Family of Man. That exhibition opened in 1955, after which it toured the nation and then, under the direction of the U.S. Information Agency, traveled the world for seven years. The format of The Family of Man echoed that of Steichen's war exhibitions in the 1940s; it resembled a magazine photo essay, in which Steichen served as "picture editor,"[151] selecting, with the help of assistants, from more than six million images those he believed would best serve his overall theme, that "Mankind is one." Photographers were required to sign over to the museum the right to print, crop, rescale, and edit their photographs.[152] Thus they were stripped, albeit voluntarily, of their role as autonomous artists, the makers of meaning for their work.

Not all of Steichen's exhibitions were staged in such a manner, however. He directed monographic and group shows, in addition to theme shows; some prints were matted and framed, others were presented in the photo essay format. In fact, the first exhibition during his incumbency was a one-man show of the work of Stieglitz, Steichen's one-time friend. What was troubling to modernists, however, was Steichen's refusal to promote one type of photography over all others, his refusal to prioritize fine-art photography, especially modernism, which they saw as the proper role for a museum dedicated to modern art. This policing of photography's artistic boundaries had been the department's original goal, as established by Newhall and Adams, who had now lost control. They feared that if the museum relinquished its role as the arbiter of taste, the medium would slip into artistic disgrace. As Adams complained: "The quality of the prints—of all his exhibits of this gross character—was very poor. . . . If a great Museum represented photography in such a style and quality, why bother about the subtle qualities of the image and the fine print?"[153]

Steichen seemed to relish his role as traitor. In 1950, he organized a symposium at the museum to discuss the question "What is modern photography?" Of the ten photographers invited to participate, seven were active in photojournalism, a theme that "dominated the discussion." As Walter Rosenblum reported, their viewpoint was summarized by panelist Irving Penn, who argued that the modern photographer "no longer works for the single print, but for the magazine page with its millions of potential readers."[154] Moreover, in his 1963 autobiography, Steichen recalled that when in the Soviet Union, he had asked to meet with "professional photographers, the journalists, not the so-called art photographers," and he claimed that when young photographers had come to the museum to show him their abstract work, he advised them that they were "working along a blind alley."[155] Although Steichen did include modernist photography in his exhibitions, it was often forced to compete with more "contemporary" genres. As Bruce Downes wrote in his review of the 1948 In and Out of Focus exhibition: "Strand and Adams seemed like anachronisms—curios in the presence of postwar photography. These men are already old-fashioned."[156] Helen Gee has pointed out that this privileging of photojournalism also reflected a regional bias. As she remembers, the reaction of New York photographers to Limelight's 1956 Ansel Adams exhibition was "cold": "They preferred the canyons of Wall Street to the canyons of the West."[157]

With the loss of institutional support, modernists were forced into the role of rebels. Mills discussed this "cult of alienation" on the part of postwar intellectuals as a "form of collapse into self-indulgence," which served to "hide the fact of powerlessness" and provide a "personal excuse for lack of political will."[158] In an elitist and romantic 1959 Aperture editorial, White listed museum theme shows as one cause of modernist rebellion. He claimed that although the rebels had been "driven underground," they would endure; they would wait until an "audience of peers" could be found. He rejected the notion of collective activity to promote the cause, however, arguing instead that a "small circle" of friends, "equal . . . or nearly equal" in terms of artistic "maturity," should "exchange fine prints" as a means to personal growth.[159]

Of course, a fundamental factor underlying the lack of institutional and public support for fine-art photography, as well as the debates among the various factions themselves, was the elevation of the combat photographer to cultural hero during World War II. In fact, after the war, no specialization within the photographic field would carry the same degree of masculine "potency" as what came to be known as "action" photography, epitomized by those photographers who actually risked, and sometimes lost, their lives in battle. It was thus the physical body of the photographer that was valorized, not his internal vision. Moreover, aesthetically, the action print was rarely pure, pristine, and finely printed; rather, it was grainy, blurred, and hastily reproduced for a mass audience. World War II, the first "picture" war, had changed everything.

2 | Combat Photography: Adventurers, Heroes, and Martyrs

For it is not in giving life but in risking life that man is raised above the animal; that is why superiority has been accorded in humanity not to the sex that brings forth but to that which kills.
Simone de Beauvoir— 1949

Yet, should it be that freedom was *not* on test in Korea, and later people speak of the war only in criticism, then let them not forget that those soldiers of the Eighth Army were living and dying in a faraway, miserable land simply because they had been told that it was their job . . . and they were Men.
David Douglas Duncan— 1951

In Alfred Hitchcock's 1954 film *Rear Window,*[1] James Stewart plays photojournalist L. B. "Jeff" Jeffries, who has recently suffered a broken leg in the line of duty: He was injured at a racetrack, where he had gone to fulfill his editor's request to get something "dramatic." Throughout the film, Jeff sits before his apartment window, powerless except for his enormous news camera with its long telephoto lens, through which he spies on the neighbors across the alley. Grace Kelly plays his girlfriend, Lisa Fremont, the epitome of 1950s femininity, dressed in the haute couture sold at the shop where she is employed. She flits around the Stewart character, continually attempting to seduce him, to draw his gaze away from the window onto the outside world. Yet Jeff does not succumb, not even when the beautiful Lisa offers herself to him wearing only a negligee. He does not allow himself to be tamed by the woman; he remains steadfastly glued to his camera, a phallic prop even more necessary now that his body is broken.

Rear Window's Jeff represents a romantic version of U.S. manhood, that signified by the active and autonomous cowboy, "the quintessential American masculine icon," which enjoyed a nostalgic resurgence in postwar culture.[2] Like the cowboy, the

world-traveling photographer could evade the feminine "trap" of domesticity. Jeff is afraid to marry Lisa, for if he does, he will not "be able to go anywhere." He will be "stuck" home with a wife who "nags," a wife who is too "Park Avenue," too "high fashion," too "cultured." When Lisa tells Jeff that she can arrange some fashion assignments for him in the city, he declines, asking her if she can imagine him driving up to the fashion shoot in a jeep and wearing combat boots.

Despite the dominance of breadwinner masculinity, other models of masculinity existed in the postwar era. In fact, some men argued that the breadwinner role implied passivity, in that individuals were forced to sacrifice autonomy in order to conform to corporate and suburban ideals. The sociologist C. Wright Mills described the "Little Man" of the new middle class, "the white collar man," as "the hero as victim, the small creature who is acted upon but who does not act, who works along unnoticed in somebody's office or store, never talking loud, never talking back, never taking a stand."[3] Middle-class men were becoming homogenized, indistinguishable from one another. Cold War anxiety also seeped into a work by business writer William H. Whyte, *Organization Man,* whose title lent the era one of its most defining phrases. Whyte bemoaned the loss of individualism that resulted from corporate "collectivization," which he believed had spread to almost every field of work, as well as to every aspect of daily life, from the homogenizing suburbs to patterns of consumption. To Whyte, the organization man was steadily replacing the heroic individualist, the self-made man; he argued that a new "social ethic" emphasizing "belongingness" was beginning to erode the Protestant ethic, which held property, thrift, hard work, and independence sacred. Whyte warned Americans that if they did not remain vigilant in their belief in individualism, the country would become "soft."[4] Indeed, it was not so much fear of Soviet invasion that fueled the Cold War as fear of the nation's crumbling from within. Men were to remain "hard," active rather than passive.

Even breadwinning photographers felt pressured to defend their manhood against the stigma of passivity. Many photojournalists felt "emasculated" by editors who told them what to shoot and then either "chopped up" or "rejected altogether" their photographs.[5] As editor Sey Chassler explained, photographers were often "frustrated" because they did not realize that the backbone of the magazine industry was "not the creative artist but the creative journeyman," that a "man who rolls up his sleeves and goes to work to produce, to the best of his instincts and talents, what the editor needs is more sought after than the inspired artist." To be successful in the magazine field, Chassler concluded, photographers "must compromise."[6] Furthermore, photography itself was considered to be tied more to the realm of mental work than to that of manual work, and as the sociologist Cynthia Cockburn argues, manual work has been traditionally identified as "hefty, masculine, and desirable," and mental work, as "effeminate and despicable."[7] Thus, even if a man enjoys high social status due to occupation or income, his physical manhood might be in question. This was especially true in the postwar years, when intellectuals were often referred to as "eggheads" and categorized as effete liberals, "soft" on communism.[8] Consequently,

many postwar photographers attempted to construct their profession as a physically active one, often involving danger and even risk to the photographer's life. Moreover, they sought to promote themselves as important "players" in the traditional masculine proving grounds—the great outdoors, the sports arena, and, above all, the battlefield. Because they were adventurers, these photographers were able to distance themselves not only from the feminine taint of "artiness" but also from the effeminacy associated with the intellectual. Infusing the profession with such virile physicality more than compensated for any emasculation by editors; these photographers were definitely "hard" men.[9] They were also potent men, "adventurers" whose "truths" are those of the "body," "full sexuality," and "open aggressiveness," truths that can only be lived on "society's frontiers,"[10] not in the office or the studio. Photographers had to be adventurers if the world was to be known, the truth discovered; consequently, they made the entire globe their "picture hunting ground."[11]

The Combat Photographer

World War II combat photographers inundated the U.S. public with photographs of war as never before. During the Civil War, photographs had been seen by only a few, for the technology did not yet exist to reproduce them in the press. Only a handful of photographers had covered the Spanish-American War; illustrators were still utilized for the majority of journalistic imagery. During World War I, journalists had been severely restricted by government censorship. Even when photojournalists were allowed access to the U.S. Army zone, their film was sent to the Army Signal Corps laboratory for developing, printing, and censoring. Forbidden were any photographs that showed troop movements or in which any military insignia or geographic location could be identified. Also taboo were any photographs that might have a negative effect on troop morale, public support for the war effort, or the relationship between the United States and the other Allies. Consequently, few images of individual soldiers were even published. As the historian Susan D. Moeller has observed, World War I photographs are "remarkably static," characterized by "the near-total absence of either a sense of the horror or the thrill of the danger" of war.[12]

During World War II, however, civilian photographers were allowed to take combat pictures, and with the aid of technological advances made over the preceding two decades—more-compact and more-portable cameras, more-powerful lenses, faster films, and faster shutter speeds—photographers were able to "bring the war home" with a greater sense of immediacy. Such immediacy also involved danger, however. Thirty-seven civilian war correspondents, including both print and photographic journalists, were killed during the war, 112 were wounded, and 50 were captured and interned in prisoner-of-war camps. Of the 21 photographers put in the field by *Life* magazine, 2 were torpedoed, 5 were wounded "in action," 1 was imprisoned, and 12 came down with malaria. Indeed, the casualty rate for civilian correspondents *covering* the war was four times greater than that for soldiers *fighting* the war.[13]

World War II brought public recognition to a number of photographers, especially

those working for *Life,* including Robert Capa, Carl Mydans, George Silk, and W. Eugene Smith. Their celebrity was as much about the risks they took to capture their images as it was about the quality of their photographs, for each shot testified to the bodily presence of the photographer within the arena of combat. Indeed, it was the dangerous conditions under which these photographs were taken that made them credible, that made them *real*.[14] Hence, the media—and the photographers themselves—emphasized their unity with the military group, their oneness with the war machine, their fundamental role in winning the war. Much as it did for the soldier, war functioned for the combat photographer as a "testing ground," a challenge to be overcome through the exhibition of those traits deemed essential to the warrior male.

The transition to manhood—the repudiation of childhood vulnerability and dependence on the nurturing maternal realm—is more difficult to achieve in societies that do not have structured initiation rites. Unlike the cultures of traditional societies, U.S. culture does not provide a clearly defined rite of passage through which all males must pass. Yet boys are still expected to become men. In the mid-twentieth century, one way to "achieve" manhood was to go to war. Coming after years of economic depression, during which many men were unable to support their families adequately, World War II provided a chance to reassert virility through those traditional markers of masculinity signified by the warrior male. Indeed, after an extensive sociological and psychological analysis of U.S. soldiers based on a series of surveys taken during and after the war, Samuel A. Stouffer and a team of researchers concluded that the primary motivation for going into combat was to prove one's manhood; patriotism and politics were of secondary concern. The researchers concluded that the role of the combat soldier had challenged men to demonstrate those "core" qualities central to all "conceptions of masculinity," which they defined as "courage, endurance and toughness, lack of squeamishness when confronted with shocking or distasteful stimuli, avoidance of display of weakness in general, reticence about emotional or idealistic matters, and sexual competency." Failure to "measure up as a soldier" was to "risk the charge of not being a man," of "being branded a 'woman,' a dangerous threat to the contemporary male personality." Because this strict "code of manliness" had been "internalized," a man once in combat had to "fight" continually to "keep his own self-respect: 'Hell, I'm a soldier.'"[15]

Men did not go to war just to prove their individual worth, however; they were also fulfilling the social requirements expected of their gender. They went to war to meet an "obligation," one "imposed" on them by "sheer virtue" of their "being male." As the psychologist Ray Raphael argues, the "intensity" of war is "essentially masculine, colored as it is by the overpowering weight of social expectation."[16] Because it is a public rite of passage, war functions to "dramatize" and "facilitate" a society's sense of masculine potency. Such rites are especially important during periods of widespread male insecurity.[17] The entry of the United States into World War II, therefore, functioned not only to resolve international political conflicts but to reassert the nation's collective virility, which had been damaged during the Great Depression.

According to the scholar of religion James McBride, "war as a ritual of male identity" acts as "demonstrative proof" of a nation's "virile asceticism."[18] Because World War II was a "good" war, its discourse was especially infused with a sense of moral purpose; it was a war against "demonic" evil—the "Japs," Mussolini, and Hitler. Consequently, those masculine attributes needed to win the war were elevated to a high spiritual and moral plane. Like masculinity, virile asceticism must be asserted repeatedly. Indeed, the United States continued to proclaim its moral superiority—its inherent goodness as the champion of democracy and the U.S. way of life—throughout the Cold War, during which it battled, both literally and symbolically and through the proliferation of weaponry and international influence, the "Red Menace." The country's moral strength remained synonymous with its military strength. Moreover, the military itself became a symbol for moral virtue, a defender of U.S. values, including a strict differentiation between masculine and feminine. In the military, men were men.

A nation's military might is visually signified by soldiers and weaponry, the focus of the *U.S. Camera Annual* for both 1945 and 1946. Editor Tom Maloney exalted the "thrilling" pictures included in the 1945 annual, subtitled *The U.S.A. at War,* claiming that they made even "the best painting dull." He also emphasized how important it was to the soldiers that these images reached the people back home, for photographs were not just a reference to war, they were the war. Indeed, Maloney claimed that photography had become "a war weapon of such might it is startling to contemplate." Not only did it serve propaganda purposes, but it was essential to espionage and reconnaissance—photography was "the eye that rules the battle in the making as well as the battle in being."[19] Like military strength and moral strength, photography and war had become intertwined, even codependent. Photography needed the war, just as the war needed photography. As George Silk recalled, "The war had made *Life* magazine into the magazine it was." Before 1939, *Life* had only "felt its way along."[20]

Unlike previous annuals, which credited each image to a photographer by name, the 1945 and 1946 *U.S. Camera Annual*s suspended this policy in order to include the work of anonymous members of the photographic units that were part of the different branches of the service. This shift in policy is not surprising, considering that Capt. Edward Steichen, who had been made chief of all naval combat photography, served as the only judge for the publication. Furthermore, some of the most "thrilling" photographs were taken by these soldier-photographers.[21] In fact, the first combat photographs published in the annual were taken by the Marine photographic unit involved in taking Tarawa Island from the Japanese. During the seventy-six hour battle, 1,026 Americans were killed and 2,557 were wounded; Maloney reprints an eyewitness report accompanied by a photograph of the unit (Figure 9). This image acts as a frontispiece to the book, producing a visual impression of the photographer as soldier, the signifier of virile masculinity—about half the men, all in camouflage fatigues, reveal bare chests to the camera; one stands defiantly with hands on hips; most are roughly shaven and have tousled hair; one smokes a cigar. Although a few

cameras are visible, there is little doubt that these men are warriors first, photographers second.

The only other photographer pictured in the annual is Sgt. John Bushemi, who had been killed in the battle for Eniwetok Atoll while covering the war for *Yank* magazine, the Army journal. Shot from below against a backdrop of clear sky, Bushemi appears the dashing and heroic young soldier-photographer, with rifle slung over his shoulder, carrying his helmet in one hand, his news camera in the other. The accompanying text extols the sergeant's courage in action, explaining that just before the invasion of Eniwetok, Bushemi had fractured his left hand, yet he "refused to stay behind." While shooting with one arm, the other in a sling, Bushemi had been struck by shrapnel from a knee-mortar shell. His last words were, "Be sure to get those pictures back to the office."[22]

This story is typical of the narratives describing combat photographers, whose first priority is invariably said to be to shoot the most intense images of combat, no matter the risk to their own safety. For example, one writer proclaimed that "no assignment was too tough, no hardship too physically punishing for them to endure. Most of them are known to have thumbed their noses figuratively at death just because they were motivated solely by one objective: *'Get that picture!'*"[23] It is as if the photographs are as important as the war itself. Indeed, to these men, as to Maloney,

Figure 9. U.S. Marine Corps, "Combat Photo Unit, Tarawa." National Archives at College Park, College Park, Maryland.

the photographs *were* the war. If we conceive of gender as a social performance, then it is easy to understand the importance placed on displaying this performance. The monumental risk involved in proving one's manhood in combat demands an audience. For a soldier, victory in battle provides an element of proof even if there is no visual trace, but for a combat photographer, the photographs themselves are the only victory, indisputable evidence that manhood has been achieved. To supplement such evidence, Maloney included a "Roll of Honor" dedicated to those combat photographers who had been killed or wounded or who were missing in action. In all, the honor roll lists forty-one military photographers as killed in the line of duty, along with fourteen wounded, five missing, and three prisoners of war.[24]

Maloney concluded the 1945 annual with a section entitled "Footnotes to War's Photographic History," written messages from civilian photographers covering the war in Europe. Although the men do refer to their attempts to take photographs, their accounts emphasize instead the danger they faced under heavy shelling. Except for the fact that they do not attempt to kill—although they do "shoot"—these photographers construct their narratives like typical war stories, with themselves as classical warriors. This valorization of the combat photographer as masculine hero is reiterated in the 1946 annual, subtitled *The Victory Volume*, especially in its tribute to W. Eugene Smith, who was severely injured on Okinawa;[25] in two articles by famed correspondent Ernie Pyle relating the adventures of combat photographers with whom he covered the war; and in Maloney's "Combat Cameramen," which summarized the contribution of photographers to the war effort and lists, as conclusively as possible, the number who were killed in the process.[26]

What is remarkable about these annuals is that they were geared not only for a mass audience but for a specialized one. For ten years, the *U.S. Camera* annuals had sought to publish the best photographs of the year, choosing the winners from a wide variety of fields. The complete absorption of photography by war, as signified by these two annuals, was to mark a shift in the very nature of the medium and its practitioners. The most memorable photographs for decades to come would be those of war; the most exalted photographers, not only among a public who eagerly consumed mass media imagery but also among the members of the photography world, would be those who experienced combat. Photography, like masculinity, had become a performance, a physically active display. The combat photographer's art was adventure; he risked his life to perform.

Perhaps the most renowned combat photographer of all was Robert Capa, who had garnered worldwide attention for his coverage of the Spanish Civil War. Indeed, after *Life* magazine published his celebrated "Falling Soldier" in 1937, Capa was widely heralded as the greatest war photographer in the world. Born Andrei Friedmann, the Hungarian native had reinvented himself as Robert Capa. This pseudonym, which became an alter ego, was chosen because Capa believed it made him sound both cosmopolitan and wealthy, which he hoped would help him sell more pictures.[27] Capa covered World War II as a photographic correspondent accredited to the U.S. Army, the only enemy alien to be accorded such status. In 1947, he published *Slightly*

out of Focus, a chronicle of these adventures that consolidated his reputation as the quintessential combat photographer: always seeking action, forever on the move, free of domestic entanglements, and not afraid of danger. In fact, Capa's motto was "If you're not close enough, your pictures aren't good enough." *Slightly out of Focus* centers on Capa's continuing attempts to photograph the most intense action of the war. However, two subplots compete—his drinking and gambling episodes, and his romance with a woman he nicknames "Pinky." Throughout the book, he describes in detail the type of liquor he drank, the quantity consumed, and the amount of money he lost playing the "manly art of poker."[28] In fact, he seems to care nothing for money, except that it can buy him alcohol, enable him to gamble, and assist his conquest of women. His affair with Pinky serves to frame the narrative. She waits for him in London, hoping to see him between battles. He hopes to see her, too; however, at one point, he drinks to his "lucky escape," because he is called to North Africa just as things begin to get serious between them.[29] Capa frequently disappoints Pinky by not arriving in London as planned. In one case, she repeatedly delays surgery for appendicitis because he is expected to arrive any day. By the time he does get to London, however, four weeks after Pinky is first diagnosed, her appendix has burst, and she must remain hospitalized for weeks. The book concludes with Pinky announcing to Capa that she is marrying his friend, a major who had accompanied Capa throughout much of the war. As she explains, "These last two years, you've been having yourself a time, but I had only a wait. Now I am in love—and am loved too." As Pinky walks out for the last time, Capa glances at the morning newspaper; the headline reads "WAR IN EUROPE OVER." Immediately following is the last line of Capa's text: "There is absolutely no reason to get up in the mornings any more."[30]

According to Capa's biographer, Richard Whelan, Capa wrote *Slightly out of Focus* with the intention of selling it to the movies; therefore, it reads as an "entertaining story" rather than a detailed description of actual events. The dust jacket states, "Writing the truth being obviously so difficult, I have in the interests of it allowed myself to go sometimes slightly beyond and slightly this side of it. All events and persons in this book are accidental and have something to do with the truth."[31] Consequently, we can read Capa's narrative as an indication of how he wanted the world to see him—a hard-drinking gambler who plays at war and romance. His heterosexuality is not in question, nor is his heroism. At great risk to himself, Capa parachuted into enemy territory, landed with the troops on the beaches at Normandy, and marched with the infantry into Paris and Berlin. After "hating" himself for shooting pictures of dead soldiers before he had himself experienced combat, Capa decided, "If I was to share the funeral, I swore, I would have to share the procession."[32]

Indeed, the procession was what excited him; his ultimate goal was to get the most-thrilling war photographs, to scoop other photographers by being the first to get pictures of a particular battle or landing. In *Slightly out of Focus,* Capa would have us believe that he *lives* for war, that he is so addicted to it that without it, there is no need to get out of bed in the morning. However, his personal competition was not with an enemy nation but with other photographers, and he was not above decep-

tion in claiming victory. In *Slightly out of Focus,* he wrote that he photographed the first paratroopers to invade Sicily, despite the fact that his photographs were actually taken two nights later. Moreover, Capa arrived in Sicily on a supply ship; he did not "parachute in" as he described in the book.[33] Of course, these "slight" stretches are, as Capa claimed, in the "interests" of truth, for Capa's primary truth was that he *did* voluntarily put himself in danger, as demonstrated by an episode concerning one of the paratroopers preparing to jump over Sicily.

As Capa relates the story, the boy asks Capa if it is true that he is really a civilian and did not have to come, that he could have flown back to the United States instead. Just before the boy jumps, he turns back to Capa and yells: "I don't like your job, pal. It's too dangerous!"[34] Thus, Capa's bravery is even greater than that of the soldier, for he does not *have* to be there—he *wants* to be. It is an adventure, and like poker, just another gamble. As he wrote about his decision to cross the channel with the troops on D-Day:

> I would say that the war correspondent gets more drinks, more girls, better pay, and greater freedom than the soldier, but that at this stage of the game, having the freedom to choose his spot and being allowed to be a coward and not be executed for it is his torture. The war correspondent has his stake—his life—in his own hands, and he can put it on this horse or that horse, or he can put it back in his pocket at the very last minute. I am a gambler. I decided to go in with Company E in the first wave.[35]

Capa's photographs of the Normandy invasion, which first appeared in the 19 June 1944 issue of *Life,* are among the most famous of the war (Figure 10). Not only do they capture the chaotic nature of the landing, but they reinforce the blurred shot as a standard aesthetic of combat photography, the permanent material inscription of the photographer's body in action. Although the blur could be attributed to the movement of the men through the water, *Life* explained that it resulted from Capa's "immense excitement," for he was also up to his chest in water, hiding behind whatever object he could find as bullets whirred past his head.[36] In actuality, however, the images are blurred because of a mistake made in their processing.[37] Like Capa's book, the story presented to the public was "slightly out of focus," as are the images, yet both functioned in the "interests" of "truth."

Capa's hypermasculinity was enacted not only through courage in combat but in his refusal to be domesticated. The "real" Pinky was legally married for the majority of their relationship and thus unattainable. In 1946, Capa became a U.S. citizen, after a marriage of convenience to an American friend. This was to be Capa's only legal marriage, and he and the friend never lived together. In fact, he was able to evade domesticity throughout his adult life. After the war, he became involved with the actress Ingrid Bergman. Although the relationship was serious enough for Capa to move to Los Angeles to be near her, he eventually broke it off under pressure to marry. According to Whelan, Capa told Bergman that if he married and had children, he would not be able to take dangerous assignments.[38] Capa's conquest of women; his friendship with Ernest Hemingway; his fondness for alcohol, gambling, and elegant

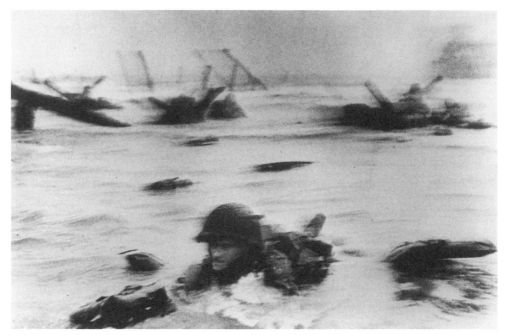

Figure 10. Robert Capa, "The First Wave of American Troops Lands at Dawn, Omaha Beach, June 6, 1944." Copyright Robert Capa R/Magnum Photos.

clothing; and his charm and good looks all contributed to the carefully constructed persona that was Robert Capa, the jet-setting, playboy adventurer.[39] Indeed, Capa described himself as a gypsy, one who revels in a rootless state. Other wars enabled this state until 1954, when Capa stepped on a Vietminh land mine in Indochina and was almost immediately killed.[40]

Capa was not the only high-profile photographer to be killed in action in the 1950s. Werner Bischof had died only a few days earlier, when his pickup truck ran off a fifteen-hundred-foot cliff in the Peruvian Andes. Bischof was Capa's friend and a fellow member of Magnum Photos. In 1956, David Seymour, "Chim," was killed. Seymour and Capa had been friends since the 1930s, when they had shared a Paris apartment and covered the Spanish Civil War together. Seymour was killed by gunfire just south of Port Said, Egypt, where he had traveled with the Allied oc-cupation forces.[41] Although neither Bischof nor Seymour had enjoyed a reputation for daring to the extent that Capa did, their deaths cemented the equation of photo-journalism with danger, the assumption that a good photojournalist was a daring photojournalist.

The primary rival to Capa's title of the world's greatest war photographer was David Douglas Duncan, the most celebrated photographer of the Korean War. Duncan had joined the staff of *Life* magazine in 1946, after having served as a Marine com-bat photographer during World War II, when he was allowed to "roam anywhere west of Pearl Harbor with carbine in one hand and camera in the other."[42] Duncan had been a boxer, diver, big-game hunter, and fisherman; he saw photography as a

means to satisfy his zest for "the Hemingway kind of life." Indeed, Duncan's "prime objective" was always "excitement and adventure," never photography.[43] As a combat photographer, Duncan was considered especially fearless, "a soldier of fortune in the best romantic sense," as described by Maloney, who awarded Duncan a U.S. Camera Achievement Award for 1950.[44] In World War II, Duncan had sealed himself inside the wing tank of a P-38 plane so that he could take photographs through Plexiglas of rocket attacks on the Japanese at Okinawa. For an hour, Duncan took pictures as the plane engaged in bombing dives, sometimes reaching speeds of three hundred miles an hour. In a 1950 article promoting its "star reporter," *Life* magazine reinforced Duncan's reputation as a daring adventurer, using "tough" rhetoric to describe a "tough" man. Not only does the article include a shot of Duncan as a "bearded, begrimed" Marine and one of him "sealed" in the wing tank, but it reprints photographs from his sporting days and from his adventures after the war, when he · "roamed" through the Balkans, the Near East, and India. One of his "feats" was working six weeks behind the Iron Curtain in Bulgaria, where he "nabbed" pictures of the Communist boss, in defiance of the ruler's guards. He also "cracked" an Arab ban on U.S. correspondents during a Palestine conflict, even managing to photograph the meeting of feuding Arab kings.[45]

Duncan was on assignment in Southeast Asia when fighting broke out in Korea, but he was able to travel there immediately, in time to garner the distinction of being the first photographer ever to fly on a jet combat mission.[46] Like Capa, Duncan published a book of his war photographs; however, its narrative is entirely different in tone from that of Capa's. Whereas Capa told an "entertaining" story about his various adventures in love, war, drinking, and gambling, Duncan's story is a seri ous tale about soldiers, the subject of his photographs. Yet it could be argued that because Duncan identified so closely with them, it is actually his story, too: "Nearly every man in this book is a U.S. Marine. It is no accident. I was one of them in World War II." Like that of the Marines whom he glorifies, Duncan's virile asceticism is taken for granted. For both the photographer-hero and the soldier-hero, the mission transcends mere politics. According to Duncan, these men fought simply because "they were Men,"[47] a motive especially important during the Korean War, a U.N. "police action" that did not generate the patriotic fervor created by World War II. These soldiers fought to preserve their gender, an ideological construction deemed natural, thus "good."

For the combat photographer, the mission is also the assertion of manhood, constructed through bravery and physical prowess but also through the quest for "truth." Therefore, regardless of the moral justification for a particular war, the photographer's motives are also always "good."[48] He is a warrior whose success does not depend on that of any military operation. His personal courage in revealing the truth is all that matters. With such a premium on truth, combat photographers fear accusations of fakery. In fact, Capa was accused of posing his most famous photograph—"Falling Soldier."[49] Paying for photographs with their blood, however, as did Capa, redeems them from the taint of suspicion, for why would a man have

to pose his shots if he was courageous enough to enter the heart of combat? Indeed, to charge him with fakery is to call him a coward and to question his honor. For the combat photographer, realism as the embodiment of truth is a transcendent value, as well as a signifier of heroism and thus manliness. It is the opposite of artifice—the feminine seductress. Capa and Duncan are never referred to as "artists," despite the careful artistry exhibited in their work. Martin Green connects this valorization of truth to the white male cult of adventure: "Our will to power, which we mask from ourselves by calling it a love of the truth, is a will to wander, to transgress limits, a will that will not be overcome."[50]

Another factor underlying this fear of the charge of fakery, however, may be an unconscious one: Too close an examination carries the risk of being "found out," of exposing war as display, performance, just a game, of revealing the line between the real and the artificial to be a precarious, perhaps nonexistent, one. It is thus no coincidence that the site of war is referred to as an "arena" or "theater." As Maloney proclaimed, "This is war—an all-too-human game."[51]

The Iconography of War: Violence, Aesthetics, and Masculine Identity

With the Yalta Conference in February 1945, the Cold War began, even though officially, the United States and the Soviet Union remained allies until World War II ended six months later. In fact, the United States did not even inform the Soviet Union about the Manhattan Project before the atomic bomb was dropped on Hiroshima, although the British had known of it from the start. A cold war, perhaps even more than a "hot" war, needs cultural expression, for there are no physical battles, no shedding of enemy blood to satisfy the desire for victory. The Cold War was an attempt to create order out of chaos on a global scale, to "contain" the spread of communism.[52] This desperate need for security was a symptom of anxiety, the "official emotion" of the era.[53] The National Security Act (1947), the Truman Doctrine (1947), and the Marshall Plan (1948) were used as weapons to help relieve this anxiety, as was photography, which packaged international conflict for consumption and provided reassurance of U.S. supremacy through iconic images of heroes, martyrs, and military might. Between 1945 and 1950, Americans fought for abstractions, for symbolic representation itself. Photographs did the work of the real by imbuing Cold War ideology with materiality, by visually affirming masculine potency. Indeed, the years immediately following World War II replayed that war in photographs in a succession of exhibitions, photo essays, and photographic books. These images of war created an imaginary of war—a vision of us versus them, although the "them" was variable, which would become evident in 1950 in Korea, when former allies became enemies and a hot war was waged for Cold War purposes.

War dramatically entered the institutional parameters of the art world in Edward Steichen's Museum of Modern Art exhibition Power in the Pacific: Battle Photographs of Our Navy in Action on the Sea and in the Sky, which ran from 24 January to 18 March 1945, after which it toured museums and art galler-

ies throughout the nation.[54] Captain Steichen had been placed in charge of Naval Aviation Photography and personally commanded a unit of officer-photographers, professionals whom he had chosen.[55] His exhibition was made up of 156 murals, photographs of up to six feet by eight feet, designed to bring "the civilian into the war with immediacy and an overwhelming sense of reality."[56] Steichen claimed that his motives for wanting to be involved in the war were based on his belief that "if a real image of war could be photographed and presented to the world, it might make a contribution toward ending the specter of war."[57] However, the photographs, wall text, and captions of Power in the Pacific did little to suggest the horrors of war. Instead, they emphasized heroism, glory, and, above all, military might, a message packaged in an installation that promised entertainment, the vicarious experience of thrill and action. Indeed, with this exhibition, Steichen succeeded in fulfilling his primary job requirement, which, according to Catherine Tuggle, "was to make aviation sexy and appealing to young men."[58] As the wall text introducing the exhibition read:

> Here is the war in the western seas, and here are the men who fight it. Here are the tools of the warrior's trade—the guns, the ships, the airplanes. Here is the force that America sent into Far East waters—Midway, Saipan, Guadalcanal, the beach of bloody Tarawa, Lingayen Gulf, and Guam and Truk, and far-off gloomy Formosa. Yesterday these men were boys; today they are seasoned warriors. Yesterday the airplanes were but lines on a thousand blueprints; today they sting the air with death, and shake the earth with blastings. Yesterday the ships lay stacked in piles of shapeless metal; today they cleave the trackless sea, belching steel and brimstone against the slimy swamps, the mountain caves, the jungle.[59]

In addition to adopting the aura of romantic poetry, a common sentimentalizing feature of much writing about war, this introductory text features those motifs that figure prominently in combat photography: the transformation of boys into warrior men, the fetishization of weaponry, the spectacle of death, and the quest to penetrate and dominate nature, signified by the territory and physical body of the enemy. These elements constitute the iconography of war, an iconography integral to the construction of masculine identity.

As Steichen later recalled, he had repeatedly stressed to his unit "the importance of photographing the men, watching the men all the time, photographing them in everything they did," because although the ships and planes would one day be obsolete, men never would be.[60] Consequently, Power in the Pacific is a visual narrative about men, a homosocial romance of male bonding. As Susan Jeffords explains, the "masculine bond insists on a denial of difference" between men, yet at the same time, "the bond itself depends for its existence on an affirmation of difference—men are not women."[61] The warrior role was still an exclusively male one, even though the feminine is deployed; it is that from which these men flee.

What is so important about this masculine collective is that it enables men to experience fusion, to allow their ego boundaries to dissolve without "slipping back"

into the feminine, signified by the maternal body from which they came. In his two-volume work *Male Fantasies,* Klaus Theweleit analyzes masculine identity as the flight from the feminine, the fear of ego dissolution. In war, however, men are able to legitimately "flow," to release their unconscious desires for fusion yet still remain men. Through unity with the military machine, the soldier male is able to achieve a totality denied him in nonmilitary life, where he must fight to maintain an ego boundary that allows him to function as a masculine individual within a capitalist patriarchal society. But during wartime, the entire nation is transformed into a war machine, led by a community of soldiers whose will is absolute. Theweleit maintains that this collective "battle for nation," the struggle to defeat a political enemy, is not unlike "men's own battle to become men," the fight to destroy the feminine that always threatens.[62]

Theweleit's exegesis on the male ego of capitalist patriarchy is indebted to the theorizing of Sigmund Freud, who recognized the ego as a sort of armor, a boundary that must be maintained against libidinal and unconscious desires that continually threaten from within. However, Freud also recognized an impulse toward ego annihilation. In "Beyond the Pleasure Principle," he formulated his notion of the "death drive," an instinctual compulsion toward death that is always present, always seeking discharge.[63] Post-Freudians, particularly object-relations theorists, have described this compulsion not as a biological one but as an unconscious desire to return to pre-Oedipal existence, to that blissful state of psychic oneness with the maternal body before the ego was formed and individuation began. Because the male child must transfer gender identification away from the mother, his "fight" to maintain his ego boundary is more difficult than that experienced by the female child. He is always in danger of merging into the feminine, which, as Theweleit points out, is experienced as residing in both the exterior world and in the interior of his body. Although he fears the dissolution of his armor, however, he also desires it, a desire he must continually repress, except in war, where this desire for annihilation can be legitimately played out.

In 1959, the U.S. philosopher J. Glenn Gray published a reflective memoir of his years as a soldier during World War II. His analysis of the appeal of war to men bears a striking resemblance to the conclusions drawn by Theweleit. Gray maintains that "men are different in degree only, not in kind," and he argues that it is modern man's estrangement from nature, "our common mother," that fuels his "destructive fury."[64] According to Gray, men are attracted to war because it enables a "delight in seeing," a "delight in comradeship," and a "delight in destruction." A man becomes so lost in the "majesty" of these delights that his "ego temporarily deserts him, and he is absorbed into what he sees." This dissolution of his ego is not frightening but, rather, empowering, for it allows "a joining and not a losing, a deprivation of self in exchange for a union with objects that were hitherto foreign."[65] Fusion with these objects—with other men, the weapons of war, and the awe-inspiring spectacle they create—is intoxicating, a sublime experience unavailable to him in civilian life.

In 1947, Steichen published a tribute to the ship on which he had served. He titled the book *The Blue Ghost: A Photographic Log and Personal Narrative of the Aircraft Carrier U.S.S. Lexington in Combat Operation.* Of course, this "personal" narrative is not only about the inanimate structure that is the actual ship, for the "Blue Ghost" is much more than that: "Captain and the crew . . . the living and the dead, men and steel, men and guns . . . images, moments, emotions . . . all are fused, become a unity—a ship." This ship is "Lady Lex."[66] For the men who reside within and upon "her," Lady Lex functions as a surrogate for the maternal body; it promises suste-nance and invites fusion. However, this fusion is experienced on masculine terms; it does not threaten masculine identity. "She" is experienced as a "living thing,"[67] the material support of nearly three thousand men, a huge floating womb. However, fusion with "her" is mediated by unity with other men; this womb is a homosocial paradise, one created by men for men. "Her" 890-foot-long flight deck serves as a playground, upon which the men play such games as "mumblety-peg," and also as a gigantic breast, to which the men attach themselves to be physically nurtured. As Steichen explains:

> The men, in small groups, are sprawled around the deck; some choose the hot sun on the open deck, others park themselves in the shade of a plane's wings; they pillow up for each other in a fine earthy fellowship, reminiscent of colts resting under a tree or alongside the fence of a pasture, the head of one colt draped over the neck of another, or again, something in the manner of a litter of puppies, all curled up over, under, and about each other.[68]

These men are able to regress to boyhood without fear of loss of manhood, for they are still warriors, military men. Furthermore, they are able to enjoy each other physi-cally, without public chastisement as homosexuals, without the stigma of being "failed men," or in other words, "women," for any homoerotic connotations can be displaced onto the ritual framework of the heterosexist military.[69] Within the context of war, they can release the feminine that they have fought so hard to repress; they can nurture and care for each other, hold and comfort one another—they are literally "brothers in arms" (Figure 11).

They are even free to engage in open expressions of narcissism and erotic contem-plation. One photograph, captioned "A Work of Art Is Placed on Exhibition" (Figure 12), depicts a sailor displaying his tattoos. Against the backdrop of the open sea, he stands in the center of the composition with shirt unbuttoned to the waist, revealing a large tattoo that covers his entire chest. Framed between his nipples are the over-lapping heads of three horses surrounded by a semicircular wreath of flowers. He also has tattoos on both forearms, visible below his rolled-up sleeves. With legs apart and hands on hips, he thrusts his chest out toward the camera but also toward the gaze of the two sailors who frame him in the photograph. One crouches below; his shirt has slid from his shoulders, and the sun caresses his back. The other stands opposite the crouching figure, his stance echoing that of the tattooed sailor, who turns his head

Figure 11. Edward Steichen, "Sailors Sleeping on Flight Deck of the USS Lexington" (1943). National Archives at College Park, College Park, Maryland.

to watch as his comrade admires his decorated chest. This sailor's shirt is also open to the waist, seductively fluttering in the wind, which threatens to blow it from his shoulders altogether.

Steichen's caption for this photograph is ambiguous; what is the "work of art" on display, the tattoos or the male bodies? Indeed, the tattoos mark the body as object, eroticize it, demand another's gaze. The subject matter of the tattoos also forces a "reading" of the man through his body; they serve as an autobiography of sorts, a record of his coming into manhood, often through possession of the feminine— his mother, a girlfriend, or a land he has visited. Duncan wrote about such visual signifiers, "And those tattoos were tremendously symbolic of the new, secret man beneath . . . for the words and colors, like their training, could never be erased."[70] Tattoos serve as emblems of membership in a sacred brotherhood; their application is conceived as an initiation rite, the achievement of manhood through violence and pain, which is endured with the support of other men.

Of course, violence and pain are what war is all about. As Elaine Scarry argues, human bodies are central to war, for it is only through the alteration of bodies that war is made real. The "massive opening of human bodies" is a "way of reconnecting the derealized and disembodied beliefs with the force and power of the mate-

Figure 12. Edward Steichen, "A Work of Art Is Placed on Exhibition." National Archives at College Park, College Park, Maryland.

rial world."[71] Moreover, McBride describes war as a "male territorial game" that celebrates the "founding violence of patriarchy through the signs of aggression and blood." Violence underwrites societal law, "binding" men in a "covenant" that must be ritually reinscribed. International law, which determines the distribution of power among patriarchal societies, is only "legitimated by its enforceability," the "willingness" of nations to go to war to preserve it. Furthermore, this "reinscription of the social order requires a sacrificial victim, someone whose blood effaces the threat of lawlessness that haunts patriarchal culture." Consequently, war "creates" its opponents from a pool of nations, which have the potential of being either friend or foe. Those opponents are then constructed as *the* enemy, demonized to the point of dehumanization, a process aided by the mechanisms of propaganda, in which photography plays an integral part.[72]

Although *The Blue Ghost* does not picture enemy soldiers, Steichen's text conveys the exhilaration involved in successful missions against the Japanese. In fact, the men

delight in killing what they refer to as "the Jap" or "the Nip." One of Steichen's photographs in *The Blue Ghost* focuses on the flames and smoke that rise into the air after a Japanese plane has been shot down. Steichen describes this episode in the text:

> As the Lex was steaming past the burning wreckage of the first plane shot down, the portside crew saw the Jap insignia, the bright red disc, on part of a plane's wing and were able to guess what happened. I hear one lad laughingly tell his chief about seeing some of the gun crew throw all the handy loose tools at what looked like the heads of Jap airmen bobbing around in the water. The chief explodes with, "What the hell did they want to do a fool thing like that for, waste good tools, why didn't they turn the machine guns on the bastards?"

No revulsion is exhibited by Steichen, who describes himself as "wearing the same style grin" as the other men. In fact, along the flight deck, everyone displays an "expansive friendliness." He explains: "War has moments when it seems almost like a ball game or a horse race. We're the winning team out here today, we're the jockey receiving a big floral horseshoe after the race."[73]

Steichen's comparison of war to a game is, of course, at the heart of McBride's argument, which is that war is a territorial game played by men to enact dominance. However, as McBride explains, enemy soldiers are only substitutes for the *real* threat:

> The absence of male power is a frightening image in a patriarchal society. The thought of emasculation produces the fear that in turn both legitimizes and motivates aggressive action. In a world of mimetic rivalry skewed by the phallic metaphor for power, competitors contemplate their rival's emasculation rather than their own. Rhetorical castration is therefore a sign of the ritual victim who exists as an interloper in a homosocial community. The feminization of the enemy is therefore not incidental but rather essential to the social dynamic of sacrificial violence in a patriarchal social order. The enemy is woman because she is what men are not but fear they might become. Ritual victimization of the enemy as female confirms male identity. Male territorial games prove that men are men—to men—and ensure the solidarity of the homosocial community.[74]

Weapons play a central role in this game, for they act as fetishes of phallic power, as security against the overwhelming castration anxiety brought about by war.[75] They are hard items that will not fail; they hold out the promise of continual erection. The photographic iconography of war celebrates the impenetrability of ships, planes, and guns, yet it denies this hardness to the enemy, who when shown, is never depicted in a heroic or powerful manner. On the contrary, he is represented as defeated, humiliated, or dead. His weapons have been destroyed; his body has been or can be penetrated. In other words, he is rapable. As Catherine MacKinnon has pointed out, "to be rapable, a position that is social not biological, defines what a woman is."[76]

Both *Power in the Pacific* and *The Blue Ghost* aestheticize, indeed fetishize, the weapons of war, as they do the male body. Charles Fenno Jacobs, one of Steichen's officer-photographers, is especially adept at uniting men and weapon, at linking the

firmness of body with the solidity of metal (Figure 13). Theweleit speaks at length about this fusion of man and machine, arguing that the metal of gun barrels takes the place of the soldier's "body armor," thus allowing the ego to transcend its own boundaries. In symbiosis with guns, the soldier can explode, yet remain intact, can penetrate enemy bodies, yet remain stable.[77] Likewise, Gray argues that weapons are "not only an extension of the soldier's own power" but "a second skin, a protective layer against the harsh outer world." However, they also enable the soldier to relinquish individual guilt for killing, for with loss of self comes loss of responsibility. According to Gray, weapons not only "cement the wall of comradeship" by filling in the spaces between men, but they make killing easier, for it can be done from a distance—like a weapon, a soldier is simply an instrument of war.[78]

Jacobs also shot an image of a Japanese prisoner of war, an image that demonstrates this contrast between hard and soft, impenetrability and rapability (Figure 14). The crew members of the battleship U.S.S. *New Jersey* gather on deck, where they

Figure 13. Charles Fenno Jacobs, "Loading Powder Bags, USS New Jersey" (1944). National Archives at College Park, College Park, Maryland.

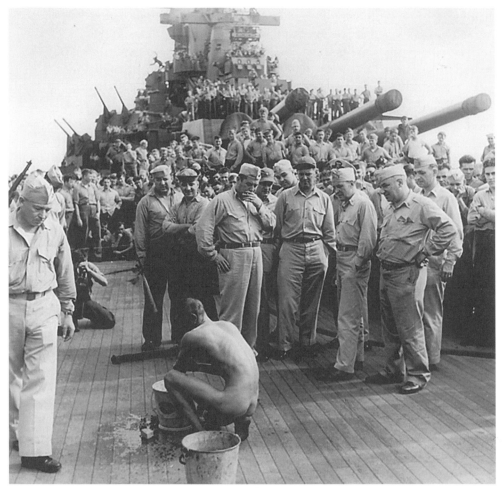

Figure 14. Charles Fenno Jacobs, "Crewmen of the Battleship USS New Jersey Watch a Japanese Prisoner Bathe Himself before He Is Issued GI Clothing" (1944). National Archives at College Park, College Park, Maryland.

strain to observe the naked body of a prisoner, who is "clipped" and "deloused" and then forced to bathe himself publicly.[79] He crouches between two buckets, his shaved head lowered to avoid the penetrating stares of the hundreds of eyes that are focused upon him. The prisoner's back is to the camera; his posterior is exposed, vulnerable to the viewer's gaze. One of the officers nearest him smokes a cigarette in casual contemplation; a burly enlisted man to the officer's right holds what appears to be a baseball bat. The prisoner is sandwiched between Jacobs's gaze and that of the entire crew, signified by another photographer, who appears to be filming the incident. This play of domination and submission is reinforced by the huge gun barrels that seem to originate from the collective body of the crew and point in the direction of the defeated prisoner, who is doubly coded as "woman," for he is not only rapable but impure. Indeed, he is physically separated from the other men, forced to "purify" himself under their scrutiny before he is allowed to don GI clothing. As McBride

argues, the "configuration of the body, woman, and filth is a commonplace in the history of Western culture."[80]

According to Theweleit, racism is "patriarchal domination in its most intense form." Because the alien race is "encoded with threatening femininity," with the "murderous forces of the man's own interior," it "must" be "exterminated."[81] During the war, the Japanese were vilified to a greater extent than were the Germans and Italians. As correspondent Pyle noted: "In Europe we felt that our enemies, horrible and deadly as they were, were still people," but "the Japanese were looked upon as something subhuman and repulsive; the way that some people felt about cockroaches or mice." Pyle even admitted that after observing Japanese prisoners "wrestling and laughing and talking just like normal human beings," they still gave him "the creeps, and [he] wanted a mental bath after looking at them."[82] Even Adm. William F. Halsey referred to the Japanese as "bestial apes" and claimed that "it is just as much pleasure to burn them as to drown them."[83] As Theweleit argues, the horror one feels toward the body of a member of an alien race is experienced as a contamination of one's own body. Thus, purification is necessary if bodily boundaries are to be maintained. Theweleit claims that it "is only in war, in an organized act of murder," that the soldier male can purify himself, "can expel the 'primitive within' without perishing in the process."[84] Likewise, McBride argues that war allows the soldier to experience continuity, "the oneness of death," without actually dying: "The bodily integrity necessary for life is ensured if the ruptured body is not one's own. The pleasures of rupture and self-annihilation are available by proxy: in 'woman' as victim. The male gaze vicariously makes the rupture its own."[85]

One of the most renowned photographs of World War II gives visual expression to such rupture: W. Eugene Smith's "Marine Demolition Team Blasting out a Cave on Hill 382, Iwo Jima" (1945). This image appeared on the cover of the 9 April 1945 issue of *Life* magazine, which included an article by Smith on the battle for the island. It was also reproduced in the 1946 *U.S. Camera Annual*, in a thirty-two-page spread dedicated to Iwo Jima.[86] The scene depicts the blasting of a blockhouse in which Japanese soldiers were hiding. On the caption sheet, Smith had written, "Sticks and stones, bits of human bones . . . a blasting out on Iwo Jima."[87]

"Sticks and Bones," as the photograph has been nicknamed, is an aestheticization of death, killing as a thing of beauty. The battle to take Iwo Jima was especially bloody, the epitome of war as a territorial game. This island, two and a half miles wide by five miles long, was a strategic site; it was only 660 miles from Tokyo, and it had two airfields and an unfinished airstrip. More important from a symbolic standpoint, Iwo Jima was part of the Japanese empire and had been so since 1887. To "take her" was literally to "rape" the enemy. Approximately 200,000 Marines fought to dislodge 23,000 Japanese soldiers, who were entrenched in underground caves and in steel-reinforced concrete blockhouses and pillboxes, many buried under three to four feet of volcanic sand at the foot and up the slopes of Mount Suribachi. Because naval bombardment was often ineffective, the fortifications had to be destroyed by demolition crews, who rigged dynamite charges at their openings while under heavy enemy

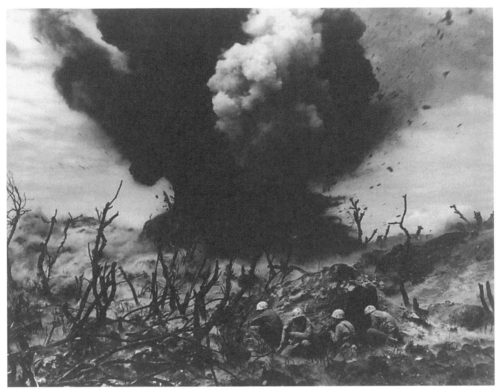

Figure 15. W. Eugene Smith, "Marine Demolition Team Blasting out a Cave on Hill 382, Iwo Jima" (1945). Copyright the Heirs of W. Eugene Smith, courtesy of Black Star, Inc., New York Collection, Center for Creative Photography, the University of Arizona.

fire and the threat of land mines. These explosive charges were supplemented by fire from carrier planes, which repeatedly circled the island. Any Japanese soldier who survived the destruction of his bunker would be met by flamethrowers, rifle shells, or grenades. Hand-to-hand combat with knives was also reported, sometimes resulting in decapitations. Smith's photograph records the devastation that resulted from this continual assault, this annihilation of all enemy life—human and otherwise. Even before the battle, the island evoked death; nicknamed Hot Rock, its beaches were black and its surface oozed yellow mists of sulfur.

Smith's photograph records one moment in the six-day battle to take Hill 382, nicknamed "the Meatgrinder" because of the hundreds of brutal deaths that occurred there. Six companies took turns assaulting this volcanic knob. On the first day, one company lost 40 men; another killed 150 Japanese. The company that finally captured the hill lost so many men, including seven officers, that it was virtually annihilated and had to be combined with another after the battle.[88] The photograph reeks of this mass death. Scorched tree branches rise from the haze of volcanic ash that shrouds the pockmarked earth, serving to frame the four members of the demolition crew who take cover behind a rock. Clouds of smoke and black sand rise into the air behind them, as the dynamite explodes and debris flies. Like a Gothic graveyard

shrouded in mist, this image is an apotheosis of death, from the twisted branches that evoke skeletal remains to the smoke that threatens to suffocate. Nothing remains alive in this small area except for the four U.S. soldiers, whose bodily integrity seems a contradiction, considering that everything around them has burst, has been blasted apart.[89] Nature has submitted to the spectacle of death, brought about by phallic hegemony, represented by the weapons of war, to which the soldier male is "coupled."[90] Indeed, "she" has been raped and murdered, acts that can be forever savored through the voyeuristic lens of the camera.

Iwo Jima was also the site of another famous war photograph, perhaps the most reproduced and most ideologically laden photograph in U.S. history: Associated Press photographer Joe Rosenthal's "The Raising of the Flag on Iwo Jima," for which Rosenthal won a Pulitzer Prize (Figure 16). In *Iwo Jima: Monuments, Memories, and the American Hero,* Karal Ann Marling and John Wetenhall trace the circumstances surrounding the taking of this photograph and the mythologizing that occurred in its wake. Their investigation into the deliberate orchestration of this U.S. icon demonstrates the centrality of visual display to the maintenance of heroic masculinity, as well as the ability of a single photograph to create the "truth," despite historical fact.

Rosenthal's photograph implies that the battle for Iwo Jima has been won; however, almost a month of fighting remained before the island was secure. Moreover, three of the men photographed would be killed on the island. The spontaneity suggested by the composition was also contrary to fact, for the decision to raise a flag on

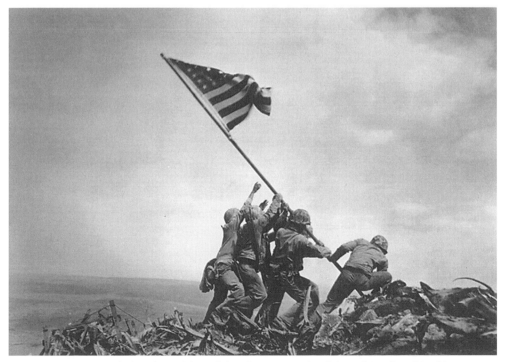

Figure 16. Joe Rosenthal, "The Raising of the Flag on Iwo Jima" (1945). National Archives at College Park, College Park, Maryland.

Mount Suribachi was made aboard the U.S.S. *Eldorado* on 22 February, the day before Rosenthal shot the photograph. Secretary of the Navy James Forrestal and Marine Gen. Holland M. Smith believed that a symbolic act was needed to raise troop morale and appease public criticism over the tremendous cost in U.S. lives. They concluded that the sight of the U.S. flag over the highest peak of the island would accomplish both, but only if civilian photographers covered the event. Therefore, Forrestal decided that he would personally witness the battle for Suribachi, for wherever he went, the photographers were sure to follow.[91]

At 8 a.m. on 23 February, four Marines blazed a trail to the top of the volcano, surprisingly unopposed by enemy fire. A few hours later, another group also reached the summit unchallenged, accompanied by Marine photographer Lou Lowery, who was covering the battle for *Leatherneck*. Lowery photographed as the men raised a small flag, which, when it was seen, brought exclamations of joy from the Marines on the beaches below. However, Lt. Col. Chandler Johnson decided that a larger flag would be even more effective. It was the raising of this second flag that Rosenthal witnessed and photographed, and it was this image, published in newspapers throughout the United States two days later, that gave the Marines the publicity they sought, for it established their reputation as *the* fighting men, immortalized them as men of "uncommon valor."[92]

Rosenthal's iconic image has become a synecdoche for the war, perhaps even for the United States itself. It encapsulates the country's belief in its own goodness, in the spirit of democracy, signified by each individual Marine working toward a common goal, represented by the U.S. flag. Undying spirit, stamina, courage, endurance—the summit was reached, the territory claimed, even though it lay in shambles beneath their feet. As Moeller argues, the "metaphor that twentieth-century war photography has most neatly embraced is that of the American frontier." And this "frontier, in short, was a frontier of violence."[93] Of course, as the image suggests, patriotism functions as a euphemism for violence. The dead, who would eventually total approximately all 23,000 Japanese and 6,775 Americans, are nowhere seen.[94] This was the picture of war that would sustain Americans throughout the early years of the Cold War; it gave materiality to ideology, physical substance to patriotism. In addition to its numerous printings in the media, Rosenthal's photograph was used as the symbol of the seventh war-bond drive, and it appeared on a postage stamp, on three and a half million posters (including recruiting posters for the Marines), and on 175,000 display cards for buses and trolleys.[95] It also inspired the 1949 film *The Sands of Iwo Jima*, starring John Wayne,[96] and the bronze memorial to the Marines at Arlington National Cemetery by Felix de Weldon, which was completed in 1954. More than any other photograph, this image functions as an icon to virile asceticism; it invokes "good" feelings about war, about the nation's superiority, both morally and in terms of military might. It also leaves no doubt as to the manliness of our fighting men, for warriors are, by definition, men—not boys, not women—and especially Marines, who were at the top of the armed forces' masculine pecking order. They were *real* men; they went in first.

Warrior masculinity requires heroes for its survival; it needs to induct young boys into the martial brotherhood. The rewards promised by war must be valued over human life, for not only must boys be transformed into killers, but they must be made willing to accept their own death. In return, they are given the chance to achieve the highest status of manhood, to gain honor, even immortality. The three surviving Marines depicted in Rosenthal's photograph were immediately transformed into national heroes; they were removed from active duty and paraded throughout the United States to promote war bonds. They were even invited to raise the flag over the U.S. Capitol on V-E Day and to reenact the flag raising for the closing scene of *The Sands of Iwo Jima,* truly a case of art imitating art. Of course, their status as heroes was a result not of their "uncommon valor" but of their being the subjects of a particular photograph. In other words, it was the image of heroism that was important, not necessarily the substance. Although the military and the press initially acknowledged the actual events and the men involved in the previous ascents up Suribachi, Marling and Wetenhall conclude that by the end of one month, fiction had won out over fact, for it was "more interesting," and it seemed "truer."[97] The "truth" was that any boy could grow up to be hero, whether a small-town boy from Wisconsin or New Hampshire or a Pima Indian from an Arizona reservation, as were the three surviving flag-raisers.

Heroic manhood is, of course, one of the most important iconographic motifs of combat photography. Heroism, however, is predicated not only on triumph but on sacrifice. The exhibit catalog for *Power in the Pacific* includes a photograph of a wounded gunner being lifted out of the turret of an Avenger torpedo bomber, which had landed on the U.S.S. *Saratoga* after a successful raid on Rabaul (Figure 17). The caption, printed in German black-letter script and given the entire facing page in the catalog, reads: "took him down and wrapped his body in clean linens."[98] Again, McBride's notion of virile asceticism is at play, for a sense of religious morality is imparted to military action. Like the biblical Christ, air crewman Kenneth Bratton offered his own life as a sacrifice; however, unlike Christ, the war hero does not turn the other cheek when threatened. Rather, as the caption accompanying a reproduction of this photograph in *U.S. Camera Annual 1945* reads, he keeps "plastering the Japs with his machine gun" until the attack is over, even though he has almost lost consciousness because of the shattering of his knee and the subsequent loss of blood.[99]

In *Violence and the Sacred,* René Girard argues that war functions to ritualize and thus purify violence. "Only blood itself, blood whose purity has been guaranteed by the performance of appropriate rites—the blood, in short, of sacrificial victims," can "cleanse" society of "contaminated blood," the "pollution" that results from indiscriminate violence.[100] War and religion are ritual frameworks that prevent "impure" violence, reciprocal acts of vengeance that might spiral out of control; cultural order and stability would thus be threatened. War, like religion, functions to unite a community, to reinforce the social fabric. During war, the violence upon which all masculine relationships are based can be redirected into "proper channels"; it can be disposed of "more efficiently" because it is not regarded as "something emanating

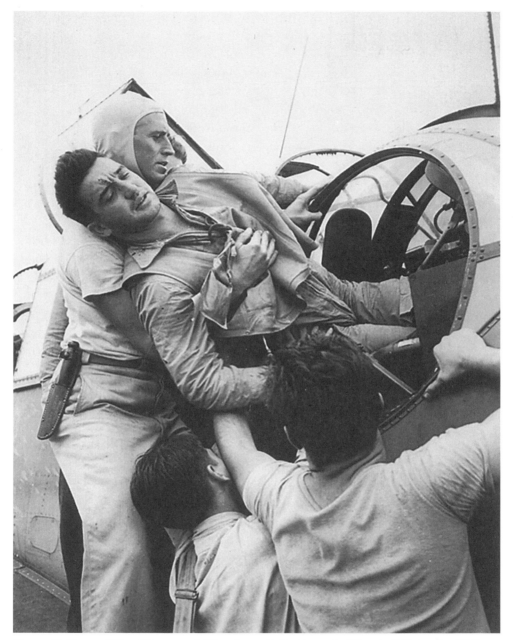

Figure 17. Wayne Miller, "Crewmen Lifting Kenneth Bratton out of Turret of TBF on the USS Saratoga after Raid on Rabaul" (1943). National Archives at College Park, College Park, Maryland.

from within themselves, but as a necessity imposed from without."[101] War is a socially sanctioned catharsis.

Nowhere is a sense of catharsis more evident than in the imagery of the atomic bomb. Indeed, the photographs taken of the bombs as they exploded over Hiroshima and Nagasaki represent the epitome of violence purified. These photographs were

published in the 1946 *U.S. Camera Annual,* along with before-and-after photographs of the two Japanese cities, eyewitness reports, and articles and diagrams explaining how the bomb works; however, no imagery of human casualties was included. Throughout this section of the annual, a cold, almost clinical, tone prevails, punctuated only by spurts of awe and fascination at the destructive power and strange beauty of the exploding bombs. Any acknowledgment of human death is suppressed beneath the rhetoric of aesthetics. The Hiroshima bomb is described as follows: "A white mushroom of smoke leaped 20,000 feet into the air, spilled into a great billowy cloud. Then, like a plucked bloom, the top of this cloud broke from its stem and rose several thousand feet." On the Nagasaki bomb, William L. Laurence of the *New York Times* is quoted: "As the first mushroom floated off into the blue it changed its shape into a flowerlike form, its giant petal curving downward, creamy white outside, rose-colored inside."[102]

Mass murder has become a spectacle, an aesthetic display. Ironically, the complete annihilation of feminine nature by masculine science is described in terms of nature's most profound beauty, that of the flower. Scarry writes, however, that discourse from the realm of vegetation often appears to deny the reality of the bodily injury inflicted during war, for it is believed that vegetable tissue is immune to pain.[103] Euphemisms are also employed to transform destructive acts into ones of creation. According to Brian Easlea, a former nuclear physicist, the metaphor of the "pregnant phallus" recurs throughout the writings and reminiscences of those involved in the development of the atomic bomb. The bomb is repeatedly referred to as a "baby," the "living" offspring of the scientists involved in its creation. Easlea argues that "compulsive masculinity," an unconscious and irrational symptom of "uterus envy," fueled the desire to create an exclusively "male birth process," one predicated on phallic penetration of, and complete dominion over, feminine nature. This compulsion, which dates from the time of Francis Bacon and the founding of modern science, eventually gave birth to "Little Boy," which had been constructed by male physicists and "delivered" from the "belly" of a B-29 bomber manned by an all-male crew. A few days later, "Fat Man" was delivered to Nagasaki.[104] Approximately 200,000 human beings were annihilated within a few seconds, in events hailed as being of "great" historical significance. Although admitting that the 16 July 1945 test bomb in Alamogordo, New Mexico, "symbolized a funeral pyre for the Japanese Empire," Laurence also wrote that it "came as a great affirmation to the prodigious labors of our scientists," who had "managed to 'know the unknowable and unscrew the inscrutable.'" It was a moment that ranked with that moment "long ago when man first put fire to work for him and started on his march to civilization."[105] The atomic bomb is masculine overcompensation on a grand scale, the culmination of eons of struggle to civilize, to control and dominate, feminine nature. Indeed, 1945 ushered in a new era: Nature could be eradicated once and for all, and it would only take a few seconds. Catharsis had never been more pure.

The imagery of the bomb was more than the imagery of death purified; it was a Cold War icon of intimidation. Although many scientists involved in the Manhattan

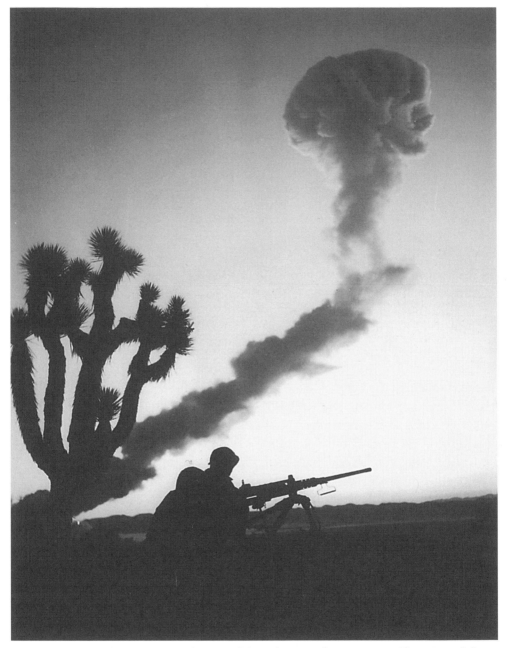

Figure 18. U.S. Marine Corps, "Marines Participate in A-Bomb Tests, Yucca Flats, Nevada" (1955).

Project initially claimed that their objective was to develop the bomb before Nazi Germany did, Easlea points out that progress on the bomb actually accelerated after V-E Day. In fact, he reiterates the long-standing argument that dropping the bomb on Hiroshima was primarily a means to intimidate the Soviet Union, not to save the lives of U.S. soldiers, as was publicly claimed.[106] Photographs of the bomb dominated newspapers and magazines in August 1945; *Life* devoted almost an entire issue to

the story.[107] These photographs came to embody atomic-age anxiety—death without warning, death so absolute, so instantaneous, so barbarous. However, that anxiety was attenuated by the aesthetic brilliance of the photographic imagery, which would increasingly conform to the traditional genre of landscape. For example, in a U.S. Department of Defense photograph of a 1955 atomic test blast in Nevada (Figure 18), a billowy cloud rises from its diagonal stem, in front of which appears the shadowed image of a cactus and a soldier, who is kneeling before his weapon. The image is reminiscent of a beautiful sunset scene in its romantic use of light and shade and in its careful framing, the flowers of the cactus echoing the blossoming billows of the cloud, the gun barrel the cloud's stem. If unaware, one might mistake the blast for an atmospheric or celestial wonder, a natural phenomenon of great beauty.

Photography enabled the public at large to experience vicariously the triumph of masculine science, the "gang rape of nature,"[108] through the socially esteemed act of aesthetic contemplation. As Gray argues, the "delight in seeing," although considered in "its higher reaches" to be a "noble" aspiration, "nearly always involves a neglect of moral ideals":

> Morality is based in the social; the ecstatic, on the other hand, is transsocial. The fulfillment of the aesthetic is in contemplation, and it shuns the patience and the hard work that genuine morality demands. The deterioration of moral fervor, which is a consequence of every war, may not be entirely due to the reversal of values that fighting and killing occasion. May it not be also a consequence of aesthetic ecstasy, which is always pressing us beyond the border of the morally permissible?[109]

Combat photography is a masculine art, for it allows the vitality of art, its status as societal excess, without the prettiness and artificiality that had come to be associated with pictorialist and modernist photography. Moreover, it mirrors the male psyche, which seeks to armor within that which continually threatens to erupt. Indeed, the rationality implied by composition is wedded to the irrationality of its subject matter—violence. Thus, the combat photograph signifies a "contained" violence analogous to war and to masculine identity—a rational irrationality. Because war is already an aesthetic, combat photography is the aestheticization of aesthetics—pure spectacle. It is war for sale, war made accessible to all, not just to the soldiers on the battlefield. The pleasure in seeing, so important to the soldier in combat, is extended to those not able to experience it firsthand. Consequently, combat photography creates a desire for even more spectacle; it whets the appetite of a population who has not experienced the horrors of war firsthand but has merely enjoyed its beauty through the voyeuristic, violent lens of the camera.

3 | Tough Guys in the City: Cameramen and Street Photographers

The uncanny parallel between the mechanism of bullet from a gun and the ejaculation of semen from the penis gives you an idea of how a technology starts. Most inventions are ideas taken from nature and the world, applied to and imposed on materials.
Louise Goueffic— 1996

The camera/gun does not kill, so the ominous metaphor seems to be all bluff like a man's fantasy of having a gun, knife, or tool between his legs. Still, there is something predatory in the act of taking a picture. To photograph people is to violate them, by seeing them as they never see themselves, by having knowledge of them they can never have; it turns people into objects that can be symbolically possessed. Just as the camera is a sublimation of the gun, to photograph someone is a sublimated murder a soft murder.
Susan Sontag— 1973

On 10 October 1958, the dramatic television series *Man with a Camera* debuted on the American Broadcasting Company (ABC) network. The show starred Charles Bronson in the role of freelance photographer Mike Kovac, who spent more time fighting crime than shooting pictures. Because Kovac, a former World War II combat photographer, takes assignments from the police, insurance companies, newspapers, and private individuals who want photographs as proof, he also plays the role of detective, one who invariably ends up solving the crime and thus emerging as the narrative's hero. In the premiere, Kovac takes on the mob to help his boyhood friend Joey, a boxer who is being pressured to fix a fight. Within the first few minutes of the show, Kovac punches out a mobster, and then he himself gets in the ring to fight Joey, an opportunity to bare his chest and display his muscular physique. Accompanied by the stereotypical postwar "blonde bombshell," another childhood friend named Dolly, Kovac eventually saves the day by outsmarting the mobsters, dodging bullets, and then wrestling the gun out of a bad guy's hands. Although Kovac is a cameraman, photography has little to do with his crime-fighting adventures; it is merely his means into the underworld, where he can display his physical prowess

and bravery. This construction of photographer as hypermasculine "tough guy" was reinforced by the show's sponsor, General Electric Flashbulbs, for after Kovac's first fight, the company ran its first commercial, one that exemplifies postwar femininity. Indeed, the action abruptly shifted from a shot of two men fighting to a scene of domestic tranquillity, a young mother taking snapshots of her toddler within the safe confines of the home.[1]

Mike Kovac was not the first fictional crime-fighting photographer to be given cultural expression in the postwar era. The radio program *Casey, Crime Photographer* featured a newspaper cameraman who, like Kovac, emerged as the hero. It was he, not the police, who solved the crimes, often with the assistance of his female companion, Annie Williams. This popular series, which was originally titled *Flashgun Casey,* ran from 1943 to 1950 and from 1953 to 1955.[2] Another fictional crime-fighting photographer was Kent Murdock, the hero of a series of novels by George Harmon Coxe. Murdock worked for the Boston *Courier-Herald,* except for a stint in the Army during World War II, when he received a Purple Heart after taking a shot in the leg. Like most heroes of the era, he was tall, dark, and handsome, sported a "lean hardness of body" and "solid, angular" jaw, and although "well mannered, intelligent and well educated, he could talk the language of cops and bookies and gamblers and circulation hustlers as though he understood them." Indeed, Murdock "could go anywhere and hold his own," and even "though he got mussed up sometimes—and most photographers did—it never seemed to bother him."[3]

Kovac, Casey, and Murdock belong to the underworld of crime and investigation, and although they are fictional characters, the stories of their exploits resemble accounts of real-life photographers who inhabited these realms. Crime and investigative photography were lucrative fields,[4] closely linked to news photography in general, which had the reputation of being the "most exciting and toughest of all photographic jobs." One writer explained: "You will do things and see things and go places that others will only read about. Your beat can take you from high in the sky to deep in the earth. Areas restricted by the police and fire departments will be open for you. Impressive names become your willing subjects."[5] In fact, even the president succumbed to the "tyranny" of the "uninhibited, brassy, irreverent" cameramen who covered the capital.[6] Through possession of a camera, even a man from humble beginnings could wield power. He could also be a hero, especially if he covered the news by plane or helicopter, for these men were often the first to arrive on the scene of a disaster.[7] Like combat photographers, these men risked their lives to perform their duty, and I would argue, to affirm their masculinity. As John J. Floherty begins *Shooting the News: Careers of the Camera Men,* his 1949 ode to the profession: "Perhaps the least mindful of danger, hardship, and if must be, death, are the men who pursue the news with a camera. Assignment to a story is a challenge not only to their fortitude but to their pride."[8]

I must stress here the emphasis on *man*. News photography was considered "hard-boiled"; its practitioners were invariably referred to as "lensmen" or "cameramen."[9] Furthermore, it was open primarily to white men, for people of color were

denied equal access to public spaces. Because most news photographers were on call twenty-four hours a day, seven days a week, such a job would have been virtually impossible for a postwar married woman, especially one with children. Even for a single woman, to be on the streets after midnight, to hang around police and fire stations, and to fight other photographers to get a picture would have been extremely difficult. Moreover, they would have had a hard time fulfilling the stereotype, considering that the ideal newsman was someone like Russ Reed, who at "six foot and 245 pounds," was "totally fearless," a man who would "do virtually anything to get a picture," including risk his life, just as he had during World War II, when he had single-handedly disarmed three enemy bombs rather than call in a bomb specialist.[10] Women could be news photographers, but only in a limited way; thus they were barred from rising to the top of the profession. Most were assigned to feature stories rather than a "beat" (a defined territory, such as city hall, a neighborhood, or a police precinct). They were given assignments similar to those given women photojournalists working for magazines, such as covering social clubs, fashion, and decorating.[11]

News photography was a job considered especially suited to men from working-class backgrounds, much like that of police officer, for it was assumed that one had to be tough enough to handle life on the streets and aggressive enough to insinuate oneself into any situation. Among the most renowned of news photographers was *PM Picture News*'s Skippy Adelman, a "legend" by the age of twenty. A 1945 article on the young sensation attributes to him all the qualities that a "crack" cameraman should possess:

He had a rough childhood. The author refers to Adelman as a "tough little kid from the East Side" who escaped a childhood of poverty and beatings by learning to take pictures for money; indeed, his "ambition" is "to make a lot of money fast."

He looks and acts tough. Adelman has "close cropped hair, dark features, intense eyes, a tough wiry figure," and "the hands of a boxer." His vocabulary is mixed with the "idioms and profanities of Hester Street." He is "hard, pitiless and young," unlike his European counterpart, Alfred Eisenstaedt, who is "cultured, mature and restrained."

He is a ladies' man. Adelman is sexually involved with a "cultivated" and much older woman and with "a lot of cupcakes," showgirls who "are flattered to have a news photographer with them for more than ten minutes."

He is the underdog, the little man who fights his way to the top, taking down hypocrites and exploiters of the poor and powerless. Adelman "pillories mean and selfish parents, bribe-taking cops, the self-loving, pompous rich, the oppressor who robs men of dignity, the silly, sassy café society."[12]

Such is the realm of hard-boiled photography. These men are aggressive; they use "muscle," "shoot from the hip," wear hats, and smoke cigars. They are overwhelmingly urban, at home in the dangerous streets, hardened to tragedy and death. As *New York Mirror* photographer Barney Coons told a reporter, he never became "personally involved." In fact, he claimed that he could "sit down and eat lunch right after covering a murder."[13] It was also a highly competitive field, one in which deceit and even

illegal actions were often necessary in order to scoop other photographers. For a staff news photographer, the only ethic was never to betray one's paper;[14] for a freelancer, no ethical code applied.

For private investigative photographers and "candid" photographers (those who attempt to capture unsuspecting celebrities on film), ethics were not even an issue, for the invasion of privacy was the actual goal. Indeed, the notorious "sneaky-Pete" photographer, Art Shay, repeatedly found himself in legal trouble because of the way he obtained his photographs. Shay considered his profession to be one of the most "unsavory" in existence, because to "steal" pictures, he argued, one must be not only a detective but a thief: On a "stake-out," a sneaky-Pete must be "armed" with an "impressive array of artillery," including well-hidden "burglary tools" both on his person and in his car.[15] The profession had benefited from photographic surveillance equipment that had been developed during the war, including Eastman Kodak's matchbox camera, which took half-inch-square pictures and came with its own vest-pocket darkroom kit. No focusing was required. One only had to aim and press a plunger.[16] In order to be able to maneuver through dangerous situations, the ideal sneaky-Pete came from the same background as the ideal news photographer. For example, "sharpshooter" Shay began his photographic career as a teenager, sneaking shots of strippers in a Times Square burlesque theater using a three-second bulb exposure on a cheap camera. The tactics and equipment used by sneaky-Petes were not confined to private investigative work. In fact, Shay claimed that he had learned his tricks from *Life* photographer Francis Miller during the twelve years the two worked together at the magazine. Shay even refused the title of the country's top sneaky-Pete, arguing that it rightly belonged to Miller, a photojournalist at the most prestigious magazine in the country, if not the world.[17]

This cops-and-robbers and cloak-and-dagger play did not confine itself to the mass media and the realm of private investigative work. At a 1950 Museum of Modern Art symposium, the photographer Morris Wright proclaimed that "a great photograph, by definition, is the invasion of the privacy of something."[18] In 1947, Edward Steichen had told a reporter that he wanted to begin his directorship at the Museum of Modern Art with an exhibition of news photographs because he believed that they best expressed the "great thing in photography," which was to "see an instant of reality and seize it."[19] In 1949, he launched The Exact Instant: Events and Faces in 100 Years of News Photography, a dramatic show of three hundred photographs that featured a vast mural of an atomic bomb blast at its entrance. The excitement and vitality associated with news photography continued to appeal to Steichen. In 1954, he remarked, "Photography has too much of a tendency to remain static. But there is a new growth, there is a new rebirth, there is a feeling of going out and, instead of making pretty pictures or technically perfect pictures, we are going out to get life."[20] Not only did news and investigative photographs enter the institutional realm of art, but the aesthetics and practices associated with such photography—gritty realism, aggression, intrusion, and spying—were appropriated by those whom we now refer

to as street photographers and who have been canonized as major figures in the history of postwar photography.

From Social Documentary to Street Photography: Gender and Cold War Politics

After World War II, photojournalism and street photography became the dominant photographic modes, supplanting social-documentary photography, which had reigned in the 1930s and early 1940s. By "social-documentary," I mean that form of straight photography that seeks to persuade the viewer to take action against social forces that are believed to be responsible for suffering or injustice.[21] The practice had its origins in the Progressive-era work of Jacob Riis, who documented immigrant tenements in the Lower East Side of New York City, and Lewis Hine, who photographed deplorable labor conditions, most notably, the exploitation of children in factories. During the Great Depression, the Rural Resettlement Administration, a New Deal agency later renamed the Farm Security Administration (FSA), set up a photographic unit under the direction of Roy Stryker; its purpose was to create a record of the harsh living and working conditions in the rural areas of the country, particularly those suffered by migrant and tenant farmers. These images were used to promote public support for the agency's programs. From 1935 to 1943, such prominent photographers as Dorothea Lange, Walker Evans, Ben Shahn, Arthur Rothstein, Gordon Parks, and Marion Post Wolcott traveled throughout the nation, compiling a huge corpus of images and establishing a new documentary tradition, one that sought to invoke an emotional response yet without sacrificing the dignity of the subjects photographed.[22] Members of the Photo League in New York and such prominent photojournalists as Margaret Bourke-White joined the photographers of the FSA in giving visual expression to those who were suffering the effects of economic depression. This documentary impulse was connected to the radical socialist thought of the era, which emphasized economic equality as opposed to the rugged individualism of competitive capitalism. As such, it was antithetical to the modernism associated with Alfred Stieglitz, Edward Weston, Paul Strand, and Ansel Adams, which emphasized individual subjectivity, the creative genius of the artist.

Lili Corbus Bezner has examined the decline of the social-documentary tradition after World War II, when not only did its ideals become suspect, but its "style" was actually "aestheticized into museum collections, its political possibilities diluted by a concern for formalism."[23] Any partisan commentary was deliberately disregarded. Although this shift in attitude was certainly related to paranoia after the Photo League was named as a subversive organization in 1947, it was also part of a larger cultural distrust of ideological intent. After the war, the New Deal came under suspicion as an ideological apparatus, a deliberate attempt to restructure the nation's democratic form of government, one closely aligned to socialism and thus communism in the minds of many postwar Americans. Emerging from the war as the world's richest and most powerful nation, the United States was in a position to

redefine itself on its own terms, yet the effort to promote a new Americanism was fueled by a fierce anticommunism directed at enemies within as well as without. The Cold War climate of fear permeated every aspect of society, including the cultural arena.[24] Even such liberal intellectuals as those associated with the *Partisan Review* and the *New Republic* supported President Harry S. Truman's foreign policies of containment, especially after the significant Communist gains of 1948 and 1949: the coup in Czechoslovakia, the blockade of Berlin, Mao's triumph in China, and the explosion of a hydrogen bomb in the Soviet Union. By the start of the Korean War in 1950, group dissent had all but disappeared, which enabled the House Un-American Activities Committee (HUAC) to carry on its crusade against communism virtually unopposed.[25] Leftist leanings, past and present, were now dangerous, especially when careers could be ruined through innuendo alone and when cultural producers could be brought before HUAC simply because of their political "tendencies." One symptom of this anti-Communist fervor was the ferreting out of anything that appeared to promote the mass over the individual, "mass man" over "existentialist man."[26] Indeed, a preoccupation with this theme was one of the most pronounced characteristics of the postwar era, informing not only scholarly studies but popular works of fiction and nonfiction, films, paintings, and photography as well.

Bezner points out that by the 1950s, social-documentary photography had been subsumed by commercial photojournalism, which functioned to strip this tradition of its political content. She views The Family of Man, the 1955 Museum of Modern Art exhibition, which relied heavily on journalistic images, as simultaneously a "marshaling of the last forces of documentary work" and a "dissolving" of such work "into an all-encompassing metaphor for universal harmony."[27] The exhibition stressed the similarities that bind all of humankind, rather than their differences, by showing people from a wide variety of cultures engaged in the same activities as they move from birth through childhood into adulthood and on to death. Without the specific partisan emphasis on matters of class and race, Bezner argues that even the most conservative forces could claim the show as their own, despite Steichen's intent, which was to counter Cold War anxiety over cultural differences, including those between the United States and Communist countries.[28]

Although The Family of Man was, and still is, the most successful photography exhibition of all time, it was criticized by many photographers and critics, who, as Bezner notes, preferred the adjective "sentimental" as a weapon to denigrate the show.[29] The negative use of this term signifies the extent to which the eradication of emotion had come to characterize postwar photography. What was sought instead was detachment from the world, the rejection of social concerns. In a repressive Cold War climate, truth and authenticity were to be found within, a safer strategy than searching for them in a political ideology. Indeed, The Family of Man was criticized for subjugating individual artistic expression to an overall theme, a theme that could be interpreted as promoting the mass over the individual. The use of the term "sentimental" also invokes the gendered connotations of leftist thought during the Cold War. In his influential 1949 book *The Vital Center: The Politics of Freedom*, the

historian Arthur Schlesinger Jr. attempts to save liberalism by distancing it from the progressive radicalism of the 1930s while at the same time arguing for its importance as a safeguard against the seductions of totalitarianism, which he claims "perverts politics into something secret, sweaty and furtive like so much, in the phrase of one wise observer of modern Russia, as homosexuality in a boys' school." According to Schlesinger, a postwar liberal holds firm against emotion, unlike the progressive, who "is soft, not hard," for "he believes himself genuinely concerned with the welfare of individuals"; therefore, his "defining characteristic" is "sentimentality," which has "softened" him for "Communist permeation and conquest." Schlesinger's most damning charge, however, is that the progressive is actually motivated by his "feminine fascination with the rude and muscular power" of the laboring class and by his "desire" to immerse "himself in the broad maternal expanse of the masses."[30] This feminization, or homosexualization, of the Left played an important role in the Red Scare. Not only were homosexuals believed more susceptible to communism—open to seduction, then subject to blackmail—but they were especially loathed by Senator Joseph McCarthy, who further lambasted the "egg-sucking phony liberals" who held "sacrosanct" both "Communists and queers."[31] The possible homosexual infiltration of the government was as feared as Communist infiltration. Both were considered a threat to the American way of life.[32] Thus, the postwar policing of gender boundaries informed both McCarthyism and the liberal reform advocated by intellectuals like Schlesinger—to be a "real" American was to be a "real" man.[33]

In such a political climate, therefore, the appeal to emotion so vital to social-documentary photography functioned to feminize the practice as well as to link it to suspect ideologies. Magazine photojournalism and news photography were forms of documentary not subject to this stigma, however, for although their subject matter was also reality, sometimes even harsh economic reality, the public assumed that the photographers were offering objective, thus politically neutral, statements. These images lacked the overt ideological intent associated with social-documentary.[34] However, they also lacked an emphasis on individual subjectivity. In journalistic photography, the photographer is presumed to be an impartial witness to events, not the creator of meaning.[35] Of course, it was around this factor that so much of the postwar debate over whether or not journalistic photographs were art circulated. For a modernist like Ansel Adams, they were not; to him, art implied an artist, the prioritizing of individual expression, a creative mind at work, not a body moving through space shooting pictures. However, Adams also rejected social-documentary photography as art, for he saw it as inauthentic, not true to the photographer's inner vision, a type of image making "costumed" with "ideological intent."[36] In social-documentary, the photographer's subjectivity was not primary; politics *was*.

However, as I discuss in chapter 1, modernism, like pictorialism, had come to be seen as escapist and old-fashioned by many of the dominant voices in the photography world. Realism (gendered masculine) was the preferred aesthetic.[37] Yet for those who ascribed to the notion that artists were the individual makers of their work, both photojournalism and social-documentary photography were problematic.

What was sought, therefore, was an aesthetic that combined both the realism of photojournalism and social-documentary with the individual subjectivity of modernism. The answer that emerged was street photography, a form of documentary in which the realistic subject matter becomes merely the means through which the photographer presents himself and, as I will argue, the feminized matter with which he constructs both his professional and masculine identities. As such, postwar street photography became the aesthetic of existentialist man—highly individualized, stripped of political ideology, experiential.

Street photography did not originate in the postwar era. Its lineage is commonly traced to the work of Eugène Atget, who took photographs of the architecture, shop-windows, and people who inhabited the streets of fin de siècle Paris.[38] Atget was little known in his own time; he operated a business that documented scenes for painters and did not consider himself an artist. After his death in 1927, the U.S. photographer Berenice Abbott arranged to purchase the five thousand negatives and prints that remained in Atget's studio, after which she promoted his work through exhibitions and publications. Indeed, Abbott was instrumental in positioning Atget as the founder of street photography (although not called that at the time), using him to legitimize her own mode of image making: documentary, but not politically overt; realistic, but not journalistic; and above all, artistic, but not pictorial, a category she disdained and in which she included the work of the salons, of the "super-pictorial" school of Stieglitz, and of abstractionist photographers, whom she considered to be merely "imitators" of abstract painting.[39]

Street photography, as it has been institutionalized, is a highly inclusive category, for it is a designation of space rather than intent. Indeed, almost any image taken in the public rather than the private sphere whose subject matter is neither portraiture nor nature, including photojournalism and social-documentary, has been included under this umbrella term. Its use has served not only to strip social-documentary of its ideological content but to aestheticize journalistic photographs, to make these images "art" in a fine-art sense, thus privileging the photographer's subjectivity over the historical conditions surrounding the subject matter. Moreover, the designation "street" serves to masculinize both photographer and photographs, for as the sociologist R. W. Connell argues, the street "shows the same structures of gender relations as the family and state. It has a division of labour, a structure of power and a structure of cathexis." The street is a masculine arena, a "setting for much intimidation of women, from low-level harassment like wolf-whistling to physical manhandling and rape."[40] Consequently, a woman photographer could never stalk the urban streets with the same freedom as could a man. Indeed, like combat photography, street photography is a bodily practice; it insists on the physicality of the photographer. Social-documentary, on the other hand, presumes transparency, or "disembodiment," despite the fact that the photographer's body is, of course, present. During the postwar years, one of the most notorious examples of both trends—the aestheticization of news photography and the masculinization associated with physical mastery of the streets—was the case of Arthur (born Usher) Fellig, who was known as Weegee.

Weegee: Crime Photography and the Aesthetics of the Boundary

At one time, Weegee had actually been a street photographer in the traditional sense of the term, a peddler of portraits on the street. At the age of fourteen, this Eastern European immigrant who lived with his impoverished family in a cold-water tenement on Manhattan's Lower East Side dropped out of school, bought a tintype outfit, and began taking pictures of people in the hopes they would purchase them. He later bought a five-by-seven view camera and rented a pony upon which to pose children, a gimmick that worked until he was unable to pay the animal's feed bill. After a series of odd jobs, much of the time homeless, Fellig began a three-year stint taking passport photos for a commercial photographer. In 1924, he took a cut in pay to work for Acme Newspictures as a darkroom assistant, eventually going out on assignments during the middle of the night so that Acme did not have to wake its photographers. Fellig supposedly became so adept at getting photographs before others knew about an event that the women in the office began to think he was psychic; therefore, they nicknamed him after the Ouija board, which Fellig adopted as a professional moniker, respelling it "WEEGEE."[41]

In 1935, Weegee quit his job at Acme and began freelancing as a press photographer, hawking his work to the tabloids and specializing in crime, the most hard-boiled field of all. He rented a room behind Manhattan Police Headquarters, and he wired his room to pick up signals from the police dispatcher and alarms from fire headquarters. The room was also above a police equipment store: "I would fall asleep to the sound of police pistols being fired."[42] Over the next ten years, Weegee made a name for himself photographing fires, traffic accidents, and, above all, the corpses of murdered gangsters. In fact, he was eventually granted a permit to carry a police radio in his car, the only press photographer to be so honored.[43] In 1940, Weegee began working for Ralph Steiner's *PM Weekly.* He soon began to be noticed as a photographer, not just a cameraman. He was given solo exhibitions at the Photo League in 1941 and 1944; the first was titled Weegee: Murder Is My Business. In 1943, his work was included in the Museum of Modern Art exhibition Action Photography, and in 1944, he was invited to the museum to give a lecture, at which members of the audience suggested that he publish a book, a compilation of his best photographs. Weegee took the advice, and in 1945, "*Naked City* was born."[44]

Weegee's book was an immediate success, a best seller and critical hit. After years on the nocturnal beat, it seemed that virtually overnight he had gone from news cameraman to celebrity photographer. He stopped covering the streets and began taking assignments from such upscale magazines as *Vogue, Life,* and *Fortune.* Instead of corpses, Weegee was now shooting fashion models and society balls. In 1947, he was made a special consultant on a film based on *Naked City,*[45] after which he moved to Hollywood, where he found work as a bit actor and as an adviser on film special effects. He also began doing "trick" portraits (optically distorted caricatures) of celebrities and politicians, his own contribution to "art" photography. Despite an active career up until his death in 1968, including the publication of two more photographic books—*Weegee's People* (1946) and *Naked Hollywood* (1953)—he is most remembered

for *Naked City,* not only for its photographs but for the persona he created for himself, which he reiterated and embellished in his 1961 autobiography, *Weegee by Weegee.* This is the Weegee who has been institutionalized and immortalized: the lowly news photographer in rumpled suit with constant fedora and cigar, the urban primitive who knew nothing of art yet "crashed the gates."[46]

Weegee the Famous, as he stamped his pictures, was an invention, a masquerade of theatrical masculinity, that of the hard-boiled "tough guy." Likewise, his photographs were transformed from journalistic artifacts into "art" of a distinctly masculine variety. Although his photographs were acknowledged to be poor in terms of the aesthetic standards of the day, they were hailed as true and alive, as vital rather than sterile. Free of the niceties that characterized the technically refined print, these images functioned as an anti-aesthetic—a raw, masculine expression, free of the feminine taint associated with social-documentary and much of fine-art photography. Indeed, from the standpoint of "civilized" society, Weegee and his photographs were outsiders, deemed innocent of societal and aesthetic convention and thus "authentic." As Paul Strand wrote in a review of *Naked City*: "You will be profoundly moved, disturbed, perhaps even frightened by the poignant truthfulness with which this man sees and speaks," a truthfulness that "could only have been made by someone who knew this all-too-large area of American life well." The renowned photographer was so impressed with Weegee's photographs that he praised them as the "first major contribution of day-to-day journalism to photography as a creative medium." Strand's description of Weegee's unique talents carried gendered implications as well. He characterized Weegee's vision as one of "violent, brutal contrasts," as opposed to the "sensibility" and "tenderness" evident in Helen Levitt's photographs of children at play in the streets of Manhattan. Indeed, Strand argued that Weegee "sees violently, abruptly and with an unerring sense of the moments of greatest tension," an effect aided by the "rawness" of the flashbulb, which "tends to intensify this explosive quality."[47]

Institutionally, Weegee has come to signify a break with the past, the rejection of a feminized social-documentary photography predicated on emotion in favor of a masculinized, heroic street photography predicated on aggressive voyeurism. As such, Weegee is posited as the "father" of postwar street photography, an en-gendering act accomplished through the decontextualization of his news photographs and the displacement of their meaning onto the man himself. Social activism is replaced by heroic individualism, an exchange paralleled by the supplanting of proletariat writing and the social-problem film by the "apolitical conservatism" of hard-boiled fiction and film noir.[48] Unlike social-documentary photographers, Weegee had no real connection to the politics that characterized the social realm. As the quintessential outsider, he signified freedom from the obligations imposed by political ideologies; moreover, as a nocturnal freelancer covering crime and vice, he fed fantasies of escape from the ritualized activities of everyday life. Like combat photography, street photography was an adventure, not a chore. The space of Weegee's city even evokes the battlefield; it is a space of violence, of cops and robbers, gangsters, and thugs.

As individual news photographs from the 1930s and 1940s, the images in *Naked City* had originally functioned as documents. However, brought together and forced to cohere with Weegee's narrative, they *become* street photography, with Weegee as author rather than passive observer.[49] Indeed, *Naked City* reads like a personal travelogue. As such, it is a narrative of space, with Weegee the solitary hero who traverses, thus maps, this space: "I keep to myself, belong to no group, like to be left alone with no axe to grind."[50] Weegee is alone, of course, except for his two loves—his camera and the city. In the book's foreword, William McCleery, the editor of *PM Picture News,* writes that Weegee "is truly in love with New York" and is thus "able to live with her in the utmost intimacy." As he sleeps, she "murmurs" to him, and "he is responsive to her." In "sickness and in health," he will go in search of her "beauty," which to him is evident even in "her most drunken and disorderly and pathetic moments."[51] The critic Aaron Sussman also refers to this romance, observing that Weegee "loves his subject; what's more, he understands her." He goes on to describe *Naked City* as a "magnificent album of snapshots and love letters," a "wise and wonderful book, full of a man's mysterious love for the ineluctable *she*."[52]

It is not unusual that McCleery and Sussman would refer to the city itself as feminine, despite the traditional gendering of the city as masculine, a product of culture rather than of nature. As Elizabeth Wilson points out, the city is masculine only "in its triumphal scale, its towers and vistas and arid industrial regions; it is 'feminine' in its enclosing embrace, in its indeterminacy and labyrinthine uncentredness." "At the heart of the urban labyrinth," she writes, lies "not the Minotaur, a bull-like male monster, but the female Sphinx," who strangles those who cannot "answer her riddle."[53] In other words, although the erection of monumental edifices and industrial machinery might be considered symptoms of the masculine, the space itself is perceived as feminine. Indeed, from an object-relations standpoint, the mother's body "becomes a kind of archetypal primary landscape to which subsequent perceptual configurations of space are related."[54] Whereas the natural landscape is considered a site of maternal nurturing where the soul can be replenished, the landscape of the city is more often regarded as a whore to be fucked. It is Babylon, a temptress who holds out the promise of sensual gratification, yet at a price. As McCleery's words suggest, the city seduces Weegee, her beauty beckons to him, and he responds, even though he recognizes her dark side, her ability to ensnare.

In a similar vein, film theorists have examined film noir as the repetitive acting out of a male hero's desire and fear of the feminine, which is embodied in the figure of the femme fatale and in the city itself.[55] These films reached their peak in the middle to late 1940s,[56] and their production and popularity has been theorized as a symptom of the anxiety experienced by U.S. men during and after World War II. Subjected to the testing of their manhood as soldiers on the battlefield and to personal upheaval due to lengthy absences from their jobs, homes, and families, their sense of masculine potency and authority was shaken. Film noir allowed a repeated "working through" of this dilemma by focusing on a lone male hero attempting to triumph over the dangers posed by the feminine, "not just women in themselves but also any

non-'tough' potentiality of his own identity as a man."[57] These heroes also struggle
with the anxiety aroused by the eradication of boundaries—between the classes, the
races, and the genders, between the public and the private, the government and the
corporation. Alone in an increasingly unstable world, the individual male fights to
maintain a foothold while simultaneously seeking to escape the repressive forces of
increasingly centralized control, signified by corporations, government agencies, and
crime syndicates.[58] The mood evoked in these films is one of cynicism and paranoia,
the subject matter a mix of violence and eroticism, the setting most often a dark
urban world of dead-end streets and harsh shadows, a claustrophobic space that
threatens to engulf.

Weegee's persona, which epitomizes the hard-boiled news photographer, had
much in common with the male heroes of these films, whose screenplays were often
based on the hard-boiled crime fiction of such writers as Raymond Chandler, Dashiell
Hammett, and Mickey Spillane, a "masculine" style that arose as "a conscious rebel-
lion against the sissified English murder mysteries."[59] Adopting the first-person
narrative common to these texts, Weegee constructs himself as an urban loner, un-
domesticated, unfettered: "I was a Free Soul . . . with no responsibilities."[60] Like that
of the heroes of these texts, his language is tough, cynical, matter-of-fact, his tone
one of hardness in the face of tragedy, violence, and death: "Crime was my oyster,
and I liked it."[61] He is unsophisticated, anti-intellectual, and rough in appearance—
unshaven, wearing oversized and rumpled clothing, with a cigar hanging from the
corner of the mouth.[62] At night, he ventures into the netherworld, where the bound-
ary between law and lawlessness breaks down. In fact, Weegee often suggested that
the association between himself and the members of "Murder, Incorporated," the
criminals whom he photographed, was more than mere reporter after the fact, that
indeed, he knew them and was alerted by them when a murder was to occur. He even
claimed that they began leaving corpses in light gray rather than black automobiles
because he had told them that black would not photograph well.[63] Therefore, not only
does Weegee give visual expression to criminal acts, but he actually dons the mys-
tique of the gangster, a cultural figure who had come to signify unrepressed mas-
culine virility and prowess, the continuation of male autonomy in an increasingly
bureaucratized society. The gangster pursued a life dedicated to intense experiences
and momentary thrills, rather than the everyday routine and delayed gratification
associated with the structured workplace. Consequently, the gangster genre fed "male
fantasies," transporting men from "the feminized workaday world to idealized arenas
of manly combat."[64] As the critic Robert Warshow wrote in 1948: "The gangster's
whole life is an effort to assert himself as an individual, to draw himself out of the
crowd."[65] Indeed, the postwar sociologist Daniel Bell argued that like the hunter,
cowboy, frontiersman, and soldier, the gangster is the mythic "American hero," the
"man with a gun, acquiring by personal merit what was denied him by complex or-
derings of stratified society."[66]

Weegee's photographic aesthetic also bears similarities to that of film noir. It
is grainy and dark, except for the harsh glare produced by his flash; space is shal-

low, and camera angles are too high, low, or oblique. There is a certain restlessness evoked by the erratic framing, and by the figures in motion, many of whom have been caught off guard by the camera's intrusion, the flash causing them to emerge from the darkness in which they are enmeshed (Figure 19). Although Weegee, too, is embedded within the enveloping "body" of the city, he is able to achieve a degree of autonomy through his camera, an agent of distance. Indeed, Weegee masqueraded not only as a gangster but as a private "dick" of the hard-boiled school, who strives to observe undetected.[67] Infrared film aided Weegee in this quest by enabling him to hide in the dark and catch his subjects unaware.[68] With *Naked City*, Weegee becomes a character in his own narrative; he pieces together clues and deciphers evidence. Indeed, his first-person text functions in a similar manner to the voice-over narration so common to films noir. Weegee even rigged portraits of himself at Manhattan Police Headquarters with a bomb that had been discovered, and with a corpse that Murder, Incorporated, had stuffed into a trunk, photographs that he included in his autobiography.

Like the cities of film noir, the one in Weegee's *Naked City* is a perilous place, a labyrinth of danger, the femme fatale herself. Indeed, the photograph that appears opposite the title page depicts the city at night, a recurrent backdrop for film noir screen credits (Figure 20); it is dark and foreboding, with only a few lights beckoning, and a bolt of lightning is striking its heart. Like "woman," Weegee's city is fluid, for

Figure 19. Weegee [Arthur Fellig], "Their First Murder" (9 October 1941). Gelatin silver print. Copyright Weegee/International Center of Photography/Getty Images.

Figure 20. Weegee [Arthur Fellig], "Striking Beauty" (29 July 1940). Gelatin silver print.
Copyright Weegee/International Center of Photography/Getty Images.

not only does it traverse the border between life and death, but it is the liminal space
of others—ethnic and racial minorities, criminals, prostitutes, transvestites—the
underbelly of New York, New York *naked*. However, through the mechanism of
the photograph, this fluidity can be fixed. As the photographer and theorist Victor
Burgin argues, the "photograph, like the fetish, is the result of a look which has,
instantaneously and forever, isolated, 'frozen', a fragment of the spatio-temporal con-
tinuum."[69] By extension, the cultural historian Miles Orvell writes that in *Naked City,*
"the act of photographic intrusion has been achieved with a kind of surgical preci-
sion, as if the subject were anesthetized."[70] Weegee has not just passively recorded; he
has violently "cut" into the spatial body.

Throughout *Naked City,* Weegee draws attention to the possible breakdown of
order by allowing the repressed—the "primitive" desire for violence, sex, and other
sensual gratification—to surface. Amid this chaos, however, Weegee's eye functions
as the law that polices the city; his camera and his photographs, as agents of mastery
and containment.[71] As masculine hero, Weegee traverses feminine space—that which
is to be conquered, mastered, *shot*. The association between the camera and the gun
has long been made; in fact, several "rifle-cameras" were designed in the nineteenth
century, cameras that looked like guns and guns that looked like cameras.[72] Weegee

understood and played upon this analogy. In one of his many staged self-portraits, he perches on a ledge over a gunsmith's shop, aiming his camera at the street, a pose that echoes the enormous replica of a revolver bearing the shop's placard, which hangs below him (Figure 21). Unlike guns, of course, cameras do not physically kill; yet like hunters and assassins, street photographers do stalk, aim, and shoot. Control is achieved through the mechanism of sight. Indeed, to photograph is to attempt to secure an object relation, to freeze time and space, to keep the world at bay. As Susan Sontag argues, photography is "a defense against anxiety," for "to photograph is to appropriate the thing photographed. It means putting oneself into a certain relation to the world that feels like knowledge—and therefore, like power."[73]

Weegee, like the protagonist of detective novels and films, is the hero who un-masks the mystery, reveals the truth about the Sphinx, the femme fatale, who is "never what she seems to be."[74] Even his pseudonym refers to the occult, that which lies hidden. *Naked City* contains photographs of transvestites who were "unmasked" and then arrested as "Gay Deceivers."[75] These people are not as they appear; conse-quently, they constitute a threat to the social order, which demands a strict boundary between male and female and a policing of sexual practices. Another threat is signi-fied by the imagery of the crowd, a liminal space in which self and others mingle, in which space becomes difficult to control. Crowds upset order, threaten borders, and

Figure 21. Unidentified photographer, "Weegee Roosting on a Windowsill, Waiting for Action" (ca. 1940). Gelatin silver print. Copyright Weegee/International Center of Photography/ Getty Images.

seek to absorb the individual into a mass, one that has traditionally been described in feminine-coded terms—unstable, hysterical, and prone to irrationality and extreme emotion.[76]

Yet as Orvell points out, just as Weegee came to represent "urban disorder," he simultaneously came to represent a "strategy for coping with the anxiety" it invokes—voyeurism.[77] In *Naked City*, the most profound signifier of boundary dissolution imaged is the corpse. As Julia Kristeva argues, it is "the utmost of abjection," the "infecting" of life with death, the return of the object of primal repression—the maternal body. Primal repression is a psychic mechanism that "demarcates space," that seeks to erect a barrier between the "subject and its objects."[78] *Naked City* is filled with corpses. Some of the dead are victims of fire or accident; their bodies tend to be covered, as opposed to those of the murdered dead, whose bloody bodies are graphically displayed. Corpses from which once-contained fluids flow are especially anxiety producing, for the boundary between interior and exterior has been violated, a transgression resulting in physical death. Yet this transgression is also fascinating. Cultural producers flirt with this transgression. Through the "safe" practice of symbolic expression, they seek to demarcate territory, to cordon off the fluidity that constantly questions their solidity. They confront the abject, the very limits of the ego; they journey to the brink of oblivion, to death itself, so that they can redraw the boundary, reconstitute the object.[79]

Like the corpse, crime is also abject, "because it draws attention to the fragility of the law," the social mechanism by which patriarchal authority is enforced, by which the maternal is repressed.[80] Weegee soothes anxiety, however, not only through the fetishizing act of photography itself but through his repeated depiction of the agents and restraints of the law (police officers, paddy wagons, police stations) and through his own detachment from the events depicted. The book's fourth chapter, entitled "Murders," opens with the matter-of-fact expression "People get bumped off . . . on the sidewalks of New York." He goes on to explain that the victims "are always neatly dressed" and "fall" with their "pearl gray hats alongside of them." Someday, he hopes to follow a guy with such a hat and "get the actual killing." This callousness is matched by the publication of an actual receipt that he received from *Life* magazine noting the sale of two murders for thirty-five dollars. Weegee writes that twenty-five dollars was for the "murder picture" opposite, "Balcony Seats at a Murder" (Figure 22), and that the other ten dollars was for a "cheap murder, with not many bullets."[81]

Weegee's verbal expression of emotional detachment is reinforced by the manner in which the act of looking displaces the act of murder. "Balcony Seats at a Murder" reduces a real-life killing to the status of theater; the murder is a spectacle to be consumed by the inhabitants of Little Italy, who peer out their windows to gaze at the scene below them. At the bottom of the frame, detectives mill about, seemingly uninterested, except for one man, who studies the corpse lying at the entrance to the Italian Cafe. This figure is the viewer's stand-in, signifier of the look. The following two-page spread, titled "Murder in Hell's Kitchen," displays two photographs, one

Figure 22. Weegee [Arthur Fellig], "Balcony Seats at a Murder" (ca. 1941). Gelatin silver print. Copyright Weegee/International Center of Photography/Getty Images.

of a murder victim (Figure 23) and the other of spectators, who squeeze into two window frames to get a look at the corpse on the sidewalk below. Weegee imposes a reading of detachment: "One looks out of the windows . . . talks about the weather with a neighbor . . . or looks at a murder."[82] Killing in Hell's Kitchen is a banality, a topic of light conversation, a common fact of life. There is even a hint of play in the photograph of the corpse, which lies bloody face down, for Weegee has framed the image so that the fallen handgun lies directly in the line of sight from viewer to

Figure 23. Weegee [Arthur Fellig], "Gunman Killed by Off Duty Cop at 344 Broome St."
(3 February 1942). Gelatin silver print. Copyright Weegee/International Center of Photography/
Getty Images.

victim.[83] Again, Weegee draws attention to the relationship between camera and gun,
between looking and shooting.

William Klein's New York: Mapping Masculinity

The gun as a metaphor for the camera also plays a significant role in the work of the
photographer William Klein, who like Weegee produced a book-portrait of New York
that has come to hold a canonical place in the historical narrative of postwar street
photography. In 1956, Klein published in France, his adopted home, *Life Is Good and*

Good for You in New York: Trance Witness Revels.[84] Klein's New York, like Weegee's, is simultaneously seductive and threatening, vital and alienating; Klein's book is also a narrative of space, a travelogue, and a personal scrapbook documenting his journey through the labyrinth.

Like Weegee, Klein was an outsider. Born in 1928 to Jewish parents who would lose everything in the crash of 1929, Klein grew up as the poor relation to a family of wealthy and powerful corporate lawyers, living in an apartment that he was ashamed to show his friends, and clashing with anti-Semitic street gangs in his predominantly Irish-Italian neighborhood on Manhattan's West Side. Subsequent readings of Klein's New York photographs have been shaped by an emphasis on alienated youth, even though Klein did a stint in the Army and then, under the GI Bill, spent six years in Paris, where he finished his degree at the Sorbonne and studied painting, before returning to New York in 1954 to shoot the photographs. As John Heilpern wrote in 1981, "Klein's upbringing in New York was crucial, for had he not felt excluded as a child he might never have exiled himself from America—or returned to it armed with a camera."[85] Klein himself is partly responsible for this interpretation:

> I was at last coming to terms with the New York I was brought up in, the city I thought had excluded me. I never felt part of the American Dream. I was poor as a kid, walking twenty blocks to save a nickel carfare. Most of the city seemed foreign to me—hostile and inaccessible, a city of headlines and gossip and sensation. And now I was back with a secret weapon—a camera. I thought New York had it coming, that it needed a kick in the balls.[86]

Unlike Weegee, Klein does not regard the city as a seductress. Instead, he sees it as a vicious opponent, and it is his violent confrontation with its streets that has earned Klein his place as the inheritor of Weegee's brutal style. Despite the fact that *Life Is Good and Good for You in New York* was published only in Europe, where, Klein recalled, it caused a "great deal of controversy, but a certain success," it was a favorite of photographers in the United States, although it was initially ignored by the critics.[87] One article, published three years after the book's publication, was predominantly negative, yet it did hint at the acclaim that was to come. The author, Herbert Keppler, deplored the "atrocious graininess and lack of tonal gradation" in the photographs, whose "quality could not conceivably have suffered more if the negative had been massaged with sandpaper." However, he also recognized the "emergence of a positive vital photographic personality," a man "quick on the draw."[88]

Of course, it is this once-despised anti-aesthetic, coupled with Klein's "vital" personality, that is now so celebrated. In their 1994 history of street photography, Colin Westerbeck and Joel Meyerowitz devote an entire chapter to Klein, reiterating the image of him as a brute with a camera, which he "brandished" at his subjects "as if it were a Saturday night special he was using to stick up a liquor store."[89] They compare him to Weegee, claiming that, like his predecessor, Klein is a "wise-assed guy whose only ambition in life is to be able to survive on his street smarts."[90] Thus, Klein has also been constructed as an urban primitive, not the hard-boiled tough

guy of the 1940s, however, but the street punk of the 1950s. With no formal training in the medium, Klein approached photography with a "no rules," "anything goes" attitude. He masqueraded as a news photographer, stalking the streets, sometimes asking people to pose, at other times just shooting haphazardly. As he told Heilpern: "Sometimes I'd take shots without aiming, just to see what happened. I'd rush into crowds—bang! bang! I liked the idea of luck and taking a chance. . . . It must be close to what a fighter feels after jabbing and circling and getting hit, when suddenly there's an opening, and bang!"[91]

Stylistically, Klein was self-consciously paying tribute to Weegee, for his desire was to emulate the tabloids:

> The New York book was a visual diary and it was also a kind of personal newspaper. I wanted it to look like the *News*. I didn't relate to European photography. It was too poetic and anecdotal for me. . . . The kinetic quality of New York, the kids, dirt, madness—I tried to find a photographic style that would come close to it. So I would be grainy and contrasted and black. I'd crop, blur, play with the negatives. I didn't see clean technique being right for New York. I could imagine my pictures lying in the gutter like the New York *Daily News*. I was a newspaperman![92]

Moreover, the subtitle of his book, *Trance Witness Revels,* recalls the common tabloid headline "Chance Witness Reveals."

Like an actor on a stage, Klein performed a role, one that gave him access to the intensity of experience on the street as well as the opportunity to subvert the accepted canon of aesthetic taste. With a camera as his "weapon," Klein attacked New York with a "vengeance."[93] Not only did he want "to get even" with the city,[94] but he wanted to break the rules of photography, especially those of Henri Cartier-Bresson, whose old Leica camera and lenses he had purchased. Indeed, Klein preferred a wide-angle lens, deliberately blurred his shots, provoked his subjects, and altered his negatives. Moreover, Klein actually seems to have taken Cartier-Bresson's advice not to shoot "like a machine-gunner" as a dare, not an admonition.[95]

Klein's *Life Is Good and Good for You in New York* is also reminiscent of Weegee's work in subject matter. Although he does not picture literal violence, he does signify violence, most emphatically in his numerous shots of children with toy guns. In fact, Klein devotes an entire chapter to the gun, a chapter that includes perhaps the most notorious of all Klein's photographs, an image, reproduced in the 1959 Keppler article, bearing the caption "New York gunfighter (underage)" and positioned over a paragraph subtitled "Documentary: Like a Pistol Going Off,"[96] characterizations that have come to define Klein's photographic persona. In the image, a young boy points a gun directly at the camera as he glares menacingly at Klein, and by extension, the viewer. Another boy watches him and reaches up as if to stop him from shooting, yet the gesture and look are not violent, but tender. This second boy serves as a foil for his gun-toting friend, a motif of calm passivity that acts to reinforce the other's violent activity. In fact, this photograph is a signifier of violence, not only that of the

"gun crazy" U.S. culture[97] but of the photographic act itself. The boy with the gun mirrors Klein with his camera. Each intrudes into the other's space, confronts the other, and draws his "gun." Klein has continued to promulgate this analogy. In a 1989 film, he exclaimed: "I like the excitement of reloading, aiming, and firing."[98]

In Klein's *Life Is Good and Good for You in New York,* the photograph opposite that of the gunfighter is of another young boy, who holds a pointed gun in front of his mouth. He appears to be either kissing or blowing as he caresses the toy weapon with both hands. Eroticism mixes with violence, creating a somewhat disturbing image, for this is only a child. Yet the 1950s saw a revival of the Western film, the creation of numerous Western television series,[99] and an explosion in the use of the cowboy motif as a merchandising ploy for children's products. Armed with toy guns and wearing cowboy hats and clothing, U.S. children could partake in this cultural love affair with the gun, the "central icon" of the nation.[100] A few pages later, Klein includes a vertical montage of three photographs, all of boys with guns. The first twirls a six-shooter around his finger and is dressed in cowboy hat, bandanna, and Lone Ranger mask; the second sits in a stroller, casually holding a revolver; and the third stands in the street with a shotgun under one arm. There is an air of nonchalance about the display, their poses and facial expressions mimicking the stony demeanor adopted by the heroes of Western films.

Whereas these images of boys and guns serve as metaphors for Klein and his camera, the other sections of the book function to create his opponent, the space through which he travels, the physical matter that he shoots. Through the act of photography, Klein is able to "map" his subjectivity, a process whereby the "knower" attempts "to 'master' his environment, occupy a secure and superior relation to it."[101] In *The Practice of Everyday Life,* the social theorist Michel de Certeau argues that spatial practices reenact detachment from the maternal body, force it to disappear and reappear. Thus, for masculine-identified subjects, to "practice space" is to play with the presence and absence of both self and other, for prior to differentiation, self was other (mother). He writes that "to walk is to lack a place," and because the city "multiplies and concentrates" the necessity of "moving about," the city itself becomes "an immense social experience of lacking a place."[102] Subjective space results from this search for place, for solidity; it is the product of an activity, a subjective mapping onto matter. Indeed, Klein mutilates physical space, slices it up and flattens it out, shatters it into a profusion of signs. These fragments are then subsumed under his own totalizing system, an abstraction that signifies the triumph of phallus and eye over maternal materiality.

In *Life Is Good and Good for You in New York,* Klein constructs a space of chaos, disorder, sensuality, rhythm, irrationality, irregularity, instability, and fragmentation—all boundary-dissolving, thus feminine-coded, terms. Moreover, like Weegee, Klein evokes the space of film noir, a space not unlike what the French existentialist Jean-Paul Sartre termed the realm of things-in-themselves.[103] To Sartre, this physical realm is a disgusting and nauseating place composed of slimy, sticky, soft, viscous

matter, which he associates with the reproducing, excessive female body. Under
Sartre's system, there is no Being, no essence to human existence, only Being-in-
itself and Being-for-itself. Being-in-itself is the slimy feminine matter that seeks
to dissolve Being-for-itself, the masculine principle, or consciousness. This dialec-
tic underlies Sartre's existential psychoanalysis, as outlined in his 1943 *Being and
Nothingness*. Unlike Freud, Sartre did not believe in the unconscious; rather, he saw
free will as the determining mechanism of individual identity. In other words, man
was to choose his existence, to render it through his actions and the choices that he
makes, all in an effort to sunder himself completely from nature, from the "sickly-
sweet" fluidity that endlessly seeks its "feminine revenge."[104]

As a philosophical school of thought, one that was not as cohesive as the term
"school" implies, existentialism is commonly traced from Søren Kierkegaard and
Friedrich Nietzsche in the nineteenth century to Martin Heidegger, Albert Camus,
and Sartre in the twentieth. Camus and Sartre are credited with popularizing ex-
istentialist thought in the 1940s and 1950s. Their literary and philosophical works
are grounded in the deep despair of an era that had experienced the oppression of
German occupation, the horrific atrocities of the Nazi regime, and the deployment of
the atomic bomb. Because this pessimistic mood continued into the Cold War years,
existentialism was able to gain a foothold even in the more positivist United States.[105]
Although I do not intend to argue that Klein's photographs are deliberate attempts to
visualize existentialism, even though there is no doubt that the Sorbonne-educated
photographer would have been quite familiar with it, the parallels between his aes-
thetic and existentialist motifs are clearly evident, just as parallels can be drawn be-
tween existentialism and film noir, even though no direct influence can be claimed.
I would suggest, however, that any attempt to historicize Klein's work must take into
account the pervasiveness of such themes, which can be read as symptomatic of wide-
spread masculine anxiety. The alienation and loneliness of modern man, the chaos
and absurdity of modern life, and the sense of paranoia and dread that permeated
modern existence were widespread preoccupations on both sides of the Atlantic, as
was the romanticization of the lone male antihero who struggles to free himself from
the sticky web of materiality in which he is entrapped.

The three themes that dominate Klein's book—the city as seductive spectacle,
the city as amorphous mass, and the city as claustrophobic labyrinth—all reference
masculine configurations of the female body. Indeed, Klein's representational space is
filled with maternal imagery; it is a space of vaginal tunnels, womb-like enclosures,
and fluid or unstable matter. Klein utilized this aesthetic throughout *Life Is Good
and Good for You in New York*. Forms dissolve, fade away, and blur into each other.
As Sartre points out, it is not just woman that is feminine, but all physical matter,
including that of the built environment. However, because a man has the freedom
to say no, he can transcend this matter and bring nothingness into being. Freedom
is thus a negation. Camus labeled such a man a rebel—one who knows he exists be-
cause he says no, despite the temptations that beckon.[106]

To construct the city as seductive spectacle, Klein draws attention to the artifice of glamour as well as of the cheap and the tawdry through his many photographs of shopwindows, lighted marquees, and advertising displays. The association between artifice and the feminine is especially evident in a photograph of two mannequins in a shopwindow, in which Klein has made it difficult to discern the "real" from a reflection of the "real." Of course, in this case, the real *is* unreal, for these are fake women, artificial to the point of being grotesque.[107]

Another recurring motif in Klein's *Life Is Good and Good for You in New York* is that of the crowd. The crowd shots highlight the amorphous mass of people that pass through the city's streets each day. As the people glide past each other, they appear to blur into one another, some figures more distinct than others. No visual contact is made between these human beings, who appear isolated from, yet at the same time smothered by, each other. Indeed, to enter the street is to risk getting swept up in its dangerous currents, losing oneself in an impersonal and alienating sea of matter.

Just as claustrophobic are Klein's shots of the city's architecture, especially those that highlight the eradication of open space by tall buildings. Klein has shot these photographs from ground level, pointing his camera toward the sky to capture the narrow strip of space between skyscrapers, which loom menacingly over the street below. No life, animal or plant, is visible. Indeed, these images invoke a feeling of suffocation in addition to claustrophobia. From the vantage point of the viewer, it is like being buried alive, a sensation of "living" death. The only hope for freedom is to move up and through the narrow passageway to the open space beyond. One two-page spread reiterates this sense of burial by moving the camera lower to capture some of the people who actually inhabit these ominous streets. They are dwarfed by the buildings and enveloped in the dark shadows they cast, their faces betraying no emotion, no sense of vitality. Buried still deeper within the bowels of the city are the crowded inhabitants of a subway car, which shoots through the maze of tunnels beneath the ground. These men seem drained of life, like corpses; like automatons, they merely go through the motions required by the business world. They have become blind, not to visual reality, as is the man who stands in the center of the car, but to the reality of "lived" experience.

Through the act of photographing and then through the publishing of these images in a book of his own design, Klein is able to position himself as "outsider," one who is able to see the truth, unlike those who are trapped within rigid social structures that undermine individual freedom. Indeed, Klein escaped New York not only by leaving it but by returning to shoot it, an alienating act reinforced by the way so many of his subjects confront him directly, a technique that emphasizes his psychic distance. Klein's actions are both colonizing and territorial; he consumes the street by aestheticizing it, yet at the same time, his aggressive posture suggests that he is resistant to its seductive charms. As Klein later wrote:

Thanks to the wide-angle lens that I'd just discovered I was able to feed my devouring hunger for faces, bodies, crowds. Crammed in the sidewalk jam I would shoot point

blank, foreground out of focus or the opposite, it didn't matter. My plan was to stuff everything, everybody, into my little chromium box. I'd left the city, aged 18, for the army. I hadn't a clue how to deal with that city; now, seven years later, I had a plan: get it all into the box, do a book and then we'll see.[108]

Like Weegee, Klein cuts a heroic swath through the city, objectifying others as he "subjectifies" himself. Street photography is a bodily practice, one that seeks to signify the photographer's masculine physicality and subjectivity without turning him into an object.

Judith Butler writes that the "camera trades on the masculine privilege of the disembodied gaze, the gaze that has the power to produce bodies, but which is itself no body."[109] However, because of the war's destructive effect on male bodies, this disembodied gaze begins to court even the photographer's body. Existentialism prioritized the male body as the site of truth—authenticity sought to be grounded in the real. As Colin Wilson writes in *The Outsider,* his 1956 survey of existentialist thought: "The body can be made drunk with its own vitality far more easily than the intellect or the emotions with theirs. Many men have experienced the feeling 'I am God' in a sexual orgasm; few have experienced it from listening to music or looking at painting; fewer still from any intellectual activity."[110] Indeed, street photography is an art of living, a performance of the body in action, a series of orgasmic episodes in which the body and the cosmos are united. According to Wilson, "the Outsider's chief desire is *to cease to be an Outsider,*" so he engages in a "mystical search" that is fueled by his desire to restore the sense of oneness with his mother that he had experienced as a child.[111] Thus, the Outsider seeks both separation and unity. He attempts to escape the social institutions and moral obligations that impose an artificial framework on everyday life, denying men individual autonomy and authentic experience, yet he longs to immerse himself in a sort of spiritual ecstasy in which body and psyche are one with the universe, a melding that enables him to see the "truth" at last.

With Klein, we see a tension between the compulsion to represent the male body—to restore it to wholeness and lend it authenticity—and the anxiety involved in objectifying, thus feminizing, that body. For a male cultural producer, representation is especially fraught with danger, for it risks abjecting the self, yielding to maternal authority by acknowledging materiality. The literary theorist Calvin Thomas argues that masculinity must always be positioned "on the active and proper side of the boundary between phallocentrism and abjection, [that] the association between the feminine and dead matter must always be maintained."[112] Roland Barthes speaks of this anxiety as it pertains to photographs of himself, claiming that they represent "that very subtle moment when, to tell the truth, I am neither subject nor object but a subject who feels he is becoming an object: I then experience a micro-version of death."[113] In *Life Is Good and Good for You in New York,* Klein's body is absent, yet it is everywhere, for it is signified by the photographs, which serve as physical evidence of his movement through space. The blurred shot is the most profound trace of this

movement.[114] It is the mirror that secures his object relation, that confirms his intact ego; yet it is empty of his own matter, the abject that continually threatens. Indeed, the abject is expelled from Klein's body and displaced onto the world. His masculine display is indexical; it reveals his body as it simultaneously transcends his body. Klein's shots are ejaculatory ones—procreative and controlling, an attempt to impose order onto chaos, to fix matter without representing his own matter.

Another signifier of Klein's bodily presence is the look of the Other, which, according to Sartre, is essential to self-knowledge. In *Being and Nothingness,* he writes that "the Other's look fashions my body in its nakedness, causes it to be born, sculptures it, produces it as it *is,* sees it as I shall never see it."[115] Klein's book is filled with these confrontational images in which the look of the Other signals the photographer's presence. One of the most dynamic images in *Life Is Good and Good for You in New York* depicts a young boy in a semi-seated position resting his back against the black-and-white checkerboard wall of a candy store. He stares directly into the camera, directly at Klein. It is this boy's look that is the actual subject of the photograph, for the boy standing next to him is cut off at the waist and is thus unimportant, except as a compositional device. The mutual gaze between boy and photographer is reinforced by Klein's blurring of the wall,[116] for the black squares appear to project into space, to cast shadows on the white squares that surround them. Indeed, they seem to rush out at Klein, as if to capture him, to eradicate the distance between him and his subject, as does the boy's steady stare. Sartre speaks of the conflict between looking and being looked at, which results in the desire to "assimilate the Other as the Other-looking-at-me" and thus gain proof of one's existence.[117]

Like Weegee, the postwar Klein seems to transcend moral and social values and political ideologies, thus preserving his individual autonomy. Because both men presume to know the world only through their own experience, the world appears to exist solely in the intersection between the male photographer and feminine matter. As such, the documentary mode is made self-consciously subjective—the photographer, through both body and mind, reorders rather than reports the world. As Sartre writes, "It is absolutely necessary that the world appear to me *in order.* And in this sense this order *is me.*"[118] To know the world is to know one's self. Indeed, according to Sartre, the only way in which to know one's own body is to experience the world through that body. Although Weegee and Klein embodied different styles—Weegee that of underground detective, Klein that of antagonistic combatant—they both inhabited and helped to construct the space of existential masculinity, which when brought to the institutional realm, worked to purge documentary (now street photography) of any feminine taint.

4 | Female Body: Artists, Models, Playboys, and Femininity

The obscenity of the feminine sex is that of everything which "gapes open." It is an *appeal to being* as all holes are. In herself woman appeals to a strange flesh which is to transform her into a fullness of being by penetration and dissolution. . . . Beyond any doubt her sex is a mouth and a voracious mouth which devours the penis a fact that can easily lead to the idea of castration.
 Jean-Paul Sartre— 1953

Always, everywhere, the man strives to rid himself of his dread of women by objectifying it.
 Karen Horney— 1967

The donning of the tough-guy persona was much more problematic for those men who constructed their careers in fashion photography. Although it was one of the most rewarding photographic fields, both creatively and financially, because of the association with fashion, it risked feminization more than any other specialization. Not only was fashion considered the realm of women, but it was obviously tied to consumerism, to the slick world of advertising. In fact, nothing signified artifice more than the fashion photograph.

Both Weegee and William Klein worked as fashion photographers, and even though their aggressive street photography marked them as sufficiently masculine, they reinforced their virile status by drawing attention to their heterosexuality. Weegee claimed that he consumed the services of at least one prostitute a day, was a favorite of showgirls and strippers, and harbored lecherous desires so extreme that even store dummies were required to satisfy him sexually.[1] Klein's sexual potency was not so theatrically expressed. He simply married a beautiful Belgian model, Jeanne Florin. Moreover, he refused to let his fashion photography betray a personal interest in fashion: "When I had photographed the collections, my wife would ask about the

latest styles, but I hadn't noticed the clothes. Other photographers would discuss the clothes with the editor first, but I never went to those meetings—all those women with hats and thick glasses."[2] This sense of sarcasm and cool detachment, which became the hallmark of Klein's fashion photography style, also served to distance him from too close a professional identification with the feminine realm of fashion, even though it was this realm he was paid to shoot.

Despite its connections with commerce, postwar fashion photography was commonly regarded as an "art." Indeed, fashion provided the rare opportunity of earning a living at art photography. As Klein recalled, "Fashion magazines were our art magazines."[3] Not only did the elite fashion magazines reproduce quality images, but they actually encouraged creative and original approaches. Thus, a photographer could develop a unique and recognizable style, make good money, and display his or her work in a prestigious vehicle with a large audience.[4] Moreover, a fashion photographer, like a combat photographer, could even become an international celebrity.

Fashioning the Female: Richard Avedon and Irving Penn

Perhaps the biggest photographic star to emerge from the postwar era was the fashion photographer Richard Avedon, whose fame was acknowledged and reinforced by the 1957 film *Funny Face,* which was loosely based on his life.[5] Although the story was originally written as a play by author Leonard Gershe, who had served in the Merchant Marine with Avedon during World War II, MGM bought the rights to it before the play could make it to the stage. Two of Avedon's favorite models, Dovima and Suzy Parker, appear as themselves in the film. And the character of Miss Prescott (played by Kay Thompson), editor of *Quality* magazine, was based on Carmel Snow, the real-life editor of *Harper's Bazaar,* where Avedon had been on staff since 1944. As the opening credits prominently explain, Avedon served as "special visual consultant." Therefore, not only was the story modeled after him, but he actually had a hand in the making of the film, staging a series of fashion shots that were used in it. Avedon's role in the production of, and as the inspiration for, the film was publicized by numerous articles, which featured a photograph of him "directing" the film's star, Audrey Hepburn, in a mock fashion shoot.[6]

In this musical tribute to the Pygmalion legend, fashion photographer Dick Avery, played by Fred Astaire, transforms ugly ducking Jo Stockton (Hepburn) into a beautiful swan. Dick "discovers" Jo when he and his female assistants, all dressed in pink, force their way into the Greenwich Village bookstore where she works; they want to use the space for a fashion shoot. Although Jo is an intellectual who wears no make-up, dresses in black and gray, and even has a "funny face," Dick is able to discern a potential for feminine beauty. Despite her initial disgust at the idea, he eventually convinces her to come to Paris and model for him. Her acquiescence comes as no surprise to the viewer, who is aware that Jo had become infatuated with Dick when he kissed her in the bookstore. Yet she tells him that she is only going to Paris because

she wants a chance to meet Emile Flostra, the father of "empathicalist" philosophy. Once there, Dick engages in a struggle to lure Jo away from the bohemian clubs and the intellectual discussions she prefers. He directs her through a series of photo shoots revolving around romantic scenarios in which he plays the object of her affection. When he kisses her as part of his direction at a train station, we see real tears in Jo's eyes as she imagines she is saying good-bye to her lover. Later, while Jo is modeling a wedding dress outside a country church, another kiss inspires her to profess her love for Dick. Despite his objections, she goes to meet Flostra, who has no interest in her mind, but only in her body. She realizes that she should have listened to Dick. All ends well back at the country church with Jo again in the wedding dress and Dick at her side.

Funny Face constructs a division between intellectualism and femininity and then reveals that the "Quality Woman," although she may be intelligent, must first and foremost be feminine. The dingy atmosphere of the bookstore and bohemian nightclub are no match for the glamorous world of design houses and fashion shoots. Moreover, the repeated transformation of Jo from drab bookworm into beautiful fashion model seduces the eye, not only because of Hepburn's visual appeal but because of striking changes in color and texture. Jo is seduced as well. In the bookstore scene, Dovima leaves behind a wide-brimmed orange hat with chartreuse veiling, a vivid shot of color against the monochromatic backdrop of the store and Jo's attire. Once alone, Jo begins to model the hat, gazing at herself in a mirror and singing about her newly awakened femininity, aroused by only "one kiss." She realizes that her facade of intellectualism is starting to crack, that the "true" woman beneath is beginning to emerge. All she needed was a man to bring it out of her.

This notion that the male photographer is able to reveal the truth of femininity became a hallmark of postwar fashion photography, and it was especially associated with Avedon and with Irving Penn, who was a photographer on the staff of the U.S. version of *Vogue*. Some historians actually "give" the entire postwar era to Avedon and Penn,[7] for their individual styles and close relationships with their models revolutionized the field at a time when the center of fashion was shifting from Paris to New York. Not content merely to document designer fashions on models serving as little more than mannequins, Avedon and Penn transformed fashion photography into a respected art form in and of itself. In fact, they are credited with modernizing the field almost by themselves, taking it out of the genteel salon tradition associated with the work of such European émigrés as Horst P. Horst and George Hoyningen-Huene and into what was almost immediately recognized as the "New American Vision."[8]

Because Avedon and Penn enjoyed almost overnight success, they were widely imitated. Certain "looks" became associated with their names, and a mystique began to develop around them. Although the "cult of the fashion photographer" is often considered a phenomenon of the 1960s,[9] I would argue that it originated with Avedon and Penn in the late 1940s and 1950s because, for the first time, the fashion photographer began to collaborate with, and at times even eclipse, the designer in defining

"the Look," that season's feminine ideal. Moreover, they were the first to sexualize the profession, not only by eroticizing the images but by drawing attention to the sexual interplay between the male fashion photographer and his female model.

Avedon was considered somewhat of a prodigy, for he rose to international prominence at the age of twenty-two. Fashion and photography had been part of his life since childhood. Born in 1923 to the daughter of a clothing manufacturer and to a father who owned a women's clothing store in Manhattan, the young Avedon had easy access to fashion magazines, and he would clip his favorite photographs and arrange them in a scrapbook. Moreover, his first job after leaving home was as an errand boy for a photographic establishment, and when he enlisted in the Merchant Marine, his father gave him a Rolleiflex camera as a going-away present. After arriving back in New York in 1944, Avedon secured a job shooting fashion for Bonwit Teller. Once he had enough photographs for a portfolio, he brought them to *Harper's Bazaar* and presented them to the magazine's art director, Alexey Brodovitch, who was impressed not with the fashion photographs but with an earlier shot of Merchant Marine seamen twins, one of whom was out of focus. Brodovitch decided to put Avedon on staff, even though he had doubts about the young man's technical abilities.[10] During the first few months, Avedon faltered in his attempts to find his way, but then in an April 1945 layout, he presented the first glimpse of what was to become one of his signature styles. By shooting his models against a plain backdrop, he was able to focus attention on the psychological interaction between himself and his female subject (Figure 24).[11]

Avedon's success had repercussions for the reigning *Harper's Bazaar* star, Louise Dahl-Wolfe, who had been at the magazine since 1936. Brodovitch soon began to privilege Avedon's "new vision" over Dahl-Wolfe's "feminine" style, and when Avedon was sent to Paris to photograph the 1947 collections, it signaled the end of Dahl-Wolfe's supremacy,[12] even though she remained on the staff until 1958. Although fashion photography had been considered "one of the best fields for women" at a 1940 conference on women in photography,[13] men became so dominant after the war that a 1951 cartoon by Erle Yahn published in the *ASMP News* lampooned the woman who dares step behind rather than remain in front of the camera (Figure 25).[14] Indeed, men had begun to redefine the field, transforming it from a subsidiary enterprise whose primary role was to promote the fashion designer into a vehicle for their own aesthetic, professional, and financial gain. They also increasingly invested the practice with a heterosexual dynamic, thus making it difficult for a postwar woman photographer to occupy fully the "masculine" position. For example, in a 1949 *Modern Photography* article, the photographer Ted Croner explains that he gets the desired response from his model by "making her do the things that will make [him] love her." He "shouts at the girls, 'I love you! I want you to love me!'"[15] Croner was a former combat photographer who opened his New York studio with the help of the GI Bill, after which he soon became known for models with the "sexiest hips ever seen in a fashion photograph."[16]

Figure 24. Richard Avedon, *McCall's* cover (August 1948).

Funny Face parodies the mystique that developed around Avedon and his models, a mystique that is also explored in a 1958 *New Yorker* profile on the photographer by Winthrop Sargent. According to Sargent, Avedon's success was due not only to his artistic and technical prowess but to the "fact that his primary interest is not in fashion but in women."[17] Avedon is likened to a director and his models to actresses, whom he chooses "not only for their beauty but for certain dramatic qualities of personality

Figure 25. Erle Yahn, from "They'll Settle for a Credit Line!" *ASMP News* (December 1951). Copyright Erle Yahn.

that he recognizes as suited to his particular theatrical needs."[18] Most often his models were professionals, but occasionally he discovered the ideal specimen in a public place, such as in an elevator or on the street getting out of a taxicab, a scenario reminiscent of the bookstore scene in *Funny Face*. Avedon was also known for remaining faithful to these leading ladies:

> But there is always one who, in his mind, is "his" model—the one on whom his creative thinking is centered, and on whom he can depend for complete projection of his ideas. Naturally, these girls change—in fashion, constancy is death—but Avedon tends to remain faithful to each one for a long time; when he finally feels obliged to let her go, he suffers intense pangs of regret. Several years ago, he felt so unhappy after dismissing a model that he continued to photograph her, trying to catch the sad, wistful essence of a woman forsaken in love.[19]

Between 1945 and 1960, Elise Daniels, Dorian Leigh, Dovima, Sunny Harnett, and Suzy Parker each took a turn as Avedon's favorite.

As Sargent notes, this close and somewhat exclusive association with his models caused speculation about the exact nature of his relationships with them. Although *Funny Face* reinforced the notion that the fashion photographer was romantically involved with his favorite model, Sargent points out that Avedon was happily married to his second wife, who had nothing to do with the fashion world and with whom he had a young son. However, one his first models, Dorcas Nowell, did become his first wife, the actress known as Doe Avedon.[20] Sargent writes that Avedon's friends had attributed the dissolution of their five-year marriage in 1950 to the fact that the

photographer had regarded her "mainly as a lovely creation of his camera eye." In fact, "nothing pleased him more than to dress her up to the nines and show her off in public." After the breakup, Avedon entered psychoanalysis, which led him to conclude: "I have to be a little bit in love with my models."[21]

Avedon's persona revolved not only around this real or imaginary love affair with his models but around his Svengali-like relationship with them. According to the mystique, it was he, and he alone, who made them beautiful. Avedon once referred to his models as "a group of underdeveloped, frightened, insecure women, most of whom have been thought ugly as children—too tall and too skinny. They are all subject to trauma where their looks are concerned. You have to make them feel beautiful."[22] With each model, Avedon created a particular look, a version of femininity that he believed them ideally suited to embody. From 1948 to 1951, Dorian Leigh played Avedon's version of an elegant but lively and spirited woman. Dovima was Avedon's femme fatale, an exotic-looking creature who reigned from 1951 to 1955. As Sargent points out, the image Avedon created for her was entirely fictive. She was actually a rather conventional Irish-American Catholic who traveled from location to location with her husband in tow and with a stack of comic books. But under Avedon's direction and camera eye, Dorothy Horan became Dovima, a dark and mysterious woman whose elaborate makeup and rigid poses belie any sense of the organic.[23] For Avedon, Sunny Harnett starred as the wealthy and sophisticated woman, an icy blond at home in diamonds, satin, and fur, whose aloof demeanor hints at danger and intrigue. Suzy Parker, like her older sister Dorian Leigh, had a sparkling smile, and for Avedon, she played a role not unlike that of Jo in *Funny Face,* a "Quality Woman" who does not let her intelligence or strong will get in the way of her femininity. In fact, Parker recalled an incident in which she protested to Avedon that she looked too "awful" that day to appear before the camera, but he silenced her with the admonition: "It doesn't matter how you look—it is *I* who make you beautiful."[24]

Because "beauty" was the very definition of femininity in postwar fashion, and to a great extent in the culture at large, such a claim implied the mastery of women, indeed, the creation of "woman."[25] It is this notion that the female model is a blank slate upon which the male photographer inscribes "the feminine" that is the most lasting legacy of the postwar Avedon. Within this ideology, woman does not exist apart from masculine control; she is his invention, the object of his creative imagination. Like the fashion designer Christian Dior, who with his "New Look" of 1947 sought to realize his "dream" of saving women "from nature,"[26] postwar fashion photographers chose models whose seemingly natural femininity would not compete with the artificial versions of femininity they created. The ideal high-fashion model was, therefore, ultra thin.[27] The only feminine excess allowed was breasts, although they had to be severely constrained. Another necessary component of this ideology was the illusion that the model had no will of her own, that she was nothing without the photographer, completely at his mercy. Avedon once said that he felt toward

his models as one feels toward kittens or puppies. Accordingly, he trained them by rewarding them with praise.[28]

Avedon's ideals, in turn, became the ego ideal for an entire generation of women, who could never measure up to these highly stylized, elaborately constructed images. As the photograph retoucher Helen Gee remembers:

> The ideal of the perfect woman—not a mole, a wrinkle, an extra ounce of weight—was one that none of us could possibly attain, however much we spent on make-up and clothes. I hated to think, as I nipped in Dovima's waist or bleached a freckle from Suzy Parker's nose, that I was helping sustain the illusion. No wonder good retouchers were prized. Where would Avedon be without Bob Bishop, his retoucher? His goose-necked women, indeed all of his women in *Harper's Bazaar*, were masterpieces of airbrush retouching, as doctored as the corpses at Whelan's.[29]

Of course, despite the impossibility of actually looking like these artificial images, women were coerced into believing that they should:

> Each year when he works on the Paris collections for *Harper's Bazaar* he chooses one girl as his leading lady. By kindness, suggestion, and a sense of the theatrically correct moment and gesture, he transforms her into the most ravishing beauty, so ravishing that she compels her viewers towards emulation—perhaps the *raison d'être* of fashion magazines in the first place.[30]

It was thus Avedon who possessed the power to bestow the status of womanhood on women, to define the feminine.

Not surprisingly, hundreds of thousands of women flocked to the modeling profession, hoping to be one of the select few chosen. It was not just the money and the glamour they craved; it was the chance to secure a rich and handsome husband, which was considered the epitome of postwar feminine success.[31] Even though top fashion models commanded up to fifty dollars an hour, their careers could be expected to last, on average, only about four to seven years. Not only did they get too old, but the fashion world, including the photographers, got "tired" of them.[32] That is why postwar models, commonly referred to as "mannequins," were chosen for their malleability, their "impersonal" faces and nonintrusive bodies.[33] The easier they were to fashion, the greater their utility *and* longevity. As Roland Barthes points out, the fashion model's function is to deliver a "deformed" rather than a "beautiful" body, one able to achieve a "formal generality." Her body is thus "no one's body," only a "pure form, which possesses no attribute."[34] The photographer can, therefore, imbue her with his aesthetic ideals and with his notion of essential feminine characteristics—seductive, enchanting, delightful, mercurial, flirtatious, and so on. "Woman" is reduced to stereotypes, a series of disparate essences, which women are induced to manifest as their feminine being.[35]

In Irving Penn's postwar fashion photographs, this sense of the female body as unformed, pliable material is even more pronounced. Penn's attitude toward the

fashion model was like that of a painter toward paint, of a sculptor toward clay. As Jonathan Tichenor wrote in 1950:

> The nature of her work requires that she be less assertive, raw material for the person she will become during the sitting, and it is Penn who makes that person come alive, who makes the model feel with him that in a certain dress or hat, she is mysterious or enchanting, tragic or petulant, but always that she is a beautiful woman, at home in the clothes she wears and true to the part she is living.[36]

Moreover, unlike Avedon, who often let his models move, Penn's women were amazingly still. His fashion photographs are analogous to still-life paintings, in that the model's body is just one element among many and does not compete for attention. Sometimes the body even appears to have no volume—patches of skin serve as negative space, and the heavily painted facial features function as decorative motifs within an abstract design.

Penn did not begin his career as a photographer. After graduating from the Philadelphia Museum School of Industrial Art in 1938, he found work as a freelance commercial artist in New York, and in 1940, he took a position in the advertising department of Saks Fifth Avenue. After one year, he decided to quit his job and go to Mexico to paint. While there, he also began to experiment with the camera. When he returned to New York, he became an assistant to Alexander Liberman, the art director at *Vogue*. During his early years at the magazine and as a volunteer photographer for the American Field Service in Italy, Austria, and India from 1944 to 1945, Penn grew more and more confident as a photographer, until in 1947, "the essential Penn—what now might be called the historic Penn—emerged."[37] This "essence" is, of course, the photographer as artist, the transformer rather than recorder of nature. As Liberman wrote in his introduction to Penn's 1960 *Moments Preserved*:

> Penn's struggle is the classical one of the artist to create order out of apparent disorder, to impose his will on nature. He has attempted to continue in photography the classical vision. He has pioneered by willfully seeking to stamp the impersonal medium of photography with the mark of the artist.[38]

Not surprisingly, Penn, more than any other postwar photographer, has been claimed by the art world as one of its own.

Just as Avedon donned the role of theatrical director, Penn took on the guise of the artist in his studio. Shot before a plain backdrop, Penn's models almost always appear as aesthetic objects rather than living beings. In fact, the model (Jean Patchett) of a black-and-white 1950 *Vogue* cover looks as if she is impaled on white canvas, like a butterfly attached to a board with pins (Figure 26). The image is fully frontal; her arms are raised to a horizontal position, then frozen in place. Black netting encloses her harshly painted face, the only part of her body that is at all exposed. This fragmented, inorganic aesthetic was characteristic of Penn's fashion work. In many of his shots, the body is cropped at the waist or chest; sometimes even the head is cut off in

the frame. Denied unity, the female body becomes a collection of easily manipulated parts. In his 1951 book *The Mechanical Bride,* Marshall McLuhan commented on the ubiquity of this aesthetic in popular imagery. He pointed out that although the "ordinary glamour girl" had given up "the tyranny of long dresses and the male-imposed modesty of the past," she had been led to accept "from a technological world the command to transform her organic structure into a machine."[39] Indeed, Penn's modernist aesthetic, which emphasizes form over content, turns his models into commodities, mere objects. Actual flesh is denied in favor of an unblemished, smooth, white, aesthetic surface, one evocative of marble, porcelain, or painted metal.

Like Avedon, Penn maintained that he would have "a favorite model," one with whom he had a "more real emotional involvement."[40] The model as an object of erotic allure for the photographer is most evident in the *Vogue* fashion shots that Penn took of his wife, Lisa Fonssagrives-Penn, who was probably the most famous and successful high-fashion model of her time. She had first appeared in *Vogue* in 1936, and when Penn met her in 1947, she was married to the fashion photographer Fernand Fonssagrives, with whom she had a daughter. Her first meeting with Penn was a highly publicized event—*Vogue*'s bringing together the twelve most-photographed models of the preceding decade for a group portrait, a photograph that has become one of Penn's most famous and frequently reproduced.[41] Their marriage in 1950 added to the already growing mythology surrounding the relationship between the male fashion photographer and his model, and of course, left no doubt as to Penn's virility. Not only did he marry the most beautiful woman in the world, but it appeared that he had stolen her from another man.

Although Penn did not enter the postwar debate about whether or not photography was an art, he did maintain that a photographer could be an artist. It was the creative mind, however, not the fine print, that he considered to be the important factor.[42] Avedon also privileged the photographer's subjectivity by asserting that he had no interest in photographic technique, that the camera was actually an impediment to his personal vision, which was the true subject of his work: "Sometimes I think all my pictures are just pictures of me. . . . I hate cameras. They interfere, they're always in the way. I wish: if I just could work with my eyes alone!"[43] Like painters and sculptors, Avedon and Penn built their artistic reputations upon their individual styles and unique personas. However, unlike most fine-art practitioners, they were not perceived as effete or genteel. Their fashioning of the female while simultaneously denying that their photographs were about fashion secured their reputations as virile, heterosexual men. Moreover, they enjoyed international fame, the esteem of their professional peers, and financial prosperity—all markers of postwar masculine success. Indeed, by 1958, Avedon was making about a quarter of a million dollars a year,[44] an amount that dwarfed even the fees commanded by *Life* photographers. Avedon and Penn were also voted among the "world's ten greatest photographers" by 243 international critics, teachers, editors, art directors, consultants, and working photographers polled by *Popular Photography* in 1958. In their personal statements to

Figure 26. Irving Penn, black-and-white *Vogue* cover (1 April 1950).

the magazine, Avedon declared his antitechnique/anticamera philosophy, and Penn proclaimed: "I am a professional photographer because it is the best way I know to earn the money I require to take care of my wife and children."[45] As breadwinners, artists, and celebrities, Avedon and Penn had it all. They even got to surround themselves each day with what were considered the most beautiful women in the world.

The Photographer as Playboy

The tough guy with a dame on his arm, the central motif of film noir and hard-boiled fiction, was primarily the province of the news photographer; for photographers who specialized in women, it was the sexual connotations of the male artist–female model relationship that were exploited. This theme formed the premise of the television situation comedy *The Bob Cummings Show,* which aired from 1955 to 1961.[46] The series featured Cummings in the role of swinging bachelor Bob Collins, who spends his days in the studio photographing beautiful models and his nights escorting these same women around town. Bob never settles down with one woman; in fact, he frequently arranges multiple dates for one evening. The story line often revolves around these attempts to secretly romance more than one model at a time. Bob lives with his widowed sister Margaret (Rosemary DeCamp) and her teenage son Chuck (Dwayne Hickman), who looks to his uncle as an authority on handling women. Chuck and his friends refer to Bob as the "king" and the "sultan," much to the dismay of Margaret, who wants Bob to act like a "proper" male mentor. She cannot understand why Bob does not want to marry and have a family of his own, which is exactly what Bob's assistant Schultzy (Ann B. Davis) would like as well, for she is secretly in love with him. With blouse buttoned to the neck and hair severely pulled back, Schultzy is made to look frumpy and unattractive, asexual even, no match for the sexy models—often French, Italian, or Scandinavian—who parade through the studio. Another undesirable female type is the recurring character Pamela Livingston (Nancy Kulp), an uptight intellectual with short hair and glasses. She also shows a romantic interest in Bob, but to no avail, of course. Pamela and Schultzy function as fodder for jokes about failed womanhood; they are unsuitable as playthings, not only too ugly but too smart.

Bob Collins represents another model of masculinity in opposition to that of breadwinner—the playboy. Like the tough guy, the playboy rejects domestication; however, unlike the tough guy, the playboy does not reject the culture of consumption. He is the consumer par excellence, the purchaser not of a suburban home, kitchen appliances, and gas grills but of elegant clothing, stereo sets, imported liquor, and sports cars. Above all, however, the playboy consumes women. In December 1953, the first issue of Hugh Hefner's *Playboy* magazine hit the stands, featuring a nude photograph of Marilyn Monroe, the first "Sweetheart of the Month." Hefner was clearly appropriating the tradition of the Petty and Varga girls, painted images of sexually desirable women that had appeared in *Esquire* magazine in the 1930s and 1940s. Like *Esquire,* for which Hefner had once worked, *Playboy* used female nudes to promote an exclusively heterosexual readership, thus deflecting any charges of effeminacy that might be associated with consumption. These images also functioned as a medium for heterosexual identity, signifiers of a collective masculine bond predicated on the exchange of women. Moreover, by using photographs rather than renderings, *Playboy* was able to make the sexual fantasies more explicit.[47] Indeed, what *Playboy* offered its clientele was the sight of "real" breasts within a format that reinforced their class

aspirations; this was not a "girlie" magazine for the blue-collar man but a "lifestyle" manual for the young, educated, wealthy, and sophisticated urban professional.[48] Regardless of any high-culture pretensions, however, it was the monthly "Playmates" that became the leitmotif of the magazine, and their photographers became the consummate playboys.

Playboy advertised itself as an "entertainment" magazine, as opposed to the various how-to, outdoors, and adventure magazines for men already on the market. This entertainment centered on male pleasure rather than responsibility, on the comforts of home but not of family. The first editorial stated: "We want to make it clear from the very start, we aren't a 'family magazine.' If you're somebody's sister, wife or mother-in-law and picked us up by mistake, please pass us along to the man in your life and get back to your *Ladies Home Companion*."[49] From the beginning, *Playboy* promoted an antimarriage agenda, a rebellion centered on money. In "Miss Gold-Digger of 1953," Bob Norman warned men that to marry was to risk eventual divorce and thus alimony payments, which "American womanhood" had "descended on" as a "natural heritage." He claimed that "even the simplest wench" was capable of earning a decent salary in 1953 and that therefore, when a marriage ended, the man, who was no longer "entitled" to the "privileges of a husband," should not have "to pay for them as if he were."[50]

Playboy's philosophy is reminiscent of that presented in Philip Wylie's immensely popular 1942 book *Generation of Vipers,* which called for men to take action against the domineering women who had turned the nation into a "gynecocracy." Wylie believed that a woman's "first purpose" was "to become a sexually desirable object."[51] Anything more would be to step out of bounds, because a woman's primary biological function was to sexually satisfy a man; to compete with him in the public arena would be unnatural. Wylie's biggest complaint, however, was that women were lazy, so their primary goal in life was to ensnare a man, drag him to the altar, and then drain him of all financial resources. He attributed this laziness to the Cinderella myth and to advancements in household technology, which had made it so simple to keep a house that women now constituted an "idle class." In fact, Wylie wrote, even childbearing had become easy, "no more of a hardship than, say, a few months of benign tumor plus a couple of hours in a dental chair."[52] Because women had all this free time on their hands, they shopped. Meanwhile, men worked, which is "natural" to them, not only to make money so that women could shop but to produce the goods that women demand. It was not that Wylie did not like women: "I like women. I like nude women. And I also like pictures of them."[53] It was just that so many of them became Cinderellas and then moms, and it was Momism that Wylie hated more than anything else:

> The machine has deprived her of social usefulness; time has stripped away her biological possibilities and poured her hide full of liquid soap; and man has sealed his own soul beneath the clamorous cordillera by handing her the checkbook and going to work in the service of her caprices.[54]

In November 1956, Wylie published an article in *Playboy* declaring that women still controlled 80 percent of the nation's wealth and did 80 percent of the nation's buying. For these calamities, in part, he blamed advertisers, because they had convinced women that they needed a vast array of products to be a "good lay" and men that only the "pansies" among them shopped for themselves.[55] In fact, one of the major themes that courses throughout *Playboy* is that men could be consumers without being feminine. Moreover, they could abdicate adult familial responsibility without raising doubts about their sexual orientation. Unmarried men beyond a certain age were often suspected of homosexuality, which was theorized as sexual and social deviancy, an escape from mature manhood, a refusal to grow up.[56] On the other hand, the *Playboy* philosophy asserted that one could remain single and still be a man, a man who could have sex with a variety of women without having to marry any of them. Indeed, in his 1958 *Playboy* article "The Womanization of America," Wylie argued that a woman, "if woman enough," should accept the fact that a man, "if truly male," would admire and enjoy a variety of women. Wylie also wrote that women are "by nature designed" to cooperate, not conquer; therefore, he decried their encroachment into what was once "a society dreamed up by males, by males pioneered, made free and kept united by males." According to Wylie, industrialization and feminism had turned women into "pseudo-males" who seek to gain authority—which is man's by nature—over both the public and private spheres.[57]

Wylie was certainly not alone in his castigation of "strong" women. In fact, social scientists and psychiatrists reinforced many of his ideas,[58] and the media were eager to report these "scientific" findings to the general public. In December 1956, *Life* magazine published the opinions of a panel of psychiatrists that it had organized to comment on what was causing the rising divorce rate. The five panel members, representing different geographical regions, concluded that the "basic disturbance" was wives "not feminine enough" and husbands "not truly male."[59] Not surprisingly, women were entirely to blame for this "sexual ambiguity." According to the psychiatrists, feminism had led to the "career woman syndrome," which encouraged women to adopt the masculine traits of "aggression, exploitation, and dominance" and to reject the feminine virtues of "receptivity, passivity, and the desire to nurture." Even non-wage-earning wives had internalized this feminist ideology and were thus no longer content with being "just" housewives. Because of their frustration, they become "dominating" wives and mothers. These "overaggressive" wives eventually forced their husbands into passivity and into taking a maternal role with the children, an especially easy task if the men had been raised by equally aggressive mothers. The "confused" husbands also might start to drink heavily, experience impotence, or turn to homosexuality.[60] The New York psychiatrist reported a case in which the wife had come to him for help after her husband had begun drinking too much, hitting her, and ignoring her sexually. The husband's response to the psychiatrist was that his failures as a "man" were due to his career-oriented wife, whom he wished would act like "more of a *woman*." Not only did she have "strong ideas" and expect "him to respond to her mood" in sexual matters, but she "dislikes housework,

she never learned how to cook," and "she turned the children over to nurses as soon as she could."[61]

In 1958, the editors of *Look* magazine published a compilation of three of its articles under the title *The Decline of the American Male*. The first, "Why Do WOMEN Dominate Him?" by J. Robert Moskin, opens by invoking the authority of science:

> Scientists who study human behavior fear that the American male is now dominated by the American female. These scientists worry that in the years since the end of World War II, he has changed radically and dangerously; that he is no longer the masculine, strong-minded man who pioneered the continent and built America's greatness. He has changed as a boy growing up, as a youth courting a girl, as a husband, father, job-holder and lover. His collapse already affects his wife and children. And the experts pin most of the blame for his new plight squarely on women.[62]

Moskin goes on to cite experts in a variety of fields to support his claim that women have seized control of almost every aspect of men's lives. He especially chastises women for demanding that their husbands satisfy them economically and sexually. This female aggressiveness is blamed for causing four maladies in the U.S. male: fatigue, passivity, anxiety, and impotence. Experts also worry, he says, about the "housework-participating father," for he will fail to model appropriate masculine behavior for the next generation of men.[63] Indeed, Moskin warns that a woman's "ability to dominate extends beyond her own personal male." He cautions that there are 1,513,000 more women than men in the United States, that they live an average of six years longer, and that they are entering the workforce, voting, and buying securities in ever-increasing numbers. Men, however, have developed a variety of retaliatory defenses, such as escaping to bars and sports arenas, engaging in extensive business travel, withholding sex from their wives, deserting their families, "fleeing" to homosexuality, or choosing to remain bachelors.[64]

Hugh Hefner had himself left his wife and children to pursue the swinging single life,[65] one in which women were merely playthings who wielded no power over men. Because of the ever-present threat of female domination, however, *Playboy* continued to publish antimarriage diatribes throughout the decade as it offered up a rotating smorgasbord of passive Playmates for viewing pleasure, nonthreatening women who supported themselves economically but confined themselves to such low-level service occupations as clerk, stewardess, and secretary. Other female "types" were considered more dangerous.[66] For example, a 1959 article presented six photographs of bare-breasted females at home—the bohemian, the career girl, the sporting type, the sophisticate, the homebody, and the rich girl—so that men could "study each specimen" in "its natural habitat" and thus be better prepared "to win over the wild creature" without themselves being "ensnared."[67] Likewise, a June 1954 article warned men to be on the lookout during this most dangerous month, when wedding-hungry female predators went on the prowl. However, even though men should guard against deceitful feminine wiles, that did not mean that they should "stick to strictly male company," for the "true playboy can enjoy the pleasures the female has to offer

without becoming emotionally involved. Like the little bee, he flits from flower to flower, sipping the sweet nectars where he finds them, but never tarries too long at any one blossom."[68] Immediately following this article is a three-page spread, by the photographer André de Dienes, featuring photographs of nude women frolicking in nature. These views of the California landscape are described as a follow-up to the January 1954 article "At Home with Dienes," which had established the photographer as the quintessential playboy, for each room of his California ranch home was furnished with a different nude model: "Some say you can judge a man by the way he furnishes his home. If that's true, photographer André de Dienes is just about the most interesting guy we've ever heard tell about." Indeed, he has a model on the sun porch, one in his bed, and one each on the two stone tables in his living room, an arrangement that he claims, with tongue in cheek, "is strictly business."[69]

De Dienes was the most celebrated photographer of the female nude in the postwar era. He had emigrated from Transylvania to the United States in 1938, initially making a career for himself in both New York and Hollywood as a fashion, advertising, and celebrity photographer. In fact, de Dienes was the first photographer to hire Marilyn Monroe (then Norma Jean Baker) to serve as a model. After a month-long photographic journey through the West in 1945, the two had become engaged. Although Monroe later broke off the engagement, they remained close friends, and de Dienes continued to photograph her.[70] After moving to a secluded hillside home near Hollywood in the early 1950s, he began to distinguish himself as a photographer of "highly polished" female nudes. In fact, Jorge Lewinski credits de Dienes with creating a "new style in nude photography," that of "slim, long-legged nudes, running and jumping in the wide expanses of the Californian dunes, and forming strong patterns of light and shade."[71] It was these photographs that appealed to Hefner—artistic, yet erotic—and it was de Dienes's lifestyle that Hefner wanted to sell. Indeed, de Dienes later admitted what had long been assumed: "An intimacy develops between a photographer and his model which often means that a long photo session ends in bed, or failing that, on the grass or on a sandy beach."[72]

Playboy photographs clearly place women back under the control of men. Whether they are objects in a tranquil pastoral setting, decorative toys in the bachelor home, or models in the studio, these women are as passive as clay, merely physical matter to be molded by the men who photograph them and to be consumed by the spectators who purchase the magazines. Furthermore, the way the photographs are presented draws attention to the privileged position of the photographer: He is the man who actually lives the fantasy. A 1954 article presents a series of photographs of a model provocatively stripping off her clothes in preparation for a photo shoot with the advertising photographer Hal Adams, whom we see "mussing" her hair and contemplating "suitable poses."[73] In "Sex on Lex," the privileged role of the advertising photographer is treated even more extensively. Photographs of provocatively posed models accompany an article that describes 480 Lexington Avenue, a twelve-story building dominated by commercial photography studios that occupies an entire city

block in Manhattan, as a "modern temple of Venus," filled with a "flurry of females, all exceptionally pretty," and presided over by the "high priest the photographer."[74]

To shoot a *Playboy* Playmate was considered the ultimate photographic experience. In one article, the photographer Norman Bigelow is himself photographed as he "prepares" a Playmate for the camera by rubbing body makeup all over her nude

Figure 27. *Playboy* cover (June 1958).

body.[75] Not surprisingly, in a 1955 poll of *Playboy* readers, 20 percent listed pho-
tography as a hobby, topping, by a wide margin, all other hobbies except reading,
which came in second with 16 percent.[76] The June 1958 issue reinforced this associa-
tion between photography and the playboy lifestyle. On the cover is a close-up of a
camera lens, in which a beautiful woman appears and around which the title of the
feature article is inscribed: "Photographing Your Own Playmate" (Figure 27). This
how-to feature immediately follows "The Well-Equipped Lensman," a discussion
of the various cameras and photographic equipment available on the market; "The
Well-Equipped Lensman" also begins with the image of a camera, this time with a
woman in the viewfinder.[77] The woman pictured in both images is the June Playmate,
an eighteen-year-old receptionist who works in the Playboy Building. According to
the article, she was chosen because she is a "fair subject," the type of woman available
to the magazine's readership—she works not as a professional model but as a secre-
tary, store clerk, stewardess, or the like. Moreover, she is "attractive, personable, and
fresh from Tennessee," the type that would do "the proper amount of hemming and
hawing" before finally agreeing to pose nude. The article stresses that although un-
comfortable at first, she actually "began enjoying the session," falling "more naturally
into the spontaneous situations that make the best playmate shots." Step-by-step
through images and text, the reader is led through the process, so that he, too, can
live the fantasy.[78]

Except for Bunny Yeager, a photographer-model who is shown both before and
behind the camera,[79] all the photographers featured in the magazine in the 1950s
are men. Russ Meyer, one of the most prominent, is even married, as are approxi-
mately one-half of *Playboy*'s readers.[80] However, his wife is definitely a fantasy wife,
a beautiful blonde Playmate, not like the wives demonized in the magazine's articles
and cartoons. In "An Evening with Eve: A Modern Bedtime Story," one of Meyer's
many layouts for the magazine, she poses in bed as her husband directs her through
a series of bedtime activities until she is ready for the finale—unclothed, she sits on
the bed, back to the camera, yet with one breast visible, her face turned toward her
husband . . . waiting.[81] According to *Playboy* historian Russell Miller, it was Hefner
who demanded this "seduction-is-imminent" pose in the early Playmate photographs,
later replacing it with the "girl next door" look.[82] Both versions emphasized passivi-
ty; these were women who did not constitute a threat to a man's ego, nor did they
induce performance anxiety. Miller explains: "Playmates were nice clean girls; there
was nothing to be feared from seducing them. Afterward they would no doubt admit,
with shining eyes, that it was wonderful."[83] The writer Gay Talese remembers the ap-
peal of these early Playmates to postwar men:

> She was their mental mistress. She stimulated them in solitude, and they often saw her
> picture while making love to their wives. She was an almost special species who exists
> within the eye and mind of the observer and she offered everything imaginable. She
> was always available at bedside, was totally comfortable . . . she behaved in a way that
> real women did not, which was the essence of fantasy.[84]

Indeed, unlike real postwar women, Playmates did not expect sexual satisfaction. Their role, like that of all women in Hefner's sexual revolution, was simply to service the needs of men.

Public attention to issues of sexuality had been intensified by the best-selling reports on human sexuality published by the Kinsey Institute in 1948 and 1953. The initial report had concluded that a man's sexual potency peaked in his late teens and then gradually declined over the rest of his life.[85] Hefner's founding of *Playboy* can thus be seen, in part, as a response to the emasculating implications of this claim, a reminder to men that their sexual adventures need not come to an end with adulthood. Five years later, the institute reported that white women of all ages and social backgrounds were far more sexually active than had been culturally acknowledged and that, unlike men's, their sexual drive actually increased in intensity as they aged.[86] Not only did the report draw attention to premarital, extramarital, and same-sex sexual activity among women, but it also concluded that "frigidity" was not the primary reason that women did not reach orgasm, as was commonly believed. Instead, the study placed the blame on insufficient physical stimulation.[87] Thus, sexual inadequacy, indeed failure, was shifted from the woman to her sexual partner. Although *Playboy* capitalized on the revelation that even "good girls" had sex, the magazine also sought to contain this female sexuality within imagery that presented the female body as readily available to the male viewer, without any suggestion that the woman might expect anything in return. According to the sociologist Helen Mayer Hacker, anxiety over sexual performance was the primary cause of masculine crises in the 1950s. Whereas virility had once been considered synonymous with male sexuality, it was now conceived as the ability to satisfy a woman sexually. Unlike the "castrating Delilahs" whom postwar men so feared,[88] the *Playboy* Playmate was an innocent, "promising all, demanding nothing."[89] Thus, it was not the sexually active woman who terrified men, but the sexually demanding one. Sexual assertiveness on the part of women was considered a symptom of gender confusion. Gender roles had relaxed during World War II, and as women continued to enter the workforce, efforts to reestablish a strict boundary between masculine and feminine increasingly turned toward the biological as the indisputable determining factor. Hence, the male was the "natural" aggressor, and the female was "by nature" passive. Although *Playboy* acknowledged women as sexual objects, it refused to recognize them as sexual beings. The "truth" of female sexuality was thus not for a woman to decide; it had to be revealed by a man—in this case, the male photographer, through whose eyes the male spectator-consumer was able to participate.

Playmate photography shared affinities with both glamour and pinup photography. The designation "glamour" was applied to photographs that emphasized ideals of feminine beauty rather than a woman's individual physiognomy and personality. The photographer William R. Harrison wrote that a "glamour photograph is *not a portrait,* it is *not a likeness*—it is an ideal." Furthermore, it is an image constructed by the photographer from the raw material that is the model: "Remember, you are not *taking* a picture but *making* one." According to Harrison, "*any* girl" could be

glamorized, no matter her size, age, or attractiveness. In fact, any "specimen of the female sex" will do,[90] because it is the photographer who creates the finished product, which functions as a testament to his expertise. His skill is the subject; she is merely the object. As he reiterates in another how-to article: "The important thing is *you, the man behind the lens.*"[91] Indeed, glamour photography, like fashion photography, operates on the assumption that the idealized woman on display is a construct, an artificial entity that displaces the "real" woman.

Glamour photography had developed its own iconography. A variety of props, backgrounds, and settings, as well as makeup, hair, and lighting techniques, were utilized to fashion these highly artificial images. How-to articles and books instructed readers on the various tools and techniques needed to turn "any" woman into a glamorous object.[92] Of course, glamour photography was suitable only for female subjects; men wanted portraits that emphasized their individual "character."[93] A variation on the glamour photograph is the pinup, which sexualizes the female body and "invites the viewer to participate vicariously in or fantasize about a personal relationship with the subject."[94] Pinups had become popular during World War II, when soldiers hung these photographs over their sleeping areas, supposedly as a form of inspiration, reminding them that U.S. womanhood was worth fighting for. Even the Army Morale Division sponsored a pinup photograph, "The Girl Back Home," to encourage the soldiers overseas to buy war bonds. Most pinups were of movie stars, however, and thus formed an important component of Hollywood studio promotion campaigns. Pinups of Betty Grable and Jane Russell were among the most popular. In fact, Russell was made a star almost exclusively through her pinup.[95]

In addition to drawing on glamour and pinup photography, *Playboy*'s imagery also drew on the tradition of the nude in art photography. In fact, before founding the magazine, Hefner had purchased photography journals just to see pictures of nude women.[96] Because they were claimed to be artistic, these nudes had been able to escape laws regulating the distribution of obscene photographs through the mail.[97] It is not surprising, therefore, that Hefner, who sought to reach an upscale clientele and whose magazine met resistance from the postal service,[98] would attempt to invest his Playmate photographs with the aura of the artistic nude, a relatively simple task considering that art photographers also explicitly revealed the female body, even though they maintained that it was simply an aesthetic tool. The photographer Alan Fontaine advised in a 1949 article: "Look upon the model as an object. Forget that she is nude and work with her as an aesthetic object that can be stretched, turned, twisted and kneaded like putty."[99] It is, however, quite obvious to the viewer that she *is* nude. In fact, it would be difficult not to notice. For example, one of Fontaine's photographs accompanying the article shows a nude model directly facing the camera. Props cover her body below the waist and her face is in shadow, but her fully exposed breasts are illuminated by a side spotlight, so that the viewer's eyes are drawn immediately to them. Indeed, they alone appear to be the subject of the photograph. Such an image is as revealing, if not more so, than those that *Playboy* would begin to publish a few years later.

Of course, what *Playboy* added was context. For example, although there may be little discernible difference, at least in terms of subject matter and composition, between a nude by de Dienes published in *Playboy* and a nude by the modernist photographer Edward Weston exhibited at the Museum of Modern Art, one could argue that the suggestive text accompanying the de Dienes and the framing mechanism of an entertainment magazine for men work to impose a more erotic reading on the photograph. On the other hand, it would be difficult to argue that de Dienes's 1958 book, *Nude Pattern*,[100] a portfolio of 105 female nudes, is aesthetic but not erotic, or even pornographic according to 1950s standards, despite the fact that it is packaged in an artistic rather than an entertainment format. Large-breasted nude women lounge around his home, lie in his bed and on his tables, gaze into his mirrors and use his shower, after which they frolic in the countryside, in the flowers and on the rocks, on the beach and in the water. Sometimes they are together, their oiled bodies touching; at other times they are alone, touching themselves or playing with a series of props— beach balls, bows and arrows, shells, fish netting, and sheep. De Dienes even had a swimming pool built with a window in the side so that he could take photographs of women underwater,[101] which enabled him to capture the way breasts appear weightless, an accompaniment to his other shots of breasts hanging, pushed up, or floating on the water's surface. In fact, the main subject of almost all of these photographs appears to be the breast (Figures 28 and 29).

According to Berkeley Kaite, the breast is the foremost signifier of femininity, for it carries with it aspects of both the maternal and the sexual.[102] And during a time when even the depiction of pubic hair was illegal, the female breast was the only physical evidence of sexual difference that could be represented. Moreover, as the art historian Anne Hollander argues, the presentation of the unclothed body in art is determined by the way the clothed body is portrayed.[103] In the 1950s, women's fashions tended to accentuate the fullness of the breasts, an aesthetic epitomized in cultural representation by screen stars such as Marilyn Monroe and Jayne Mansfield. Therefore, whether in *Playboy* or in artistic venues, photographs of the female body highlighted, indeed fetishized, the breast. In Freudian terms, fetishization is a symptom of castration anxiety. The male subject within patriarchy displaces fear of his own castration onto the female body; however, the sight of this "castrated" or "castrating" body terrifies him.[104] Thus, to lessen his anxiety, the disavowing subject replaces the real with an object that can be taken for the real: He turns the entire body, one of its parts, or an item of clothing into a substitute penis. In photographic representations, actual bodies or their parts can be controlled and reshaped under the direction of the photographer and contained within the regulatory regime of photography. They can be phallicized, transformed "from natural flesh to fetish."[105] As Linda Williams argues, fetishism works to diminish the "threat of woman" by denying women any meaning or existence beyond that of "marker of sexual difference."[106]

Detailed instructions on how to depict "woman" as "breast" were relayed by the photographer Lewis Tulchin in his 1950 how-to book *The Nude in Photography*.

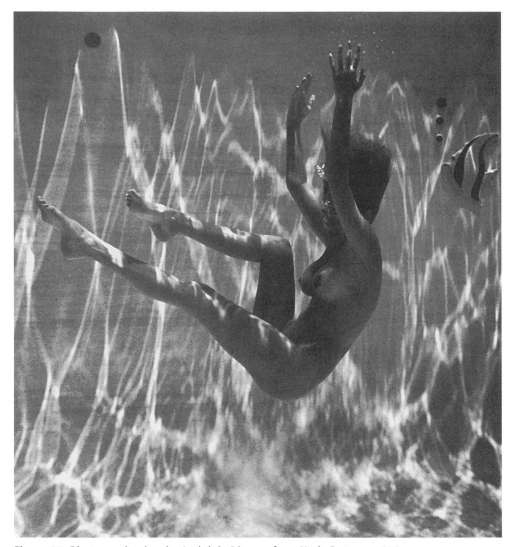

Figure 28. Photograph taken by André de Dienes, from Nude Pattern, 1958.

Tulchin emphasizes the importance of the photographer's "primordial sex drive" in any approach to artistic photography of the female nude. Therefore, he argues that the male photographer should strive to "express" the model's "essential femininity," for that is what inspires him as a man.[107] Of course, as part of his role as a "true artist," he must also reject that which does not fit his notion of feminine beauty:

> Once he finds his theme, his inner feeling is expressed in portraying the beautiful structure of the feminine form. He places his lights so that what he sees in her must dominate everything else visible. He subdues the unessential with lower tones of light. He knows what he wants to say. The less than perfect form of his model does not discourage him, for he is painting with light. He shows the perfections and subdues the imperfections.[108]

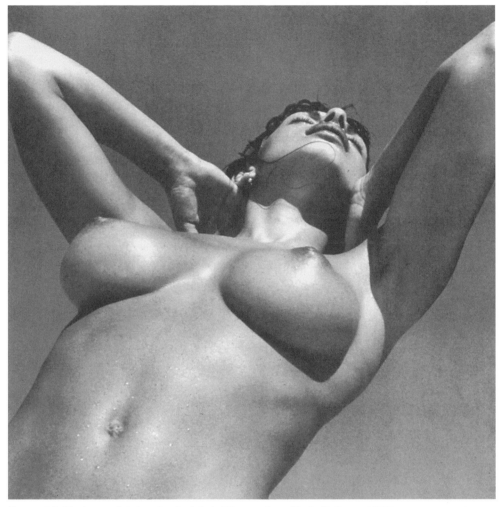

Figure 29. Photograph taken by André de Dienes, from Nude Pattern, 1958.

The "dominant point of interest" in the examples Tulchin provides is most often the breast, the emblem of sexual difference, the badge of essential femininity. In one illustration, Tulchin explains how to light the breasts, so as to bring out their beauty, while simultaneously suppressing the face and head, which are inessential details.[109] As a 1950 *U.S. Camera* article points out, the photographer should suppress anything that might personalize the image, for that would detract from representing "the qualities inherent in all *women*."[110] Thus, in artistic photographs of the female body, it is often the face that is hidden, whether cast in shadow or turned away from the camera, for the face would individualize the woman and thus detract from the photographer's attempt to present his notion of the "truth" of femininity. That "truth," not the actual women depicted, is the subject matter of these photographs. They provide visual evidence of sexual difference; they affirm that women are only "woman" after all. They are mere objects, just things, not individual speaking and

demanding subjects. As Annette Kuhn writes, such images "participate in photography's more general project of privileging the visible, of equating visibility with truth." And this truth is that "woman" is "reducible to bodily parts which are exclusively sexual in function."[111]

This compulsive probing into the nature of the sexual difference that seems to define "woman" is also symptomatic of the fear induced by the ever-present threat of real women, whose sexuality postwar society sought so desperately to contain.[112] According to the art historian Lynda Nead, the transformation of the female body into the female nude polices the boundaries of female sexuality. Moreover, it sanitizes the corporeal in an attempt to keep the abject at bay:

> If the female body is defined as lacking containment and issuing filth and pollution from its faltering outlines and broken surface, then the classical forms of art perform a kind of magical regulation of the female body, containing it and momentarily repairing the orifices and tears. This can, however, only be a fleeting success; the margins are dangerous and will need to be subjected to the discipline of art again . . . and again.[113]

Art photographers take the organic female body and transform it into a sculptural object, one from which no fluids can flow. Through the use of light and shadow, flesh is made to appear smooth, like polished marble. De Dienes even confessed that he sometimes wished his "model would turn to bronze or purest marble."[114] According to French philosopher Jean-Paul Sartre, erotic representations insist on the "smooth whiteness of a woman's body" because "what is smooth can be taken and felt but remains no less impenetrable."[115] Thus, the female body can be repeatedly possessed, but it never gives way. As Nead argues, the surface of the body becomes a fetish, a masculinized "frame" that works to delineate the boundaries of feminine matter, restoring to it that "erectile definition" that it is perceived to lack.[116] The surface of the body also hides, indeed negates, the abject interiority of the body, sealing it in a sort of aesthetic vacuum, replacing debased matter with sanctified form, transforming nature into culture.

By turning the female body into an object that can be possessed, a commodity that can be bought, sold, and exchanged, man strives to gain control over his masculine subjectivity. As Luce Irigaray reminds us: "If traditionally, and as mother, woman represents *place* for man, such a limit means that she becomes *a thing*. . . . [She] serves as an *envelope*, a *container*, the starting point from which man . . . creates *his* identity."[117] The repeated delineation of the female body, the sealing of its pores, reassures men that the strict boundary between femininity and masculinity can be maintained, and even more important, that it is they who retain control. In the words of anthropologist Mary Douglas, the "body is a model which can stand for any bounded system. Its boundaries can represent any boundaries which are threatened or precarious."[118]

By the mid-twentieth century, photographs of the unclothed female body so permeated U.S. culture that "the commodification of sexual images seems to have partially supplanted the commodification of sexual acts."[119] The sensational and

immediate success of *Playboy* contributed to an increased demand for such photographs, which were sought for mass-market magazines and for specialized photography journals and books as well.[120] Indeed, *Playboy* spawned a number of imitators, including *Cabaret, Jaguar, Jem, Nugget, U.S. Male,* and *Duke.* Photographs make a more effective fetish than rendered images because they carry with them the aura of the real; thus mastery is intensified. However, this factor also makes photographs more anxiety-producing, for the trace of the real complicates containment. Therefore, the female body must be repeatedly shot and repossessed.

Because of the almost compulsive obsession to photograph the female body, the distinction between art and pornography became the subject of much debate in the 1950s. Because the female body has historically functioned as the primary signifier of nature, Nead argues that its transmutation symbolizes "art" itself. Consequently, the female body functions as the primary battleground upon which the line between art and obscenity is drawn and redrawn, as well as the surface upon which masculine virility in the form of artistic expression and individual style is inscribed.[121] Postwar photographers took part in these debates. A 1959 symposium on glamour photography sponsored by *Infinity* concluded that erotic or even "suggestive" photographs could be considered art if they were in "good taste."[122] In response, *Playboy* picture editor Vincent Tajiri chastised the members of the panel for hiding behind the designation "glamor," insisting that what these photographers created were actually pinups, which could also be done in "good taste," as they were, he argued, in *Playboy.*[123] Of course, even tasteful photographs could give "rise to lustful thoughts of a lewd nature," which was the definition of pornography according to most obscenity laws.[124] Indeed, when *Playboy* took the artistic female nude and placed it within a pornographic context—the site for viewing the corporeal rather than the transubstantiated—it broke the rules and thus invoked anxiety over cultural boundaries.[125] Books like those published by de Dienes further eroded the border between art and pornography by removing the artistic nude from the gallery wall and placing it in the hands of private viewers.

Whereas some photographers felt the need to defend their practice against the charge of pornography, especially after the U.S. Post Office began intensifying its campaign against obscenity in the late 1950s, others seemed to relish the renewed association between photography and eroticism, especially as it enhanced their own reputations as "men." For example, *Playboy* published a four-page spread on a "Playboy Party" sponsored by the Hollywood division of the ASMP. These photographs of lensmen cavorting with unclothed and scantily clad models, including six former Playmates, were supplied by the photographers themselves.[126] In a 1960 *Camera 35* article, a panel of fifteen photographers and a psychiatrist expressed their views on the nude controversy,[127] which had been exacerbated by the 1956 publication of Sir Kenneth Clark's *The Nude: A Study in Ideal Form,* in which the eminent critic and former director of London's National Gallery claimed that any artistic nude, no matter how abstract, should be able to "arouse in the spectator some vestige of erotic feeling." If not, he argued, it is simply "bad art."[128] The few photographers

who disagreed with Clark maintained that the nude female body was simply a natural form to be used as a compositional element; the erotic should be suppressed. The majority of the photographers, however, agreed with Clark, and some of them even elaborated on his statement by stressing the important role the photographer's own subjectivity plays in the expression of this eroticism. Peter Basch, who had published seventeen books featuring his female nudes between 1956 and 1969, asserted that the "treatment" of the nude "has always revealed the personality of the artist" and that the "man who completely divests the human form of its erotic elements is neither much of an artist nor much of a *man*."[129] One of Basch's nudes had appeared in the 1955 *U.S. Camera Annual* as a two-page spread, a centerfold of sorts within a section devoted to the female nude; the introduction to the section proclaimed that this tradition had now "passed" from painters and sculptors to photographers.[130] Eroticism is clearly the desired effect here, for the reclining model is shown fully frontal, her head thrown back and her breasts thrust toward the camera (Figure 30).

Photographing the female body allowed a postwar photographer to be an artist without the effeminate connotations associated with the fine arts. Whether an amateur artist producing nudes or a commercial artist shooting fashion or pinups, the virility of the male photographer was not in question. Furthermore, by objectifying women, male photographers subjectified themselves, not only as artists but as men.

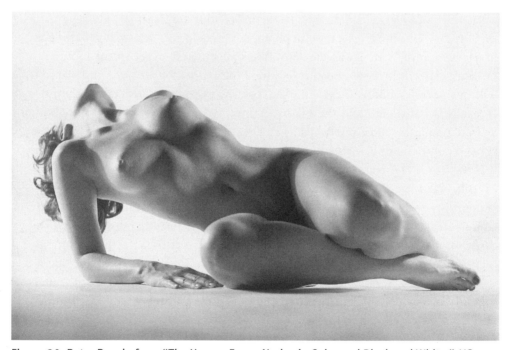

Figure 30. Peter Basch, from "The Human Form: Nudes in Color and Black and White," *US Camera Annual 1955*–ed. Tom Maloney (New York: U.S. Camera Publishing, 1954). Copyright Peter Basch.

5 | Masculine Triumph: The Male Body, the Beats, and Existentialist Modernism

> Impotence takes many forms one of them being the reckless physical expenditure of physical potency.
> *Joyce Carol Oates— 1987*

> Men's bodies are the most dangerous things on earth.
> *Margaret Atwood— 1994*

In the popular and critically acclaimed 1946 film *The Best Years of Our Lives*,[1] Navy veteran Homer Parrish, having lost both hands in battle, returns home after World War II. The character, who is played by bilateral hand amputee Harold Russell, attempts to come to terms with his physical disability and with the reactions of his family members and his fiancée, Wilma (played by Cathy O'Donnell), to the sight of two metal hooks where his hands used to be. In one of the most dramatic scenes in the film, Homer allows Wilma to help him undress for bed, and she sees his stumps for the first time. Although Homer expects Wilma to turn away in shock, she instead reacts with love and affection. They marry, and the audience is reassured that the disabled veteran can be successfully reintegrated.

The historian David A. Gerber has analyzed the way *The Best Years of Our Lives* negotiated the public's anxiety over the reintegration of the disabled veteran into society, an anxiety that actually reached a state of "alarm" because of the warnings that had begun to be generated by social workers, psychiatrists, the military, the clergy, and social scientists even before the war's end.[2] Gerber draws attention to two types of proposed ways to deal with the crisis: economic aid in the form of the GI Bill and

familial assistance, which was advocated in a proliferation of advice literature. Most such literature was aimed at women, who were advised to relinquish their wartime independence and devise strategies to force their disabled mates to reclaim the dominant position in the relationship.[3] Accordingly, *The Best Years of Our Lives* emphasizes the important role that women must play if disabled men are to be successfully reintegrated. Women must refuse to recognize the damage done to the men's bodies. They must insist that these men are still "whole," even though their bodies are not.[4]

One of the few postwar photographers to address this issue was Homer Page.[5] His "Amputee from a Place Called 'Korea'" (Figure 31) which was published in the 1953 *U.S. Camera Annual*, focuses on the anguish experienced by a young veteran who has lost his arm. Page does not soften the horror; he places the bandaged stump at the very center and front of the composition, forcing the viewer to confront the man's mutilation. Directly above is a framed photograph of a young woman, presumably his wife or sweetheart, whose smile creates an odd juxtaposition to the pose of the veteran, who leans over and hides his face in his other arm. Shame, grief, anger—a number of emotions present themselves. As the composition suggests, however, it is the woman in the picture who holds the key to what the outcome of this tragedy will be. It is through her eyes that we are invited to see him, through which he is to see himself.

The physical body as the very essence of manhood is also the theme that runs throughout the 1957 film *The Incredible Shrinking Man*.[6] Scott Carey (played by Grant Williams), while boating with his wife Louise (April Kent) a few months after exposure to an atomic cloud, notices that he is shrinking in size. Scott's anxiety over his diminishing stature is played out through his physical relationship with his wife. After he informs Louise of his condition, he asks her for a kiss, as if to prove to himself that he is still a man in her eyes. Soon, however, she no longer needs to reach up to kiss him, and eventually their physical relationship ends, signified by the slipping of his wedding ring from his shrunken finger. In anguish, he cries out that he is now a "child" who only "looks like a man," and he speaks of his "desperate need" for his wife as she retires to their marital bed without him. In fact, he has become so small that he is forced to live in a dollhouse. One day, while Louise is at work, the cat chases Scott toward the basement door, and when Louise closes the door upon her return, the draft blows him down the stairs: "The man of the house is gone."[7] Unable to find Scott, Louise assumes that the cat has eaten him. Meanwhile, in the basement, the tiny Scott is forced to battle a spider, which he eventually defeats by using a pin and a hook: "With these bits of metal I was a man again!"

Not only does *The Incredible Shrinking Man* force a direct confrontation with physical lack, it also plays on postwar anxieties about the diminishing physical presence of men in the domestic sphere, the fear that man was "disappearing" from view. Corporate men were working longer hours, and the move to the suburbs added a lengthy commute to each day. Man's traditional role as family patriarch was being undermined, and it was feared that women were becoming the undisputed "masters" of the home. This distress over the eradication of male authority in the family, added

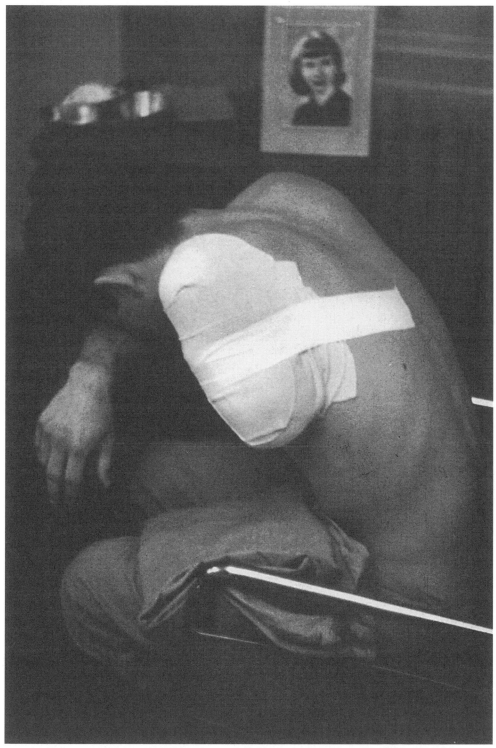

Figure 31. Homer Page, "Amputee from a Place Called 'Korea.'" From *US Camera Annual 1953*—ed. Tom Maloney (New York: U.S. Camera Publishing, 1952). Copyright Homer Page.

to the trauma from damage done to male bodies and psyches in World War II and the Korean War, contributed much to the widespread masculine crisis recognized by social scientists. The male body was an embattled body. Moreover, it was feared that the gray-flannel-suited organization man, encased in his corporate uniform, had lost access to the rugged physicality that was so much a part of idealized U.S. manhood. In fact, he had become feminized, forced to use persuasion, manipulation, even charm, rather than physical brawn, to make his place in the world. One avenue of escape from this stifling of the physical body was sports and recreation: golf, tennis, hunting, fishing, woodworking, and the like. Another was to live vicariously through the male heroes of novels, film, and television: the cowboy, the gangster, the soldier, and the private detective.

Although the media were able to maintain a continuum in the cultural representation of fictional masculine heroes, photography was able to provide visual evidence of "real" ones, proving that strong, whole, and skillful male bodies had not disappeared after all. In fact, after World War II, photographers increasingly turned to the subject of the male hero/antihero, to the cowboy, the athlete, and, with the increasing influence of the Beats, the African American male and the juvenile delinquent. Like "woman," these photographs could function as mirrors, reflecting back to men the image of themselves that they needed to see. Moreover, unlike individual women, photographic imagery could be controlled—it would not let them down.

The Active Body: Cowboys and Athletes

In times of widespread masculine crisis, men in the United States turn toward the physical body in hopes of remaking the man. In the late nineteenth century, anxiety over the increasing feminization of culture was met with a series of physical "crazes," those of competitive sports, fitness, and the outdoors. According to the historian E. Anthony Rotundo, Victorian men began to seek out "primitive masculinity," those traits deemed unique to males, which included lust, greed, selfishness, ambition, and physical assertiveness. Although these qualities had previously been viewed as "dangerous," the recovery of these "animal instincts" was now believed essential to the restoration of a rugged masculinity, one that was strong enough to reclaim the martial virtues necessary for world domination. Indeed, in his 1899 "Strenuous Life" address, Theodore Roosevelt linked individual strength with national strength and thus argued that a nation was only as strong as its men.[8] It is not surprising that the postwar United States would experience a resurgence of this ideology. Anxiety over the domestication of the U.S. male, cultural stress over the reintegration of veterans, and Cold War dependency on the projection of masculine potency on an international scale assured it.

The cowboy was the archetypal American hero, the signifier of ideal masculinity. In 1951, *Life* photographer Leonard McCombe published *The Cowboy*, with text and captions by John Bryson. This book was an expanded version of a photo essay McCombe had earlier published in *Life* magazine, which had sent him to the JA Ranch

in the Texas panhandle in search of authentic cowboys. McCombe's photographs did what movie Westerns could not; they proved that the cowboy still existed, although he was endangered: "The pictures in this book are perhaps a final honest look at a life that is disappearing and at a vanishing breed of rugged, skillful men." Bryson's text reinforces McCombe's imagery, especially in his descriptions of range boss Clarence Hailey Long's masculine physicality. We learn that Long's face is "sunburned to the color of saddle leather" with "cowpuncher's wrinkles radiating from pale blue eyes." He wears the uniform of the cowboy, a ten-gallon Stetson hat, a bandanna around his neck, a bag of Bull Durham tobacco with its yellow string dangling from his pocket, and blue denim, the "fabric of the profession," in which his "hard, sinewy 150 lbs. are encased." Like the heroes of Western films, Long is a man of few words, "a silent man, unassuming and shy to the point of bashfulness." He is also "single, lives out on the range almost all year and is master of all the crafts a cowboy must know." In fact, according to Bryson, Long is "not much unlike Texas cowboys of a century ago," who "constitute America's greatest single contribution to the romantic folklore of the world."[9]

McCombe's photographs of the cowboy coincide with this romantic notion of a heroic man on a horse,[10] despite Bryson's frequent assertion that these real-life cowboys are nothing like those of film and literary Westerns (Figure 32). In fact, as he points out, they work much harder, do not sing around the campfire, have no need to carry guns, and have no time or opportunity to romance women while out on the range. Yet in describing McCombe's photographs of Long, Bryson reminds us that the wind

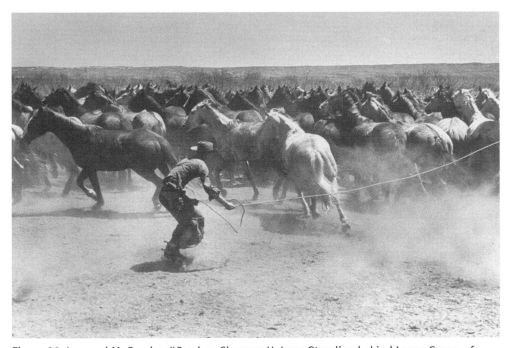

Figure 32. Leonard McCombe, "Cowboy Clarence H. Long Standing behind Large Group of Galloping Horses" (1949). Copyright Leonard McCombe/Timepix.

that threatens to blow out the cowboy's lit match is the same wind felt by Captains Meriwether Lewis and William Clark as they journeyed across the prairie, and that "the cowboy himself might be Owen Wister's Virginian, relentlessly pursuing Trampas." Indeed, McCombe's photographs invoke nostalgia, the longing for a preindustrial, precorporate era of which the Western myth was, and still is, the foremost signifier.[11] In the photographs, no trace of modern civilization is evident; only virgin land unfolds behind the cowboy, the master of this untouched prairie. No clock, no commuter train, no gray flannel suit, no domineering wife—he is "self-reliant" and "free."[12]

In his commentary on the postwar proliferation of Western films, Marshall McLuhan explains the appeal of the cowboy myth to U.S. men, who were struggling to come to terms with rapid societal and technological change:

> Men flounder in such times. The male role in society, always abstract, tenuous, and precarious compared with the biological assurance of the female, becomes obscured. Man the provider, man the codifier of laws and ritual, loses his confidence. For millions of such men horse opera presents a reassuringly simple and nondomestic world in which there are no economic problems.[13]

To fantasize about life in the West is thus to escape to an all-male realm, free from the burdens of familial and corporate responsibility, one in which conflicts are settled with physicality rather than intellect, where being a man is a matter of the body rather than the mind.

According to Lee Clark Mitchell, a "preoccupation with the problem of manhood" is the "one constant" that unites the entire Western genre. Geography plays a crucial role in resolving this "problem":

> The one aspect of the landscape celebrated consistently in the Western is the opportunity for renewal, for self-transformation, for release from constraints associated with an urbanized East. Whatever else the West may be, in whatever form it is represented, it always signals freedom to achieve some truer state of humanity.[14]

In his analysis of the Western hero, the postwar critic Robert Warshow observed that this sense of a suffocating East is represented by women: "In the American mind, refinement, virtue, civilization, Christianity itself, are seen as feminine." But "the West," he added, which lacks the "graces of civilization, is the place 'where men are men.'"[15] In the Western genre, then, an artificial, constrained feminine civilization is left behind in favor of an authentic, unrestrained masculine nature. This return to physicality functions to essentialize masculinity, to get at its primitive core and thus strengthen it, to shore it up against looming emasculating forces. Thus, we see a reversal of the gendering of the mind-body duality so central to Enlightenment thought, or perhaps a refusal or inability to maintain the artificial split upon which patriarchal capitalism is based. Yet such a reversal carries with it much risk, especially for photography, for within its conventions, to objectify the body is to feminize it. Consequently, the male body must be inscribed within ritual frameworks of masculine-coded violence, such as war, sports, crime, gunfighting, and cattle roping.

Another option is to render it through the aesthetic of violence: blur, shadow, and graininess. This emphasis on violence and action, whether exhibited by the subjects photographed or inscribed formally into the image by the photographer, fights the fetishization of the male body, refuses to let it be "fixed."[16] Although the cowboy can be photographed in an immobile state, this inactivity signals composure and self-restraint rather than passivity; the cowboy is a silent hero, "a figure of repose," as Warshow put it.[17] Moreover, his aesthetic is somewhat of an anti-aesthetic; his visual appeal lies in his rugged, disheveled, even soiled, appearance, a physical self-fashioning that aims for the opposite of what is culturally marked as feminine.

Somewhat riskier in terms of masculine physical "types" is the athlete, for within the realm of sports, chances to contemplate the male body aesthetically, often in a partially unclothed state, are much greater. Moreover, the emphasis on physical display is most obvious with the athlete, who obsessively constructs and reconstructs his body. In fact, no photograph of the male body was considered more "feminine" than that of the postwar "muscleman," for whom visual display was the actual goal.[18] In the 1950s, as physique-photography magazines and manuals proliferated, so did government attempts to censor them. As the art historian William Stern has pointed out, unlike photographs of the female body, photographs of the male body, even those invested with the aura of the artistic nude, were not able to evade obscenity laws.[19] In the homophobic fifties, such overt displays of masculine beauty could not be targeted exclusively at male spectators, unless, of course, this display could be disguised beneath the banner of competitive sports, in which the male body is active rather than passive and where the male-on-male gaze is deemed legitimate.[20]

The decade of the 1950s was the decade of the sports photograph, just as it was the decade of the Playmate. In fact, Henry Luce's *Sports Illustrated* "burst out of the starting gate in August 1954," just a few months after Hugh Hefner had launched *Playboy.* Like Hefner's baby, Luce's "colt" was a runaway success, doubling its initial circulation of 450,000 by 1960.[21] With *Sports Illustrated*, Luce was taking quite a gamble, for at the time of its debut sports magazines were considered "pulp" and were read primarily by teenage boys and working-class men. In fact, spectator sports were considered a blue-collar affair, and interest in them was predominantly regional. Despite repeated warnings that a weekly magazine with a national focus would never gain a sufficient readership or enough advertisers to survive, Luce went ahead with the proposition. Aided by the recent invention of color television, which brought a larger audience to sports, and the first modern jet flights, which enabled nationwide leagues to form, *Sports Illustrated* not only survived but thrived, and in the process, it helped turn spectator sports into a middle-class obsession. Although it was initially conceived as a "class" magazine covering such "martini-set" sports as yachting and tennis, it increasingly privileged the "beer and pretzel" sports of baseball, football, and boxing.[22]

Like *Life, Sports Illustrated* was a picture magazine. Photographs were primary, text secondary, as its founders acknowledged: "Sport, in all its endless variety, is always something to be seen. It is magic to the eye. It lingers in the life-long treasury

of vision."[23] Moreover, the magazine's success depended on offering a different type
of sports picture, one that could not be seen in other venues. Therefore, its editors de-
cided to feature as many color photographs as possible and to focus on the drama of
a particular sport through images that captured its "essence," instead of the custom-
ary "point pictures" of the decisive moment in the outcome of an event. For example,
whereas a newspaper would publish a shot of a winning runner crossing the finish
line, *Sports Illustrated* would run shots of his determined face, his tense leg muscles,
and the strained neck of an opponent trying to overtake him during the course of
the race. Such images stress physical performance and competition, the male body
pushed to the extreme. As associate editor Norton Wood explained, the magazine
"embraced the fairly novel idea of using color pictures for the sake of the pictures
themselves—not to prove points or to embellish a writer's words, but to please the
eye and stir the emotion of the viewer who lingers upon the page." Their photogra-
phers were not to worry about details; rather, they were "to shoot for atmosphere and
mood, for the essential *feeling* of an event or for a particular human experience."[24]

Although press photographers had been covering sports for years, it was not until
the postwar era that sports photography became a recognized specialty, a field that
demanded special skill with color film and the 35-mm camera, as well as an "expert's
grasp" of sports.[25] Because *Sports Illustrated* employed only a few full-time staff pho-
tographers, it relied heavily on freelancers. Would-be sports photographers, whether
aspiring to professional status or interested in amateur shots, could turn to pho-
tography journals for advice on techniques and equipment.[26] These how-to articles
stressed the importance of getting into the action, even though it could be danger-
ous. In fact, the rhetoric of sports photography bears a striking similarity to that of
combat photography and press photography in general. Competition and risk are its
defining elements; consequently, the ideal practitioner must be tough, aggressive, and
daring. Hy Peskin, *Sports Illustrator* staff photographer and "the top daredevil of the
business," was famous for his dramatic, low-angle, head-on, close-up shots. In such
venues as ski runs, racetracks, and rodeo rings, he thrust his body as close as pos-
sible to the action, a feat that required him to put on his own "displays of athletic
prowess."[27] In describing his working philosophy, Peskin even took on the persona of
the athlete: "What counts most in sports photography, just like in a game, is the sheer
will to win, the drive to try to outrun, outlast, outfight the next guy."[28]

This personal identification with the athlete also extended to the viewers of these
photographs, for not only were the images composed in such a way as to force em-
pathetic engagement, but they fed into male narcissism by providing a steady supply
of ego ideals. Indeed, *Sports Illustrated* strengthened and extended the androcentric
bond enabled by sports by making sports national in scope. Men all over the country
eagerly awaited each week's issue, pored over the same images, the same heroes. As
the sociologist R. W. Connell argues, in Western countries, "images of ideal mascu-
linity are constructed and promoted most systematically through competitive sport,"
which enables the "social definition of men as holders of power" to be translated "into
muscle tensions, posture, the feel and texture of the body." Through sports, masculine

"power" becomes "naturalized."[29] Repeatedly and ritualistically, gender identity is inscribed upon the male body through sports, especially football and boxing, which are heavily predicated on violence and which were, in the 1950s, still exclusively male. In his discussion of the importance of football to U.S. masculinity, James McBride argues that such ritualistic social performances function to repeatedly prove—to men—that men are still men, not women. Thus, athletic competitions are somewhat analogous to war. Indeed, the successful athlete requires many of the same characteristics upon which warrior masculinity is constructed: courage, stamina, discipline, and physical strength. The athlete even protects himself with a coat of armor, which is achieved through the donning of athletic gear or through the hardening of his own flesh. Like the soldier, he also engages in a struggle for dominance in which he seeks to emasculate his opponent and, in the process, masculinize himself.[30]

Nowhere in the postwar United States was this ritual so highly publicized and so elaborately played out as in boxing. A boxing match was not only a contest; it was a national event. Not surprisingly, the first issue of *Sports Illustrated* chose the Ezzard Charles–Rocky Marciano fight as the subject of "Spectacle," its regular four-page section featuring color photographs. Even before the founding of *Sports Illustrated*, however, boxing had been considered a prime assignment for a press photographer. Not only did the sport enjoy a huge national following, but it carried the most potential for dramatic shots of the male body in action.

In his discussion of the Western, Mitchell argues that it is the male body that is at the center of the genre's preoccupation with "making the man." He writes:

> The frequency with which the body is celebrated, then physically punished, only to convalesce, suggests something of the paradox involved in making true men out of biological men, taking their male bodies and distorting them beyond any apparent power of self-control, so that in the course of recuperating, an achieved masculinity that is at once physical and based on performance can be achieved.[31]

Like the Western hero, I would argue, the boxer must be ritually emasculated, so that he can rise again, whether in this match or the next. This rebirth functions as a symbolic negation of the male's origins in the maternal and simultaneously signals his achievement of the pinnacle of masculine success, for not only has he given birth to himself as a man, but, like the combat hero, he was willing to risk his own life. In fact, in the early days of sports photography, the two most frequently published boxing shots were the facial punch and the knockout. Both are combined in Herb Scharfman's 1952 photograph of Rocky Marciano driving his right glove into the jaw of champion Joe Walcott, the punch that would take him down and give Marciano the title eleven seconds later (Figure 33). As is typical of facial-punch photographs, viewers are invited to linger over the brutal crushing of a boxer's facial features, the swelling of the eyes, the bruising of the skin, and the pushing of facial features out of position. Further underscoring the force with which Walcott's face is impacted is the spray of water and perspiration that encircles his head and the straining leg and arm muscles of Marciano, who seems to come at Walcott with every iota of his strength.

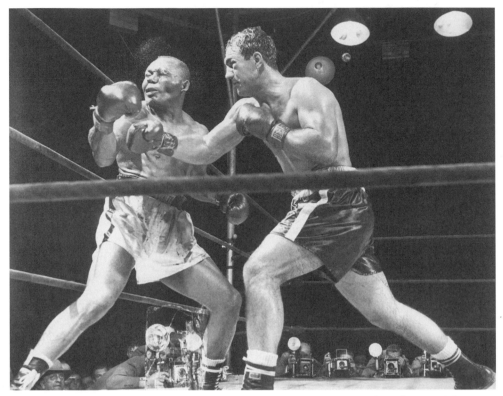

Figure 33. Herb Scharfman, "Rocky Marciano Drives Right to Walcott" (1952). Copyright Bettman/CORBIS.

Another factor that boxing has in common with both the Western genre and the military is that it enables men to gaze legitimately upon the bodies of other men. As Gerald Astor, *Sports Illustrated*'s picture editor, proclaimed, sport is, at its core, about "visible physical action,"[32] and the boxer, more than any other athlete, displays "elemental virility," unadulterated physicality.[33] The writer Joyce Carol Oates maintains that "a boxer is his body," and his "masculinity is his use of his body," or more specifically, the attempt to "triumph over another's use of his body."[34] Boxing is an exhibitionist enterprise, one in which beautifully constructed male bodies are put on public display and then beaten. Although this visual destruction of the male body can be read as masochism, as a self-imposed punishment for allowing homoerotic desire to surface,[35] it also serves as a visual dramatization of the ideology of a self-made manhood achieved through competition, violence, and pain. Moreover, the construction of hard, large muscles reinforces the phallus as the supreme emblem of power without necessitating focus on the penis, which not only fails to remain hard but carries too great a homoerotic charge. Boxing is, as writer Gerald Early puts it, "antihomosexual theater," a sport that appeals to the latent homosexuality of the "normal," heterosexual, virile male, for it entails an eroticism that denies it is erotic, that announces the chastity of its innocence by insisting on the purity and danger of the contest.[36]

The importance of a boxer's visual appeal is evident in a 1949 *Modern Photography* article detailing Leonard McCombe's *Life* magazine assignment to cover the prize-fighter Vince Foster. According to the article's author, *Life* had spent three months searching for the perfect subject for the piece. Their primary requirement was that he be "photogenic." When two editors spotted Foster, "a young half-breed Indian welter-weight," on television, they were "impressed with his skill and ferocity" and with the fact that he "photographed extremely well." When they researched him further, they discovered that he had another asset: "He was from a poor family, and he had been fighting all of his life."[37] Thus, it is not only self-made physical manhood that is important in boxing but the achievement of economic success, another important marker of masculine status. To rise from poverty to riches through sheer physical might and determination, with the added bonus of overcoming racial barriers, is an irresistible Horatio Alger story.

Boxing also functions to essentialize and thus strengthen masculinity by strip-ping it of its historical and social contexts, by insisting upon its primitive core. Oates writes: "Men fighting one another with only their fists and their cunning are all contemporaries, all brothers, belonging to no historical time. The crowd, borne along with them, belongs to no historical time."[38] The type of photography promoted by *Sports Illustrated* contributed to this universalization of masculinity by distilling sport down to its "essence." It was no longer the details of a particular event that were important; it was the drama of physical competition—the contest between men for supremacy—that commanded center stage.

This sense of masculinity as a universal essence, one that knows no barriers of race, class, or time, also plays an important role in the photography of Robert Frank, perhaps the single most influential photographer to come out of the postwar era, and Bruce Davidson, who like Frank, would become associated with the philosophy of the Beat writers and their emphasis on rebellious masculinity. Although the 1950s saw intense racial conflict—the birth of the civil rights movement and the violent back-lash against it—certain voices among the cultural and intellectual Left began to look to the African American male as the source for a renewed national virility. They also turned to the juvenile delinquent, widely considered a major threat to mainstream middle-class mores, as a symbol of masculine autonomy in the face of a homogeniz-ing corporate-suburban culture.

Robert Frank: The Rebel and the Road

In 1955 and 1956, the Swiss-born photographer Robert Frank traveled throughout the United States supported by a John Simon Guggenheim Memorial Fellowship. In his grant application, Frank had stated that he wanted to capture a "picture record of things American, past and present," and thus compile "a visual study of a civiliza-tion."[39] A selection of these photographs was originally published in 1958 in France as *Les Américains* and was published a year later in the United States as *The Americans*.[40] This photographic book was to make Robert Frank *the* postwar photographer within

the subsequent narrative of the medium's history. Although *The Americans* received its original notoriety because of negative critical reviews, the book is now acknowledged as a "masterpiece," the most important influence on the next generation of U.S. photographers. Indeed, Frank's photographs brought together many of the postwar currents that I have previously discussed: a gritty anti-aesthetic of blurred shots and erratic framing, a growing emphasis on the photographer's own subjective response to realistic subject matter, the sense of photography as a bodily practice in which the photographer journeys through space in search of truth, and attention to the aesthetics of the male body as inscribed within legitimate frameworks of looking.

Frank had first come to the United States in 1947 and was soon hired by Alexey Brodovitch to take photographs for *Harper's Bazaar* and its subsidiary, *Junior Bazaar*. Over the next six years, he traveled to South America and several times to Europe while making a living in the fashion field, even though his aspiration was to become a freelancer and sell his work to such publications as *Life* magazine.[41] In this endeavor, he did achieve some success; his photographs appeared occasionally in such periodicals as *Life, Look, McCall's, Vogue,* and *Fortune.* He also managed to achieve some institutional recognition. His work was published in *Camera, Popular Photography, Infinity, Modern Photography,* and *U.S. Camera* and its annuals, and it also appeared in a number of Museum of Modern Art exhibitions, including the 1955 *The Family of Man.*[42] In fact, Frank had served as Edward Steichen's translator when the photography department director traveled to Europe to promote the exhibition. In turn, Steichen wrote a recommendation on Frank's behalf to accompany his application for the fellowship that would result in the photographs for *The Americans,*[43] as did the renowned documentary photographer Walker Evans, who also served as a mentor for Frank during this time. In fact, it was Evans who inspired Frank to move toward a more personal vision and to reject the possible co-optation of this vision by others, especially those connected to the commercial realm.[44] It was also Evans, who in introducing a portfolio of Frank's Guggenheim photographs in the 1958 *U.S. Camera Annual,* first heralded the coming of modernism's messiah: "Assuredly the gods who sent Robert Frank, so heavily armed, across the United States did so with a certain smile."[45]

I will return to this image of Frank as an "armed" man, but first I want to address Frank's role as modernist rebel. As I discussed in chapter 1, the circle of photographers associated with the journal *Aperture,* especially Ansel Adams and Minor White, had been waiting for the moment when they could wrest photography away from the dominating forces of photojournalism and from Steichen at the Museum of Modern Art. By the late 1950s, the time was ripe. Not only was television eroding the supremacy of photography as the medium of "unmediated truth," but the cultural hegemony of the McCarthy era was giving way to countercultural forces, including the youth rebellion, which found expression in popular music, films, and the Beat movement. Although the photographs in *The Americans* were shot before Frank met the Beat writer Jack Kerouac, their subject matter and aesthetic meshed so easily with Beat philosophy that Kerouac readily agreed to write the introduction for the

English-language version of Frank's book. In that introduction, Kerouac likened the photographs to poetry, perhaps the most important genre to the Beats, claiming that Frank had "sucked a sad poem right out of America onto film, taking rank among the tragic poets of the world."[46] The connection between the Beats and *The Americans* was thus firmly established, an association that would solidify the reading of Frank as a countercultural hero and thus give the modernists what they had been seeking— a subjective mode that would resist the charges of effeminacy associated with the aesthetics of the fine print and that could not be dismissed as self-indulgent and thus culturally irrelevant. Indeed, Frank's engagement with realistic subject matter linked him to both photojournalism and social-documentary photography, but his anti-aesthetic and his insistence on a personal stance, one not shaped by the demands of editors or the ideology of organized political movements,[47] drew widespread attention to this new form of modernism, an existentialist mode that was already evident in the work of other photographers, most notably William Klein.[48]

Following Frank's portfolio in the 1958 *U.S. Camera Annual* is a short statement by the photographer himself that has functioned as a sort of manifesto, at least in terms of how *The Americans* has been received. Frank begins by thanking the Guggenheim Foundation for allowing him to "work freely." He then defends himself against accusations that he distorts his subject matter by admitting that his "view is personal" and that this subjective response, even though critical, "can come out of love." In keeping with the Beat emulation of jazz music, Frank goes on to assert his spontaneity and preference for improvisation, claiming that his "photographs are not planned or composed in advance." Above all, however, he declares his artistic independence:

> It is a different state of affairs for me to be working on assignment for a magazine. It suggests to me the feeling of a hack writer or a commercial illustrator. Since I sense that my ideas, my mind and my eye are not creating the picture but that the editors' minds and eyes will finally determine which of my pictures will be reproduced to suit the magazines' purposes.
>
> I have a genuine distrust and "mefiance" towards all group activities. Mass production of uninspired photo journalism and photography without thought becomes anonymous merchandise. The air becomes infect *[sic]* with the "smell" of photography. If the photographer wants to be an artist, his thoughts cannot be developed overnight at the corner drug store.[49]

I have quoted at length from Frank's statement because I believe this passage to be the cornerstone upon which his rebellious persona rests. Of course, it is also in keeping with what Adams and White had been asserting about artistic integrity since the late 1940s. What is unique, however, is that this statement was made by a freelancer who had depended upon magazine editors and advertising executives for an income for almost a decade. Moreover, Frank's statement further claimed that it was Walker Evans and the British photographer Bill Brandt who had been the greatest influences on his work, with no mention of Steichen. That claim could be construed as another

rejection of commercial work and, in particular, a betrayal of Steichen's cause, especially considering that Evans, in his essay, had written that Frank's photographs were a "far cry from all the woolly, successful 'photo-sentiments' about human familyhood,"[50] an obvious stab at The Family of Man, which ironically had included seven photographs by Frank, including two of his pregnant wife, Mary, and one of a Spanish mother and baby, as well as a photograph of Robert and Mary Frank as young lovers, taken by Louis Faurer.

Lili Corbus Bezner argues that Frank's "rebellion" against Steichen—his friend, mentor, and even father figure—was a necessary step in his "shift toward a more private, insistently personal voice in photography."[51] Indeed, Frank's close relationship with Evans, Steichen's long-time nemesis, clearly removed Frank from the realm of photojournalism and middle-class "taste," yet it also moved him closer to the 1930s documentary style of the FSA, for which Evans had taken photographs. In his review of the 1958 *U.S. Camera Annual*, Minor White wrote admiringly of Frank's portfolio, noting the return of the "objectivity" associated with FSA documentary.[52] White is clearly comparing this mode favorably to that associated with the disbanded Photo League, which his circle saw as contaminated with socialist ideology. White is undoubtedly also referring to Evans, who was known for his independence of mind and his modernist sensibility, traits that had enabled White and Adams to accept Evans as a kindred spirit.

Frank's rebellious act—the rejection of his "father"—was the first step in the trajectory that would eventually earn him antihero status. The second step was gaining the wrath of the critics. *The Americans* was a controversial book, primarily because it was viewed as an attack on the nation's citizens by a foreigner who privileged his own viewpoint over any attempt to present an accurate portrait of the United States in its entirety, which most critics believed the title promised. In fact, even White, who had praised the smaller portfolio, reacted vehemently against the French version of the book, asking whether Frank's "disgust" is "so great that he is willing to let his pictures be used to spread hatred among nations?"[53] In response to the English-language version, the seven editors of *Popular Photography* each published an individual statement. Although there is some positive acknowledgment of the sensitivity, even beauty, evident in individual photographs, the overwhelming response is anger at Frank's audacity. Les Barry speaks of his "warped objectivity." Bruce Downes calls him a "joyless man" and a "liar." Arthur Goldsmith labels him a man of "spite, bitterness, and narrow prejudices," an attitude Goldsmith connects to Kerouac and the Beats. James M. Zanutto also compares Frank to the Beats, noting that he exhibits "the same studious inattention to the skills of craft, the same desire to shock and provide cheap thrills." Indeed, both Goldsmith and Zanutto characterize Frank's aesthetic as a Beat one, Goldsmith noting his "meaningless blur, grain, muddy exposure, drunken horizons, and general sloppiness," and Zanutto closing the collective essay with the observation: "If you dig out-of-focus pictures, intense and unnecessary grain, converging verticals, a total absence of normal composition, and a relaxed snapshot quality, then Robert Frank is for you."[54]

The characterization of Frank's view as distinctly "Beat" was noted by other crit-
ics as well. In "Art: Beatniks and Beaux," Frank Getlein writes that Frank displays
"neither pity nor anger, only an adolescent disgust with the surfaces of life among the
lower and upper middle bourgeoisie."[55] William Hogan dismisses Frank's "neurotic"
and "dishonest" viewpoint as merely "a beat interpretation,"[56] and in her scathing
review for *Modern Photography*, Patricia Caulfield writes that you can only "dig
this book" if "you are an enthusiast of Kerouac, of Ginsberg, or of the beat outlook
in general."[57] This vein of critical response, of course, added to Frank's rebellious
image by aligning him even more emphatically with the counterculture. Even though
he was in his midthirties, Frank was positioned securely on the youth side of the
generational conflict, a conflict that the mainstream media helped propagate by
creating the stereotypical "beatnik" and opposing Hip to Square. As *Life* magazine
warned its readership in 1959, the Beats were engaged in a "War against the Squares,"
a war against "Mom, Dad, Politics, Marriage, the Savings Bank, Organized Religion,
Literary Elegance, Law, the Ivy League Suit and Higher Education, to say nothing of
the Automatic Dishwasher, the Cellophane-wrapped Soda Cracker, the Split-Level
House and the clean, or peace-provoking H-bomb."[58] It was Frank's outsider atti-
tude that contemporary critics of *The Americans* responded to with distaste, and it is
admiration for that attitude that has preoccupied critics and historians ever since.[59]
Indeed, the subsequent valorization of Frank as a rebellious hero who exposed the
"truth" has gone virtually unchallenged. Almost all critics and historians who have
written about *The Americans* connect Frank's photographs to Beat philosophy, and
it is invariably the critique of mainstream consumer culture and its loss of spiritual
values that they emphasize. I have no intention of challenging this interpretation.
Instead, I want to explore just what *else* it is about Frank that has so fascinated, and
continues to fascinate, so many critics and historians and to draw attention to the
subject of the male body, a recurring motif in *The Americans* that has either gone un-
noticed or been repressed.

 I have often wondered what place Frank would hold in the history of photography
if he had never gone "on the road," for to me, the unvoiced subtext in the numerous
celebratory essays on Frank's *The Americans* is a fascination with the journey, the
narrative of the book's creation. Indeed, I would argue that it is Frank's unseen, un-
spoken body that is the real object of this enduring romance. The images themselves,
if taken out of the context of this western sojourn, would not carry as much impact,
regardless of their perceived quality. For certainly there were other "good" photo-
graphs similar in subject matter and aesthetic taken by such photographers as Klein,
DeCarava, and Faurer.[60] Yet none of these men undertook such a highly publicized
and, in the popular imagination, almost mythic quest. Frank's travels across the
western landscape—Texas, New Mexico, Arizona, Nevada, Utah, Idaho, Montana,
and California—resonated, and still resonate, with the aura of escape, the freedom of
the open road, as celebrated in Kerouac's novel *On the Road*, the unofficial handbook
of the Beat Generation.[61] In the novel, the heroes Dean Moriarty and Sal Paradise
repeatedly take to the road in search of rapturous experience and to flee confinement

by the law, the workplace, women, and children. Frank places himself on that road in his photograph "U.S. 91, Leaving Blackfoot, Idaho." The extreme close-up shot of two men in the front seat of a moving car testifies to Frank's physical presence. In this case, he is not a voyeur or indifferent observer but a companion on their journey. In his introduction to *The Americans,* Kerouac wrote:

> Robert picks up two hitch hikers and lets them drive the car, at night, and people look at their two faces looking grimly onward into the night ("Visionary Indian angels who *were* visionary Indian angels" says Allen Ginsberg) and people say "Ooo how mean they look" but all they want to do is arrow on down that road and get back to the sack—Robert's here to tell us so.[62]

Indeed, these stern young men in denim jackets do appear menacing, but of course, as Kerouac reminds us, that is only how they look to mainstream eyes. They simply want to sleep, to attend to their basic needs. Frank was himself arrested twice during his photographic journey, first in Detroit for having two sets of license plates and again in a small Arkansas town, where he was held by the state police, who suspected him of being a Communist or a foreign spy.[63] These arrests have contributed to the romanticization of Frank and to the attributing to him of outsider status.

Like the Beats, Frank was attracted to outsider subjects: males who had been neither subsumed within the gray-flannel-suited uniformity of the corporate sphere nor domesticated by women. In fact, the most sympathetically portrayed subjects in *The Americans* are those who do not fit the stereotype of white middle-class conformity. Much of this alternative imagery, I would argue, worked to sustain belief in an active model of masculinity at a time when the ideological pressure on men was to serve as breadwinner and loyal company employee. Whereas official postwar culture reinforced this familial and corporate ideal, others denounced it as emasculating, an assault on the traditional notion of the autonomous male in the United States, as signified by the archetype of the cowboy. Indeed, an undercurrent of aggression and outright defiance permeates Frank's photographs of African American men, motorcycle gang members, and outlaws.

Postwar attacks on conformity were launched by writers, sociologists, and psychologists, and many of them were infused with Cold War anxiety over collectivization, the fear that Americans could slip into a state resembling the "mass man" of Soviet communism. David Riesman warned that the "new" middle class was becoming increasingly "other-directed," relying on larger social groups for guidance and approval, rather than inner-directed, as had been typical of the "old" middle class.[64] The pressure to conform at the expense of one's individuality was also the theme of William H. Whyte Jr.'s *Organization Man* and Robert Lindner's *Must You Conform?*[65] Whyte chastised corporations for encouraging team play over individual initiative, for he believed team play made U.S. men too soft, no longer rugged competitors, and Lindner claimed that the push toward conformity could damage individual egos because man is by nature a rebel who cannot conform. Therefore, if men did

not find positive avenues for rebellion, they risked becoming psychopaths, threats to civilization.

Of course, as discussed in earlier chapters, others placed the blame for masculine "weakness" on women. Philip Wylie claimed that "destroying" mothers held their sons "captive," demanding their worship and fidelity and, above all, their money. Indeed, he declared that the U.S. male had become merely the "attachment of the female," spending 80 percent of his time supplying the parasitic women in his life with material goods.[66] Edward Strecker continued Wylie's protest, accusing mothers of producing unmanly sons and of creating daughters who refused to occupy the subordinate roles assigned them, a rebellion that threatened to strip men of their rightful positions of authority within society.[67] Unlike the critique of corporate culture, this strain of protest was complicit with dominant ideologies, those that sought to keep women in their "place," to contain them within the home.

In terms of literary and cultural expression, the Beat movement most epitomizes postwar male rebellion against the emasculating threat of *both* workplace and women. In the introduction to their 1958 anthology *The Beat Generation and the Angry Young Men,* Gene Feldman and Max Gartenberg argue that "to create a new reality, one in which vivid experience is everything," the Beats were "stepping out of the competitive arena which custom has marked as the proving ground of manhood" and back "into the marginal existence of the adolescent." Work and marriage were thus deemed irrelevant, traps with no "substance."[68] According to Barbara Ehrenreich, however, this rejection of work and marriage was not the "nihilistic withdrawal from all human attachments" that these men claimed it was, for the "Beat pioneers were deeply, if intermittently, attached to each other." Within this homosocial realm, demands by women that these men act responsibly toward them and the children they fathered were considered "at worst, irritating and more often just uninteresting."[69] As Kerouac proclaimed in his 1959 article for *Playboy,* the "core" of the Beat generation was "a swinging group of new American men intent on joy."[70] Of course, this joy included sexual liaisons with equally disaffected young women who had no other means of rebellion but to attach themselves to Beat men, for whom they "existed" only to provide "sexual satisfaction."[71] Not surprisingly, in the issue directly following the one in which Kerouac's article appeared, *Playboy* chose the "beatnik" Yvette Vickers as its Playmate of the Month.[72]

In *The Americans,* one rarely finds either the distinctive gray-flannel-suited executive or the happy suburban father, the official postwar masculine figures who dominated advertising imagery and television situation comedies. When they do appear, they are there to be undermined, exposed as hypocrites, or stripped of their stature or even their humanity. In "Bank—Houston, Texas," prominence is given to four empty leather chairs rather than to the only human being visible, a banker who sits at his desk in the upper right-hand corner of the composition. The zigzag pattern created by the chairs lends a sense of anxiety to the scene, for the eye is led from the out-of-focus desktop that fills the bottom third of the photograph through

the staggered chairs to the banker, who impassively talks on the phone and writes, his bald head out of focus, a pasty white mass. Like a minefield, the chairs block access to the person who holds the key to granting a loan, a powerful man made small and insubstantial through the lens of Frank's camera.

Other male figures loom large. In "Rodeo—New York City," a man dressed in cowboy garb fills the picture plane from top to bottom. Frank photographs him head-on as he leans nonchalantly against a sidewalk trash basket and bows his head in the act of rolling a cigarette. Thus, it is not his face that we are encouraged to explore but his long, lean body, which is outfitted in tight-fitting plaid shirt and blue jeans, Western belt, and cowboy boots. In fact, an implied line leads the eye directly from the cowboy hat through the cigarette, the row of shirt buttons, the fly zipper, and the line separating his legs, which culminates in the pointed boots that cover his crossed feet. The sleekness of this line is further enhanced by the straight edge of the curb, which functions to delineate the left side of his body. The emphasis here is clearly on physical display. Even a man in the background looks, or perhaps catches Frank looking, at this well-fashioned reminder of the masculine hero who had come to signify the independent spirit upon which the nation was built but who is now relegated to rodeo performances for urban audiences. Frank refers to this irony by juxtaposing the cowboy with the brand name "DODGE," which is emblazoned on the back of the truck parked farther down the street.

Another photograph that places the modern cowboy at center stage is "Bar—Gallup, New Mexico," which, more than any other image in the book, exemplifies the masculinization of subject matter, aesthetic, and photographic practice that I have been tracing throughout this book. The space depicted is clearly a masculine one. Not only is it filled with working-class men in cowboy hats and blue jeans, but there is a strong undercurrent of violence, even danger, in this confrontational scene, one reminiscent of barroom showdowns in Western movies. Indeed, the only figure who is fully shown stands with hands in his pockets, glaring across the room in the direction of Frank, who appears to be hiding behind two other people and secretly shooting the picture with his small 35-mm camera at hip level, as suggested by the skewed framing, low camera angle, and absence of flash. The only illumination comes from an overhead florescent lamp, which lends a harsh and eerie light to this otherwise dark interior. Not only has Frank given visual expression to the physical vitality that still animates these Western outlaws, he has broken photography's rules, thus becoming, in effect, photography's own rebellious son. Like a gunfighter in a shoot-out, he "shoots from the hip," producing this poorly lit, grainy image, framed seemingly by chance. It could never be classified as pictorialist, nor even modern-ist in the classical sense, for not only does it ignore recognized aesthetic standards, but there is no emphasis on the fine print and no sense of transcendence, for Frank's body is ever present. On the other hand, it lacks the objectivity characteristic of photojournalism and the link to an organized political movement that was consid-ered essential to social-documentary photography. It is a hybrid, one that retains the masculine characteristics of both photojournalism and modernism—gritty realism

and individual artistic expression—but that lacks their feminine connotations; there is no personal compromise in an attempt to please editors and no adherence to elevated subject matter and technical proficiency. Moreover, Frank's personal politics lends his work the cultural relevancy associated with social-documentary, yet without its "sentimentality." Like William Klein's *Life Is Good and Good for You in New York*, *The Americans* is an existentialist project, an exemplar of postwar street photography, but unlike Klein's book, it resonates with the masculine rebellion associated with the Beats and thus grants its creator the same outsider status.

Besides the cowboy, another masculine type that Frank romantically portrays is the motorcycle gang member. In "Newburgh, New York," a young white man in black leather jacket, blue jeans, and sunglasses sits on a motorcycle that points directly away from the camera, yet he turns his head around to confront the photographer. This man is flanked by two standing companions, one black and one white, who are costumed in similar dress and whose motorcycles await them in the background. A virile sexuality pervades this image, expressed not only in the strong bodies of the men and the penetrating gaze and open legs of the strikingly handsome man on the motorcycle, but in the sensuousness with which light gleams off the metal studs on their clothing, the chrome on their bikes, and the leather of their decorated jackets. In the minds of the public, the association between the Beats and motorcycle gangs already carried a sexual charge, for the nationally publicized obscenity trial over Allen Ginsberg's 1955 poem *Howl* had centered on a passage in which the poet writes that the "best minds" of his generation had "let themselves be fucked in the ass by saintly motorcyclists and screamed with joy."[73]

Motorcycle gangs signified the type of youthful revolt most feared by mainstream society, a rebellion with no identifiable motive beyond rebellion itself. As the gang member played by Marlon Brando in the 1954 film *The Wild One* responded when asked what he was rebelling against: "What've you got?" In this controversial film, a motorcycle gang terrorizes a small town for no apparent reason and is never brought to justice.[74] This same defiant spirit is, of course, what made motorcycle gangs so attractive to the Beats. They were open-road adventurers who rejected the trappings of work and family in favor of a life of crime, violence, and male camaraderie—autonomous except for their devotion to each other. This strong masculine bond even transcended racial boundaries.

According to Leerom Medovoi, cross-racial masculine identification was an important component in the formation of an oppositional youth culture in the 1950s. He argues that school desegregation, set in motion by *Brown v. Board of Education* (347 US 483), the 1954 U.S. Supreme Court decision declaring segregation unconstitutional, engendered the fear among white middle-class Americans that social stability was beginning to collapse. The emerging counterculture was able to feed off this fear by embracing the notion of racial integration and combining it with that other disruptive force that so preoccupied postwar society: the juvenile delinquent. Consequently, oppositional discourse centered on the "bad boy," a motif that found its most potent expression in the image of the interracial gang.[75] Medovoi goes on to argue that a

"collectivity of bad boys," including Holden Caulfield in J. D. Salinger's *Catcher in the Rye* (1951), Jim Stark in the film *Rebel without a Cause* (1955), and the gang members in the film *The Blackboard Jungle* (1955), eventually became the "dominant representation of American youth," and that "by valorizing youth as the only site of rebellion in an otherwise suspiciously conformist society," this collectivity "offered an opportunity for cultural empowerment to young people willing to identify with it." By 1957, he notes, this representation had become identified in the public mind as the Beat Generation.[76]

The Beat writers also capitalized on the anxiety and fear that the prospect of racial integration and increasing juvenile delinquency aroused. In his 1957 essay "The White Negro: Superficial Reflections on the Hipster," Norman Mailer, a self-proclaimed "near-beat adventurer," declared the hero of the Beat Generation to be the "hipster," an "American existentialist" composed of a "ménage-à-trois": the bohemian, the Negro, and the juvenile delinquent.[77] To Mailer, the hipster is a psychopath, but rather than fearing him as a threat, Mailer exalts him as a redeemer, the hope for a new personality type predicated on personal liberation, one who acts freely on his instinctual impulses, both violent and sexual. Of the three partners in this "wedding of the white and the black," it is the Negro who Mailer believed was most able to contribute these "primitive" impulses, for he had been forced to survive on the margins and thus "could rarely afford the sophisticated inhibitions of civilization." Of course, a Negro could not *be* a hipster; he could only supply the raw material. Hipsters were *white* Negroes, "urban adventurers" who "had absorbed the existentialist synapses of the Negro."[78] Mailer wanted to appropriate, for a white intellectual and cultural elite of which he considered himself a member, the Negro's privileging of the body over the mind, psychopathic behavior, and uninhibited sexual potency. The black man was merely to serve as "noble savage" or "walking phallic symbol," as the writer James Baldwin put it in his 1961 *Esquire* essay "The Black Boy Looks at the White Boy," which was, in part, a personal and critical commentary on "The White Negro."[79]

In the initial critical response to *The Americans*, it was often noted that the only subjects Frank portrayed in a positive light were African Americans. It is certainly true that the sincere warmth and spontaneous joy evident in an image like "Beaufort, South Carolina" is totally lacking in his photographs of the white bourgeoisie, who often look like ghosts, mannequins, or caricatures, totally devoid of life. For example, in "Movie Premiere, Hollywood," a young woman with platinum hair and a heavily made-up face stands motionless within an elaborate interior. Her white fur stole, elegant black dress, and intricate earrings contribute to the artificiality she exemplifies, a subjectivity predicated on exterior constructions rather than interior authenticity. She is like a statue or a doll, as dead as the woman in "Beaufort, South Carolina" is alive. The sterility of "whiteness" is also evident in "Cocktail Party—New York City," for although the upper-class subjects in the photograph are smiling, there is no sense of warmth or spontaneity. Their smiles and mannerisms are affectations, as false as their materialistic values.

Although creating a sympathetic portrayal of African Americans during the

height of the civil rights movement was laudable, I would suggest that there is a fine line between admiration and primitivism. As Norman Podhoretz wrote in his infamous critique of the Beat writers, "It will be news to the Negroes to learn that they are so happy and ecstatic."[80] To be fair to Frank, he did not ignore the issue of segregation, a cruel reality most literally expressed in "Trolley—New Orleans." Yet, as I have suggested, one could also argue that in his photographs, African Americans serve as raw material in a struggle to recover for white middle-class masculinity the virile physicality it was believed to lack. In "Indianapolis," Frank returns to the motorcycle theme. Shot directly from the side is an African American couple, a man in denim clothing with metal studs seated on a Harley-Davidson, a woman nestled close behind him. There is a suggestion of steely defiance in their faces, which they turn down and away from the camera's lens. As in "Newburgh—New York," sexuality is conveyed through the sensuality of materials, a suggestion that is here reinforced by the revving of the engine, which will soon take the couple speeding off into the night. If, as Frantz Fanon suggested in 1952, Western culture locates the "fact of blackness" in the body, and if, for "white men," the "Negro is the incarnation of a genital potency beyond all moralities and prohibitions,"[81] then to represent the black male body is to seek to represent masculine potency in its purest state.

Perhaps for Frank, an unconscious identification with African American and other outsider men served as a mechanism for achieving his own uniquely American masculinity. As a Jewish immigrant, he was already an outsider, just not the "right" type. Within postwar culture, the Jewish man was aligned with the intellect rather than the body, with societal compliance rather than defiance. The stereotype of the "nice Jewish boy" who obeys his mother and submits to his wife prevailed.[82] Yet by going West "armed" with a subversive camera, Frank could take on the role of societal outlaw without having to picture his own body, which might give away his ethnicity, not to mention his short, slender stature. He could also position himself as the hero within a quest tradition that had been given renewed cultural currency with the 1949 publication of Joseph Campbell's *Hero with a Thousand Faces*.[83] Like the archetypal male hero whom Campbell traces through so many cultures and times, Frank journeys into the netherworld in search of hidden "truth" and personal renewal. Indeed, Frank has been mythologized as a truth teller, a prophet of the unrest and upheaval that was to shake the nation in the following decade. Moreover, as "bad boy," he was himself to shake the foundations of the photography world, a role that he has continued to promulgate. In a 1975 lecture, he proclaimed: "I could get a camera and make a very beautiful picture. It could be almost as good as Ansel Adams. But I don't want to take a beautiful picture, and I can't, really."[84]

Bruce Davidson's Gang Photographs and the Aesthetics of Outlaw Masculinity

Of those photographers who were to achieve renown in the 1960s, Bruce Davidson is most like Frank in his attraction to the subject of the outsider male and in his inscription of masculinity into photographic imagery through a deliberate anti-aesthetic.

Moreover, Davidson's work exemplifies the shift from social-documentary photography to what came to be known as social-landscape photography, a depoliticization commonly traced to Frank's *Americans*.[85] Like such other notable 1960s photographers as Lee Friedlander and Garry Winogrand, Davidson has been canonized within a trajectory that leads directly back to Frank.[86] Indeed, as is typical in canon formation, Frank has been made to "father" these men,[87] even though they were all active photographers in the 1950s.[88]

During an eleven-month period in 1958 and 1959, Davidson shot a series of photographs of teenage members of a Brooklyn gang who called themselves the Jokers. Five of these images were published in the June 1960 issue of *Esquire* magazine, with commentary by Norman Mailer.[89] A larger group was published in the summer 1962 issue of *Contemporary Photographer,* and between 1960 and 1964, sixteen prints from this series were acquired by and exhibited at the Museum of Modern Art in New York. Davidson had read about the gang in the newspapers, after which he contacted the New York Youth Board in hopes of photographing them. A Youth Board worker then accompanied Davidson to the gang's hangout, so that he could "take pictures of their wounds from a gang war."[90] Davidson's gang series presents the male body in pain; however, this wounded body is a heroic one, for it signifies masculinity self-constructed through courage, honor, loyalty, and physical prowess.

In the postwar era, an enormous amount of media, government, and scholarly attention was directed toward juvenile delinquency as a mounting problem.[91] Davidson's images do not focus on the negative aspects of these boys' lives, however. These photographs are not in the social-documentary tradition; they do not plead with the viewer to alleviate suffering. Rather, they romanticize, even glorify, gang life, overlooking the harsh economic conditions and bleak prospects that these boys may have actually faced. Through the lens of Davidson and the pen of Mailer, the "pain" that these young men endure appears to be evidence of their fighting for the noble cause of masculinity, not the pain of children whose basic needs were not being met, as many sociologists and psychologists asserted. Although Mailer does admit that "broken homes, submarginal housing, overcrowding in the schools and cultural starvation" may be one "root" of juvenile delinquency, he claims that the other root, which he defines as the need for "courage, loyalty, honor," and "adventure," is "more alive." In fact, he suggests that the gang members may simply be bored:

> They suffer from only one disease—it is boredom. If their conversation runs the predictable riverbed of sex, gang war, drugs, weapons, movies, and crazy drunks, well, at least they live out a part of their conversational obsession, which is more than one can say for the quiet, inhibited, middle-aged desperadoes of the corporation and the suburbs.[92]

To Mailer, gang culture provides a space for active masculinity, a site in which to play warrior and to resurrect the theme of the western outlaw. Indeed, the motif of the gang may have served to satisfy the desire to locate a powerful masculinity outside the parameters of official society. Not only are these boys physically strong, but they are young, permanently affixed on the threshold of manhood through the

photographic medium. They never need cross into the realm of social and familial responsibility. Gang culture represents independence from institutional control yet promises group solidarity; gang members exist outside official societal boundaries because of their violent law-breaking activities, yet they remain members of a homo-social "pack." As the postwar sociologist Albert K. Cohen observed, gangs represent "group autonomy" in that they are intolerant of "restraint except from the informal pressures within the group itself." But in terms of society, the "delinquent is the rogue male."[93]

Moreover, with the gang, the homoerotic can be suppressed beneath heterosexual machismo. Indeed, girls in the gang, or "debs," are often included in Davidson's photographs as markers of the subjects' heterosexuality. Peter Lehman refers to this practice as the "heterosexual veneer," whereby the presence of women works to dis-avow the homoerotic content.[94] In "A Couple Kissing in the Back of the Car," the girl draws attention away from the spectacle of the male body, from the manner in which the light caresses bare skin and emphasizes the contours of muscular back and arm (Figure 34).

Furthermore, any hint of domestication is negated, because the deb would be understood as a "bad" girl, available for sex but not expecting marriage. That debs were sexually active was stressed by the reporter Harrison E. Salisbury, who wrote a series of articles for the *New York Times* and a popular book based on his experiences researching Brooklyn gangs in 1958. Salisbury observed that few boys went steady, because girls made "demands" that could divert them from the gang—their "main

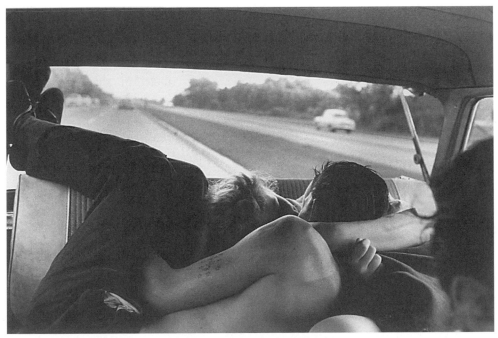

Figure 34. Bruce Davidson, "A Couple Kissing in the Back of the Car" (1959). Copyright Bruce Davidson/Magnum Photos.

occupation." The girls functioned not as romantic partners but as grounds for sexual bragging rights. Not all the girls attained the status of debs, however. Some were considered "plain lays" or "in-betweens." Although "lays" were treated with "sadistic contempt," all three categories satisfied what Salisbury referred to as the gang members' "primitive sexual needs." Moreover, the boys were reluctant to use contraceptives, and they would tell a girl that she was "no good" if she insisted. Even if she did succeed in getting the boy to comply, he would often prick the condom with a pin, hoping to give her a "surprise," for to impregnate was to prove "manly virility."[95] These boys offered no financial support and married only when threatened with a charge of statutory rape.[96]

Such extreme expressions of heterosexual prowess are symptomatic of homophobia, for heterosexual masculinity is constructed and maintained not only through the negation of the feminine but also through the repression of male-male desire. Conversely, for masculinity to be learned, legitimate arenas for the male viewing of male bodies must be erected. Men's magazines like *Esquire* act as a medium for such homosocial exchange, as do the arenas of organized sports. Davidson's gang photographs may have provided a fantasy space for *Esquire* readers, who tended to be successful men with all the trappings of societal authority.

One fantasy may have revolved around sexual potency. Anxiety over this issue had arisen after the Kinsey reports on sexual behavior were published in 1948 and 1953. The reports claimed that although men's sexuality peaked in their late teens, women's full responsiveness did not arrive until their late twenties and early thirties and then remained constant into their fifties and sixties.[97] Whereas the gang members would be considered at the pinnacle of male sexual potency, the debs had not yet "awakened," so there would be little pressure to satisfy them sexually. They were simply vehicles through which men could seek "apocalyptic orgasm," the Holy Grail of the hipster.[98] Mailer, for example, included a description of a gang member's sexual conquests, as well as one of his fantasies, which was to "make," or "drill," a jazz singer "right on the floor when she's singing."[99]

Fantasy is certainly involved in this *Esquire* piece. In fact, Mailer describes his first meeting with the gang as a situation that belonged "more to the movies than to life," in which they were "obeying an archetypal scene in a gangster movie or a Western—a stranger had come to visit."[100] The gang motif is reminiscent of both the Western and the gangster film genres, with the emphasis on gang "turf" as landscape and on the gang members' role as urban outlaws. Indeed, the body types emphasized in Davidson's photographs range from the tall and muscular physique, typical of the movie cowboy, to the short, sinewy look common to the Hollywood gangster.[101] This ideal is similar to the physical description Mailer provides of the hipster: "A hipster moves like a cat, slow walk, quick reflexes; he dresses with a flick of chic; if his dungarees are old, he turns the cuffs at a good angle."[102] Although the overall appearance of the gang members is somewhat disheveled, their display is deliberately coded—greaser hair, T-shirts with rolled-up sleeves, tattoos, dark glasses—intentional subversions of the gray-flannel-suited ideal of the corporation and the suburb, rendered

even more extreme through the lens of Davidson, whose Beat aesthetic veils the boys in a shadowy haze.

Masculine display is overtly demonstrated in "Boy with Tattoo in Front of a Candy Store" (Figure 35). Four seated boys watch two standing youths, who have their backs to the viewer. One of the boys has let his shirt drop from his shoulders. He appears to be in motion, in the act of disrobing, as is suggested by the diagonal lines of his clothing and the blurred appearance of his right arm. We do not see his chest, which he reveals to the other gang members; our gaze is displaced to his muscular back with its tattoo, which catches the light in this otherwise dark scene. Also emerging from the shadows is the boy on the left, who leans back to take in what he sees, his eyes keenly focused on the spectacle before him. This figure acts as our surrogate, the viewer's entry into the circle.

Indeed, entry into this circle is what Davidson and Mailer sought. When Mailer first encountered the gang, Davidson had already been "friendly" with them for about a year, and Mailer delights that within only fifteen minutes of meeting them, they "found a common ground" in the description of their various "prescriptions for odd kicks," their favorite methods for attaining a drug-induced high. Mailer goes on to bond with the group through the swapping of war stories, theirs of rumbles and his of World War II. He also attended one of their dances, although he was disappointed because the fight he had been promised never took place. What seems to be going on is a sort of "primitivizing," as if these boys are males in their "natural" state, before their instincts have been repressed by society. Indeed, Davidson's subjects tend

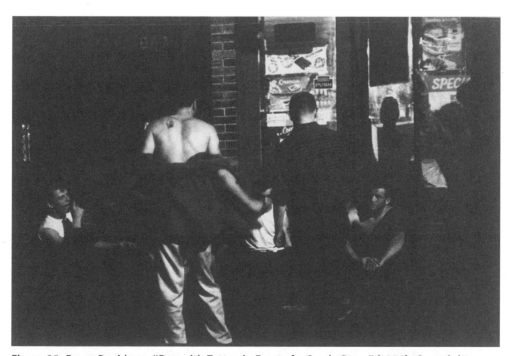

Figure 35. Bruce Davidson, "Boy with Tattoo in Front of a Candy Store" (1959). Copyright Bruce Davidson/Magnum Photos.

to appear as innocents, free of guilt or responsibility, delighting in their physicality. Moreover, by giving artistic expression to the gang, Davidson and Mailer offer access to this "unrestrained" masculinity, whose appropriation could serve to infuse the hegemonic model with needed vigor. Of course, the power implications of such primitivizing also revolve around the issue of class. Although these working-class boys signify an active masculinity, through the photographic medium, they have become passive objects of the consuming gaze of the upscale readership of *Esquire,* of visitors to the Museum of Modern Art, and of consumers of photographic books, in which a number of these images have been published.

In his gang series, Davidson also emphasizes separation from mainstream society. Gangs create a parallel world with its own language, costume, rituals, and leadership hierarchy. That it is a patriarchal one functions to deny the failure of masculinity itself, thus making gang members attractive as models for those seeking to retain belief in the adequacy of the male subject while working to overturn the dominant masculine ideal. These outlaws refuse regulation; they are subversive bodies that cannot be contained. As such, they demonstrate society's tenuous hold on phallic power, which can then be reinscribed elsewhere.

All this notwithstanding, gang members, especially the underprivileged or those with no positive male figures in their lives, may fear they are unable to measure up to the phallus. Their prospects for social and economic success seem bleak; therefore, they "drop out" and reconstruct a system in which they can bear the phallus, where being a man is simply a matter of physical and sexual prowess. Thus, they attempt de-Oedipalization through their challenge to official society, a challenge in which they no longer recognize masculine potency and authority, yet they must remain heterosexual to be "men"—hence the emphasis on sexual prowess.[103] They are also men who have successfully rejected infantile dependence on the mother. The prominent postwar sociologist Talcott Parsons theorized juvenile delinquency in terms of this masculine rebellion. If "good" behavior is associated with the mother, who is the agent of social discipline, then asserting "bad" behavior is a means to deny the boy's identification with the mother, a tie that may be even stronger in cases where the father is physically or emotionally absent.[104]

Not only do gang members create their own subculture, but they literally attempt to create themselves, as is evident by their muscular bodies and the scars that they bear, which provide visual proof of having survived combat conditions. Not only do these "bad boys" inflict pain, they must endure pain to give birth to themselves as "men." As Mailer proclaimed, "being a man is the continuing battle of one's life."[105] Gang culture provides the opportunity to become a man in the classical sense—to display courage, to construct codes of masculine honor, to be a combat hero. Mailer's account of a gang rumble emphasizes their warrior status: He describes Terry, with his "natural military ability," who carries his bleeding comrade beneath his arm, and Whitey, who displays "heart," or courage, in battle. Mailer describes how the boys used a steak knife and Davidson's water pistol to taunt each other and bystanders, an incident precipitated by jokes about the small size of a gang member's penis, visible

when he urinated before the group.[106] Such playacting underscores the socially con-
structed element of masculinity, its status as learned behavior, yet this episode also
draws attention to the central role of the physical body within such constructions.

Pain as the price for the construction of physical manhood is also signified by
the tattoos prominently displayed on the bared arms and backs of Davidson's sub-
jects. These tattoos recall the mobility associated with the sailor and the biker, yet
they also denote group solidarity, their application acting as an initiation ritual.[107]
Furthermore, the tattoos invite the gaze; they force contemplation of the body, its
eroticization. Although the dark, grainy quality of some of the prints conceals parts
of the bodies, this tactic also functions to entice. Indeed, fascination with gang
culture may have involved a prurient element. Salisbury reported group sexual
activities among gang members in Brooklyn, including the "line-up," in which a
girl is "conned" into having intercourse with a boy and then, despite her protests, is
passed along to about half a dozen others in succession. Another group activity was
mass masturbation. Up to twenty boys would join in this ritual "circle jerk," in the
center of which a male-female couple would sometimes provide an exhibition.[108] Eve
Kosofsky Sedgwick has argued that women often act as conduits of men's homosocial
desire for other men, and that men's homosocial and heterosexual desires may be
complicit.[109] Clearly, the extreme homosocial nature of gang life, coupled with group
sexual activity, blurs the lines between rigidly defined heterosexuality and homo-
sexuality, as does, I would assert, the pleasure involved in the viewing of eroticized
male bodies by the supposed heterosexual readership of *Esquire* magazine.[110] Yet this
spectatorship can also be read in terms of narcissism; thus, an oscillation between
scopophilic desire and gender identification is at play. From a Freudian standpoint,
a male heterosexual spectator first desires and then identifies with the male hero.[111]
Previous discussions of Davidson's gang series have refused to deal with the objec-
tification of the gang members. The eroticized bodies are disavowed, and scholarly
and critical attention is directed instead toward the photographer and his personal
artistic vision. Masculinity is thus able to retain its status as a seamless natural state
rather than an ever-shifting set of constructed *masculinities,* fully implicated within
specific historical and cultural contexts.

The construction of gang members as antiheroes also revolved around their vio-
lent, even suicidal, exploits, which, in the summer of 1958, resulted in eleven highly
publicized deaths in New York City. The Beats romanticized death. Indeed, except
for the quest for the apocalyptic orgasm, living with the ever-present possibility of
death is what Mailer celebrates most in "The White Negro." This flirtation with death
was joined by an emphasis on religious mysticism. Mailer associated Catholicism
with Hip,[112] and he defined the mystic as "one who has chosen to live with death."[113]
One of the gang photographs published in *Esquire* depicts two boys walking past a
church's crucifix and other religious statues (Figure 36). One boy appears to be cross-
ing himself, while the other pulls his jacket up over his head and clasps his hands, in
effect, echoing the draped saints behind him. The image is blurred, out of focus, and
overlaid with mist. This revival of mysticism is nostalgic in its rejection of the secular

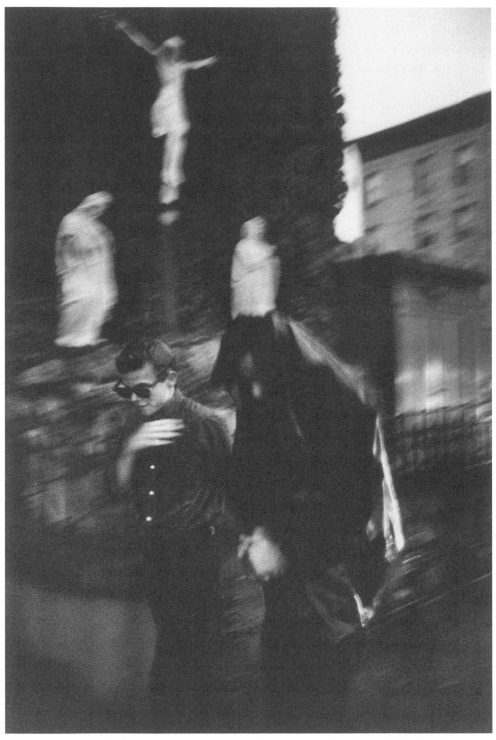

Figure 36. Bruce Davidson, "Two Young Men Walking Past a Church at Night" (1959).
Copyright Bruce Davidson/Magnum Photos.

and scientific character of modern life and in its elevation of "bad boys" to the status of martyrs. Of course, to Mailer, the psychopath is a sainted hero, the figure who can lead the way out of a repressive postwar society through the restoration of the instinctual.

A certain romanticism extended to Davidson, who once proclaimed: "I am free as long as I am true, and true as long as I seek. I seek through photography."[114] This manifesto of artistic purpose is in keeping with the Beats' emphasis on individual freedom and authenticity. Critics contributed to this persona. In a 1961 essay, Linda Gravenson described Davidson as an "elusive," and "disarming" photographer, who "sees the world through a veil of shadow, mist, and grain" yet whose "hand steals to his camera in a gesture reminiscent of our slow-moving, fast-shooting cowboy heroes."[115] Furthermore Davidson's photo essay format tends to foreground his own subjectivity by drawing attention to his authorial role in the construction of a visual narrative, one in which he also acts as participant. Hence, Davidson himself becomes something of a hero. Indeed, Davidson interacted with the gang members not merely to document them but also to share in their adventures and thus to recover for an artistic bohemianism and his own identity a nostalgic, sentimentalized model of masculinity.

Davidson's Brooklyn Gang series also reveals a paradox: The subversion of hegemonic masculinity can function to reinforce patriarchy. Indeed, Davidson's photographs work to normalize and universalize patriarchy, for the boys are "read" in terms of a primitive, thus naturally potent, masculinity. Although the rebellion associated with the gang may provide a sense of liberation for some men, it leaves little space for women other than oppression. In fact, oppression is frequently greater within these patriarchal subcultures, for it is necessary to exaggerate gender constructions to retain phallic power outside institutional support. Like Frank's outsider males, Davidson's outlaw imagery functioned to deny male lack at a time when masculinity within the law seemed threatened.

Postscript

In 1959, Robert Frank and the painter Alfred Leslie released *Pull My Daisy,* a film adaptation of Jack Kerouac's play *The Beat Generation. Pull My Daisy* parodies middle-class family life, with the woman, of course, representing the deathly trap of domestic conformity.[116] Its production also signals film as the preferred medium of both avant-garde practice and cultural critique. *Pull My Daisy* was considered an important forerunner to the independent cinema of the 1960s, its filmmakers instrumental in the formation in September 1960 of the New American Cinema Group, which produced a nine-point manifesto declaring a belief in artistic independence and rejecting censorship and the values associated with mainstream Hollywood cinema. Throughout the 1960s, Frank devoted himself to filmmaking. Indeed, at the height of his notoriety as a photographer, he played the ultimate rebellious son: He rejected the practice altogether.[117] As he later explained: "Photography? I loved it, spent my talents

and energy on it, I was committed to it; but when respectability and success became part of it, then it was time to look for a new mistress or wife."[118]

By 1960, the moving image had begun to erode still photography's dominance as the medium of the "real." Television eventually supplanted the picture magazine as the vehicle of "truth." The Vietnam War would be a television war rather than a photography war, and never again would a photography exhibition garner the worldwide attention accorded The Family of Man. Indeed, with Steichen's retirement from the Museum of Modern Art in 1962, such a show was no longer even possible. John Szarkowski, his successor, favored "personal" documentary work, in which the photographer acts as a detached observer rather than as a social commentator. In the decade of cultural revolt, humanism was passé.

Ironically, at a time when photography was losing currency in the world at large, it began to claim a larger role in the academy and the museum-gallery system. As teaching positions multiplied and prints began to command higher prices, practitioners were increasingly able to make a living as fine-art photographers.[119] The proliferation of photography classes within university art departments also exposed the medium to aspiring artists, many of whom utilized it in their painting in the form of silk screen or as elements within mixed media or conceptual works.[120] Moreover, postwar stereotypes still surface in books, films, and television shows, especially that of the world-traveling photojournalist and the fashion/centerfold photographer. In 1962, a photographer even became a superhero. Indeed, Peter Parker/Spiderman is a "man with a camera," the epitome of masculine potency.

Acknowledgments

This book marks the end of a long journey into my "blind spot," the years just preceding my entry into this life, as my former professor Madeline Brainerd once explained it. They are the formative years of my late parents—my father, a sailor in World War II, married my teenaged mother in 1958, an event that marked the beginning of their journey into the domestic ideal that marked that era. In so many ways, this is their story.

Along the way, I have been fortunate to be surrounded by mentors who have also been supportive friends. I can never thank Angela Miller enough for her kindness and amazing generosity, not to mention her keen insights and careful editing. Karen Fiss helped me find my theoretical voice and has been a constant source of encouragement. William E. Wallace has been a most ardent supporter, as has Elizabeth C. Childs, who buoyed my spirits when I needed it most. Thanks also to Gerald Early, for teaching me to love the 1950s. I would also like to acknowledge the personal and professional debt that I owe to Robert Jensen, who sparked my interest in this topic, and to Yael Even, who nurtured my feminist aspirations.

My thanks also go to the entire faculty and staff of the Department of Art History

and Archaeology at Washington University for their unwavering and overwhelming support throughout my years as a graduate student, during which this book took seed. I would like to extend a special thanks to the department for granting me research funds to travel to New York in the summer of 1996, and to the Graduate School of Arts and Sciences for awarding me a Dean's Fellowship for the 1996–1997 academic year. I am also indebted to the Center for Creative Photography at the University of Arizona for awarding me an Ansel Adams Research Fellowship, which enabled me to travel to the Center and conduct research in the spring of 1997. I would especially like to thank Amy Rule, Leslie Calmes, Pat Evans, and Trudy Wilner Stack for their assistance during my stay at the Center. I would also like to thank Virginia Gogier of the Museum of Modern Art in New York and the staffs of Magnum Photos, the International Center of Photography, the Museum of Television and Radio in New York City, the New York Public Library, and the St. Louis Public Library for their assistance in researching this project. Thanks also to the staffs of Olin Library and the Art and Architecture Library at Washington University, and to the staff of the Montana State University–Billings Library, without whose assistance this project could never have been completed.

My gratitude to the University of Minnesota Press, especially to my editor Carrie Mullen, who has been an unwavering pillar of support since I first approached her with my manuscript. I would also like to thank Jason Weidemann, editorial assistant, Catherine Clements, production coordinator, Adam Grafa, design and production manager, and Kathy Delfosse for her meticulous copyediting.

Finally, my thanks to colleagues and friends Connie Landis, Neil Jussila, Peter Whitson Warren, John Pollock, Brian Cast, Cynthia Zyzda, Daniel Zirker, Debra Ross, Mark Tauer, Melinda Payne, Molly Hutton, Carol Christ, Martha Ahrendt, and Felicia Else; and especially to my family, my sister Deanne Vettel Mohr, my brother Scott Vettel, my remarkable and ever-supportive husband Richard Vettel-Becker, and my extraordinary daughters, Angelica Tom Cheeley and Shoshana Tom, who sacrificed so much time with their mother so she could write this book—I dedicate this to you.

Notes

Introduction

1. Eric J. Sandeen, *Picturing an Exhibition: The Family of Man and 1950s America* (Albuquerque: University of New Mexico Press, 1995), 4.

2. Edward Steichen, "Last Call," *Infinity* 3 (February 1954): 8.

3. Not all postwar women adhered to the domestic stereotype so prevalent in television situation comedies. See Joanne Meyerowitz, ed., *Not June Cleaver: Women and Gender in Postwar America, 1945–1960* (Philadelphia: Temple University Press, 1994); Eugenia Kaledin, *Mothers and More: American Women in the 1950's* (Boston: Twayne Publishers, 1984); and Susan M. Hartmann, *The Home Front and Beyond: American Women in the 1940s* (Boston: Twayne Publishers, 1982).

4. According to S. L. A. Marshall, *Men against Fire: The Problem of Battle Command in Future War* (New York: William Morrow, 1947), 50, in World War II, 75 percent of soldiers were unable to fire their weapons against the enemy.

5. Kaja Silverman, *Male Subjectivity at the Margins* (New York and London: Routledge, 1992), 54–65.

6. Ibid., 55. For the "crisis of masculinity" that occurred in Great Britain during and after World War I, see Joanna Bourke, *Dismembering the Male: Men's Bodies, Britain, and the Great*

War (London: Reaktion Books, 1996), which is one of the few studies to examine the effects of war on male bodies. See also Carolyn J. Dean, *The Frail Social Body: Pornography, Homosexuality, and Other Fantasies in Interwar France* (Berkeley and Los Angeles: University of California Press, 2000). Dean, like Silverman, addresses the way maintenance of a collective belief in masculine virility and wholeness, especially after the trauma of war, functions to support the social fabric of a nation, in this case France after World War I.

7. Quoted in George Lipsitz, *Class and Culture in Cold War America: "A Rainbow at Midnight"* (South Hadley, Mass.: J. F. Bergin, 1981), 235. Stephens College in Columbia, Missouri, offered courses in grooming, charm, and beauty. In 1945, the school's president, James Madison Wood, boasted "that 85% of its graduates get married within five years," a record he intended to maintain. Quoted in "Courses in Charm," *Life* 18 (16 April 1945): 73.

8. See William Henry Chafe, *The American Woman: Her Changing Social, Economic, and Political Roles, 1920–1970* (New York: Oxford University Press, 1972), 199–225, for a summary of what, in the postwar years, was commonly referred to as the "woman problem."

9. Abigail Solomon-Godeau, "Male Trouble," in *Constructing Masculinity,* ed. Maurice Berger, Brian Wallis, and Simon Watson (New York and London: Routledge, 1995), 73.

10. I borrow these terms from Howard S. Becker, *Art Worlds* (Berkeley and Los Angeles: University of California Press, 1982).

11. On the institutional transformation of photographers and photographs into canonical artists and art, see Abigail Solomon-Godeau, "Introduction" and "Canon Fodder: Authoring Eugène Atget," in *Photography at the Dock: Essays on Photographic History, Institutions, and Practices,* with a foreword by Linda Nochlin (Minneapolis: University of Minnesota Press, 1991); Andy Grundberg, "What Kind of Art Is It?" Connoisseurs versus Contextualists," in *Crisis of the Real: Writings on Photography, 1974–1989* (New York: Aperture Foundation, 1990), 168–72; Rosalind Krauss, "Photography's Discursive Spaces," *Art Journal* 41 (Winter 1982): 311–19; Christopher Phillips, "The Judgment Seat of Photography," *October* 22 (Fall 1982): 27–63; Douglas Crimp, "The Museum's Old/The Library's New Subject," *Parachute* 22 (Spring 1981): 32–37; and Allan Sekula, "The Instrumental Image: Steichen at War," *Artforum* 14 (December 1975): 26–35.

12. John Szarkowski, *Looking at Photographs: 100 Pictures from the Collection of the Museum of Modern Art* (New York: Museum of Modern Art, 1973).

13. Although the use of labels to define the various modes of photographic practice may seem reductive, such labels were important tools in the fashioning of one's identity as a photographer. Therefore, throughout the book, I have attempted to use the categorical terms that the postwar photographers and writers themselves used to describe themselves and others.

1. Gendering Photographic Practice

1. Silvia Gherardi, *Gender, Symbolism, and Organizational Cultures* (London: Sage Publications, 1995), 3–4.

2. Harriet Bradley, *Men's Work, Women's Work: A Sociological History of the Sexual Division of Labour in Employment* (Minneapolis: University of Minnesota Press, 1989), 223–32.

3. Margaret Bisland, "Women and Their Cameras," *Outing* 17 (October 1890): 37–38.

4. See Naomi Rosenblum, *A History of Women Photographers* (New York: Abbeville Press, 1994), 55–113; and C. Jane Gover, *The Positive Image: Women Photographers in Turn of the Century America* (Albany: State University of New York Press, 1988), 18.

5. Frances E. Willard, "Women as Photographers," in *Occupations for Women* (Cooper Union, N.Y.: Success Company, 1897), 242–43.

6. Richard Hines Jr., "Women and Photography," *American Amateur Photographer* 11 (March 1899): 118.

7. Gover, *The Positive Image*, 17–33, 104–34.

8. "How Women Have Won Fame in Photography," *Wilson's Photographic Magazine* 51 (May 1914): 202.

9. On women's participation in the bicycling and snapshooting "crazes," see Barbara Lynn Ricca, *The Camera, Bikes, and Bloomers,* History of Photography Monograph Series (Tempe: Arizona State University, 1983).

10. Amy W. Loomis, "Kodak Women: Domestic Contexts and the Commercial Culture of Photography, 1800s–1980s" (Ph.D. diss., University of Massachusetts, 1994), 49–50; and Colin Ford, ed., *The Story of Popular Photography* (North Pomfret, Vt.: Trafalgar Square Publishing, 1989), 65–66.

11. John R. Whiting, "Candid Shots," *Popular Photography* 12 (May 1943): 16.

12. *Life* magazine's circulation had climbed from 2.3 million in 1940 to 5.2 million in 1949, with an estimated readership of 22 million. By 1956, circulation had increased to 5.8 million. Loudon Wainwright, *The Great American Magazine: An Inside History of "Life"* (New York: Alfred A. Knopf, 1986), 174, 178.

13. Jim Hughes, *W. Eugene Smith: Shadow and Substance. The Life and Work of an American Photographer* (New York: McGraw-Hill, 1989), 185.

14. C. Wright Mills, *White Collar: The American Middle Classes* (New York: Oxford University Press, 1951), 73.

15. Gordon Parks, *Voices in the Mirror: An Autobiography* (New York: Doubleday, 1990), 102, 131, 149.

16. On the importance of home address and occupational income as status markers, see Vance Packard, *The Status Seekers* (New York: David McKay, 1959), 61–113.

17. Elaine Tyler May, *Homeward Bound: American Families in the Cold War Era* (New York: Basic Books, 1988), 18. On the breadwinner role in the postwar era, see also Michael Kimmel, *Manhood in America: A Cultural History* (New York: Free Press, 1996), 245–51. The importance of breadwinning to middle-class notions of manhood originated in the nineteenth century, when the patriarchal tradition of property ownership began to be replaced by an emphasis on salary earned in the workplace. With industrialization, a man's work came to define his masculine identity. See Peter N. Stearns, *Be a Man! Males in Modern Society,* 2d ed. (New York: Holmes and Meier, 1990), 51–52, 108–53; and E. Anthony Rotundo, *American Manhood: Transformations in Masculinity from the Revolution to the Modern Era* (New York: Basic Books, 1993), 167–93.

18. Morris Zelditch Jr., "Role Differentiation in the Nuclear Family: A Comparative Study," in *Family, Socialization, and Interaction Process,* ed. Talcott Parsons and Robert F. Bales (Glencoe, Ill.: Free Press, 1955), 339 (emphasis in the original).

19. See David Riesman, *The Lonely Crowd: A Study of the Changing American Character,* with Reuel Denny and Nathan Glaser (New Haven and London: Yale University Press, 1950); and William H. Whyte Jr., *The Organization Man* (New York: Simon and Schuster, 1956).

20. Riesman, *The Lonely Crowd,* 46–47.

21. Chas. N. Tunnell, "Start Going after that 'Post-War Business' Now," *Commercial*

Photographer 20 (March 1945): 183–88; Frederick C. Darragh and Paul Linwood Gittings, "So You Want to Turn Pro?" *U.S. Camera* 11 (May 1948): 26–29, 128–37; George R. Hoxie, "Does It Pay to Turn Pro?" *Modern Photography* 13 (October 1949): 52–57, 128–31; Jarvis Woolverton Mason, "Jack-of-All-Trades . . . for Veterans," *Minicam Photography* 10 (January 1947): 60–67, 121; and "Photo Study for Veterans Here," *New York Times*, 24 January 1946. On freelancing, see Gilbert C. Close, "How to Make and Sell Stock Photos," *Minicam Photography* 11 (March 1948): 80–89, 124–28; Richard W. Bishop, "A Case for the Free-Lance," *Minicam Photography* 11 (August 1948): 92–97, 117–19; Karl A. Barleban, "Cash from Your Camera," *American Photography* 47 (July 1953): 64–67; Ray Atkeson, "Who Wants to Be a Free-Lance Photographer?" *U.S. Camera* 17 (January 1954): 51–53, 97; and "Symposium—Freelance Photography," *U.S. Camera* 19 (May 1956): 97–104, 116.

22. Rus Arnold, "The Company Magazine," *Infinity* 8 (March 1959): 5–9, 24–25; Louis Hochman and Bob Willoughby, "Moguls and ASMPers: A New Approach in the Aesthetics and Economics of Covering Movies," *Infinity* 6 (September 1957): 13–15; and David I. Zeitlin, "The 35 in Hollywood," *Camera 35* 2, no. 2 (1958): 94–113.

23. W. S. Goldwire, letter to the editor, *National Photographer: The Professional Journal of Photography* 1 (July 1950): 6.

24. Julian Levy, *Memoir of an Art Gallery* (New York: Putnam, 1976), 68.

25. Letter from Helen Gee to W. Eugene Smith, 18 October 1953, Helen Gee/Limelight Gallery Archive, Center for Creative Photography, Tucson, Arizona (hereafter CCP). On Gee and the Limelight, see also Helen Gee, *Limelight: A Greenwich Village Photography Gallery and Coffeehouse in the Fifties* (Albuquerque: University of New Mexico Press, 1997); Peter Bunnell, "Remembering Limelight," in *Helen Gee and the Limelight: A Pioneering Photography Gallery of the Fifties* (New York: Carlton Gallery, 1977); Willa Percival, "Limelight," *Infinity* 3 (May 1954): 8–9; Barbara Lobron, "Limelight Lives!" *Photograph* 1, no. 3 (1977): 1–3, 30–31; and Lili Corbus Bezner, "Helen Gee in the Limelight: Expanding Exhibitions of Photography in the 1950s," *History of Photography* 20 (Spring 1996): 78–81.

26. Letter from Helen Gee to Wynn Bullock, 27 October 1955; letter from Imogen Cunningham to Helen Gee, 21 October 1954; letter from Helen Gee to Minor White, 18 November 1954; letter from Paul Strand to Helen Gee, 4 October 1954; letter from Helen Gee to Paul Strand, 10 January 1955, all Helen Gee/Limelight Gallery Archive, CCP.

27. Letter from Helen Gee to Harry Callahan, 7 January 1955, Helen Gee/Limelight Gallery Archive, CCP.

28. Letter from Helen Gee to Eliot Porter, 25 April 1955, Helen Gee/Limelight Gallery Archive, CCP.

29. Charles Arrowsmith, "Why Exhibit?" *Infinity* 8 (December 1959): 30.

30. "The Exhibit That Failed," *Infinity* (June–July 1954): 8–9.

31. On DeCarava's gallery, which presented twelve exhibitions between March 1955 and May 1957 and charged from twelve to twenty-five dollars a print, see Peter Galassi, *Roy DeCarava: A Retrospective*, with an essay by Sherry Turner DeCarava (New York: Museum of Modern Art, 1996), 22–23, 269–70. In 1952, the Museum of Modern Art held its first Christmas Show, offering photographs for sale to the general public. Fifty-eight prints were sold, for a total of $1,005. See "The Museum of Modern Art Picture Show," in *U.S. Camera Annual 1953*, ed. Tom Maloney (New York: U.S. Camera Publishing, 1952), 158.

32. For Steichen's exhibition policies at the Museum of Modern Art, see Christopher Phillips, "The Judgment Seat of Photography," *October* 22 (Fall 1982): 39–53.

33. "Memorable Photographs by *Life* Photographers," undated 1951 press release, Museum of Modern Art Archives, New York.

34. For New York photographers and the photographic book and filmmaking, see Jane Livingston, *The New York School: Photographs, 1936–1963* (New York: Stewart, Tabori and Chang, 1992), 267–71.

35. See "Symposium: The Agencies," *Infinity* 2 (February 1953): 4–7, 12–15; and "The Agency Story," *Infinity* 9 (January 1960): 10–11.

36. Jacquelyn Judge, "Magnum," *Minicam Photography* 12 (April 1949): 51. See also John Morris, "Magnum Photos: An International Cooperative," in *U.S. Camera Annual 1954,* ed. Tom Maloney (New York: U.S. Camera Publishing, 1953), 110–60; and Byron Dobell, "Magnum," *Popular Photography* 41 (September 1957): 86–95, 133–36.

37. "The First Ten Years," *Infinity* 3 (October 1954): 12.

38. See "The Good Old Days," *Infinity* 6 (Christmas 1957): 20–23, 30.

39. Jeff Hearn, *The Gender of Oppression: Men, Masculinity, and the Critique of Marxism* (New York: St. Martin's Press, 1987), 121–46.

40. E. J. Light, "Blueprint for Making 'Bare Shoulder Portraits' of Girls (with a Tilt)," *Camera* 73 (December 1950): 32–34; Axel Bahnsen, "Glamour à la Carte," *Camera* 73 (June 1950): 26–33; Robert J. Smith, "Don't Do It!" *Camera* 73 (November 1950): 67–69; Lou Jacobs, "Your Girl Friend at the Beach," *Modern Photography* 13 (June 1950): 34–35, 93–94; and Earle W. Thompson, "How to Photograph the Girlfriend," *U.S. Camera* 21 (August 1958): 63–65.

41. Molly Brooks, "I Married a Lensman!" *Camera* 73 (February 1950): 143.

42. [Ruth Hartmann], "Found: A Letter!" *Infinity* 9 (April 1960): 11.

43. Mrs. Barrett Gallagher, "Lady's Day," *Infinity* 4 (Summer 1955): 8–9, 17.

44. Mrs. F. S. Huntress, "A Wife's a Handy Photo Gadget," *Popular Photography* 25 (December 1949): 97.

45. Anne Witz and Mike Savage, "The Gender of Organizations," in *Gender and Bureaucracy,* ed. Mike Savage and Anne Witz (Oxford: Blackwell Publishers, 1992), 11–12. On the growing importance in the postwar era of the ideal "corporate wife" to a businessman's career success, see William H. Whyte Jr., "The Wife Problem," *Life* 32 (7 January 1952): 32–48.

46. Mrs. Clinton E. Ford, "Twenty–Five Years as a Photographer's Wife," *Professional Photographer* 76 (February 1949): 88–89.

47. Linda Carpenter, "Women in the Dark," *U.S. Camera* 14 (September 1951): 78–79.

48. Barbara Ehrenreich, *The Hearts of Men: American Dreams and the Flight from Commitment* (Garden City, N.Y.: Anchor Books/Doubleday, 1983), 38–41. On the importance of hobbies to the maintenance of physical masculinity for suburban postwar men, see Steven M. Gelber, "Do-It-Yourself: Constructing, Repairing, and Maintaining Domestic Masculinity," *American Quarterly* 49 (March 1997): 66–112, esp. 90–104.

49. Jane Ellis, "Is Photography for Men Only?" *American Photography* 40 (February 1946): 37.

50. Enid Rubin, "Ladies' Day," *Camera 35* 4 (April–May 1960): 77, 30.

51. Lucille Nappi, "I Hate Cameras!" *Camera 35* 3, no. 1 (1959): 40–41.

52. Rita Cummings, "Are Women Allergic to Photography?" *Popular Photography* 43 (July 1958): 72–73, 117–18.

53. Joyce M. Starr, "How to Live with Your Husband's Hobby," *Camera 35* 3, no. 3 (1959): 238–39.

54. Julia Newman, "Meet Mr. U.S. Camera," *U.S. Camera* 22 (March 1959): 56.

55. Stearns, *Be a Man!* 194.

56. According to Loomis, "Kodak Women," 60, postwar Kodak ads increasingly emphasized men as the "arbiters" of "more 'advanced' and complicated equipment."

57. Lehman Wendell, "Photography: The Professional Man's Safety Valve," *Camera* 67 (September 1945): 24.

58. Rita Connolly, "Sixteen Men and a Girl: Baltimore Camera Club Members Engage in 'Operation Model Shoot' and Prove That One Subject Can Be Interpreted in Many, Many Ways," *Camera* 74 (April 1951): 32–37, 112–13.

59. Victoria Deer, "For Ladies Only," *Camera* 71 (January 1949): 64–69, 146.

60. See "Six Women Photographers," *Modern Photography* 13 (January 1950): 62–65, 137.

61. Judge, "Magnum," 42.

62. Wilson Hicks, *Words and Pictures: An Introduction to Photojournalism* (New York: Harper and Brothers, 1952), 51.

63. Dora Jane Hamblin, *That Was the Life* (New York: W. W. Norton, 1977), 69.

64. Ibid., 69–71.

65. Robert Mottar, "Look, Maw . . . No Hands!" *Infinity* 1 (April 1952): 5.

66. Ibid., 13.

67. Philip Wylie, *Generation of Vipers* (New York: Rinehart, 1942), 184–204. Wylie's book was immensely popular; by 1946, it was in its twelfth printing.

68. Edward A. Strecker, *Their Mothers' Sons: The Psychiatrist Examines an American Problem* (Philadelphia: J. B. Lippincott, 1946).

69. Hamblin, *That Was the Life,* 61.

70. "My Life with the Great Artist: Anonymous Researcher Tells What Happens on Those Wild Trips with Photographers," *ASMP News* (December 1950): 4–5, 20.

71. Eliot Elisofon, "Reporters Can Be Pains, Too . . . A Reply," *ASMP News* (January 1951): 8–9, 14.

72. Gherardi, *Gender, Symbolism, and Organizational Cultures,* 15.

73. Ibid., 16.

74. See Ruth Milkman, *Gender at Work: The Dynamics of Job Segregation by Sex during World War II* (Urbana and Chicago: University of Illinois Press, 1987), 99–127; and George Lipsitz, *Class and Culture in Cold War America: "A Rainbow at Midnight"* (South Hadley, Mass.: J. F. Bergin, 1981), 233–38.

75. According to Hicks, *Words and Pictures,* 51, reporters had previously been called researchers, but once *Life* began "employing as researchers young men who were considered potential writers, the designation reporter seemed more fitting." Thus, the job title was "masculinized" only after men began taking the position.

76. Ibid., 58, 47.

77. Deer, "For Ladies Only," 64.

78. Ibid., 69, 146.

79. Rosenblum, *A History of Women Photographers,* 187, 296; Julie Arden, "Girl on Assignment," *Popular Photography* 16 (February 1945): 36–37, 94.

80. On Bannister, see Kathryn Sullivan, "Constance Bannister: Camera Girl," *Popular Photography* 13 (September 1943): 19–21, 77–80. On Hoban, see Deer, "For Ladies Only," 68, 146; and "Six Women Photographers," 64–65, 137. On Ylla, see Charles Rado, "Ylla," *Infinity* (Summer 1955): 4–5, 10.

81. On Mieth, see Hansel Mieth Hagel, "On the Life and Work of Otto Hagel and Hansel Mieth," *Left Curve* 13 (1988): 4–18.

82. Robert W. Marks, "Portrait of Bourke-White" (1939), reprinted in *Camera Fiends and Kodak Girls II: Sixty Selections by and about Women in Photography, 1855–1965*, ed. Peter E. Palmquist (New York: Midmarch Arts Press, 1995), 219.

83. See Vicki Goldberg, *Margaret Bourke-White: A Biography* (New York: Harper and Row, 1986); and Jonathan Silverman, *For the World to See: The Life of Margaret Bourke-White* (New York: Viking Press, 1983).

84. Photographer Suzanne Szasz referred to photography as such during a radio interview; it was quoted in "Grapevine," *Infinity* 8 (September 1959): 24.

85. Mottar, "Look, Maw," 5, 13.

86. On the parallel between the news media and science in the use of "objectivity" as a shield for male self-interest, see David Croteau and William Hoynes, "Men and the News Media: The Male Presence and Its Effect," in *Men, Masculinity, and the Media,* ed. Steve Craig (Newbury Park, Calif.: Sage Publications, 1992), 154–68.

87. Evelyn Fox Keller, *Reflections on Gender and Science* (New Haven and London: Yale University Press, 1985), 76–77.

88. Ibid., 79.

89. Hicks, *Words and Pictures,* 15.

90. Transcript of 1959 television interview, reprinted in "The Photojournalist," *Infinity* 8 (May 1959): 21. The show was one in a series produced by station WGBH-TV, Boston, under a grant from the Fund for the Republic.

91. Hamblin, *That Was the Life,* 48–67.

92. Hicks, *Words and Pictures,* 145–59.

93. Henri Cartier-Bresson, *The Decisive Moment* (New York: Simon and Schuster, 1952), n.p.

94. Hicks, *Words and Pictures,* 13.

95. Siegfried R. Gutterman, "Photography Is Art," *Minicam Photography* 9 (August 1946): 68. Hostility toward those men who chose a bohemian lifestyle, especially artists and poets, rather than accepting the responsibility of providing for a family originated in the nineteenth century with the emphasis on breadwinning as a marker of masculinity. It was also feared that "manhood itself might be eroded if beauty or sensuality replaced tough realism." Stearns, *Be a Man!* 66–67.

96. Margaret Mead, *Male and Female: A Study of the Sexes in a Changing World* (New York: William Morrow, 1949), 306.

97. Hicks, *Words and Pictures,* 99–100.

98. Russell Lynes, *The Tastemakers* (New York: Harper and Brothers, 1949), 265. On the postwar feminization of art and all "highbrow" culture, see also Leo Gurko, *Heroes, Highbrows, and the Popular Mind* (Indianapolis and New York: Bobbs-Merrill, 1953), 21–83. Gurko, 22, wrote that "at best," culture was "regarded as a harmless pastime for idle females."

99. Alfred C. Kinsey, Wardell B. Pomeroy, and Clyde E. Martin, *Sexual Behavior in the Human Male* (Philadelphia: W. B. Saunders, 1948), 610–66.

100. George W. Henry, *All the Sexes: A Study of Masculinity and Femininity,* with a foreword by David E. Roberts (New York: Rinehart, 1955), 577. The linking of aestheticism with effeminacy and homosexuality can be traced to the late nineteenth century, particularly in the public's reaction to Oscar Wilde during his lecture tour through the United States in 1882

and after his conviction for homosexual conduct in 1895. See Sarah Burns, *Inventing the Modern Artist: Art and Culture in Gilded Age America* (New Haven and London: Yale University Press, 1996), 89–100.

101. Pierre Bourdieu, *The Field of Cultural Production: Essays on Art and Literature,* ed. and with an introduction by Randal Johnson (New York: Columbia University Press, 1993), 40–43, characterizes this conflict as one between the "heteronomous principle," which seeks economic and political privilege, and the "autonomous principle," which sees itself as somewhat independent of the economic sphere, to the point of regarding financial success as a "sign of compromise." Bourdieu maintains that this hierarchical struggle defines all artistic fields.

102. Cynthia Cockburn, *Brothers: Male Dominance and Technological Change* (London: Pluto Press, 1983), 132–33 (emphasis in the original).

103. Walter Rosenblum, "Some Thoughts about the Photo League," *Photo Notes* (November 1947): 7.

104. Andreas Huyssen, "Mass Culture as Woman: Modernism's Other," in *Studies in Entertainment: Critical Approaches to Mass Culture,* ed. Tania Modleski (Bloomington and Indianapolis: Indiana University Press, 1986), 188–207.

105. Packard, *The Status Seekers,* 110–13.

106. Mills, *White Collar,* 150, 156–57.

107. The details of Adams's speech were reported by Lester Talkington in "Ansel Adams at the Photo League," *Photo Notes* (March 1948): 4–6.

108. Minor White, "The Pursuit of Personal Vision," editorial, *Aperture* 4, no. 1 (1956): 3. As White later recalled, *Aperture* was founded in opposition to the Pictorial Society of America's journal. *Dialogue with Photography,* ed. Paul Hill and Thomas Cooper (New York: Farrar, Straus and Giroux, 1979), 354–55.

109. Ansel Adams, "The Profession of Photography," *Aperture* 1, no. 3 (1952): 13, 3.

110. Ibid., 3.

111. Ansel Adams, "Pictures That Speak," *Infinity* 9 (February 1960): 12, 18, 22. The question of whether or not photographers should be licensed was debated throughout the postwar era. For a summary of the arguments against licensing, see Oliver W. Marvin, "Should Photographers Be Licensed?" *American Photography* 42 (March 1948): 164–65.

112. Packard, *The Status Seekers,* 29–45.

113. Letter from Ansel Adams to Minor White, 23 June 1952, Ansel Adams Archive, CCP (emphasis in the original).

114. Letter from Ansel Adams to Martin Harris, 20 May 1950; letter from Ansel Adams to Philippe Halsman, 17 April 1954, both Ansel Adams Archive, CCP. The boundary separating photography as work from photography as art has always been a precarious and thus contested one because of the medium's dependence on industrial and scientific processes and apparatuses. See Steve Edwards, "Photography, Allegory, and Labor," *Art Journal* 55 (Summer 1996): 38–44.

115. Ansel Adams, address to the Bay Area Photographers at the California School of Fine Arts in San Francisco, pre-1958 (audiotape), Ansel Adams Archive, CCP. Adams, who was an aspiring musician before he took up photography, was a member of an "old" and once-prosperous San Francisco lumber family, which had gradually lost its fortune during his childhood. Ansel Adams, with Mary Street Alinder, *Ansel Adams: An Autobiography* (Boston: Little, Brown, 1985), 4–6, 39–47.

116. Adams, as quoted in Christina Page, "The Man from Yosemite: Ansel Adams," *Minicam Photography* 10 (September–October 1946): 42.

117. Business and financial records, 1928–1983, Ansel Adams Archive, CCP. Other major sources of income were reproduction fees and book royalties. In addition to his deals with Polaroid and Eastman Kodak, Adams received equipment from Hasselblad Cameras in exchange for the use of his name and his photographs in their advertising promotions. Among his corporate clients were Kennecott Copper, Bank of America California, IBM, Rohm and Haas Company of Philadelphia, Varian Associates, Bell Telephone, Standard Oil Company, and the California Packing Corporation. His work appeared in their annual reports, booklets, magazines, and advertisements. He also sold his photographs for use in calendars and was a frequent contributor to the travel magazines *Arizona Highways, Holiday,* and *Motorland* and to the business periodical *Fortune.*

118. Hicks, *Words and Pictures,* xiii, 34, 104.

119. Arrowsmith, "Why Exhibit?" 5.

120. Adams, *An Autobiography,* 112.

121. Minor White, "Your Concepts Are Showing," *American Photography* 45 (May 1951): 291–92, 295, 296.

122. Letter from Ansel Adams to Edwin Land, 12 March 1956, in *Ansel Adams: Letters and Images, 1916–1984,* ed. Mary Street Alinder and Andrea Gray Stillman, with a foreword by Wallace Stegner (Boston: Little, Brown, 1988), 233–34.

123. Ellen Handy, "Genius Loci, Ingenious Locations, and Landscape Photography Today: Nostalgia, Femininity, and Looking toward the Millennium," *Camerawork* 23 (Fall–Winter 1996): 5.

124. Beaumont Newhall, *The History of Photography from 1839 to the Present Day* (New York: Museum of Modern Art, 1949), 158. See also Edward Weston, "What Is Photographic Beauty?" (1936), *American Photography* 45 (December 1951): 739–43.

125. Deborah Bright, "Of Mother Nature and Marlboro Men: An Inquiry into the Cultural Meanings of Landscape Photography," in *The Contest of Meaning: Critical Histories of Photography,* ed. Richard Bolton (Cambridge: MIT Press, 1989), 137–38.

126. Ibid., 128–29.

127. Siskind, unpublished statement, 1954; quoted in Beaumont Newhall, *The History of Photography from 1839 to the Present Day,* rev. ed. (New York: Museum of Modern Art, with the George Eastman House, 1964), 199.

128. Abigail Solomon-Godeau, "The Armed Vision Disarmed: Radical Formalism from Weapon to Style" (1983), in *Photography at the Dock: Essays on Photographic History, Institutions, and Practices,* with a foreword by Linda Nochlin (Minneapolis: University of Minnesota Press, 1991), 80–82.

129. Siskind, quoted in "Where I Find My Pictures," *Modern Photography* 22 (February 1958): 149.

130. Minor White, editorial, *Aperture* 7, no. 4 (1959): 135.

131. Letters from Ansel Adams to Nancy Newhall, 28 August 1945 and 2 September 1945. In a letter to Nancy Newhall, 5 September 1945, Adams wrote that he did not want anything included in the exhibition that "isn't Edward at his greatest and clearest and most *potent*" (emphasis mine). All Beaumont and Nancy Newhall Archive, CCP.

132. Letter from Ansel Adams to Nancy Newhall, 11 September 1945, Beaumont and

Nancy Newhall Archive, CCP. There is no doubt that Adams feared "contaminating" a member of his fiercely defended lineage with pictorialism. The photographs in question do resemble pictorialist works from the period: staged tableaus, some with painted backdrops, cats on boxes and in baskets, and so on.

133. Charles S. Martz, "When Is a Pictorial Photograph Pictorial?" *Camera* 67 (August 1945): 34–38, 98–99; Raymond E. Hanson, "The Classification of Creative Work," *American Photography* 44 (February 1950): 22–24; "Pictorialism Today, Part I: A Portfolio of Prints from Adolf Fassbender," interview, *American Photography* 46 (February 1952): 35–41, 54.

134. Quoted in "Pictorialism Today, Part II," *American Photography* 46 (April 1952): 51.

135. Sey Chassler, "Is Photography an Art?" *Infinity* 8 (June 1959): 4–6, 24. The show was also criticized because photographers had not been invited to submit their own work. See the editorial "The Day Photography Was Kicked in the Head," *Modern Photography* 23 (August 1959): 45, 108, 114.

136. Ray Shorr, "Grapevine," *Infinity* 9 (May 1960): 20.

137. Photography Department exhibition records, Museum of Modern Art Archives, New York.

138. Edward Steichen, "Freedom and the Artist," in *A Life in Photography* (Garden City, N.Y.: Doubleday, with the Museum of Modern Art, 1963), 15.

139. Ebria Feinblatt, introduction to *Photography Mid-Century* (Los Angeles: Los Angeles County Museum, 1950), 8.

140. Beaumont Newhall, "Photography at Mid-Century," in *Photography at Mid-Century: Tenth Anniversary Exhibition* (Rochester, N.Y.: George Eastman House, 1959), n.p. In his *History of Photography from 1839 to the Present Day* (1949 ed.), 143, Newhall had also downplayed Stieglitz's years as a pictorialist, arguing that even though Stieglitz had been an advocate and practitioner of pictorialism, he was actually a "straight" photographer at heart, preferring "all his life to stick closely to the basic properties of camera, lens and emulsion." This book was instrumental in creating photography's artistic canon.

141. Hearn, *The Gender of Oppression*, 132–33.

142. Dody, "Weston, Strand, Adams," *American Photography* 45 (January 1951): 48.

143. Beaumont Newhall, "Program of the Department," *Bulletin of the Museum of Modern Art* 8, no. 2 (December–January 1940–41): 4.

144. Phillips, "The Judgment Seat of Photography," 37.

145. Beaumont Newhall, "The Exhibition: Sixty Photographs," *Bulletin of the Museum of Modern Art* 8, no. 2 (December–January 1940–41): 5.

146. "Museum of Modern Art Exhibits Official Photographs of Naval Sea and Air Action in the Pacific," press release, 24 January 1945, Museum of Modern Art Archives, New York.

147. "Edward Steichen Appointed Head of Photography at Museum of Modern Art," undated 1947 press release, Museum of Modern Art Archives, New York.

148. The money never actually materialized. Letter from Nancy Newhall to Ansel Adams, 22 June 1947, Beaumont and Nancy Newhall Archive, CCP.

149. Letter from Ansel Adams to Nancy Newhall, 7 January 1946, in Alinder and Stillman, *Ansel Adams: Letters and Images,* 166.

150. *Aperture* 1, no. 1 (1952): 2.

151. Phillips, "The Judgment Seat of Photography," 48.

152. On the design and preparation for the exhibition, see Eric J. Sandeen, *Picturing an*

Exhibition: The Family of Man and 1950s America (Albuquerque: University of New Mexico Press, 1995), 39–75.

153. Quoted in Phillips, "The Judgment Seat of Photography," 48, note 48.

154. Walter Rosenblum et al., "What Is Modern Photography?" Symposium at the Museum of Modern Art, 20 November 1950, *American Photography* 45 (March 1951): 148. Over five hundred people attended the symposium, which was recorded for overseas broadcast by the U.S. State Department's Voice of America and broadcast live by a New York City radio station.

155. Edward Steichen, "The Museum of Modern Art and 'The Family of Man,'" in *A Life in Photography,* 17.

156. Bruce Downes, "Angle of View," *Popular Photography* 22 (August 1948): 149.

157. Gee, *Limelight,* 156.

158. Mills, *White Collar,* 159–60.

159. [Minor White], "Photographs in Boxes," *Aperture* 7, no. 1 (1959): 22–24. For the importance of admiration and acceptance by one's peers, rather than by museums or collectors, in the "consecration" of a photographic "virtuoso" and in ascribing the status of "artist" to a photographer, see Jean-Claude Chamboredon, "Mechanical Art, Natural Art: Photographic Artists," in Pierre Bourdieu with Luc Boltanski, Robert Castel, Jean-Claude Chamboredon, and Dominique Schnapper, *Photography: A Middle-Brow Art* (1965), trans. Shaun Whiteside (Stanford: Stanford University Press, 1990), 146–47.

2. Combat Photography

1. *Rear Window* was produced and directed by Alfred Hitchcock, and written by John Michael Hayes after a novel by Cornell Woolrich.

2. David Savron, *Communists, Cowboys, and Queers: The Politics of Masculinity in the Work of Arthur Miller and Tennessee Williams* (Minneapolis: University of Minnesota Press, 1992), 18–19.

3. C. Wright Mills, *White Collar: The American Middle Classes* (New York: Oxford University Press, 1951), xvi, xii.

4. William H. Whyte Jr., *The Organization Man* (New York: Simon and Schuster, 1956), 5–7.

5. Mark Strage, "Magazine Photography—What's New?" *Infinity* 8 (January 1959): 7.

6. Sey Chassler, "The Creative Photographer in the Cold Cruel World," *Infinity* 3 (1954): 4–5, 53.

7. Cynthia Cockburn, *Brothers: Male Dominance and Technological Change* (London: Pluto Press, 1983), 139.

8. On the postwar "man of action's" contemptuous feelings toward the "intellectual," see Murray Kempton, "The Professor" (1957), in *America Comes of Middle Age: Columns, 1950–1962* (Boston: Little, Brown, 1963), 53–55.

9. The words "hard," "rough," and "tough" permeate a Lou Jacobs Jr. article on a *Life* photographer's expedition to the North Pole: "George Silk Does It the Hard Way," *Popular Photography* 37 (December 1955): 84–89, 170–74. For the equating of photography with danger and adventure, see also Karl O. Townsend, "Pictures: Dangerous and Otherwise," *American Photography* 42 (March 1948): 152–54; Herbert C. Lanks, "Hunting and Fishing with Rod, Gun, and Camera," *American Photography* 43 (November 1949): 702–3; and John Chapman and Ira Latour, "Join the Army and Shoot the World," *Photography* 34 (February 1954): 64–65, 95.

10. Martin Green, *The Adventurous Male: Chapters in the History of the White Male Mind* (University Park: Pennsylvania State University Press, 1993), 6, 103.

11. Jacquelyn Judge, "Magnum," *Minicam Photography* 12 (April 1949): 42.

12. Susan D. Moeller, *Shooting War: Photography and the American Experience of Combat* (New York: Basic Books, 1989), 126. On the history of war photography, see also Frederick S. Voss, *Reporting the War: The Journalistic Coverage of World War II* (Washington and London: Smithsonian Institution Press, 1994), 41–79; Jorge Lewinski, *The Camera at War: A History of War Photography from 1848 to the Present Day* (London: Octopus Books, 1986); Frances Fralin, *The Indelible Image: Photographs of War—1846 to the Present,* with an essay by Jane Livingston (New York: Harry N. Abrams; Washington, D.C.: Corcoran Gallery of Art, 1985); and Robert E. Hood, *Twelve at War: Great Photographers under Fire* (New York: G. P. Putnam's Sons, 1967).

13. Moeller, *Shooting War,* 182–83. On *Life* correspondents, see "Preface: A Salute," in *Life's Picture History of World War II* (New York: Time, 1950), v–vi.

14. According to Ulrich Keller, "Photojournalism around 1900: The Institutionalization of a Mass Medium," in *Shadow and Substance: Essays on the History of Photography,* ed. Kathleen Collins (Bloomfield Hills, Mich.: Amorphous Institute Press, 1990), 283–99, the determination to serve the public at any cost was built into the profession of photojournalism from the beginning, and from this professional ideology arose the linkage of danger and credibility in war photography.

15. Samuel A. Stouffer et al., *The American Soldier: Combat and Its Aftermath,* vol. 2, *Studies in Social Psychology in World War II* (Princeton: Princeton University Press, 1949), 131–32, 149–51. S. L. A. Marshall, in *Men against Fire: The Problem of Battle Command in Future War* (New York: William Morrow, 1947), 148–49, wrote that "personal honor" was valued by the soldier more than "life itself" and that to flee from danger in combat would be considered the "final act of cowardice and of dishonor." According to the psychologist Barry McCarthy, in "Warrior Values: A Socio-Historical Survey," in *Male Violence,* ed. John Archer (London and New York: Routledge, 1994), 105–20, the "intimate bond" between "warrior values" and "conventional notions of masculinity" is "almost universal." The four primary values are physical courage, endurance, strength and skill, and honor.

16. Ray Raphael, *The Men from the Boys: Rites of Passage in Male America* (Lincoln: University of Nebraska Press, 1988), xvi.

17. Ibid., 12.

18. James McBride, *War, Battering, and Other Sports: The Gulf between American Men and Women* (Atlantic Heights, N.J.: Humanities Press, 1995), 54.

19. Tom Maloney, "The U.S.A. at War," in *U.S. Camera Annual 1945: The U.S.A. at War* (New York: U.S. Camera Publishing, 1944), 8–9. The U.S. Strategic Bombing Survey concluded that approximately 85 percent of all Allied intelligence had been derived from aerial photography. "Wings, Guts, and a Lens," *Flying* 49 (November 1951): 137. See also C. A. Harrison, "Wartime Versatility in Aerial Cameras," *American Photography* 39 (March 1945): 18–21. Photo reconnaissance became even more sophisticated during the Korean War, which relied heavily on pinpoint bombing. See "War Territory Photos Radioed from Planes," *Science News Letter* 59 (January 27, 1951): 54; "New Gun Camera Aids Air Corps," *American Photography* 45 (April 1951): 245; "Photo Reconnaissance: Eyes of the Air Force," *Flying* 48 (May 1951): 124–25, 168; "Cameras over Korea," *Flying* 48 (May 1951): 126–27, 176–78; "Speaking of Pictures," *Life* 31 (July 9, 1951): 6–7; Col. George W. Goddard, "Our Eyes Aloft Spy Out the

Enemy," 2 parts, *Popular Mechanics* 54 (October 1951): 97–102, and (November 1951): 141–45, 246–54; Harry Lever, "Strat Recon + Technical Aids = 'Pinpoint' Bombing," *Flying* 50 (April 1952): 16–17, 56–57; and "Photographs Snapped as Plane Gun Starts Firing," *Science News Letter* 62 (October 4, 1951): 213.

20. Silk, quoted in Moeller, *Shooting War*, 200. On *Life*'s coverage of World War II, see Loudon Wainwright, *The Great American Magazine: An Inside History of "Life"* (New York: Alfred A. Knopf, 1986), 121–59.

21. The most comprehensive study to date on World War II military photographers is Peter Maslowski, *Armed with Cameras: The American Military Photographers of World War II* (New York: Free Press, 1993).

22. Sgt. Marion Hargrove, "In Memoriam—Sgt. John Bushemi," in *U.S. Camera Annual 1945*, 66.

23. S. W. Morris, "Combat Cameramen," *Camera* 67 (October 1945): 26 (emphasis in the original).

24. "Roll of Honor: War's Combat Photographers," in *U.S. Camera Annual 1945*, 296–97.

25. Smith was in the process of shooting when shrapnel hit him, tearing through his jaw. Smith captured on film the mortar explosion responsible, and the image is reproduced in Jim Hughes, *W. Eugene Smith: Shadow and Substance: The Life and Work of an American Photographer* (New York: McGraw-Hill, 1989). On Smith's injury, see also Barbara Green, "W. Eugene Smith," *Camera* 68 (September 1946): 20–25.

26. Tom Maloney, "Combat Cameramen," in *U.S. Camera Annual 1946: The Victory Volume*, ed. Tom Maloney (New York: U.S. Camera Publishers, 1945), 370–76, 429. Maloney was also a war correspondent. In "Over Tokyo in a B-29," in the same volume, 13–15, 422–24, he recounts his own courage in battle, when he became the first correspondent to make a B-29 photo-reconnaissance trip over Tokyo. On the combat cameraman as "true hero" during the Korean War, see Tom Maloney, "Korea—and the Unsung Combat Cameraman," *U.S. Camera* 16 (August 1953): 43–45, 101.

27. See John Hersey, "The Man Who Invented Himself" (1947), reprinted in *Robert Capa, 1913–1954*, ed. Cornell Capa (New York: International Fund for Concerned Photography/Grossman Publishers, 1974), 14–18.

28. Robert Capa, *Slightly out of Focus* (New York: Henry Holt, 1947), 48.

29. Ibid., 32.

30. Ibid., 242–43.

31. Quoted in Richard Whelan, *Robert Capa: A Biography* (New York: Alfred A. Knopf, 1985), 181.

32. Capa, *Slightly out of Focus*, 25.

33. Whelan, *Robert Capa*, 194–96.

34. Capa, *Slightly out of Focus*, 69–70.

35. Ibid., 144.

36. "Beachheads of Normandy: The Fateful Battle for Europe Is Joined by Sea and Air," *Life* 16 (19 June 1944): 27.

37. According to Whelan, *Robert Capa*, 214, excessive heat in the drying cabinet had melted the film emulsion on the negatives. Out of seventy-two images, only eleven were printable.

38. Ibid., 244.

39. Capa was the model for the debonair world-traveling *Life* photographer Matt Cole, a character in the Fay Kanin play *Goodbye, My Fancy,* which opened in New York on

17 November 1948. In 1951, Warner Brothers released a film version of the play, directed by Vincent Sherman, produced by Henry Blanke, and with screenplay by Ivan Goff and Ben Roberts.

40. For responses to Capa's death, see John Morris, "An Appreciation: Robert Capa, Werner Bischof," *Infinity* 3 (May 1954): 5; "A Great War Reporter and His Last Battle," *Life* 36 (7 June 1954): 27–33; John Steinbeck, "Robert Capa: A Memorial Portfolio," *Popular Photography* 35 (September 1954): 48–53, and "Death with a Camera," *Picture Post* 63 (12 June 1954): 5; Irwin Shaw, "Robert Capa's Last Assignment—Retreat in Indo-China," *Picture Post* 63 (12 June 1954): 15–17; and Jozefa Stuart, "'That's How It Was'—Capa," *Infinity* 9 (May 1960): 8–10.

41. On Bischof, see Morris, "An Appreciation," 6–7. On Bischof and Capa, see also "In Memoriam," *U.S. Camera Annual 1955*, ed. Tom Maloney (New York: U.S. Camera Publishing, 1954), 184–93. On Seymour, see John Morris, "The World of David Seymour," *Infinity* 6 (Winter 1957): 8–11, 13; and Mary P. R. Thomas, "Chim," *Camera 35* 1, no. 1 (1957): 68. For a tribute to Capa, Bischof, and Seymour, see *Picture: ASMP Picture Annual,* ed. Jerry Mason (New York: Ridge Press, 1957), 184–85, which opens: "They lived with their cameras and died with them, photographers to the last. But first they were men."

42. Frederic Sondern Jr., "Dave Duncan and His Fighting Camera," *Reader's Digest* 58 (May 1951): 45. On Duncan and the Korean War, see also Peter Pollack, *The Picture History of Photography, from the Earliest Beginning to the Present Day* (New York: Harry N. Abrams, 1962), 388–403.

43. Bruce Downes, "Assignment: Korea," *Popular Photography* 28 (March 1951): 98.

44. "U.S. Camera Achievement Awards, 1950," *U.S. Camera* 13 (December 1950): 39–45; "U.S. Camera Awards Presented," *U.S. Camera* 14 (January 1951): 63–65, 83–87.

45. "Speaking of Pictures: These Are by *Life*'s David Duncan, New Star Reporter Now Covering Korea," *Life* 29 (24 July 1950): 16–17.

46. "'Thunderbolts along My Spine': *Life*'s David Douglas Duncan Describes Jet Fighter Strike Which He Photographed from a Combat Plane at 600 MPH," *Life* 29 (17 July 1950): 28–31.

47. David Douglas Duncan, *This Is War! A Photo-Narrative in Three Parts* (New York: Harper and Brothers, 1951), n.p. Duncan's photographs were initially published in "This Is War," *Life* 29 (18 September 1950): 41–47, and "There Was a Christmas," *Life* 29 (25 December 1950): 8–15.

48. Allan Sekula, in "The Instrumental Image: Steichen at War," *Artforum* 14 (December 1975): 26–35, points out that the "myth" of the war photographer is that he "transcends complicity and politics" because as an "'innocent' witness," his "sympathies" are believed to be "universal" (32).

49. For the controversy over Capa's photograph, see Caroline Brothers, *War and Photography: A Cultural History* (London and New York: Routledge, 1997), 178–84; Philip Knightley, *The First Casualty, from the Crimea to Vietnam: The War Correspondent as Hero, Propagandist, and Myth Maker* (New York: Harcourt Brace Jovanovich, 1975), 209–12; and Lewinski, *The Camera at War,* 88–92.

50. Green, *The Adventurous Male,* 133.

51. Maloney, "The U.S.A. at War," 9.

52. The term "containment" was first used by George F. Kennan, director of the U.S. State

Department's Policy Planning Staff, in his article "The Sources of Soviet Conduct," *Foreign Affairs* 25 (July 1947): 572–76, 580–82.

53. Arthur Schlesinger Jr., *The Vital Center: The Politics of Freedom* (Boston: Houghton Mifflin, 1949), 52.

54. A number of war photography exhibitions toured the nation in 1945, including some funded by private corporations to advertise their contributions to the war effort. The United States Steel Corporation sponsored a show of sixty photographs, which was viewed by over one million spectators. See "Steel Goes to War," *American Photography* 39 (April 1945): 28–29. Graflex, a camera company, sponsored Photography at War, an exhibition held at the Museum of Science and Industry in New York, and Graflex Sees the War, exhibits of war photographs that toured the country in conjunction with war-bond drives. These exhibitions were promoted in advertisements that appeared in a number of different photography journals. The ads emphatically stressed the important role that photography, and thus corporate producers of photographic equipment, played in the waging of war. In addition to Graflex, the Fairchild Camera and Instrument Corporation, Kodak, and the Universal Camera Corporation all highlighted their war contributions.

55. On Steichen's Navy commission and the formation of his band of officer-photographers, see Christopher Phillips, *Steichen at War* (New York: Harry N. Abrams, 1981), 20–27, 46; and Maslowski, *Armed with Cameras,* 213–19. Steichen would compile another group of Navy photographs for *U.S. Navy War Photographs: Pearl Harbor to Tokyo Harbor* (New York: U.S. Camera Publishing, 1947).

56. "Museum of Modern Art Exhibits Official Photographs of Naval Sea and Air Action in the Pacific," press release, 24 January 1945, exhibition records, Museum of Modern Art Archives, New York.

57. Edward Steichen, "World War II: Adventures in the Pacific," in *A Life in Photography* (Garden City, N.Y.: Doubleday, with Museum of Modern Art, 1963), 12.

58. Catherine Tuggle, "Edward Steichen: War, History, and Humanity," *History of Photography* 17 (Winter 1993): 365.

59. Power in the Pacific, exhibition records, Museum of Modern Art Archives, New York.

60. Edward Steichen, interview by Wayne Miller (1954), reprinted in *Wisdom: Conversations with the Elder Wise Men of Our Day,* ed. and with an introduction by James Nelson (New York: W. W. Norton, 1958), 41.

61. Susan Jeffords, *The Remasculinization of America: Gender and the Vietnam War* (Bloomington and Indianapolis: Indiana University Press, 1989), 59–60. The World War II military was still segregated by race; thus, not all men were the "same." Still, boundaries of class, region, and ethnicity were suspended in service of the masculine bond. By the time of the Vietnam War, Jeffords writes, the effacement of racial boundaries had become a central focus of war narratives and memoirs. In fact, she relates a number of cases in which U.S. soldiers felt a stronger sense of comradeship with the Vietcong (because they too were soldiers) than with the civilians back in the United States (54–62).

62. Klaus Theweleit, *Male Fantasies,* vol. 2, *Male Bodies: Psychoanalyzing the White Terror,* trans. Erica Carter and Chris Turner, with a foreword by Anson Rabinbach and Jessica Benjamin (Minneapolis: University of Minnesota Press, 1989), 81–82. Theweleit's two-volume work, which is the most extensive investigation to date into the psyche of what he termed the "soldier male," is based on his examination of the novels, letters, and memoirs of the German

Freikorps—small bands of private volunteer soldiers that roamed Germany in the aftermath of World War I. Many of these men would play an active role in the rise of Nazism. Theweleit used their artifacts to theorize the fascist imagination, which he suggested may be "the norm for males living under capitalist-patriarchal conditions" (27). He saw the development of the fascist male as part of a wider history, one that began with early modern Europe and the emergence of the bourgeois individual: the "civilized" male. McCarthy, "Warrior Values," 105–20, identifies a similar historical trajectory, one that culminated at the turn of the twentieth century, when the warrior ideal was renewed and "manly" masculinity was equated with "warrior values." A post–World War II study based on a series of surveys conducted on U.S. subjects, published in T. W. Adorno, Else-Frenkel-Brunswick, Daniel J. Levinson, and R. Nevitt Sanford in collaboration with Betty Aron, Maria Hertz Levinson, and William Morrow, *The Authoritarian Personality* (New York: Harper and Brothers, 1950), concluded that a potential for fascism can be detected in a person's personality and that the greatest potential was exhibited by those who valued extreme masculine traits.

63. Sigmund Freud, "Beyond the Pleasure Principle" (1920), in *The Standard Edition of the Complete Psychological Works of Sigmund Freud,* trans. James Strachey, 24 vols. (London: Hogarth Press, 1953–66), 18: 1–64.

64. J. Glenn Gray, *The Warriors: Reflections on Men in Battle* (New York: Harcourt, Brace, 1959), 233, 206, 237.

65. Ibid., 28–29, 33. For the libidinal structure of the military, which ties the individual members into a collective, a brotherhood, see Sigmund Freud, "Group Psychology and the Analysis of the Ego" (1921), in *Standard Edition,* 18: 93–99. On warfare and male desire, see Adam Farrar, "War: Machining Male Desire," in *War/Masculinity,* ed. Paul Patton and Ross Poole (Sydney: Intervention Publications, 1985), 59–70. Like Theweleit and Gray, Farrar considers the appeal of war to be the obliteration of the subject-object dualism.

66. Edward Steichen, *The Blue Ghost: A Photographic Log and Personal Narrative of the Aircraft Carrier U.S.S. Lexington in Combat Operation* (New York: Harcourt, Brace, 1947), 149. A motion picture about the ship, *The Fighting Lady,* was filmed by Dwight Long under Steichen's supervision. The ship was also nicknamed "the Blue Ghost" because the enemy so often claimed to have sunk it. Phillips, *Steichen at War,* 35.

67. Steichen, *The Blue Ghost,* 11. In the exhibition catalog accompanying Power in the Pacific, the carrier is referred to as a "nest" to which the "eagles" (planes) return. U.S. Navy, *Power in the Pacific: A Dramatic Sequence of Official Navy, Coast Guard, and Marine Corps Photographs Depicting the Men, the Sea, the Ships and Planes, Bombardments, Landing Operations, and Attacks on the Enemy's Fleet,* designed and directed by Capt. Edward J. Steichen, with text by Lt. Roark Bradford (New York: William E. Rudge's Sons, for the Museum of Modern Art, 1945), 25. The famed correspondent Ernie Pyle served on a carrier nicknamed "the Iron Woman," the dwelling place of "over 1000 men," who "put their ship above their captain. They saw captains come and go, but they and the ship stayed on forever." Ernie Pyle, *The Last Chapter* (New York: Henry Holt, 1946), 58–59. During the war, my own father served on the U.S.S. *Nassau,* which was affectionately referred to as "the Princess."

68. Steichen, *The Blue Ghost,* 58. According to McCarthy, "Warrior Values," 107, the greatest "pleasures and satisfactions" that twentieth-century warriors report are associated with comradeship.

69. For a contemporary analysis of the way the homosocial environment of the military allows "straight" men to experience physical and emotional closeness, including male-male

sexual activity, without considering themselves or being considered by others to be "gay," see Steven Zeeland, *Sailors and Sexual Identity: Crossing the Line between "Straight" and "Gay" in the U.S. Navy* (New York: Haworth Press, 1995), and *The Masculine Marine: Homoeroticism in the U.S. Marine Corps* (New York: Haworth Press, 1996).

70. Duncan, *This Is War!,* n.p. On the origins of the tattoo as a signifier of masculine identity and membership in a select brotherhood, see Simon P. Newman, "Wearing Their Hearts on Their Sleeves: Reading the Tattoos of Early American Seafarers," in *American Bodies: Cultural Histories of the Physique,* ed. Tim Armstrong (New York: New York University Press, 1996), 18–31. On the importance of tattoos to sailors, see also Samuel M. Steward, *Bad Boys and Tough Tattoos: A Social History of the Tattoo with Gangs, Sailors, and Street-Corner Punks, 1950–1965* (New York and London: Harrington Park Press, 1990), esp. 102–12.

71. Elaine Scarry, *The Body in Pain: The Making and Unmaking of the World* (New York: Oxford University Press, 1985), 128.

72. McBride, *War, Battering, and Other Sports,* 111–12.

73. Steichen, *The Blue Ghost,* 99.

74. McBride, *War, Battering, and Other Sports,* 135–36.

75. As Freud argues in "Medusa's Head" (1922), *Standard Edition,* 18: 274, "To display the penis (or any of its surrogates) is to say: 'I am not afraid of you. I defy you. I have a penis.'" Cameras were also fetishized as weapons. In June 1945, Kodak began advertising its new aerial lens, which it named Big Boy. During the Korean War, Bob Schwalberg, in "Army Unveils 70-mm Camera," *ASMP News* 1 (May 1952), 5, referred to a new Signal Corps "semi-automatic" camera as a "weapon" that can fire "as many as 10 consecutive single shots in as little as 5 seconds."

76. Catherine A. MacKinnon, *Toward a Feminist Theory of the State* (Cambridge, Mass.: Harvard University Press, 1989), 178.

77. Theweleit, *Male Bodies,* 179–81.

78. Gray, *The Warriors,* 81, 177–79.

79. So reads the original caption, as reprinted in Fralin, *The Indelible Image,* 172.

80. McBride, *War, Battering, and Other Sports,* 28. As Julia Kristeva argues in *Powers of Horror: An Essay on Abjection,* trans. Leon S. Roudiez (New York: Columbia University Press, 1982), the "abject," that which is loathed because it is impure, is associated with the feminine, that which threatens to dissolve the ego.

81. Theweleit, *Male Bodies,* 76–77.

82. Pyle, *The Last Chapter,* 5. Of course, unlike the Germans and the Italians, the Japanese had attacked the actual territory of the United States; however, this alone does not explain the dehumanization, which would, of course, culminate in the annihilation of thousands of Japanese people at Hiroshima and Nagasaki. One of the surveys published in Stouffer et al., *The American Soldier,* 34, reveals that among those training for combat, 38 to 44 percent said they would "really like to kill a Japanese soldier," whereas only 5 to 9 percent felt the same way about a German one. In another survey, which asked soldiers what they would like to see happen to the enemy after the war, 67 percent of enlisted men answered that they would like to "wipe out" the entire Japanese nation, but only 29 percent said the same thing about the Germans. For officers, the answer was 44 and 15 percent, respectively (158).

83. Halsey, quoted in Paul Fussell, *Wartime: Understanding and Behavior in the Second World War* (New York and Oxford: Oxford University Press, 1989), 116.

84. Theweleit, *Male Bodies,* 75–76. John W. Dower, *War without Mercy: Race and Power*

in the Pacific War (New York: Pantheon Books, 1986), 153–54, traces the characterization of the Japanese as a "primitive" group, analogous to women, to recapitulationist theory, which developed in the mid-nineteenth century.

85. McBride, *War, Battering, and Other Sports,* 147.

86. W. Eugene Smith, "The Battlefield of Iwo: An Ugly Island Becomes a Memorial to American Valor," *Life* 18 (9 April 1945): 93–101, and "Iwo Jima," in *U.S. Camera Annual 1946,* 164–95. Other Iwo Jima photographs by Smith were published in "Marines Win Bloody, Barren Sands of Iwo," *Life* 18 (12 March 1945): 34–37. Smith's Iwo Jima photographs were exhibited in 1946 in shows of Smith's war photographs sponsored by the ASMP and the New York Camera Club.

87. *W. Eugene Smith: His Photographs and Notes,* with an afterword by Lincoln Kirstein (New York: Aperture Foundation, 1969), n.p.

88. W. Eugene Smith, war correspondence: *Life* no. 4, Iwo Jima, March 1945; and eyewitness report from S. Sgt. David Dempsey, Photographic Essay Project files, 1944–46, W. Eugene Smith Archive, CCP.

89. Of course, Smith was also there. Tom Maloney, "Wonderful Smith," in *U.S. Camera Annual 1946,* 372, described Smith as "rash to the point of insanity," a photographer who always shoots "with his neck out."

90. Theweleit, *Male Bodies,* 178.

91. Karal Ann Marling and John Wetenhall, *Iwo Jima: Monuments, Memories, and the American Hero* (Cambridge, Mass.: Harvard University Press, 1991), 39.

92. On the base of the Marine Corps Memorial are inscribed the words of Adm. Chester W. Nimitz: "Among the Americans who served on Iwo island, uncommon valor was a common virtue."

93. Moeller, *Shooting War,* 21.

94. Only one hundred Japanese prisoners were taken; the rest were "wiped out." "Iwo Jima," *U.S. Camera Annual 1946,* 424.

95. Knightley, *The First Casualty,* 295, note. In 1960, *U.S. Camera* voted it one of the top twenty-five U.S. photographs of all time. Julia Newman, "Twenty-Five Great American Photographs," *U.S. Camera* 23 (January 1960): 62–81.

96. This influential war drama was directed by Allan Dwan, produced by Edmund Grainger, distributed by Republic Pictures, and written by Harry Brown and James Edward Grant.

97. Marling and Wetenhall, *Iwo Jima,* 97.

98. U.S. Navy, *Power in the Pacific,* 26.

99. "Central Pacific Offensive," *U.S. Camera Annual 1945,* 103.

100. René Girard, *Violence and the Sacred,* trans. Patrick Gregory (Baltimore: The Johns Hopkins University Press, 1977), 36.

101. Ibid., 48, 10, 14.

102. *U.S. Camera Annual 1946,* 322–23. Of course, the Japanese were considered subhuman; thus, the reality of "human" death was far easier to repress. For the effect of this dehumanization on exterminationist policies, see Dower, *War without Mercy,* 77–93. On the photographic recording of the bomb blasts and the events leading up to them, see Rachel Fermi and Esther Samra, *Picturing the Bomb: Photographs from the Secret World of the Manhattan Project,* with an introduction by Richard Rhodes (New York: Harry N. Abrams, 1995).

103. Scarry, *The Body in Pain,* 66. On the aestheticization of the atomic bomb blasts, the way the "reality" of death and destruction was eventually displaced by photographic imagery that could be translated through the tradition of the sublime, see Peter B. Hales, "The Atomic Sublime," *American Studies* 32 (Spring 1991): 5–31.

104. Brian Easlea, *Fathering the Unthinkable: Masculinity, Scientists, and the Nuclear Arms Race* (London: Pluto Press, 1983), 92–98, 11–39, 111–12. On the gendering of nuclear weapons, see also Helen Caldicott, *Missile Envy: The Arms Race and Nuclear War* (New York: William Morrow, 1984); Caldicott considers the nuclear arms race to be the result of an exclusively male psychopathology, related to feelings of sexual inadequacy, the constant need to assert virility, and a fascination with death. See also Carol Cohn "'Clean Bombs' and Clean Language," in *Women, Militarism, and War: Essays in History, Politics, and Social Theory,* ed. Jean Bethke Elshtain and Sheila Tobias (Savage, Md.: Rowman and Littlefield, 1990), 33–55; like Easlea, Cohn is particularly interested in metaphors of male birth and creation. She tells of her visits to missile sites and nuclear submarines, when she was repeatedly invited to "pat the missile," as if it were an innocent child (36–37).

105. William L. Laurence, "The Atomic Bomb," reprinted in *U.S. Camera Annual 1946,* 328, 318.

106. Easlea, *Fathering the Unthinkable,* 98–110. Easlea writes that when Japan was told it must surrender unconditionally on 26 July 1945 or face "prompt and utter destruction," atomic weapons were not explicitly mentioned. If Japan had been informed, not only would the Soviets have wanted details, but the Japanese might have surrendered before the weapon could be used. Furthermore, the Soviets planned to enter the war in Asia that month. If they had been victorious, they might have emerged as a significant force in postwar Japan and an even greater rival for world dominance. For a discussion of this argument, which was first publicly articulated in the late 1940s and became more widely accepted in the 1960s, see also Paul Boyer, *By the Bomb's Early Light: American Thought and Culture at the Dawn of the Atomic Age,* with a new preface by the author (Chapel Hill: University of North Carolina Press, 1994), 191–93; and Howard Zinn, *Postwar America: 1945–1971* (Indianapolis and New York: Bobbs-Merrill, 1973), 7–20.

107. The anthropomorphization of nature, the equating of enemy territory to the human body, is strikingly evident in "The War Ends: Burst of Atomic Bomb Brings Swift Surrender of Japanese," *Life* 19 (20 August 1945): 25–38. According to the text that accompanies the photographs, although the Hiroshima bomb "obliterated" that city and the Nagasaki bomb "disemboweled" that city, strategic bombing had already "ripped the guts out of" Japan.

108. Easlea, *Fathering the Unthinkable,* 20.

109. Gray, *The Warriors,* 39.

3. Tough Guys in the City

1. The premiere was produced by Don W. Sharpe and Warren Lewis, directed by Gerald Mayer, and written by William Fay. Ruta Lee played Dolly, and Tom Laughlin played Joey. The last episode of *Man with a Camera* aired on 29 February 1960.

2. Casey was played by Staats Cotsworth and Annie by Lesley Woods.

3. George Harmon Coxe, *The Jade Venus* (1945), reprinted in the author's anthology *Triple Exposure* (New York: Alfred A. Knopf, 1959), 168, 208–9.

4. Mark Finley, "Crime Photography Pays," *Camera* 73 (January 1950): 42–49. The

Brooks Institute in Santa Barbara, California, specialized in crime photography. Its students were referred to as "Brooks men." See Lou Jacobs Jr., "School for Camera Sleuths," *Popular Mechanics* 100 (August 1953): 140–43, 218.

5. Jack Gorman, "So You Want to Be a Press Photographer," *Photography* 33 (July 1953): 42, 126.

6. Peter Lisagor, "The Boys Who Boss the President," *Coronet* 39 (March 1956): 98–99.

7. On the heroic acts performed by news photographers in the air, see John G. Hubbell, "Air Beat," *Flying* 54 (May 1954): 20–21, 38, 40.

8. John J. Floherty, *Shooting the News: Careers of the Camera Men* (Philadelphia and New York: J. B. Lippincott, 1949), vii.

9. The rigid gender divisions in this field are evident in an article on the choosing of the best New York press photographs of 1952 by "14 men and a glamour girl." The men were all editors, and the "glamorous female" was MGM's "sultry-eyed Rita Gam," who had stopped in New York en route to Morocco to do a picture. Jack Downey, "Exclusive: 1952 Best of the New York Press," *Photography* 32 (March 1953): 47–48. Moreover, a number of press associations held beauty pageants to crown a "queen." See Paul Threlfall, "Press Photography," *U.S. Camera* 13 (June 1950): 6; and "Press Photographers Pick Queen," *U.S. Camera* 13 (September 1950): 46–47.

10. Al Martinez and Alex Haley, "Russ Reed: Newsman on the Run," *U.S. Camera* 22 (April 1959): 62–65.

11. An exception was Harriet Plotnick, a Long Island freelance photographer, who learned the trade from her father and brothers. See Harriet Plotnick, "Newscamera-Girl," *Camera* (February 1948): 27–34. Plotnick's nickname was "Tabloid Tillie." William Eckenberg, "News Photography," in Institute of Women's Professional Relations, *Proceedings of the Conference on Photography: Profession, Adjunct, Recreation* (New London: Connecticut College, 1940), 30. Eckenberg also wrote that the future for women was in feature photography, not all-around news photography, for women entered the photographic profession not in "competition" with men but, rather, to "fill gaps" (41).

12. Aron M. Mathieu, "The Hard Boiled School of Photography: The Legend of Skippy Adelman, *PM*'s Picture Ace," *Minicam Photography* 8 (April 1945): 30, 80, 33, 80, 82.

13. James A. Skardon, "He 'Shoots' the News," *Coronet* 45 (April 1959): 92.

14. Gorman, "So You Want to Be a Press Photographer," 127.

15. Edward J. Boylan, "Sneaky-Pete," *Infinity* 8 (November 1959): 11–12. Fully "armed" for Shay would be cameras in his briefcase, his topcoat, his pants, a hollowed-out *Reader's Digest,* and his cigarette lighter, with two more on his car floor and one under the seat. He also carried one under a newspaper for "close-up" confrontations.

16. Edna Hoffman Evans, "Camera Trails," *Nature Magazine* 42 (March 1949): 142. On investigative techniques, see also Ray Shorr, "Pro's Clinic: On Making Candids," *Infinity* 6 (October 1957): 12–13. Developments in police photography also found their way into the private sector. On police photography and its "founding father," Edward F. Burke, who "shoots—and brings 'em back alive," see Bill Davidson, "Cop with a Camera," *Collier's* 128 (5 March 1949): 28, 53–54. Burke was a police officer, FBI agent, and Army investigator before being hired as a consultant for Eastman Kodak, and he was the first person to take photographs of crime scenes to be used as investigative tools.

17. Boylan, "Sneaky-Pete," 13, 26.

18. Quoted in "What Is Modern Photography?" *American Photography* 45 (March 1951): 149.

19. Gilbert Bailey, "Photographer's America," *New York Times Magazine* (31 August 1947): 39.

20. Edward Steichen, interview with Wayne Miller (1954), reprinted in *Wisdom: Conversations with the Elder Wise Men of Our Day,* ed. and with an introduction by James Nelson (New York: W. W. Norton and Company, 1958), 42.

21. William Stott, *Documentary Expression and Thirties America* (New York: Oxford University Press, 1973; reprint, Chicago and London: University of Chicago Press, 1986), 18–25. Social-documentary was considered only one mode of documentary photography. The term "documentary" was used liberally from the 1930s to the 1950s, encompassing almost any type of straight photography, including photojournalism and street photography.

22. James Guimond, *American Photography and the American Dream* (Chapel Hill and London: University of North Carolina Press, 1991), 101–48. On FSA photography, see also James Curtis, *Mind's Eye, Mind's Truth: FSA Photography Reconsidered* (Philadelphia: Temple University Press, 1989); Carl Fleishhauer and Beverly Brannan, eds., *Documenting America, 1935–1943* (Berkeley and Los Angeles: University of California Press, 1988); Pete Daniel, Maren Stange, Sally Stein, and Merry A. Foresta, *Official Images: New Deal Photography* (Washington and London: Smithsonian Institution Press, 1987); and F. Jack Hurley, *Portrait of a Decade: Roy Stryker and the Development of Documentary Photography in the Thirties* (Baton Rouge: Louisiana State University Press, 1972).

23. Lili Corbus Bezner, *Photography and Politics in America: From the New Deal into the Cold War* (Baltimore and London: The Johns Hopkins University Press, 1999), 12.

24. For an overview of the effect of the Cold War on postwar culture, see Stephen J. Whitfield, *The Culture of the Cold War* (Baltimore: The Johns Hopkins University Press, 1991).

25. Richard H. Pells, *The Liberal Mind in a Conservative Age: American Intellectuals in the 1940s and 1950s,* 2d ed. (Middletown, Conn.: Wesleyan University Press, 1989), 96–107.

26. The fear of totalitarianism as a threat to "the American way of life" informs Eric Hoffer, *The True Believer: Thoughts on the Nature of Mass Movements* (New York: Harper and Row, 1951), even though the author claims to be simply explaining the attraction of mass movements rather than warning against them.

27. Bezner, *Photography and Politics in America,* 121.

28. Bezner's analysis of Steichen and The Family of Man complicates the characterization of Steichen as a conservative reactionary, a mouthpiece for corporate interests. She argues that in light of the trend toward a more introspective approach in photographic expression, Steichen's attempt to create a humanitarian message promoting worldwide peace and accord appears almost subversive. Likewise, Eric J. Sandeen, *Picturing an Exhibition: The Family of Man and 1950s America* (Albuquerque: University of New Mexico Press, 1995), points to Steichen's attempt to negate belief in U.S. exceptionalism at the height of the Cold War and to his explicit warning about nuclear war.

29. Bezner, *Photography and Politics in America,* 171. The exhibition catalog has never gone out of print. In 1970, it was still the number-two bestseller in the world, second only to the Bible. Edward Steichen, interview with Paul Cummings (5 June 1970), transcript, Oral History Program, Archives of American Art, Smithsonian Institution, Washington, D.C.

30. Arthur Schlesinger Jr., *The Vital Center: The Politics of Freedom* (Boston: Houghton Mifflin, 1949), 151, 36–37, 46. In 1947, Schlesinger had served as one of the founding members

of Americans for Democratic Action, an organization dedicated to purging liberalism of any taint of Stalinism.

31. McCarthy, quoted in Lawrence S. Wittner, *Cold War America: From Hiroshima to Watergate* (New York: Praeger, 1974), 95.

32. On the political persecution of homosexuals and the complicity of Cold War liberals, including Schlesinger, in this process, which resulted in the dismissal from the federal government of more gays and lesbians than of suspected Communists, see Robert J. Corber, *In the Name of National Security: Hitchcock, Homophobia, and the Political Construction of Gender in Postwar America* (Durham, N.C., and London: Duke University Press, 1993), 1–55.

33. On the postwar equation of patriotism with "normative" masculinity, see Elaine Tyler May, *Homeward Bound: American Families in the Cold War Era* (New York: Basic Books, 1988), 92–113.

34. Consequently, Gerry Badger, in "From Humanism to Formalism: Thoughts on Post-War American Photography," in *American Images: Photography 1945–1980,* ed. Peter Turner (New York: Viking Press/Barbican Art Gallery, 1985), 12–13, terms postwar photojournalism "humanist documentary."

35. Of course, many photojournalists did attempt to inject a subjective, even political, element into their work. W. Eugene Smith retired from *Life* magazine in 1955, after years of arguing with editors over the way his photographs were to be presented. Although Smith is considered the master of the photo essay, he never enjoyed total creative control while at the magazine. See Jim Hughes, *W. Eugene Smith: Shadow and Substance. The Life and Work of an American Photographer* (New York: McGraw-Hill, 1989).

36. Ansel Adams, "The Profession of Photography," *Aperture* 3 (1952): 32.

37. Richard Slotkin, *Gunfighter Nation: The Myth of the Frontier in Twentieth-Century America* (New York: Atheneum, 1992), 156–69, discusses the late-nineteenth- and early-twentieth-century association of masculinity with realist literature and of femininity with sentimentalist and reformist literature. The "virilist" realism of the "red-blooded" writers rejected both "idealism and sentimentalism" in favor of a competitive "tough-minded" view in keeping with social Darwinism and the Frontier Myth. They preferred the action and adventure themes of the dime novel to the "genteel" values of more "serious" literary fiction, which was associated with "an emasculated and intellectually exhausted American upper class."

38. Colin Westerbeck and Joel Meyerowitz, *Bystander: A History of Street Photography* (Boston: Little, Brown, 1994); the book is divided into four sections, each structured around a "founding father." Atget serves as the founder of the first section, which covers the nineteenth century.

39. Berenice Abbott, "It Has to Walk Alone," *ASMP News,* November 1951, 6–7, 14; Berenice Abbott, "What the Camera and I See," *Art News* 50 (September 1951): 36–37, 52. For a critique of the way Atget has been discursively defined, indeed invented, in order to serve the interests of twentieth-century photographers, critics, historians, connoisseurs, dealers, and museum directors and curators, see Abigail Solomon-Godeau, "Canon Fodder: Authoring Eugène Atget," in *Photography at the Dock: Essays on Photographic History, Institutions, and Practices,* with a foreword by Linda Nochlin (Minneapolis: University of Minnesota Press, 1991), 28–51.

40. R. W. Connell, *Gender and Power: Society, the Person, and Sexual Politics* (Stanford: Stanford University Press, 1987), 134, 132.

41. Arthur Fellig, *Weegee by Weegee: An Autobiography,* with an introduction by Bruce

Downes (New York: Ziff-Davis, 1961), 34. According to Miles Barth, "Weegee's World," in *Weegee's World*, ed. Miles Barth (Boston: Bulfinch Press; New York: International Center of Photography, 1997), 15–17, the name may actually have been derived from "squeegee boy," which Fellig was called because of his skill at using that tool to remove moisture from prints.

42. Fellig, *Weegee by Weegee*, 55.

43. Ibid., 51.

44. Ibid., 83.

45. Ibid., 98. According to Joseph Marshall, "Weegee the Famous and the New York Milieu" (Ph.D. diss., University of New Mexico, 1993), 32–33, the producer, Mark Hellinger, paid Weegee for the rights to the title, but there is little evidence that Weegee was an official "consultant." He is not listed in the screen credits, nor is the film directly related to Weegee's book. The film was, however, one of the first to be shot entirely on location, and it does have a documentary feel to it. On *The Naked City*, see J. P. Telotte, *Voices in the Dark: The Narrative Patterns of Film Noir* (Urbana and Chicago: University of Illinois Press, 1989), 158–60; Telotte classifies the film as "documentary *noir.*"

46. Bruce Downes, introduction to Fellig, *Weegee by Weegee*, 1–2. Weegee played up this characterization of himself in his autobiography, which, along with *Naked City*, has been the primary source for almost everything that has been written about the photographer since 1961.

47. Paul Strand, "Weegee Gives Journalism a Shot of Creative Photography," *PM Daily* 6 (22 July 1945): 13–14.

48. Woody Haut, *Pulp Culture: Hardboiled Fiction and the Cold War* (London: Serpent's Tail, 1995), 73.

49. Subsequent criticism has replicated this division by reading the photographs through Weegee the "man" and his unique "aesthetic"—the way he frames the shot, his use of flash, his insight, and so on. See Ellen Handy, "Picturing New York, the Naked City: Weegee and Urban Photography," in Barth, *Weegee's World*, 148–58; Jane Livingston, *The New York School: Photographs, 1936–1963* (New York: Stewart, Tabori and Chang, 1992), 316–19, 379; Westerbeck and Meyerowitz, *Bystander*, 335–41; John Coplans, *Weegee's New York: Photographs 1935–1960* (Munich: Schirmer/Mosel Verlag, 1982); Allene Talmey and Martin Israel, *Weegee* (New York: Aperture, 1978); and Louis Stettner, ed., *Weegee* (New York: Alfred A. Knopf, 1977). An exception is Marshall, "Weegee the Famous," which attempts to recontextualize Weegee's news photographs and thus read them as historical documents of actual events, places, and people.

50. Weegee, *Naked City*, with a foreword by William McCleery (New York: Essential Books, 1945; reprint, New York: Da Capo Press, 1975), 11. Reviews of *Naked City* reiterated Weegee's solitary life. See "Modest and Assuming," *Newsweek* 26 (23 July 1945): 74, 76; and "Weegee," *Time* 46 (23 July 1945): 70–71.

51. McCleery, foreword to Weegee, *Naked City*, 6.

52. Aaron Sussman, "The Little Man Who's Always There," *Saturday Review of Literature* 28 (28 July 1945): 17 (emphasis in the original). This gendering of the city endured. For example, in 1969, Harvey V. Fondiller wrote about Weegee: "His bride was the city and the pleasures of her infinite variety satisfied his urgent need." Harvey V. Fondiller, Norman Rothschild, and David Vestal, "Weegee: A Lens of Life, 1899–1968," *Popular Photography* 64 (April 1969): 93.

53. Elizabeth Wilson, *The Sphinx in the City: Urban Life, the Control of Disorder, and Women* (Berkeley and Los Angeles: University of California Press, 1991), 7.

54. Annette Kolodny, *The Lay of the Land: Metaphor as Experience and History in American Life and Letters* (Chapel Hill and London: University of North Carolina Press, 1975), 156. On the primacy of a male's early relationship with his mother in the constitution not only of his masculine identity but of his entire conceptual understanding of the universe, see Eva Feder Kittay, "Woman as Metaphor," *Hypatia* 3 (Summer 1988): 63–86.

55. On the femme fatale in film noir, see Mary Ann Doane, *Femmes Fatales: Feminism, Film Theory, Psychoanalysis* (London and New York: Routledge, 1991); and the essays in E. Ann Kaplan, ed., *Women in Film Noir* (London: British Film Institute, 1978). In postwar hard-boiled fiction, men also considered women "unfathomable," having an attractive surface beneath which lurked danger. Hence, it was essential that they be domesticated. This containment within the home also assured the "organization man" an arena of power, which was denied him in the oppressive public sphere. Haut, *Pulp Culture,* 106–8. On the rigid gender stereotypes informing hard-boiled fiction, see also Jon Thompson, *Fiction, Crime, and Empire: Clues to Modernity and Postmodernism* (Urbana and Chicago: University of Illinois Press, 1993), 142–44.

56. Film historians, critics, and theorists debate the parameters of this "cycle" or "genre." *The Maltese Falcon* (1941) is commonly considered to be its precursor, and the 1944 films *Laura, The Woman in the Window,* and *Double Indemnity* its full flowering; its most prolific phase occurred during the late 1940s and early 1950s. The end is signaled by either *Kiss Me Deadly* (1955) or *Touch of Evil* (1958). For those who consider film noir to be a genre, it is even discussed in relation to such contemporary films as *Chinatown* (1974), *Body Heat* (1981), and *The Grifters* (1991). For a summary of these debates, see Foster Hirsch, *The Dark Side of the Screen: Film Noir* (San Diego: A. S. Barnes, 1981; reprint, New York: Da Capo Press, 1983), 8–21; and Telotte, *Voices in the Dark,* 9–14.

57. Frank Krutnik, *In a Lonely Street: Film Noir, Genre, Masculinity* (London and New York: Routledge, 1991), 42. On "woman" as the signifier of a man's own potential for weakness, the possibility that he might fail to uphold masculine codes of toughness and potency by succumbing to the feminine within, see also James F. Maxfield, *The Fatal Woman: Sources of Male Anxiety in American Film Noir, 1941–1991* (London: Associated University Presses, 1996). For a reading of film noir that considers the subversive possibilities associated with the genre's frequent inclusion of homosexual characters—despite the stereotypical and often homophobic connotations—along with an analysis of the nostalgic version of masculinity conveyed by the hard-boiled hero, see Robert J. Corber, *Homosexuality in Cold War America: Resistance and the Crisis of Masculinity* (Durham, N.C., and London: Duke University Press, 1997), 9–15, 53–85.

58. On film noir and (male) class anxiety, see Paul Arthur, "The Gun in the Briefcase; or, The Inscription of Class in Film Noir," in *The Hidden Foundation: Cinema and the Question of Class,* ed. David E. Jones and Rick Berg (Minneapolis: University of Minnesota Press, 1996), 90–113, and George Lipsitz, *Class and Culture in Cold War America: "A Rainbow at Midnight"* (South Hadley, Mass.: J. F. Bergin, 1981), 176–78.

59. Hirsch, *The Dark Side of the Screen,* 26. The hard-boiled style, which attempts to imitate the language of the real criminal world, originated with *Black Mask* magazine, founded in 1920 by H. L. Mencken and George Jean Nathan. In 1926, stories by Hammett and Chandler began to be published. See Haut, *Pulp Culture,* 9, for a discussion of the evolution of the style after World War II, when it became a staple of the paperback industry and Cold War paranoia

began to frame the genre's traditional emphasis on "capitalism's relationship to crime, cor-ruption, desire, and power."

60. Weegee, *Naked City,* 158 (ellipses in the original).

61. Fellig, *Weegee by Weegee,* 36. Ralph Willett, in *The Naked City: Urban Crime Fiction in the USA* (Manchester and New York: Manchester University Press, 1996), 7–8, argues that wisecracks, slang, and other "verbal toughness" is employed in crime fiction as a sort of "weapon," an "assertion of autonomy," a way to separate an "investigator out from the crowd." According to Krutnik, *In a Lonely Street,* 43, such masculine language is a "sign of the hero's potency" and "is often more a measure of the hero's prowess than the use of guns and other more tangible aids to violence."

62. According to Richard Dyer, "Homosexuality and Film Noir," *Jump Cut* 16 (1977): 18–21, a careless lack of concern for one's appearance indicates that a man is both hetero-sexual and single (wives would take care of their husband's clothes). Homosexual men, on the other hand, were coded as "fastidious" about appearance and knowledgeable about art.

63. Fellig, *Weegee by Weegee,* 72–73; Murray Martin, "Flash Suit, Flash Myth: An Interview with Weegee's Widow, Wilma Wilcox," *Creative Camera* 218 (February 1983): 835. Marshall, "Weegee the Famous," xx–xxi, xxiv–xxvi, argues that Weegee's claims were greatly exagger-ated, that he would never have risked getting involved with such "vicious and deadly" men. Not only would he have put his life in danger, but he would have jeopardized his relationship with the police.

64. David E. Ruth, *Inventing the Public Enemy: The Gangster in American Culture, 1918–1934* (Chicago and London: University of Chicago Press, 1996), 93–94.

65. Robert Warshow, "The Gangster as Tragic Hero" (1948), in *The Immediate Experi-ence: Movies, Comics, Theatre, and Other Aspects of Popular Culture* (New York: Doubleday, 1962), 88.

66. Daniel Bell, *The End of Ideology: On the Exhaustion of Political Ideas in the Fifties,* rev. ed. (New York: Free Press, 1962; reprint, Cambridge, Mass.: Harvard University Press, 1988), 128–29.

67. On his technique, see Weegee, "For Super-Candids, Try Infrared Flash," *Photography* 33 (December 1953): 80–81. For a discussion of Weegee as "private eye," see Alain Bergala, "Weegee and Film Noir," in Barth, *Weegee's World,* 69–77.

68. One of Weegee's favorite hiding places was the movie theater, where he would wait until he could catch couples in intimate moments. In "Here's Fun from My Bag of Camera Tricks," *Popular Mechanics* 105 (April 1956): 234, Weegee wrote: "What a golden opportunity to be invisible here."

69. Victor Burgin, "Photography, Phantasy, Function," in *Thinking Photography,* ed. Vic-tor Burgin (London: Macmillan, 1982), 190. On the photograph as fetish, see also Christian Metz, "Photography and Fetish," *October* 34 (Fall 1985): 81–90.

70. Miles Orvell, "Weegee's Voyeurism and the Mastery of Urban Disorder," in *After the Machine: Visual Arts and the Erasing of Cultural Boundaries* (Jackson: University Press of Mis-sissippi, 1995), 82.

71. On the role that photography plays in reinforcing existing social hierarchies, see Mar-tha Rosler, "In, Around, and Afterthoughts (on Documentary Photography)," in *The Contest of Meaning: Critical Histories of Photography,* ed. Richard Bolton (Cambridge: MIT Press, 1989), 303–41.

72. See Bill Jay, "The Photographer as Aggressor," in *Observations: Essays on Documentary Photography,* ed. David Featherstone (Carmel, Calif.: Friends of Photography, 1984), 19–20; and Donna Haraway, *Primate Visions: Gender, Race, and Nature in the World of Modern Science* (New York and London: Routledge, 1989), 42–46. Amy W. Loomis, "Kodak Women: Domestic Contexts and the Commercial Culture of Photography, 1800s–1980s" (Ph.D. diss., University of Massachusetts, 1994), 96–97, notes that after World War II, the correlation between "shooting film" and "ammunition" became more pronounced in Kodak advertisements.

73. Susan Sontag, "In Plato's Cave," in *On Photography* (New York: Farrar, Straus and Giroux, 1977), 8, 4.

74. Doane, *Femmes Fatales,* 1.

75. Weegee, *Naked City,* 175.

76. Wilson, *The Sphinx in the City,* 7.

77. Orvell, "Weegee's Voyeurism," 71. An earlier essay that also focuses on Weegee's voyeurism is John Coplans, "Weegee the Famous," *Art in America* 65 (September–October 1977): 37–41. On photography as a fetishizing agent of urban control, a "technology of surveillance," see also Anne McClintock, *Imperial Leather: Race, Gender, and Sexuality in the Colonial Contest* (New York and London: Routledge, 1995), 118–31, which explores the way the ruling classes of the late nineteenth century feminized urban crowds composed of the underclass, even though these crowds were predominantly male. Crowd behavior was considered unruly, even primitive, and thus feminine.

78. Julia Kristeva, *Powers of Horror: An Essay on Abjection,* trans. Leon S. Roudiez (New York: Columbia University Press, 1982), 4, 10.

79. Ibid., 8.

80. Ibid., 4.

81. Weegee, *Naked City,* 78 (ellipses in the original).

82. Ibid., 80 (ellipses in the original).

83. Weegee was most famous for his images of corpses. In "Speaking of Pictures: Weegee Shows How to Photograph a Corpse," *Life* 21 (August 12, 1946): 8–10, Weegee is shown instructing students at a six-week photographic seminar at the Chicago Institute of Design on the proper techniques. He even poses for gag shots in which he lies down next to the dummy, holds its hand, and pretends to be dead.

84. William Klein, *Life Is Good and Good for You in New York: Trance Witness Revels* (Paris: Editions du Seuil, 1956).

85. John Heilpern, profile in William Klein, *William Klein, Photographs, etc.: New York and Rome, also Moscow and Tokyo, also Elsewhere* (New York: Aperture, 1981), 11–13.

86. Klein, *William Klein,* 13.

87. Klein, quoted in Livingston, *The New York School,* 315.

88. Herbert Keppler, "What Does Wm. Klein Do?" *Modern Photography* 23 (September 1959): 54, 56.

89. Westerbeck and Meyerowitz, *Bystander,* 345.

90. Ibid., 347.

91. Klein, *William Klein,* 16.

92. Ibid., 15–16.

93. Ibid., 15, 16.

94. Klein, quoted in Westerbeck and Meyerowitz, *Bystander,* 345.

95. Henri Cartier-Bresson, *The Decisive Moment* (New York: Simon and Schuster, 1952),

n.p. On Klein's techniques, see Keppler, "What Does Wm. Klein Do?" 56–58; Livingston, *The New York School*, 314–15; and Westerbeck and Meyerowitz, *Bystander*, 345–47.

96. Keppler, "What Does Wm. Klein Do?" 54.

97. *Gun Crazy* is a 1950 film noir that enjoys a cult following today. It was directed by Joseph H. Lewis, produced by Maurice and Frank King, and released through United Artists.

98. *Contacts: William Klein*, film (Paris: Riff International Productions, 1989). Klein, quoted in Livingston, *The New York School*, 314, refers to this photograph as a self-portrait, representing two contradictory aspects of himself, gun-toting yet "angelic-looking." Westerbeck and Meyerowitz, *Bystander*, 348, also reads the photograph as a self-portrait, a sort of before-and-after, with the boy on the right representing Klein before the streets made him tough.

99. In 1959, there were forty-eight Western series running on television. Garry Wills, *John Wayne's America: The Politics of Celebrity* (New York: Simon and Schuster, 1997), 312. According to Slotkin, *Gunfighter Nation*, 347, the Cold War was the "Golden Age of the Western." The number of Western feature films rose almost steadily from fourteen in 1947 to forty-six in 1956.

100. Jim Kitses, *Gun Crazy* (London: British Film Institute, 1996), 68. According to Slotkin, *Gunfighter Nation*, 379–404, the Cold War variation of the "outlaw theme" was the "Cult of the Gunfighter," which developed between 1950 and 1953.

101. Kathleen M. Kirby, "Re: Mapping Subjectivity: Cartographic Vision and the Limits of Politics," in *Bodyspace: Destabilizing Geographies of Gender and Sexuality*, ed. Nancy Duncan (London and New York: Routledge, 1996), 48. On the "interface" between bodies and cities, their production of each other, a process that "coincides" with the "shape" and "space" of the psyche, see also Elizabeth Grosz, "Bodies-Cities," in *Sexuality and Space*, ed. Beatriz Colomina (New York: Princeton Architectural Press, 1992), 241–53.

102. Michel de Certeau, *The Practice of Everyday Life* (1974), trans. Steven Rendall (Berkeley and Los Angeles: University of California Press, 1984), 109–10, 103. De Certeau's theory of spatial practice draws on Freud's discussion of the *fort-da* game in "Beyond the Pleasure Principle" (1920), in *The Standard Edition of the Complete Psychological Works of Sigmund Freud*, trans. James Strachey, 24 vols. (London: Hogarth Press, 1953–66), 18: 1–64. Freud interpreted his grandson's repetitive act of making objects appear and disappear as an attempt to gain mastery over separations from his mother.

103. The parallels between film noir and existentialism have long been noted. See specifically, Robert G. Porfirio, "No Way Out: Existential Motifs in the Film Noir," *Sight and Sound* 45 (Autumn 1976): 212–17.

104. Jean-Paul Sartre, *Being and Nothingness: An Essay on Phenomenological Ontology* (1943), trans. and with an introduction by Hazel E. Barnes (New York: Philosophical Library, 1956), 609.

105. On existentialism's acceptance in the United States after World War II, see William Barrett, *Irrational Man: A Study in Existential Philosophy* (Garden City, N.Y.: Doubleday, 1958), 7–19.

106. Albert Camus, *The Rebel* (1951), trans. Anthony Bower and with a foreword by Sir Herbert Read (New York: Alfred A. Knopf, 1954).

107. Rita Felski, *The Gender of Modernity* (Cambridge, Mass., and London: Harvard University Press, 1995), 94–95, traces this association between the feminine and the artificial to the mid-nineteenth century, when modernist writers became fascinated with women's use

of jewelry, cosmetics, and dress to fashion an aesthetically pleasing display. She writes that in "becoming identified with such conventionalized signifiers, femininity loosened itself from its moorings in the natural body" and became "an ensemble of signs."

108. William Klein, *William Klein Close Up* (London: Thames and Hudson, 1989), 6.

109. Judith Butler, *Bodies That Matter: On the Discursive Limits of "Sex"* (New York and London: Routledge, 1993), 136.

110. Colin Wilson, *The Outsider* (Boston: Houghton Mifflin, 1956), 102.

111. Ibid., 90 (emphasis in the original).

112. Calvin Thomas, *Male Matters: Masculinity, Anxiety, and the Male Body on the Line* (Urbana and Chicago: University of Illinois Press, 1996), 28.

113. Roland Barthes, *Camera Lucida: Reflections on Photography,* trans. Richard Howard (New York: Hill and Wang, 1981), 14.

114. Of course, Klein's aesthetic owed much to advances in film speed and sensitivity. However, I refuse to attribute the blur simply to a desire to "exploit" the medium's potential, as does John Szarkowski, *Looking at Photographs: 100 Pictures from the Collection of the Museum of Modern Art* (New York: Museum of Modern Art, 1973), 180.

115. Sartre, *Being and Nothingness,* 364 (emphasis in the original).

116. This effect was achieved in the darkroom by moving the enlarger head. Westerbeck and Meyerowitz, *Bystander,* 346.

117. Sartre, *Being and Nothingness,* 364–65.

118. Ibid., 309 (emphasis in the original).

4. Female Body

1. Arthur Fellig, *Weegee by Weegee: An Autobiography,* with an introduction by Bruce Downes (New York: Ziff-Davis, 1961), 31–33, 43–44, 55–58, 93, 100, 122.

2. Klein, quoted in Martin Harrison, *Appearances: Fashion Photography since 1945* (New York: Rizzoli, 1991), 98. On Klein's fashion photography, see also "Long Lens on Fashion," *Camera 35* 2, no. 3 (1958): 296–300.

3. Klein, quoted in Jane Livingston, *The New York School: Photographs 1936–1963* (New York: Stewart, Tabori and Chang, 1992), 265. On the characterization of fashion photography as an "art," see "Five Fashion Editorials: A Portfolio," *Infinity* 7 (September 1958): 4–10.

4. Harry Spotts Jr., "Make a Career in Fashion," *American Photography* 46 (January 1952): 28–33; Mark Strage, "Magazine Photography—What's New?" *Infinity* 8 (January 1959): 5; Stephen Baker, "An Art Director Talks about Photography," *Infinity* 8 (June 1959): 16; "Are You a Photographer or an Expert?" *Infinity* 4 (September–October 1955): 12.

5. The film was produced by Roger Edens, released by Paramount, written by Leonard Gershe, and directed by Stanley Donen.

6. Bradley Smith, "Avedon on Movies," *Infinity* 6 (August 1957): 7–8; Peggy Cook, "A Photographer and His Model Make a Pretty Movie," *Cosmopolitan* 142 (February 1957): 50–53; Phyllis Lee Levin, "Fantasy Marks the Work of Fashion Photographer," *New York Times,* 5 April 1957. Avedon's role in the making of the film was also publicized in "Photographer in Motion," *Good Housekeeping* 144 (May 1957): 14.

7. Nancy Hall-Duncan, *The History of Fashion Photography,* with a preface by Yves Saint Laurent and a foreword by Robert Riley (Rochester, N.Y.: International Museum of Photography; New York: Alpine, 1979), 136–57; *The Studio* (New York: Time-Life Books, 1971),

126–29; Edward Anthony Dalmacio, "History of Fashion Photography," (M.A. thesis, California State University, Long Beach, 1980), 73–93.

8. Harrison, *Appearances,* 25.

9. According to Jennifer Craik, *The Face of Fashion: Cultural Studies in Fashion* (London and New York: Routledge, 1994), 106–9, the cult reached its peak with the "Terrible Three" (David Bailey, Terence Donovan, and Brian Duffy), London fashion photographers renowned for their sexual exploits with, and sexist treatment of, their models.

10. Winthrop Sargent, "Profiles: Richard Avedon," *New Yorker* 34 (8 November 1958): 57–58, 60.

11. Harrison, *Appearances,* 26–27, 30. These photographs appeared in "Mexican Spring," *Harper's Bazaar* 64 (February 1945): 126–27, and in "Through the Looking Glass," *Harper's Bazaar* 64 (April 1945): 116–20.

12. Harrison, *Appearances,* 26. Indeed, Avedon became so prominent that his byline appeared under one-third of all fashion photographs published in the magazine between 1944 and 1957. Levin, "Fantasy Marks the Work of Fashion Photographer," 21.

13. Wynn Richards, "Photography—A Profession," in Institute of Women's Professional Relations, *Proceedings of the Conference on Photography: Profession, Adjunct, Recreation* (New London: Connecticut College, 1940), 18.

14. The cartoon accompanies "They'll Settle for a Credit Line!" *ASMP News* (December 1951): 11, 21, an anonymous diatribe by a male fashion photographer who wants the "pretty girl" to stay out of his profession.

15. Julius Adelman, "Young Man with a Camera," *Modern Photography* 13 (September 1949): 133.

16. Ibid., 34.

17. Sargent, "Profiles," 49.

18. Ibid., 62, 64.

19. Ibid., 64.

20. On Doe Avedon, see "Theatre Arts Introduces Doe Avedon to Vinton Freedley," *Theatre Arts* 33 (January 1949): 41; and "Doe Avedon," *Theatre Arts* 33 (March 1949): 23. Doe was the model for the photographs that appeared in "Mexican Spring," as cited in note 11 of this chapter.

21. Sargent, "Profiles," 64, 66.

22. Quoted in ibid., 66.

23. On Avedon and Dovima, see "High Fashion in a Menagerie," *U.S. Camera* 19 (June 1956): 64–65, 104–5.

24. Quoted in Sargent, "Profiles," 68, 70 (emphasis in the original).

25. On the intersection of consumerism, beauty, and feminine constructs, see Fred Davis, *Fashion, Culture, and Identity* (Chicago and London: University of Chicago Press, 1992), 33–54.

26. Dior, quoted in Jane Mulvach, *Vogue History of Twentieth-Century Fashion,* with a foreword by Valerie D. Mendes (London: Viking Press, 1988), 194. Dior's New Look (cinched waist with rounded shoulders and long full skirt) and his "sheath" of 1950 created a great deal of public debate, as did his 1954 "H-line," which the public feared might be "a supremely un-American attempt to eliminate the female bosom" altogether. "The Shapes Stay Shapely after All," *Life* 37 (6 September 1954): 8.

27. On the cultural and biological interrelationship between fat and femininity, see Noelle Caskey, "Interpreting Anorexia Nervosa," in *The Female Body in Western Culture: Contemporary Perspectives,* ed. Susan Rubin Suleiman (Cambridge, Mass., and London: Harvard University Press, 1986), 175–89; and Susan Bordo, "Reading the Slender Body," in *Body/Politics: Women and the Discourses of Science,* ed. Mary Jacobus, Evelyn Fox Keller, and Sally Shuttleworth (New York and London: Routledge, 1990), 83–112.

28. Sargent, "Profiles," 66, 52.

29. Helen Gee, *Limelight: A Greenwich Village Photography Gallery and Coffeehouse in the Fifties* (Albuquerque: University of New Mexico Press, 1997), 132. Whelan's was a funeral home.

30. "Richard Avedon: A Portfolio," *U.S. Camera Annual 1955,* ed. Tom Maloney (New York: U.S. Camera Publishing, 1954), 65. On the promotion of the fashion model as the ideal "role model" for women, see Craik, *The Face of Fashion,* 70–91.

31. According to the anthropologist Margaret Mead, *Male and Female: A Study of the Sexes in a Changing World* (New York: William Morrow, 1949), 323, success for a postwar woman meant, above all, "success in finding and keeping a husband."

32. Peter W. Cobb, "Good Models Say No!" *Woman's Home Companion* 74 (September 1947): 36, 153–55. On the myths and realities of the lives of models and the postwar public's fascination with them, see also "Model's Portfolio," *Life* 19 (13 August 1945): 55–58; Gilbert Millstein, "The Modeling Business: New York's Agencies," *Life* 20 (25 March 1946): 110–14, 116, 118, 120; "Teen-Age Siren," *Life* 22 (20 January 1947): 83–84, 86; David E. Scherman, "Notions about Models: A Few Facts Explode Them," *Life* 22 (12 May 1947): 14–16; Madelon Mason, "What It Takes to Be a Model," *American Magazine* 144 (October 1947): 28–29, 108–11; John Stanton, "Paris Mannequin," *Life* 28 (8 May 1950): 61–64, 67–68; Charlotte Payne, "What It Takes to Be a Big-Time Model," *American Magazine* 160 (November 1955): 22–23, 116–18; Mickey Pallas, "Fashion Smashion," *Infinity* 6 (Christmas 1957): 10–11; "What Models Earn and How They Earn It," *Good Housekeeping* 145 (October 1957): 56–57; and Lyn Levitt Tornabene, "Modern Pygmalions," *Cosmopolitan* 148 (June 1960): 38–49.

33. George Barris, "My Hour with the Big Four," *Popular Photography* 36 (May 1955): 105.

34. Roland Barthes, *The Fashion System,* trans. Matthew Ward and Richard Howard (New York: Hill and Wang, 1983), 259. For a similar argument from a feminist perspective, see Susan Griffin, *Pornography and Silence: Culture's Revenge against Nature* (New York: Harper and Row, 1981), 232–37.

35. On the relationship between the female viewer and the fashion photograph, see Stuart Ewen and Elizabeth Ewen, *Channels of Desire: Mass Images and the Shaping of American Consciousness* (New York: McGraw-Hill, 1982), 75–187; Kaja Silverman, "Fragments of a Fashionable Discourse," in *Studies in Entertainment: Critical Approaches to Mass Culture,* ed. Tania Modleski (Bloomington and Indianapolis: Indiana University Press, 1986), 139–59; Iris Marion Young, "Women Recovering Our Clothes," in *Throwing Like a Girl and Other Essays in Feminist Philosophy and Social Theory* (Bloomington and Indianapolis: Indiana University Press, 1990), 177–88; Diana Fuss, "Fashion and the Homospectatorial Look," *Critical Inquiry* 18 (Summer 1992): 713–37; and Leslie W. Rabine, "A Woman's Two Bodies: Fashion Magazines, Consumerism, and Feminism," in *On Fashion,* ed. Shari Benstock and Suzanne Ferriss (New Brunswick, N.J.: Rutgers University Press, 1994), 59–75.

36. Jonathan Tichenor, "Irving Penn and Thirty-Six of His Photographs of Women," in *U.S. Camera Annual 1951,* ed. Tom Maloney (New York: U.S. Camera Publishing, 1950), 161.

37. John Szarkowski, *Irving Penn* (New York: Museum of Modern Art, 1984), 23. On Penn's

career, see also Colin Westerbeck, ed., *Irving Penn: A Career in Photography* (Boston: Bulfinch Press; Chicago: Art Institute of Chicago, 1997).

38. Alexander Liberman, introduction to Irving Penn, *Moments Preserved* (New York: Simon and Schuster, 1960), 8.

39. Herbert Marshall McLuhan, *The Mechanical Bride: Folklore of Industrial Man* (New York: Vanguard Press, 1951), 154.

40. Penn, quoted in Polly Delvin, *Vogue Book of Fashion Photography, 1919–1979*, with an introduction by Alexander Liberman (New York: Simon and Schuster, 1979), 137.

41. *Life* magazine even published the photograph twice: "Speaking of Pictures . . . America's Most Photographed Models Pose for a Portrait," *Life* 22 (12 May 1947): 14–15; "Penn's People," *Life* 49 (14 November 1960): 103.

42. "What Is Modern Photography?" Symposium at the Museum of Modern Art, 20 November 1950, *American Photography* 45 (March 1951): 148; and Willard Clark, "A Look at Irving Penn," *Camera 35* 2, no. 2 (1958): 120–25, 154.

43. Richard Avedon, *Observations,* with comments by Truman Capote (New York: Simon and Schuster, 1959), 7.

44. Sargent, "Profiles," 54.

45. "The World's 10 Greatest Photographers," *Popular Photography* 42 (May 1958): 71, 83.

46. The show premiered on the National Broadcasting Company (NBC) on 2 January 1955, moved to the Central Broadcasting Company from July 1955 through September 1957, and then moved back to NBC until September 1959. The title was then changed to *Love That Bob* for its daytime run on ABC from October 1959 to December 1961.

47. Although *Esquire* did attempt a few photographic layouts modeled after the *Playboy* format, by late 1958, the magazine had ceased publishing sexualized images of women. Thus, it took itself out of direct competition with *Playboy.* In fact, it began to promote itself as more of a literary magazine. Mark Gabor, *The Pin-Up: A Modest History* (New York: Bell, 1972), 30, 76–77.

48. A 1958 survey of magazine readership revealed that *Playboy*'s readers were younger (median age of twenty-five), were better educated (over 54 percent had college degrees), and had a higher median income ($7,234, more than 30 percent above the national average) than the readership of any other men's magazine. Moreover, the average *Playboy* reader spent more money on clothes, tobacco, and liquor than the average reader of any of the other forty-nine magazines in the survey. "Meet the Playboy Reader," *Playboy* 5 (April 1958): 63, 76–77. *Playboy* capitalized on this image, using its back cover to sell subscriptions through its "What sort of man reads *Playboy*?" ads.

49. *Playboy* 1 (December 1953): 2. On *Playboy*'s construction of a particularly masculine domesticity, one predicated on sophisticated technological devices and the bachelor apartment as the site for heterosexual masculine performance, see Steven Cohan, "So Functional for Its Purposes: Rock Hudson's Bachelor Apartment in *Pillow Talk,*" in *Stud: Architectures of Masculinity,* ed. Joel Sanders (New York: Princeton Architectural Press, 1996), 28–41. In monthly installments in 1956, *Playboy* published instructions for designing the perfect "penthouse apartment," complete with floor plan, renderings of furnished rooms, and suggestions for what furniture to buy. These articles are reprinted in Sanders, *Stud,* 54–67.

50. Bob Norman, "Miss Gold-Digger of 1953," *Playboy* (December 1953): 6–7. According to Barbara Ehrenreich, *The Hearts of Men: American Dreams and the Flight from Commitment* (Garden City, N.Y.: Anchor Books/Doubleday, 1983), 42, Norman was actually Hefner's

friend Burt Zollo. Neither Zollo nor Hefner dared put their real names on the first issue; Hefner's editorial statement is unsigned. Ehrenreich devotes chapter 5 to *Playboy* and its rejection of family commitment. Indeed, her work locates the beginning of what is commonly referred to as the "breakdown of the American family" with midcentury male rebellions rather than with the contemporary women's movement, to which opponents of feminism so often attribute it. On *Playboy* and postwar masculinity, see also Michael Kimmel, *Manhood in America: A Cultural History* (New York: Free Press, 1996), 254–57.

51. Philip Wylie, *Generation of Vipers* (New York and Toronto: Rinehart, 1942), 64. The book was so popular that by 1954, it had sold over 180,000 copies and was still selling about 5,000 copies in hard cover a year. It did not even come out in paperback until 1958. Truman Frederick Keefer, *Philip Wylie* (Boston: Twayne Publishers, 1977), 102.

52. Wylie, *Generation of Vipers,* 49–50.

53. Ibid., 63.

54. Ibid., 186–87. For a discussion of how Wylie's ideas about women found expression in postwar films, see Michael Paul Rogin, "*Kiss Me Deadly*: Communism, Motherhood, and Cold War Movies," in *Ronald Reagan, the Movie, and Other Episodes in Political Demonology* (Berkeley and Los Angeles: University of California Press, 1987), 236–71.

55. Philip Wylie, "The Abdicating Male and How the Gray Flannel Mind Exploits Him through His Women," *Playboy* 3 (November 1956): 23–24, 50, 79.

56. According to Abram Kardiner, *Sex and Morality* (Indianapolis and New York: Bobbs-Merrill, 1954), 175, men turned to homosexuality because they felt inadequate in their ability to fulfill the economic, sexual, and emotional demands of the adult masculine role. On male homosexuality as a symptom of immaturity, see also George Henry, *All the Sexes: A Study of Masculinity and Femininity,* with a foreword by David Roberts (New York: Rinehart, 1955), 581–88.

57. Philip Wylie, "The Womanization of America," *Playboy* 5 (September 1958): 79, 52.

58. One of the most notorious of these books was Ferdinand Lundberg and Marynia F. Farnham, M.D., *Modern Woman: The Lost Sex* (New York and London: Harper and Brothers, 1947). This sociologist and psychiatrist team lent scientific credence to many of Wylie's ideas, particularly in their insistence that women who stepped out of their "natural" feminine roles caused mental and sexual disorders in their children and their husbands and spread unhappiness throughout society at large. For this, they blamed the "feminist complex," which encouraged women to take on masculine traits. A counter to this strain of thought is Ashley Montagu, *The Natural Superiority of Women* (New York: Macmillan, 1954), which sought to overturn many of the prevailing "myths" about women's inferiority by arguing in favor of their biological, emotional, and psychological superiority. Although many of Montagu's arguments essentialize femininity, he did insist that it was men who were to blame for society's ills, not women, and that it was perfectly understandable why a woman might be unhappy with the rigid roles society assigned her.

59. Robert Coughlan, "Changing Roles in Modern Marriage," *Life* 41 (24 December 1956): 109.

60. Ibid., 109–14.

61. Ibid., 110 (emphasis in the original).

62. J. Robert Moskin, "Why Do WOMEN Dominate Him?" in *The Decline of the American Male* (New York: Random House, 1958): 3–4. For a similar argument, which appears in a book supposedly sympathetic to women, see Oliver Jensen, *The Revolt of American Women:*

A Pictorial History of the Century of Change from Bloomers to Bikinis—from Feminism to Freud (New York: Harcourt, Brace, 1952), 200; Jensen asks, "Is the former master just the doormat now?"

63. Ibid., 10–11, 14–15.

64. Ibid., 18–20, 22.

65. Russell Miller, *Bunny: The Real Story of Playboy* (New York: Holt, Rinehart and Winston, 1984), 24–68.

66. Richard A. Kallan and Robert D. Brooks, "The Playmate of the Month: Naked but Nice," *Journal of Popular Culture* 8 (Fall 1974): 328–36.

67. Jerry Yulsman, "Girls in Their Lairs," *Playboy* 6 (February 1959): 60–63.

68. Burt Zollo, "Open Season on Bachelors," *Playboy* 1 (June 1954): 37–38. For similar antimarriage arguments, see Phil Silver, "Comes the Resolution," *Playboy* 4 (January 1957): 77; and William Iversen, "Apartness," *Playboy* 5 (May 1958): 35–36.

69. "With de Dienes," *Playboy* 1 (June 1954): 39–41; and "At Home with Dienes," *Playboy* 1 (January 1954): 41–43.

70. De Dienes published these photographs of Monroe along with his account of their relationship in *Marilyn, Mon Amour: The Private Album of André de Dienes, Her Preferred Photographer* (New York: St. Martin's Press, 1985).

71. Jorge Lewinski, *The Naked and the Nude: A History of the Nude in Photographs, 1839 to the Present* (New York: Harmony Books, 1987), 128.

72. De Dienes, *Marilyn, Mon Amour,* 51.

73. "Sex Sells a Shirt," *Playboy* 1 (March 1954): 36–40.

74. Carl Bakal, "Sex on Lex," *Playboy* 4 (April 1957): 59, 62.

75. "Photographing a Playmate," *Playboy* 1 (December 1954): 20–25. See also "Preparing to Be a Playmate," *Playboy* 3 (February 1956): 34–35.

76. "The *Playboy* Reader," *Playboy* 2 (September 1955): 37.

77. "Photographing Your Own Playmate," *Playboy* 5 (June 1958): 35–41; Vincent T. Tajiri, "The Well-Equipped Lensman," *Playboy* 5 (June 1958): 31–34, 46, 52.

78. "Photographing Your Own Playmate," 35–41. An earlier article (albeit satirical) on how to become a playboy-photographer is Marshall King, "Photography Can Be Fun: Advice for the Beginner from a Self-Acknowledged Expert," *Playboy* 3 (March 1956): 26–29. Photography magazines also advised men to always be on the lookout for prospective models. See Ozzie Sweet, "How I Find Models," *Minicam Photography* 12 (September 1948): 26–32, 137–38; and "Your Model Lives Next Door," *Popular Photography* 37 (November 1955): 94–95.

79. "Double Exposure," *Playboy* 2 (May 1955): 41–47; and "Alone with Lisa," *Playboy* 4 (December 1957): 64–67. On Yeager, see Roy Pinney, "World's Prettiest Photographer," *U.S. Camera* 16 (August 1953): 50–53.

80. "The *Playboy* Reader," 36.

81. Russ Meyer, "An Evening with Eve: A Modern Bedtime Story," *Playboy* 3 (March 1956): 52–53. Meyer would go on to make a name for himself as a filmmaker. His 1960 *The Immortal Mr. Teas,* which he wrote, directed, and photographed, is little more than a filmed version of *Playboy,* in that it revolves around the voyeuristic fantasies of a middle-class man.

82. Miller, *Bunny,* 49–51. During its first year of publication, *Playboy* purchased its "nudes" from outside sources. Once it could afford it, the magazine began staging its own pictorials.

83. Ibid., 52.

84. Talese, quoted in Griffin, *Pornography and Silence,* 34. On the way sexual imagery functions in fantasy, see Elizabeth Cowie, "Pornography and Fantasy: Psychoanalytic Perspectives," in *Sex Exposed: Sexuality and the Pornography Debate,* ed. Lynne Segal and Mary McIntosh (New Brunswick, N.J.: Rutgers University Press, 1993), 132–52.

85. Alfred C. Kinsey, Wardell B. Pomeroy, and Clyde E. Martin, *Sexual Behavior in the Human Male* (Philadelphia: W. B. Saunders, 1948), 218–62.

86. Institute for Sex Research, *Sexual Behavior in the Human Female* (Philadelphia and London: W. B. Saunders, 1953), 371–408.

87. Ibid., 373–74. According to William L. O'Neill, *American High: The Years of Confidence, 1945–1960* (New York: Free Press, 1986), 45–48, the report on female sexuality had a much greater impact than had the earlier report on the male. On the initial controversy surrounding Kinsey's findings, see "All about Eve: Kinsey Reports on American Women," *Newsweek* 42 (24 August 1953): 68–71; and "5940 Women," *Time* 62 (24 August 1953): 51–58.

88. Helen Mayer Hacker, "The New Burdens of Masculinity," *Marriage and Family Living* 19 (August 1957): 231, 228.

89. Calvin Tompkins, "Mr. Playboy of the Western World," *Saturday Evening Post* (23 April 1966): 101.

90. W. R. Harrison, "Vanity, Thy Name Is Pin-Up," *Minicam Photography* 8 (June 1945): 48–52 (emphasis in the original).

91. William R. Harrison, "Glamour Made to Order," part 1, *Minicam Photography* 11 (January 1948): 27 (emphasis in the original).

92. In addition to Harrison, "Vanity, Thy Name Is Pin-Up" and "Glamour Made to Order," part 1, see William R. Harrison, "Glamour Made to Order," part 2, *Minicam Photography* 11 (February 1948): 65–73; Shep Shepherd, "Whitey Schafer—Glamour Expert," *The Camera* 68 (November 1946): 20–25, 121; George Boardman, "Improve Your Leg Poses," *Minicam Photography* 11 (March 1948): 44–45; "Alan Fontaine Shoots Glamour and Fantasy," *U.S. Camera* 16 (June 1953): 45–47, 82; Carl Bakal, *How to Shoot for Glamour* (San Francisco: Camera Craft, 1955); B. Bernard, "Glamour in Color," *U.S. Camera* 18 (March 1955): 81–82; "Peter Basch's Glamour Lighting Technique," *U.S. Camera* 19 (January 1956): 66–67; Carl Bakal, "Fifty Glamour Tips," *Popular Photography* 38 (April 1956): 52–57, 135–40; Arthur Goldsmith, "Bert Stern's Approach to Glamor," *Popular Photography* 39 (September 1956): 62–67, 94–95; "Murray Laden: Photographer of Glamour," *U.S. Camera* 19 (October 1956): 55–59; "Ed Lettau Shoots Glamor without Flash," *Popular Photography* 39 (November 1956): 62–67; Sandi Nero, "Your Home, a Glamor Studio," *Popular Photography* 40 (January 1957): 64–65; "Glamour Makes Fine Pictures," *U.S. Camera* 20 (March 1957): 52–63; "How to Achieve Glamour by Lighting," *U.S. Camera* 20 (March 1957): 66–67; "One Girl + Beach = Glamour," *U.S. Camera* 20 (April 1957): 80–81; Sam Wu, "How Hollywood Pro Shoots Glamor with a 35," *Popular Photography* 40 (May 1957): 72, 116–17; John Rawlings, "Six Elements of Glamour," *U.S. Camera* 20 (August 1957): 52–53; "New Views for Glamour," *U.S. Camera* 21 (October 1958): 68–69; Don Ornitz, "Glamour Backgrounds Are Everywhere," *U.S. Camera* 22 (September 1959): 49–51; and "Glamour—Indoors/Outdoors," *U.S. Camera* 23 (September 1960): 58–59. See also the four-part series by Peter Gowland, "Glamor," *Popular Photography* 46 (January 1960): 26; 46 (April 1960): 26, 104; 46 (May 1960): 23, 103; 46 (June 1960): 26.

93. Don Nibbelink, "For Men Only," *Minicam Photography* 10 (December 1946): 66–71, 143; and Pat Liveright, "Portraiture of Men," *Camera* 73 (April 1950): 24–31, 128.

94. Gabor, *The Pin-Up*, 23. For advice on shooting pinups, see "Pin-Up Gals," *U.S. Camera* 14 (August 1951): 35–38; and Bernard of Hollywood, "Forever Pin-Ups," *U.S. Camera* 14 (August 1951): 40–41. On the pinup, see also Ralph Stein, *The Pin-Up: From 1852 to Now* (Chicago: Ridge Press/Playboy Press, 1974).

95. Roman Freulich, "Pin-Ups: The Army's Favorite Reading Matter," *Minicam Photography* 8 (March 1945): 28–34.

96. Miller, *Bunny*, 17. Hefner worked for a time as the promotion manager for the Publishers' Development Corporation of Chicago, which published the journal *Art Photography*, a "girlie" magazine that relied on the category "art" to legitimize its nude photographs (29). According to Ulrich F. Keller, "The Myth of Art Photography: An Iconographic Analysis," *History of Photography* 9 (January–March 1985): 7, photographers had been disguising "sex as art" since the nineteenth century, when the common practice was to fashion nudes as goddesses, odalisques, and nymphs.

97. On the use of the designation "art" to get around censorship laws, see Gabor, *The Pin-Up*, 65–72.

98. On Hefner's struggles with the U.S. Post Office, which he successfully sued in 1955 after it withheld second-class-postage privileges, see Miller, *Bunny*, 63–64.

99. Alan Fontaine, "Colored Background for Nudes," *Modern Photography* 13 (December 1949): 132. On techniques for working with models, see also Peter Gowland, "Beauty and the Beach," *American Photography* 42 (July 1948): 421–23; Peter Gowland, *How to Photograph Women* (New York: Crown Publishers, 1953), abridged version reprinted in *Photography* 33 (October 1953): 137–48; "Posing the Model," *U.S. Camera* 18 (February 1955): 68–69; Peter Basch, "Figure and Form in Color," *Camera 35* 1, no. 1 (1957): 48–49; "We Asked the Pros: Professional or Amateur Models?" *Popular Photography* 40 (June 1957): 34; Martin Dain, "Many Moods of a Model," *Camera 35* 2, no. 1 (1958): 32–33; "How to Photograph a Girl," *Modern Photography* 23 (August 1959): 66–73; "Framing the Figure," *U.S. Camera* 22 (June 1959): 62–63; and Hugh Conant, "How I Work with a Model," *Popular Photography* 47 (November 1960): 70–73, 99–100.

100. André de Dienes, *Nude Pattern*, with a foreword by Norman Hall (London: Bodley Head; New York: Amphoto, 1958). De Dienes published a total of eleven books featuring his female nudes, beginning with *The Nude* in 1956. His nudes also appeared in "The Human Form," a regular feature of *U.S. Camera* magazine: *U.S. Camera* 17 (September 1954): 56–57; 19 (May 1956): 72–73; 22 (March 1959): 57–59; and 22 (October 1959): 56–57.

101. Peter Gowland's California home also had a glass-walled swimming pool. Photographs of it were featured in Peter Gowland, "The House That Glamour Built," *U.S. Camera* 20 (August 1957): 66–72. A photograph of one of his underwater nudes was featured in "The Human Form," *U.S. Camera* 19 (January 1956): 78–79.

102. Berkeley Kaite, *Pornography and Difference* (Bloomington and Indianapolis: Indiana University Press, 1995), 37–40.

103. Anne Hollander, *Seeing through Clothes* (New York: Viking Press, 1978).

104. For a critique of Freud's notion of the female body as "castrated" rather than "castrating," see Barbara Creed, *The Monstrous-Feminine: Film, Feminism, Psychoanalysis* (London and New York: Routledge, 1993), 105–21.

105. Kaite, *Pornography and Difference*, 40. On the male compulsion to fetishize women's breasts, as opposed to women's experience of their own breasts, see Iris Marion Young, "Breasted Experience: The Look and the Feeling," in *Throwing Like a Girl*, 189–209.

106. Linda Williams, *Hard Core: Power, Pleasure, and the "Frenzy of the Visible"* (Berkeley and Los Angeles: University of California Press, 1989), 41–42. Fetishism here is not to be understood only as pathological. As Valerie Steele argues in *Fetish: Fashion, Sex, and Power* (New York and Oxford: Oxford University Press, 1996), 12, "a *degree* of fetishism appears to be extremely common among men—normative, in other words, if not 'normal.'"

107. Lewis Tulchin, *The Nude in Photography: A Treatise on the Esthetics and Techniques of Nude Photography* (New York: Grayson, 1950), 14–15.

108. Ibid., 17.

109. Ibid., 40.

110. "How to Photograph the Nude," *U.S. Camera* 13 (April 1950): 64–71 (emphasis in the original). On technique, see also "Angles on Figures," *U.S. Camera* 14 (August 1951): 44–49; "Posing the Human Form," *U.S. Camera* 18 (February 1955): 54–55; Peter Gowland, "Ten Tips on Shooting Girls," *U.S. Camera* 18 (September 1955): 76–80, 117; and "The Human Form," *U.S. Camera* 18 (October 1955): 82–83.

111. Annette Kuhn, "Lawless Seeing," in *The Power of the Image: Essays on Representation and Sexuality* (London and Boston: Routledge and Kegan Paul, 1985), 40, 35.

112. See Elaine Tyler May, *Homeward Bound: American Families in the Cold War Era* (New York: Basic Books, 1988), 92–134.

113. Lynda Nead, *The Female Nude: Art, Obscenity, and Sexuality* (London and New York: Routledge, 1992), 6 (ellipses in the original). On the perception of the female body as a "mode of seepage," see also Elizabeth Grosz, *Volatile Bodies: Toward a Corporeal Feminism* (Bloomington and Indianapolis: Indiana University Press, 1994), 202–10.

114. André de Dienes, *The Nude*, with a foreword by Norman Hall (New York: G. P. Putnam's Sons, 1956), 3.

115. Jean-Paul Sartre, *Being and Nothingness: An Essay on Phenomenological Ontology* (1943), trans. and with an introduction by Hazel E. Barnes (New York: Philosophical Library, 1956), 579.

116. Nead, *The Female Nude*, 18.

117. Luce Irigaray, "Sexual Difference," in *An Ethics of Sexual Difference*, trans. Carolyn Burke and Gillian C. Gill (Ithaca, N.Y.: Cornell University Press, 1993), 10.

118. Mary Douglas, *Purity and Danger: An Analysis of the Concepts of Pollution and Taboo* (New York and London: Routledge, 1966; reprint, 1995), 116 (page reference is to reprint edition).

119. Joanne Meyerowitz, "Women, Cheesecake, and Borderline Material: Responses to Girlie Pictures in the Mid-Twentieth-Century U.S.," *Journal of Women's History* 8 (Fall 1996): 13.

120. Gabor, *The Pin-Up*, 78; David Sutton, "A Roundup of Editorial Opinion on the Sex Bundle Next Door," *Infinity* 6 (August 1957): 14–15; and P. S. Marsh, "Reporting the Magazines," *Infinity* 8 (May 1959): 26.

121. Nead, *The Female Nude*, 18–25, 55–60. On the female nude as the site of the art-pornography debate, see also Nead, "The Female Nude: Pornography, Art, and Sexuality," in Segal and McIntosh, *Sex Exposed*, 280–94.

122. "Round-Table on Glamor," *Infinity* 8 (October 1959): 13.

123. Vincent Tajiri, "Glamor or Pin-Up?" *Infinity* 8 (October 1959): 4–5.

124. Don Storing, "It's the Law," *Minicam Photography* 10 (April 1947): 39. On the fine line between "art" and "obscenity," see also George Chernoff and Hershel B. Sarbin, "The

Nude—Is It Art?" *Popular Photography* 36 (January 1955): 18, 145. The definitions of the terms "pornography" and "obscenity" are, of course, not stable. They are categories of legal, moral, and cultural regulation and are thus subject to geographical and historical specificity. See John Ellis, "On Pornography," *Screen* 21 (Spring 1980): 81–108.

125. According to Abigail Solomon-Godeau, "Reconsidering Erotic Photography: Notes for a Project of Historical Salvage," in *Photography at the Dock: Essays on Photographic History, Institutions, and Practices,* with a foreword by Linda Nochlin (Minneapolis: University of Minnesota Press, 1991), 220–37, photographs of the unclothed female body have functioned as a risk to the culturally drawn distinctions between the artistic, the erotic, and the pornographic ever since photography's invention in 1839.

126. "Photographers and Models Ball," *Playboy* 7 (July 1960): 58–61.

127. "The Nude in Photography . . . the Pro and the Con," *Camera 35* 4 (February–March 1960).

128. Kenneth Clark, *The Nude: A Study in Ideal Form* (Washington D.C.: National Gallery of Art and Pantheon Books, 1956), 8.

129. Basch, quoted in "The Nude in Photography . . . the Pro and the Con," 26 (emphasis mine). On Basch's insistence on capturing the "feminine" qualities of the female body rather than its "abstract" form, see also "The Human Form," *U.S. Camera* 18 (April 1955): 64–65.

130. "The Human Form: Nudes in Color and Black and White," *U.S. Camera Annual 1955,* ed. Tom Maloney (New York: U.S. Camera Publishing, 1954), 94. On Basch, see also "How Peter Basch Shoots a Cover," *U.S. Camera* 23 (March 1960): 66–67.

5. Masculine Triumph

1. The film was produced by Samuel Goldwyn, directed by William Wyler, and written by Robert Sherwood after Mackinlay Kantor's novel *Glory for Me.*

2. David A. Gerber, "Heroes and Misfits: The Troubled Social Reintegration of Disabled Veterans in *The Best Years of Our Lives,*" *American Quarterly* 46 (December 1994): 547.

3. Ibid., 550–51.

4. Although Kaja Silverman, *Male Subjectivity at the Margins* (New York and London: Routledge, 1992), 69–74, argues that Wilma "acknowledge[s] and embrace[s]" Homer's castration, I read it more as a disavowal, a case of "I know, but just the same . . ." In other words, although Wilma realizes that Homer has lost his hands, she refuses to accept his state as one of lack. In his review of the film, the critic Robert Warshow, in "The Anatomy of Falsehood" (1947), reprinted in *The Immediate Experience: Movies, Comics, Theatre, and Other Aspects of Popular Culture,* with an introduction by Lionel Trilling (Garden City, N.Y.: Doubleday, 1962), 111, points out that Wilma's "virtue" lies in her ability to "really" love Homer, despite his disability. Only then would the loss of his hands "make no difference" to society.

5. In 1946 or 1947, Minor White produced a series entitled "Amputations," now lost, of fifty photographs and poems. Paul Hill and Thomas Cooper, *Dialogue with Photography* (New York: Farrar, Straus and Giroux, 1979), 344.

6. The film was produced by Albert Zugsmith, directed by Jack Arnold, and released by Universal-International; its screenplay was by Richard Matheson after his novel.

7. Paul Wells, "The Invisible Man: Shrinking Masculinity in the 1950s Science Fiction B-Movie," in *You Tarzan: Masculinity, Movies, and Men,* ed. Pat Kirkham and Janet Thurmin (New York: St. Martin's Press, 1993), 189.

8. E. Anthony Rotundo, *American Manhood: Transformations in Masculinity from*

the Revolution to the Modern Era (New York: Basic Books, 1993), 227, 235–36. On late-nineteenth-century masculinity and the rise of physical culture, see also Michael Kimmel, *Manhood in America: A Cultural History* (New York: Free Press, 1996), 117–55, and "Consuming Manhood: The Feminization of American Culture and the Recreation of the Male Body, 1832–1920," in *The Male Body: Features, Destinies, Exposures,* ed. Laurence Goldstein (Ann Arbor: University of Michigan Press, 1995), 12–41.

9. John Bryson, in Leonard McCombe, *The Cowboy,* with text by John Bryson (Garden City, N.Y.: Garden City Books, 1951), 3.

10. According to the film critic Parker Tyler, "The Horse: Totem Animal of Male Power—An Essay in the Straight-Camp Style," in *Sex Psyche Etcetera in the Film* (New York: Horizon Press, 1969), 27–36, the "coupling" of man and horse, a motif analogous to the mythic centaur, lends the cowboy a degree of majesty and sexual power that he could not achieve on his own.

11. On the origins of this nostalgia in the late nineteenth century, see Alexander Nemerov, *Frederic Remington and Turn-of-the-Century America* (New Haven and London: Yale University Press, 1995).

12. Bryson, in McCombe, *The Cowboy,* 55.

13. Herbert Marshall McLuhan, *The Mechanical Bride: Folklore of Industrial Man* (New York: Vanguard Press, 1951), 156.

14. Lee Clark Mitchell, *Westerns: Making the Man in Fiction and Film* (Chicago and London: University of Chicago Press, 1996), 5–7. Mitchell also notes that "the genre's recurrent rise and fall coincides" with public debate over women's place in society, "moments when men have invariably had difficulty knowing how manhood should be achieved" (152). On the explosion of the Western genre onto television screens in the 1950s, see Gary A. Yoggy, "Prime-Time Bonanza! The Western on Television," in *Wanted Dead or Alive: The American West in Popular Culture,* ed. Richard Aquila (Urbana and Chicago: University of Illinois Press, 1996), 160–85.

15. Robert Warshow, "Movie Chronicle: The Westerner" (1954), in *The Immediate Experience,* 91.

16. The groundbreaking texts dealing with the risk to a heterosexist and patriarchal society of allowing the camera to fetishize the male body are Laura Mulvey, "Visual Pleasure and Narrative Cinema," *Screen* 16 (Autumn 1975): 6–18; and Steve Neale, "Masculinity as Spectacle," *Screen* 24 (November–December 1983): 2–16.

17. Warshow, "Movie Chronicle," 91.

18. Bodybuilding did not gain mainstream acceptance until the late 1970s and 1980s. See Sam Fussell, "Bodybuilder Americanus," in Goldstein, *The Male Body,* 43–60; and Mark Simpson, "Big Tits! Masochism and Transformation in Bodybuilding," in *Male Impersonators: Men Performing Masculinity,* with a foreword by Alan Sinfield (London and New York: Routledge, 1994), 21–44.

19. William Stern, "Aestheticizing Masculinity: The Example of Physique Photography," *Thresholds: Viewing Culture* 9 (1996): 40–44. For the history of physique photography and its censorship in the 1950s, see also F. Valentine Hooven III, *Beefcake: The Muscle Magazines of America, 1950–1970* (Cologne: Benedikt Taschen, 1995), 54–103.

20. On the sports arena as a "safe" space for the male viewing of male bodies, see Michael Hatt, "Muscles, Morals, Mind: The Male Body in Thomas Eakins' *Salutat,*" in *The Body*

Imaged: The Human Form and Visual Culture since the Renaissance, ed. Kathleen Adler and Marcia Pointon (Cambridge and New York: Cambridge University Press, 1993), 57–69.

21. John Devaney, "Inside S.I.," *Infinity* 9 (March 1960): 10.

22. On the founding and early years of the magazine, see Michael MacCambridge, *The Franchise: A History of "Sports Illustrated" Magazine* (New York: Hyperion, 1997), 4–102.

23. Prepublication document, in *The Spectacle of Sport from "Sports Illustrated,"* ed. and compiled by Norton Wood (Englewood Cliffs, N.J.: Prentice-Hall, 1957), 5.

24. Norton Wood, "The Spectacle of Sport," *Camera 35* 2, no. 3 (1958): 208–9 (emphasis in the original).

25. Devaney, "Inside S.I.," 10–12.

26. Harold G. Swahn, "Football Photography," *American Photography* 42 (September 1948): 560–61; "Take Me out to the Ball Game," *Minicam Photography* 12 (September 1948): 26–32, 137–38; Dick Turner, "You Can Shoot Football," *U.S. Camera* 14 (November 1951): 53–55, 102, and "Shoot Basketball Pictures," *U.S. Camera* 16 (January 1953): 38–39; Dan Rubin, "Action on Land, Sea, and Air," *American Photography* 47 (March 1953): 28–33; Doug Kilgour, "Camera on the Sidelines," *Photography* 33 (November 1953): 44–45, 102; "Sports and Action," *Photography* 333 (December 1953): 74–75; "Triple-Barreled Still Camera," *Photography* 34 (April 1954): 72–73, 86; "Action-Camera," *U.S. Camera* 19 (August 1956): 42–55; Dick Turner, "35mm Sports Photography," *U.S. Camera* 19 (September 1956): 50–53; Daniel R. Rubin, "How to Shoot a Sports Car Race," *Popular Photography* 40 (April 1957): 100–101, 189–93; "Sports Coverage with 35mm," *U.S. Camera* 22 (June 1959): 60–61; "Action for Amateurs—From A to Z," *U.S. Camera* 23 (May 1960): 14–31; and Neil Leifer, "Football Action," *Camera 35* 4 (October–November 1960): 58–61.

27. Carlton Brown, "Hy Peskin: Nation's No. 1 Sports Photographer," *Popular Photography* 36 (June 1955): 126.

28. Peskin, quoted in ibid., 126.

29. R. W. Connell, *Gender and Power: Society, the Person, and Sexual Politics* (Stanford: Stanford University Press, 1987): 84–85. On sports as a major site for the inscription of masculine identity, see also Brian Pronger, *The Arena of Masculinity: Sports, Homosexuality, and the Meaning of Sex* (New York: St. Martin's Press, 1990), 13–39; and David Whitson, "Sport in the Social Construction of Masculinity," in *Sport, Men, and the Gender Order: Critical Feminist Perspectives,* ed. Michael A. Messner and Donald F. Sabo (Champaign, Ill.: Human Kinetics Books, 1990), 19–29.

30. James McBride, *War, Battering, and Other Sports: The Gulf between American Men and Women* (Atlantic Heights, N.J.: Humanities Press, 1995), 77–106.

31. Mitchell, *Westerns,* 155.

32. "A Discussion of Sports Photography by Gerald Astor," *Infinity* 9 (November 1960): 7.

33. Elliot Gorn, *The Manly Art: Bare-Knuckle Prize Fighting in America* (Ithaca, N.Y.: Cornell University Press, 1986), 247.

34. Joyce Carol Oates, *On Boxing* (Garden City, N.Y.: Doubleday, 1987), 72.

35. For this viewpoint, see Neale, "Masculinity as Spectacle," 8, 11–16; and Robert E. Haywood, "George Bellows's *Stag at Sharkey's*: Boxing, Violence, and Male Identity" (1988), in *Critical Issues in American Art: A Book of Readings,* ed. Mary Ann Calo (Boulder, Colo.: Westview Press, 1998), 243–51.

36. Gerald Early, "James Baldwin's Neglected Essay: Prizefighting, the White Intellectual,

and the Racial Symbols of American Culture," in *Tuxedo Junction: Essays on American Culture* (Hopewell, N.J.: Ecco Press, 1989), 188–89.

37. John Bryson, "Picture of a Fighter," *Modern Photography* 13 (September 1949): 86–87.

38. Oates, *On Boxing,* 114, 116.

39. Robert Frank, "Guggenheim Application and Renewal Request," reprinted in *Robert Frank: New York to Nova Scotia,* ed. Anne W. Tucker and Philip Brookman (Houston: Museum of Fine Arts; New York: New York Graphic Society, 1986), 20.

40. Robert Frank, *Les Américains,* with text selected and edited by Alain Bosquet (Paris: Robert Delpire, 1958), reprinted as *The Americans,* with an introduction by Jack Kerouac (New York: Grove Press, 1959).

41. Sarah Greenough, "Fragments That Make a Whole Meaning in Photographic Sequences," in Sarah Greenough, Philip Brookman, and Robert Frank, *Robert Frank: Moving Out* (Washington, D.C.: National Gallery of Art; New York: SCALO, 1994), 105. In 1951, Frank did win second place in a photography contest sponsored by *Life* magazine. See "*Life* Announces the Winners of the Young Photographers Contest," *Life* 31 (26 November 1951): 21.

42. For a comprehensive listing of the venues in which Frank's photographs appeared before 1960, see Stuart Alexander, *Robert Frank: A Bibliography, Filmography, and Exhibition Chronology 1946–1985* (Tucson, Ariz.: Center for Creative Photography, 1986), 1–23.

43. On Frank's relationship with Edward Steichen, see Eric J. Sandeen, *Picturing an Exhibition: The Family of Man and 1950s America* (Albuquerque: University of New Mexico Press, 1995), 156–57.

44. On Evans and Frank, see Tod Papageorge, *Walker Evans and Robert Frank: An Essay on Influence* (New Haven: Yale University Art Gallery, 1981); Lesley K. Baier, "Visions of Fascination and Despair: The Relationship between Walker Evans and Robert Frank," *Art Journal* 41 (Spring 1981): 55–63; and Ken Takata, "Towards an Elegance of Movement—Walker Evans and Robert Frank Revisited," *Journal of American Culture* 12, no. 1 (1989): 55–65.

45. Walker Evans, "Robert Frank," *U.S. Camera Annual 1958,* ed. Tom Maloney (New York: U.S. Camera Publishing, 1957), 90. Photographs from his Guggenheim trip were also published in Gotthard Schuh, "Robert Frank," *Camera* 36 (August 1957): 339–56; and "A Pageant Portfolio: One Man's U.S.A.," *Pageant* 13 (April 1958): 24–35.

46. Kerouac, introduction to Frank, *The Americans,* 9. The characterization of Frank as a "poet" photographer actually predated *the Americans.* See Byron Dobell, "Feature Pictures: Robert Frank . . . The Photographer as Poet," *U.S. Camera* 17 (September 1954): 77–84.

47. On Frank's rebellion against editorial authority, see William S. Johnson, "Public Statements/Private Views: Shifting the Ground in the 1950s," in *Observations: Essays on Documentary Photography,* ed. David Featherstone (Carmel, Calif.: Friends of Photography, 1984), 81–92.

48. According to Philip Brookman, "Windows on Another Time: Issues of Autobiography," in Greenough, Brookman, et al., *Robert Frank: Moving Out,* 146, during the late 1940s, Frank became interested in the work of Sartre and Camus, which influenced his decision to seek a more personal artistic vision than was possible for him at *Harper's Bazaar.* One of the few historians to give William Klein as much credit as Robert Frank (with Diane Arbus completing the trilogy) for creating a more subjective and "iconoclastic" form of documentary is James Guimond, *American Photography and the American Dream* (Chapel Hill and London: University of North Carolina Press, 1991), 207–44.

49. Robert Frank, "A Statement," *U.S. Camera Annual 1958,* 115. W. T. Lhamon Jr., *Deliber-*

ate Speed: The Origins of a Cultural Style in the American 1950s (Washington and London: Smithsonian Institution Press, 1990), 129, compares Frank's "associative" photographic sequencing in *The Americans* to early Delta blues songs.

50. Evans, "Robert Frank," 90.

51. Lili Corbus Bezner, *Photography and Politics in America: From the New Deal into the Cold War* (Baltimore: The Johns Hopkins University Press, 1999), 178. For a reading of *The Americans* as a critical reversal or parody of Steichen's simplistic message in The Family of Man, see Mark Hinderaker, "*The Family of Man* and *The Americans,*" *Photographer's Forum* 2 (September 1980): 22–28; and Jno Cook, "Robert Frank: Dissecting the American Image," *Exposure* 24 (Spring 1986): 31–41.

52. [Minor White], "Book Reviews: Three 1958 *Annuals,*" *Aperture* 5, no. 4 (1957): 173.

53. [Minor White], "Book Reviews: *Les Américains,*" *Aperture* 7, no. 3 (1959): 127.

54. "An Off-Beat View of the U.S.A.: *Popular Photography*'s Editors Comment on a Controversial New Book," *Popular Photography* 46 (May 1960): 104–6.

55. Frank Getlein, "Art: Beatniks and Beaux," *New Republic* 142 (11 January 1960): 22.

56. William Hogan, "A Bookman's Notebook: Photo Coverage of the Ugly American," *San Francisco Chronicle,* 27 January 1960.

57. Patricia Caulfield, "New Photo Books: *The Americans,*" *Modern Photography* 24 (June 1960): 33.

58. Paul O'Neil, "The Only Rebellion Around: But the Shabby Beats Bungle the Job in Arguing, Sulking, and Bad Poetry," *Life* 47 (30 November 1959): 115.

59. See especially John Brumfield, "'The Americans' and *The Americans,*" *Afterimage* 8 (Summer 1980): 8–15; Jno Cook, "Robert Frank's America," *Afterimage* 9 (March 1982): 9–14; George Cotkin, "The Photographer in the Beat-Hipster Idiom: Robert Frank's *The Americans,*" *American Studies* 26 (Spring 1985): 19–33; and W. S. Di Piero, "Not a Beautiful Picture: On Robert Frank," *Tri-Quarterly* 76 (1989): 146–65.

60. DeCarava, an African American, was also a Guggenheim Fellowship recipient (1952) and used his award to photograph Harlem. Ninety-two of these photographs were published in *The Sweet Flypaper of Life,* with text by Langston Hughes (New York: Simon and Schuster, 1955). Although it was a critical and popular success, the book—and DeCarava—have not received nearly as much attention from the photography establishment as have *The Americans* and Frank.

61. Kerouac's *On the Road* was published in 1957 but had supposedly been produced during a frenzied three weeks of spontaneous writing in 1951. The 120-foot-long roll of paper on which the novel was typed still exists, although as Ann Charters points out in her introduction to the 1991 reprint edition of the book, the manuscript was retyped a number of times. Jack Kerouac, *On the Road,* with an introduction by Ann Charters (New York: Penguin Books, 1991), xx–xxiii.

62. Kerouac, introduction to Frank, *The Americans,* 6 (emphasis in the original).

63. Jane Livingston, *The New York School: Photographs, 1936–1963* (New York: Stewart, Tabori and Chang, 1992), 363.

64. David Riesman, *The Lonely Crowd: A Study of the Changing American Character,* with Nathan Glazer and Reuel Denney (New Haven and London: Yale University Press, 1950), 17–25.

65. William H. Whyte Jr., *The Organization Man* (New York: Simon and Schuster, 1956); Robert Lindner, *Must You Conform?* (New York: Rinehart, 1956). On the personal and

political apathy of Americans in their twenties and thirties, see also Caroline Bird, "Born 1930: The Unlost Generation," *Harper's Bazaar* 91 (February 1957): 104–7, 174–75.

66. Philip Wylie, *Generation of Vipers* (New York: Rinehart, 1942), 196, 203, 205.

67. Edward A Strecker, *Their Mother's Sons: The Psychiatrist Examines an American Problem* (Philadelphia: J. B. Lippincott, 1946); and Edward A. Strecker and Vincent T. Lathbury, *Their Mothers' Daughters* (Philadelphia: J. B. Lippincott, 1956).

68. Gene Feldman and Max Gartenberg, introduction to *The Beat Generation and the Angry Young Men,* ed. Gene Feldman and Max Gartenberg (New York: Citadel Press, 1958), 17, 10.

69. Barbara Ehrenreich, *The Hearts of Men: American Dreams and the Flight from Commitment* (Garden City, N.Y.: Anchor Books/Doubleday, 1983), 54.

70. Jack Kerouac, "The Origins of the Beat Generation," *Playboy* 6 (June 1959): 32.

71. Wini Breines, "The 'Other' Fifties: Beats and Bad Girls," in *Not June Cleaver: Women and Gender in Postwar America, 1945–1960,* ed. Joanne Meyerowitz (Philadelphia: Temple University Press, 1994), 397.

72. "Beat Playmate," *Playboy* 6 (July 1959): 47–50.

73. Allen Ginsberg, *"Howl" and Other Poems* (San Francisco: City Lights, 1955), 64. Catharine R. Stimpson, in "The Beat Generation and the Trials of Homosexual Liberation," *Salmagundi* 58–59 (Fall 1982–Winter 1983): 373–92, argues that male-male sexual activity was part of the Beat writers' quest to appropriate for themselves every facet of sexual experience. It also served to strengthen their homosocial bond. Moreover, these descriptions of homosexual acts were intended more as weapons to shock the public than as political steps toward gaining greater acceptance for those who identified as homosexuals.

74. The film was directed by Laslo Benedek, written by John Paxton, produced by Stanley Kramer, and released by Columbia.

75. Leerom Medovoi, "Bad Boys: Masculinity, Oppositional Discourse, and American Youth Culture in the 1950s" (Ph.D. diss., Stanford University, 1995), 76–110. This chapter of Medovoi's dissertation has been revised and is reprinted in Leerom Medovoi, "Reading the Blackboard: Youth, Masculinity, and Racial Cross-Identification," in *Race and the Subject of Masculinities,* ed. Harry Stecopoulos and Michael Uebel (Durham, N.C., and London: Duke University Press, 1997), 138–53. For a feminist critique of the way interracial male bonds in novels and films have functioned to strengthen the notion of the United States as an "exclusive masculine realm," see Robyn Wiegman, *American Anatomies: Theorizing Race and Gender* (Durham, N.C., and London: Duke University Press, 1995), 115–46, and "Negotiating AMERICA: Gender, Race, and the Ideology of the Interracial Male Bond," *Cultural Critique* 13 (Fall 1989): 89–117.

76. Medovoi, "Bad Boys," 111. On interracial friendships among Beat writers and artists, see Mona Lisa Savoy, "Black Beats and Black Issues," in *Beat Culture and the New America: 1950–1965,* ed. Lisa Phillips (New York: Whitney Museum of American Art; Paris and New York: Flammarion, 1995), 153–65.

77. Norman Mailer, "The White Negro: Superficial Reflections on the Hipster" (1957), reprinted in Norman Mailer, *Advertisements for Myself* (New York: G. P. Putnam's Sons, 1959), 335, 339–40. For the influence of existentialism, as well as of Marxism, psychoanalysis, and the *"machismo"* of Ernest Hemingway, on Mailer's conception of the hipster, see Robert Ehrlich, *Norman Mailer: The Radical as Hipster* (Metuchen, N.J., and London: Scarecrow Press, 1978).

78. Mailer, "The White Negro," 340–41.

79. James Baldwin, "The Black Boy Looks at the White Boy" (1961), reprinted in *Nobody Knows My Name: More Notes of a Native Son* (New York: Dial Press, 1961), 221, 217.

80. Norman Podhoretz, "The Know-Nothing Bohemians" (1958), reprinted in *Doings and Undoings: The Fifties and After in American Writing* (New York: Farrar, Straus and Giroux, 1964), 151.

81. Frantz Fanon, *Black Skin, White Masks* (1952), trans. Charles Lam Markmann (New York: Grove Press, 1967), 109, 177.

82. On Jewish masculinity, see the collection of essays in Harry Brod, ed., *A Mensch among Men* (Freedom, Calif.: Crossing Press, 1988).

83. Joseph Campbell, *The Hero with a Thousand Faces* (New York: Pantheon Books, 1949).

84. Frank, quoted in Di Piero, "Not a Beautiful Picture," 155.

85. The term was firmly established with two exhibitions in the mid-1960s. See the following exhibition catalogs: Danny Lyon, ed., *Toward a Social Landscape: Contemporary Photographers* (New York: Horizon Press; Rochester, N.Y.: George Eastman House, 1966); and *Twelve Photographers of the American Social Landscape*, with an introduction by Thomas H. Garver (New York: October House; Waltham, Mass.: Rose Art Museum, Brandeis University, 1967).

86. Julia Scully and Andy Grundberg, "Currents: American Photography Today. Robert Frank's Iconoclastic Outsider's View of America in the 1950s Provided Both Form and Substance for the Next Generation," *Modern Photography* 42 (October 1978): 94–97, 196, 198, 200.

87. Colin Westerbeck and Joel Meyerowitz, in *Bystander: A History of Street Photography* (Boston: Bulfinch Press, 1994), position Robert Frank as the fourth and last "father" of street photography. See also Colin Westerbeck, "Beyond the Photographic Frame, 1946–1989," in Sarah Greenough, Joel Snyder, David Travis, and Colin Westerbeck, *On the Art of Fixing a Shadow: One Hundred and Fifty Years of Photography* (Washington, D.C.: National Gallery of Art, 1989), 355–60. For an overview of Frank's influence on photographers in the 1960s and 1970s, see Gerry Badger, "From Humanism to Formalism: Thoughts on Post-War American Photography," in *American Images: Photography 1945–1980*, ed. Peter Turner (New York: Viking Press/Barbican Art Gallery, 1985), 11–22.

88. On Davidson's early career, see Patricia Caulfield, "Bruce Davidson: New Eye on Old Subjects," *Modern Photography* 22 (August 1958): 46–51, 92; and Barbara Miller, "Bruce Davidson," *Camera* 4 (April 1959): 6–20.

89. Norman Mailer, "Brooklyn Minority Report," photographed by Bruce Davidson, *Esquire* (June 1960): 129–37.

90. Bruce Davidson, *Bruce Davidson Photographs*, with a preface by Henry Geldzahler (New York: Agrinde/Summit, 1978), 10. On Davidson's decision to photograph the gang, see also Livingston, *The New York School*, 329–31.

91. The literature on this subject ranges from sociological, criminological, and psychological studies to government surveys and investigations. A useful guide to this period is Dorothy Campbell Tompkins, comp., *Juvenile Gangs and Street Groups: A Bibliography* (Berkeley: Institute of Governmental Studies, University of California, 1966).

92. Mailer, "Brooklyn Minority Report," 137. Despite the seriousness with which he addresses the issue of juvenile delinquency, a similar romanticization occurs in Paul Goodman, *Growing Up Absurd: Problems of Youth in the Organized System* (New York: Random House, 1960), 13; like Mailer, Goodman argues that the only real problem facing young men is that organized society, unlike the gang, provides no means to be a *real* man.

93. Albert K. Cohen, *Delinquent Boys: The Culture of the Gang* (New York: Free Press, 1955), 31, 140.

94. Peter Lehman, *Running Scared: Masculinity and the Representation of the Male Body* (Philadelphia: Temple University Press, 1993), 126.

95. Harrison E. Salisbury, *The Shook-Up Generation* (New York: Harper and Brothers, 1958), 33–34.

96. Ibid., 34.

97. Alfred C. Kinsey, Wardell B. Pomeroy, and Clyde E. Martin, *Sexual Behavior in the Human Male* (Philadelphia: W. B. Saunders, 1948), 218–62; Institute for Sex Research, *Sexual Behavior in the Human Female* (Philadelphia: W. B. Saunders, 1953), 371–408.

98. Mailer, "The White Negro," 347. The classic critique of Mailer's extreme sexism is Kate Millet, *Sexual Politics* (Garden City, N.Y.: Doubleday, 1970), 314–35.

99. Mailer, "Brooklyn Minority Report," 137.

100. Ibid., 129.

101. See Lehman, *Running Scared*, 101.

102. Norman Mailer, "Hipster and Beatnik: A Footnote to 'The White Negro,'" in Mailer, *Advertisements for Myself*, 373.

103. The "ganging process" as a proving ground for manhood is discussed in Herbert Bloch and Arthur Niederhoffer, *The Gang: A Study in Adolescent Behavior* (New York: Philosophical Library, 1958), 133–37.

104. Talcott Parsons, "Certain Primary Sources and Patterns of Aggression in the Social Structure of the Western World," *Psychiatry* 10 (May 1947): 167–81.

105. Norman Mailer, "Advertisement for the 'Homosexual Villain,'" in Mailer, *Advertisements for Myself*, 222.

106. Mailer, "Brooklyn Minority Report," 129, 137.

107. Samuel M. Steward, *Bad Boys and Tough Tattoos: A Social History of the Tattoo with Gangs, Sailors, and Street-Corner Punks, 1950–1965* (New York and London: Harrington Park Press, 1990), 57, 67–69, 112–27.

108. Salisbury, *The Shook-Up Generation*, 34.

109. Eve Kosofsky Sedgwick, *Between Men: English Literature and Male Homosocial Desire* (New York: Columbia University Press, 1985).

110. See Kenon Breazeale, "In Spite of Women: *Esquire* Magazine and the Construction of the Male Consumer," *Signs* 20 (Autumn 1994): 1–22, for a discussion of the magazine's attempts to promote a specifically heterosexual male readership through the presentation of women as erotic objects. I would also argue that in order to fashion the "*Esquire* Man," the visual support of the male body as a model for such a construction would be necessary.

111. Freud argues that when the boy identifies with the mother during the pre-Oedipal phase, the father becomes an object-choice; however, he must suppress these fantasies to identify with the father and resolve the Oedipus complex. Thus, masculine identification is a defense against the ever-present possibility of homoerotic desire for the father. See Sigmund Freud, *The Ego and the Id*, trans. Joan Riviere (New York and London: W. W. Norton, 1960), 28–30.

112. Norman Mailer, "Catholic and Protestant," in Mailer, *Advertisements for Myself*, 426–28.

113. Mailer, "The White Negro," 342.

114. Bruce Davidson, "What Photography Means to Me," *Popular Photography* 25 (May 1962): 87.

115. Linda Gravenson, "Portrait of the Artist as a Young Photographer," *Infinity* 10 (April 1961): 5, 18.

116. On the production of the film, see Blaine Allan, "The Making (and Unmaking) of *Pull My Daisy*," *Film History* 2, no. 3 (1988): 185–205. On its critical reception, see Tony Floyd, "*Pull My Daisy*: The Critical Reaction," *Moody Street Irregulars* 22–23 (1989–90): 11–14.

117. The manifesto is reprinted in John G. Hanhardt, "A Movement toward the Real: *Pull My Daisy* and the American Independent Film, 1950–65," in Lisa Phillips et al., *Beat Culture and the New America: 1950–1965* (New York: Whitney Museum of American Art/Flammarion, 1995), 223. Frank would return to photography with *The Lines of My Hand* (Tokyo: Yugensha, Kazuhiko Motomura, 1972; New York: Lustrum Press, 1972), a photographic autobiography.

118. Robert Frank, quoted in Robert Silberman, "Outside Report: Robert Frank," *Art in America* 75 (February 1987): 132.

119. For an overview of these institutional changes, see John Szarkowski, *Mirrors and Windows: American Photography since 1960* (New York: Museum of Modern Art, 1978), 14–16; and Gerry Badger, "From Humanism to Formalism: Thoughts on Post-War American Photography," in Turner, *American Images*, 15–22.

120. On the use of photography as a tool rather than as an end in itself, see Andy Grundberg and Kathleen McCarthy Gauss, *Photography and Art: Interactions since 1946* (New York: Abbeville Press, 1987).

Index

Abbott, Berenice, 68
abjection, 76, 84–85, 110, 161n80
abstract expressionism, 23
Acme Newspictures, 69
Action Photography (exhibition), 69
Adams, Ansel, xii, 5, 18–22, 24, 26–28,
 65, 67, 124–26, 133, 152n115, 153n117,
 153–54nn131–32
Adams, Hal, 102
Adelman, Skippy, 63
advertising photography, 4, 17, 102–3
aesthetics, xiv–xv, 14, 20–21, 23–29, 57–59,
 70, 72–73, 79–80, 95–96, 124–26, 130–31,
 133, 139, 141, 172n114
African American males: as masculine icons,
 xv, 116, 123, 128, 132–33
American Broadcasting Company (ABC), 61

American Photography (magazine), 20, 26
Americans, The/Les Américains (Frank), xv,
 123–34, 184–85n49
American Society of Magazine Photographers
 (ASMP), 6–7, 19, 111. *See also ASMP News;
 Infinity*
Aperture (journal), xii, 18, 23–24, 27, 29, 124,
 152n108
Arlington National Cemetery, 54
Armstrong-Jones, Antony, 7
Army Morale Division, 106
Army Signal Corps, 27, 33
Arrowsmith, Charles, 20
art, xiii, 111, 152n101; gendering of, xii, 16–17,
 33, 42, 70, 112; photography and, xii–xiii,
 15–18, 20–21, 59, 68–69, 88, 95–96, 106,
 108, 142, 152n114, 155n159, 179n96

ASMP News (journal), 6, 12, 90. *See also* American Society of Magazine Photographers

Associated Press, 53

Astaire, Fred, 88

Astor, Gerald, 122

Atget, Eugène, xiv, 68, 166nn38–39

athletes, 116–23

Avedon, Doe (Dorcas Nowell), 92–93, 173n20

Avedon, Richard, xiv, 5, 88–97, 173n12

Bacon, Francis, 57

Baldwin, James, 132

Bannister, Constance, 13

Barry, Les, 126

Barthes, Roland, 84, 94

Basch, Peter, 112

Bayer, Herbert, 26

Beat Generation, The (play; Kerouac), 141

Beat movement/philosophy, xv, 116, 124–29, 131–32, 139, 141, 186n73; Beatniks, 127, 129

Bell, Daniel, 72

Bergman, Ingrid, 39

Best Years of Our Lives, The (film), 113–14, 181n4

Bezner, Lili Corbus, 65–66, 126

Bigelow, Norman, 103–4

Bischof, Werner, 40

Bisland, Margaret, 2

Blackboard Jungle, The (film), 132

Blue Ghost, The (Steichen), 45–49, 160n66, 165n28

blurred shot, xiv–xv, 29, 39, 84–85, 139. *See also* aesthetics

Bob Cummings Show, The (television series), 98, 175n46

bodybuilding, 182n18; and physique photography, 119

bomb, atomic, 66, 127, 163n104, 163nn106–7; photographs of, ix–x, 56–59, 64, 163n103

Bourke-White, Margaret, 10, 13, 65

boxing, xiv, 121–23

Brando, Marlon, 131

Brandt, Bill, 125

Bratton, Kenneth, 55–56

breadwinner role, xi–xiii, 4, 7, 18, 32–33, 96–97, 114–16, 129, 147n17, 151n95; men's rejection of, 98–100, 118, 127–29, 135–38, 141, 175–76n50

Bright, Deborah, 21–22

Brodovitch, Alexey, 90, 124

Bronson, Charles, 61

Brooklyn Gang series (Davidson), xv, 134–41

Brooks, Charlotte, 13

Brown v. Board of Education, 131

Bryson, John, 116–18

Bubley, Esther, 10

Burgin, Victor, 74

Bushemi, Sgt. John, 36

Cabaret (magazine), 111

camera, 2–3, 8–9, 14, 33, 64, 84, 90, 96–97, 104, 120, 142; companies, 3, 10, 27, 159n54; as weapon, 74–75, 78, 80–81, 83, 124, 130, 133, 161n75, 170n72

Camera (journal), 124

Camera Clubs, 10

Camera 35 (journal), 111

Camera Work (journal), 25

Campbell, Joseph, 133: *Hero with a Thousand Faces,* 133

Camus, Albert, 82, 184n48

Capa, Robert (Andrei Friedmann), 6, 34, 37–42, 157n37, 157–58n39

Cartier-Bresson, Henri, 6, 15, 25, 80

Casey, Crime Photographer (radio program), 62

castration anxiety, 48, 107, 110–11, 113–16, 138, 181n4. *See also* Freud, Sigmund

Catcher in the Rye (Salinger), 132

Caulfield, Patricia, 127

Chandler, Raymond, 72

Charles, Ezzard, 121

Chassler, Sey, 24–25, 32

Chim. *See* Seymour, David

Chicago Institute of Design, 22, 170n83

civil rights movement, 123

Civil War, 33

Clark, Sir Kenneth, 111–12

class, social, xii, xv–xvi, 18–19, 32, 98–99, 123, 126, 128, 131–33, 138; and

photography, 4, 6, 9–10, 19–20, 25; in relation to sports, 119
Cockburn, Cynthia, 16, 32
Cohan, Albert K., 135
Cold War, x, xv, 22, 32, 35, 41–42, 54, 57–59, 65–68, 82, 116, 128, 158–59n52, 163n106, 166n32, 168–69n59, 171nn99–100
conformity, 4, 128–29, 132, 134–35, 141; due to corporations, xiii, 4, 32; non-conformity, 19
Connell, R. W., 68, 120
Connolly, Rita, 10
consumption, postwar cult of, 98–99, 127
Contemporary Photographer (magazine), 134
Coons, Barney, 63
cowboy, 31–32, 72, 80–81, 116–19, 128, 130, 182n10
Coxe, George Harmon, 62
crime photography, xiv, 61–65, 69–78, 163–64n4, 164n16
Croner, Ted, 6, 90
Culp, Nancy, 98
Cummings, Bob, 98
Cunningham, Imogen, 5

Dahl-Wolfe, Louise, 90
Daniels, Elise, 92
Davidson, Bruce, xv, 6, 123, 133–41; Brooklyn Gang series, xv, 134–41
Davis, Ann B., 98
DeCamp, Rosemary, 98
DeCarava, Roy, 5, 127, 185n60
de Certeau, Michel, 81
de Dienes, André, 102, 107, 111, 179n100; *Nude Pattern*, 107
Deer, Virginia, 13
detective novels. *See* hard-boiled fiction
de Weldon, Felix, 54
Diogenes with a Camera (exhibitions), 25
Dior, Christian, 93, 173n26
documentary photography, 5, 18–19, 23, 25, 85, 124, 184n48; social-, xiv, 23, 65–68, 70, 125–26, 130–31, 134, 165n21
Dody, 26
domesticity, postwar cult of, ix–x, 4, 62, 145n3

Donaghy, Don, 6
Douglas, Mary, 110
Dovima (Dorothy Horan), 88–89, 92–94
Downes, Bruce, 28, 126
Duke (magazine), 111
Duncan, David Douglas, 6, 40–42, 46

Early, Gerald, 122
Easlea, Brian, 57–58
Eastman Kodak, 3, 20, 159n54, 161n75, 164n16, 170n72. *See also* camera
Ehrenreich, Barbara, 8, 129
Eisenstaedt, Alfred, 63
Eisner, Maria, 6
Elisofon, Eliot, 12
Ellis, Jane, 8
Engel, Morris, 6
Esquire (magazine), 98, 132, 134, 135, 138–39, 175n47, 188n110
Evans, Walker, 65, 124–26
Exact Instant: Events and Faces in 100 Years of News Photography, The (exhibition), 64
existentialism, xv, 23, 66, 68, 81–84, 125, 131–32, 171n103

Family of Man, The (exhibition), ix–x, 27, 66, 124, 126, 142, 165nn28–29
Fanon, Frantz, 133
Farm Security Administration (FSA), 3, 65, 126
fascism, 159–60n62
fashion models, xiv, 87–89, 91–98
fashion photography, xiv–xv, 87–98, 112, 124, 173n9
Fassbender, Adolf, 20–21
fatherhood, x
Faurer, Louis, 6, 126–27
Feinblatt, Ebria, 25
Feldman, Gene, 129
Fellig, Arthur. *See* Weegee
female body, xv, 93–95, 107–11; as raw material, xiv, 105–6, 110; as space/place, 43–45, 71, 79, 81–82, 110, 171n101
feminine, the: as artifice, 14, 23, 83, 93, 171–72n107; within men, 43–44, 48, 51, 71–72, 168n57; as nature, 53, 57–59; as

physical matter, 81–82, 85, 110; as unruly, 75–76, 81–82, 170n77

femininity, xv, 1, 14–15, 25, 108, 118–19; breast as signifier of, 107–10; postwar constructions of, xi, xiii, 2, 13, 31–33, 62, 88–90, 93–94, 98–101, 105, 129, 176n58

feminism, 100, 175–76n50, 176n58

femme fatale, 71–75, 93, 168n55

fetishism/fetishization, 43, 48, 74, 76, 107, 110–11, 119, 170n77, 180n106

film noir, xiv, 70–74, 81–82, 98, 168nn55–57, 171n97, 171n103

Floherty, John J., 62

Florin, Jeanne, 87

Fonssagrives, Fernand, 96

Fonssagrives-Penn, Lisa, 96

Fontaine, Alan, 106

Ford, Mrs. Clinton E., 8

Forrestal, James, 54

Fortune (magazine), 69, 124

Foster, Vince, 123

Frank, Mary, 126

Frank, Robert, xv, 6, 123–34, 141–42, 184n41, 184n46, 184n48; *Americans, The/Les Américains,* xv, 123–34, 184–85n49; *Pull My Daisy* (film), 141

Friedlander, Lee, 134

Freud, Sigmund, 44, 82, 107, 139, 160n65, 161n75, 171n102, 188n111

Funny Face (film), 88, 91–93

gang members, 131–41. *See also* juvenile delinquents

gangsters, 70, 72, 116, 136

Gartenberg, Max, 129

Gee, Helen, 5, 28, 94. *See also* Limelight Gallery and coffeehouse

Generation of Vipers (Wylie), 12, 99, 129, 176n51

George Eastman House, 25–27

Gerber, David A., 113–14

Gershe, Leonard, 88

Getlein, Frank, 127

Gherardi, Silvia, 1, 13

GI Bill, 113

Ginsburg, Allen, 127–28, 131; *Howl,* 131

Girard, René, 55–56

glamour photography, xiv, 105–6, 111. *See also* pinup/centerfold photography

Goldsmith, Arthur, 126

Gowland, Peter, 179n101

Grable, Betty, 106

Gravenson, Linda, 141

Gray, Glenn J., 44, 59

Great Depression, 3, 7, 34, 65

Green, Martin, 42

Guggenheim Foundation/Fellowship, 123–25, 185n60

Hacker, Helen Mayer, 105

Halsey, Adm. William F., 51

Halsman, Philippe, 6

Hamblin, Dora Jane, 11–12, 15

Hammett, Dashiell, 72

Handy, Ellen, 21

hard-boiled fiction, xiv, 62, 72, 98, 168n55, 168–69n59, 169n61

Harnett, Sunny, 92–93

Harper's Bazaar/Junior Bazaar (magazine), 88, 90, 124

Harrison, William R., 105–6

Hartmann, Ruth, 7

Hearn, Jeff, 7, 25

Hefner, Hugh, 98, 101–2, 104–6, 119, 175–76n50, 179n96. *See also Playboy*

Heidegger, Martin, 82

Heilpern, John, 79–80

Hemingway, Ernest, 39

Henry, George W., 16

Hepburn, Audrey, 88

Hero with a Thousand Faces (Campbell), 133

heterosexuality: as marker of manhood, 16, 98–99, 122, 135–36, 138, 175n49

Hickman, Dwayne, 98

Hicks, Wilson, 10, 13–16, 20

Hine, Lewis, 65

Hines, Richard, Jr., 2

Hip/hipster, 127, 132, 136, 139

Hiroshima, 42, 56–57

Hitchcock, Alfred, 31

Hoban, Tana, 10, 13

hobby, photography as a, 2, 8–10, 104

Hogan, William, 127

Hollander, Anne, 107

homoeroticism, xv, 45, 122, 135, 139

homophobia, 119, 122, 131, 136, 168n57

homosexuality, 16, 45, 67, 100–101, 105, 119,
 122, 131, 139, 151n100, 166n32, 168n57,
 169n62, 176n56, 186n73

Horst, Horst P., 89

House Un-American Activities Committee
 (HUAC), 13, 66

Howl (Ginsberg), 131

Hoyningen-Huene, George, 89

Huyssen, Andreas, 17

In and Out of Focus (exhibition), 28

Incredible Shrinking Man, The (film), 114

Infinity (journal), 6–7, 11, 18, 25, 111, 124.
 See also American Society of Magazine
 Photographers

Irigaray, Luce, 110

Iwo Jima, 51–55, 162n86, 162n92, 162n94

Jacobs, Charles Fenno, 48–50

Jaguar (magazine), 111

Japanese, 51

Jeffords, Susan, 43

Jem (magazine), 111

Johnson, Lt. Col. Chandler, 54

Judge, Jacquelyn, 6

juvenile delinquents, xv, 116, 123, 131–32,
 134, 187n92

Kaite, Berkeley, 107

Keller, Evelyn Fox, 14

Kelly, Grace, 31

Keppler, Herbert, 79

Kerouac, Jack, 124–29, 141; *On the Road*,
 127–28, 183n61; *The Beat Generation*, 141

Kierkegaard, Søren, 82

Kinsey Institute reports, 16, 105, 136, 178n87

Klein, William, xiv, 5, 78–85, 87–88, 125,
 127, 131, 171n98, 184n48; *Life Is Good and
 Good for You in New York*, 78–85, 131

Korean War, xiv, 40–42, 66, 114–16, 156n19,
 157n26, 161n75

Kristeva, Julia, 76

Kuhn, Annette, 110

Ladies Home Companion (magazine), 99

landscape: aesthetics of, xiv, 57–59; pho-
 tography, 21–22; as source of masculine
 renewal, 118

Lange, Dorothea, 10, 65

Larsen, Hazel Frieda, 10

Laurence, William L., 57

Leatherneck, 54

Leen, Nina, 10, 13

Lehman, Peter, 135

Leigh, Dorian, 92–93

Leslie, Alfred, 141; *Pull My Daisy* (film), 141

Levitt, Helen, 6, 10, 70

Levy, Julian, 4

Lewinski, Jorge, 102

liberalism, 67, 165–66n30

Liberman, Alexander, 95

Life (magazine), 2– 3, 5, 10–15, 26, 33–35,
 37, 40, 51, 64, 69, 76, 96, 100, 116–17, 123,
 124, 127, 147n12, 150n75

Life Is Good and Good for You in New York
 (Klein), 78–85, 131

Limelight Gallery and coffeehouse, 5, 28

Lindner, Robert, 128–29

Long, Clarence Hailey, 117–18

Longwell, Daniel, 13

Look (magazine), 3, 13, 101, 124

Los Angeles County Museum, 25

Lowery, Lou, 54

Luce, Henry, 119

Lynes, Russell, 16

Lyons, Louis M., 15

MacKinnon, Catherine, 48

Mailer, Norman, 132, 134–39, 141

male body, xi, xv, 127; on display, 45–46,
 48–49, 119–23, 136–37, 139; as essence
 of manhood, 113–18; in pain, 46–47,
 121–22, 134, 138–39; as rapable, 48–51;
 as site of truth, xv, 84–85

Maloney, Tom, 27, 35–37, 41–42, 157n26
Manhattan Project, 42, 57–58
Manifest Destiny, 22
Man Ray, 25
Mansfield, Jayne, 107
Man with a Camera (television series), 61–62, 163n1
Marciano, Rocky, 121
Marling, Karal Ann, 53–55
Marshall Plan, 42
mass culture: gendering of, 17, 166n37
May, Elaine Tyler, 4
McBride, James, 35, 47–48, 50–51, 55, 121
McCall's (magazine), 91, 124
McCarthy, Joseph, 67, 124
McCleery, William, 71
McCombe, Leonard, 116–18, 123
McLuhan, Marshall, 96, 118
Mead, Margaret, 16
Medovoi, Leerom, 131–32
Metropolitan Museum of Art (New York), 23–25
Meyer, Russ, 104, 177n81
Meyerowitz, Joel, 79
Mieth, Hansel, 13
Miller, Francis, 64
Miller, Russell, 104
Miller, Wayne, ix–x, 55–56
Mills, C. Wright, 17, 29, 32
Mitchell, Lee Clark, 118
Model, Lisette, 10
modernist photography, xii–xiii, xv, 16, 20–22, 24–28, 65, 67, 124–26, 130–31
Modern Photography (magazine), 90, 123–24, 127
Moeller, Susan D. 33, 54
Moholy-Nagy, Laszlo, 25
Momism, 11, 99, 129. *See also* Wylie, Philip
Monroe, Marilyn, 98, 102, 107
Morgan, Barbara, 13
Moskin, J. Robert, 101
motherhood, x–xi, 2, 11, 138. *See also* women
Mottar, Robert, 11–14
Museum of Modern Art (New York), ix, xii, 5, 10, 16, 23–27, 42–43, 64, 66, 69, 107, 124, 134, 138, 142, 148n31

Must You Conform? (Lindner), 128–29
Mydans, Carl, 34

Nagasaki, 56–57
Naked City (Weegee), 69–78, 167n45
Naked Hollywood (Weegee), 69
Nappi, Lucille, 8
National Security Act, 42
Naval Aviation Photography, 43, 45–51
Nead, Lynda, 110
New American Cinema Group, 141
New American Vision, 89
New Deal, xiii, 19, 65
Newhall, Beaumont, xii, 5, 25–28
Newhall, Nancy, 23
New Republic (journal), 66
news photography, 4, 62–65, 67, 164n9, 164n11
New Yorker (magazine), 91
New York Mirror, 63
New York Times, 57, 135
Nietzsche, Friedrich, 82
Norman, Bob (Burt Zollo), 99, 175–76n50
Normandy invasion, 38–39
nude, the: artistic tradition of, 106, 111–12, 119; in photography, xiv, 98, 102, 106–12, 119, 177n82, 179n96
Nude Pattern (de Dienes), 107
Nugget (magazine), 111

Oates, Joyce Carol, 122–23
O'Donnell, Cathy, 113
Okinawa, 37, 41
On the Road (Kerouac), 127–28, 185n61
Organization Man (Whyte), 128
Orvell, Miles, 74, 76

Packard, Vance, 18–19
Page, Homer, 114–15
Pageant (magazine), 24
Parker, Suzy, 88, 92–94
Parks, Gordon, 3, 15, 65
Parsons, Talcott, 138
Partisan Review (journal), 66
Patchett, Jean, 95
Penn, Irving, xiv, 28, 89, 94–97

Peskin, Hy, 120
Philadelphia Museum School of Industrial Art, 95
Philips, Christopher, 26
Photographer's Association of America, 4
Photographic Society of America (PSA), 23
Photography at Mid-Century (exhibitions), 25
Photography in the Fine Arts (exhibition), 24
photojournalism, xii–xiii, 7, 11–12, 14–15, 20, 24–26, 28, 31–33, 65, 67–68, 124–26, 130, 142, 156n14, 166n35. *See also* news photography
Photo League, 5, 17–19, 23, 65, 69, 126
Photo Notes, 17. *See also* Photo League
Photo-Secession, 25, 27
pictorialism, xiii, 18, 20–21, 23–26, 67–68, 130, 153–54n132, 154n140
picture agencies, xii–xiii; Black Star, 6; FPG, 6; Globe, 6; Graphic House, 6; Magnum, 6, 11, 40; Pix, 6; Rapho Guillumette, 6
pinup/centerfold photography, xiv–xv, 105–6, 111–12, 142
Playboy (magazine), xiii–xv, 98–107, 111, 129, 175nn48–49, 177n82; Playmates, 98, 101–6, 119, 129
playboys, xi–xii, 98–99, 101–2, 129; photographers as, xiv–xv, 98, 102–4, 111–12
PM Picture News, 63, 71
PM Weekly, 69
Podhoretz, Norman, 133
Polaroid Corporation, 19
Pollock, Jackson, xiv
Popular Mechanics (magazine), xii
Popular Photography (magazine), xii, 3, 96, 124, 126
pornography, 111, 180–81nn124–25
Porter, Eliot, 5
portrait photography, xiii, 2–4
Power in the Pacific (exhibition), 26, 42–43; catalog, 55, 160n67
Princess Margaret (Great Britain), 7
Pull My Daisy (film; Frank and Leslie), 141
Pyle, Ernie, 37, 51, 160n67

Rabaul, 55–56
race, xv–xvi, 23, 62–63, 74, 123, 128, 131–33, 159n61
racism, xiv, 47–48, 51, 62–63, 131–33, 161n82, 161–62n84, 162n102
Raphael, Ray, 34
Rear Window (film), 31–32
Rebel without a Cause (film), 132
rebellion: female, 129, 135–36; male, xi–xii, xv, 123, 127–29, 131–41, 175–76n50; modernist, 26–29, 126; youth, 124, 127, 131–41
Reed, Russ, 63
Riesman, David, 4, 128
Riis, Jacob, 65
Road to Victory (exhibition), 26
Rockefeller, Nelson, 27
Rodger, George, 6
Roosevelt, Theodore, 116
Rosenblum, Walter, 17, 28
Rosenthal, Joe, 53–55
Rothstein, Arthur, 65
Rotundo, E. Anthony, 116
Rubin, Enid, 8
Ruge, John, 9, 12
Rural Resettlement Administration, 65
Russell, Harold, 113
Russell, Jane, 106

Saks Fifth Avenue, 95
Salinger, J. D., 132
Salisbury, Harrison E., 135–36
Sands of Iwo Jima, The (film), 54–55
Sargent, Winthrop, 91–93
Sartre, Jean-Paul, 81–82, 85, 110, 184n48
Savage, Mike, 8
Scarry, Elaine, 46–47, 57
Scharfman, Herb, 121
Schlesinger, Arthur, Jr., 66–67, 165–66n30, 166n32
science, x, xiii, 14–18, 57–58
Sedgwick, Eve Kosofsky, 139
sexuality: female, 105, 135–36, 178n87; male, 105, 108, 129, 132–33, 135–36, 139, 160–61n69
Seymour, David (Chim), 6, 40
Shahn, Ben, 65

Shay, Art, 64, 164n15

Siegel, Laurence, 5

Silk, George, 34–35

Silverman, Kaja, xi

Siskind, Aaron, 22–24

Sixty Photographs: A Survey of Camera Esthetics (exhibition), 26

Smith, George Kidder, 26

Smith, Gen. Holland M., 54

Smith, W. Eugene, 3, 15, 34, 37, 51–53, 157n25, 162n86, 162n89, 166n35

Snow, Carmel, 88

social-documentary photography, xiv, 17, 23, 65–68, 70, 125–26, 130–31, 134, 164n21

social-landscape photography, 134

Solomon-Godeau, Abigail, xii, 23

Spanish-American War, 33

Spanish Civil War, 37, 40

Spillane, Mickey, 72

sports, 116, 119; and formation of masculine identity, 120–23; photography, xv, 33, 119–23

Sports Illustrated (magazine), 119–23

Starr, Joyce M., 9

status: anxiety, 3–4, 6, 18; of photography as a career, 4–7, 16–18

Stearns, Peter N., 10

Steichen, Edward, ix–x, 5, 25–29, 35, 42–43, 45–48, 64, 66, 124–26, 142; *Blue Ghost, The,* 45–49, 160n66, 165n28

Steiner, Ralph, 69

Stephens College, xi

Stern, William, 119

Stewart, James, 31

Stieglitz, Alfred, xiii, 17, 19, 21, 25, 27–28, 65, 68, 154n140

Stouffer, Samuel A., 34

Strand, Paul, xii, 5, 17, 19–21, 25–26, 28, 65, 70

Strecker, Edward A., 11–12, 129

street photography, xiv, 68, 75, 78–85, 131; gendering of, 70, 84–85

Stryker, Roy, 3, 65

Susssman, Aaron, 71

Szarkowski, John, xiii, 142

Tajiri, Vincent, 111

Talese, Gay, 104

Tarawa Island, 35

tattoos, 45–46, 136–37, 139, 161n70

television, x–xi, 2, 116, 119, 124, 129, 142, 171n99, 182n14

Theweleit, Klaus, 44, 51

Thomas, Calvin, 84

Thompson, Edward K., 13

Thompson, Kay, 88

Tichenor, Jonathan, 95

Truman, Harry S., 66

Truman Doctrine, 42

Tuggle, Catherine, 43

Tulchin, Lewis, 107–9

U.S. Army, 33, 37

U.S. Camera (magazine), 109, 124

U.S. Camera Annual, 27, 35–37, 51, 55, 57, 112, 124, 126

U.S. Information Agency, ix, 27

U.S. Male (magazine), 111

U.S. Marine Corps, 35–36, 40–42, 51–55, 162n92

U.S. Navy, 42–43, 45–51

U.S. Post Office, 111

U.S.S. *Eldorado,* 54

U.S.S. *Lexington,* 45–48

U.S.S. *New Jersey,* 49–51

U.S.S. *Saratoga,* 55–56

Vandivert, Bill, 6

veterans, xi, 4, 113–14

Vickers, Yvette, 129

Vietnam War, 142, 159n61

violence, 46–47, 54–59, 70–72, 74, 80–81, 118–19, 121, 130–32, 139

Vogue (magazine), 69, 89, 95–96, 124

voyeurism, xiv, 59, 70, 76, 177n81

Walcott, Joe, 121

warrior ideal/values, xi–xii, 7, 34–35, 44, 54–55, 134, 138, 156n15, 159–60n62, 160n68; and combat photography, 35–43

Warshow, Robert, 72, 118

Wayne, John, 54

Weegee (Arthur Fellig), xiv, 5–6, 68–79–80, 84–85, 87, 166–67n41, 167n46, 167n49, 167n52, 169n63, 169n68, 170n83; *Naked City,* xiv, 69–78, 167n45; *Naked Hollywood,* 69; *Weegee by Weegee,* 70; *Weegee's People,* 69

Weegee by Weegee (Weegee), 70

Weegee: Murder Is My Business (exhibition), 69

Weegee's People (Weegee), 69

Weiner, Dan, 15

Westerbeck, Colin, 79

Western, the (genre), 23, 81, 117–18, 121, 130, 136, 171n99, 182n14

Weston, Edward, 19–21, 23–26, 65, 107, 153–54nn131–32

Wetenhall, John, 53–55

Whelan, Richard, 38

White, Minor, 5, 18, 20, 23, 28, 124–26

Whyte, William H., 32, 128; *Organization Man,* 128

Wild One, The (film), 131

Willard, Frances, E., 2

Williams, Linda, 107

Wilson, Colin, 84

Wilson, Elizabeth, 71

Winogrand, Garry, 134

Witz, Anne, 8

Wolcott, Marion Post, 65

women: as amateur photographers, xiii, 2–3; as emasculators, 11, 100–101, 129; as photographers' wives, 7–9; as professional photographers, xiii, 13–14, 63, 90, 164n11; role in formation/maintenance of masculinity, x–xi, 13, 100–101, 113–16, 168n54, 181n4; vilification of, 99–101

Wood, Norton, 120

World War I: photographs of, 33; trauma of, 145–46n6

World War II, xiv; and manhood, 34–37, 44, 159n61; photographs of, 29, 33–34, 42–43, 159n54; pinup photography during, 106; trauma of, xi, 114–15

Wright, Morris, 64

Wylie, Philip, 12–13, 99–101, 129; *Generation of Vipers,* 12, 99, 129, 176n51

Yahn, Erle, 90

Yalta Conference, 42

Yank (magazine), 36

Yeager, Bunny, 104

Ylla (Kamilla Koffler), 13

Zanutto, James M., 126

Patricia Vettel-Becker is assistant professor of art history at Montana State University–Billings.